ART PHOTOGRAPHY NOW

ART PHOTOG

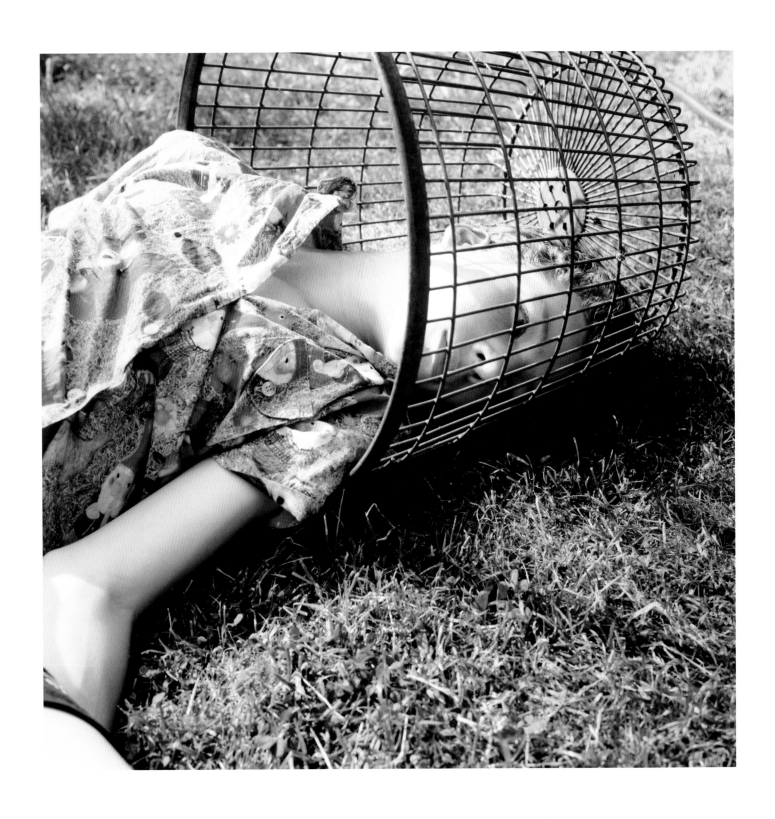

RAPHY NOW

SUSAN BRIGHT

aperture

Published by arrangement with
Thames & Hudson Ltd, London
© 2005 Susan Bright

First Aperture edition
Printed and bound in China by C&C Offset Printing Co., Ltd.
10 9 8 7 6 5 4 3 2 1

Library of Congress Control Number: 2005926074
ISBN 1-931788-91-X

Book and jacket design by Anna Perotti

Aperture Foundation books are available
in North America through:
D.A.P./Distributed Art Publishers
155 Sixth Avenue, 2nd Floor
New York, N.Y. 10013
Phone: (212) 627-1999
Fax: (212) 627-9484

aperturefoundation
547 West 27th Street
New York, N.Y. 10001
www.aperture.org

The purpose of Aperture Foundation, a non-profit organization, is to advance photography in all its forms and to foster the exchange of ideas among audiences worldwide.

For Mike

Thank you to all the photographers, artists and galleries who gave their time and energy to the project.

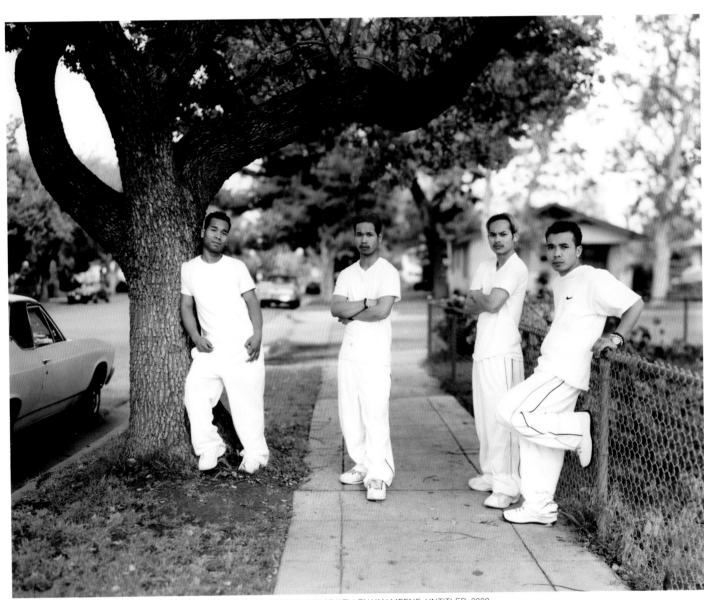

ABOVE RICHARD RENALDI, FRESNO: DY, THAI, SOKHA AND LAY, 2003 TITLE PAGE HELLEN VAN MEENE, UNTITLED, 2000

'This is part of a series from Fresno, California. I wanted to show the beauty of the people and the environment. I saw the four guys getting out of a house and I thought they looked amazing. What was funny was that they had just come from a portrait studio where they had had their portraits taken, which is why they are all dressed alike. They are cousins, even though they look like a gang.'

CONTENTS

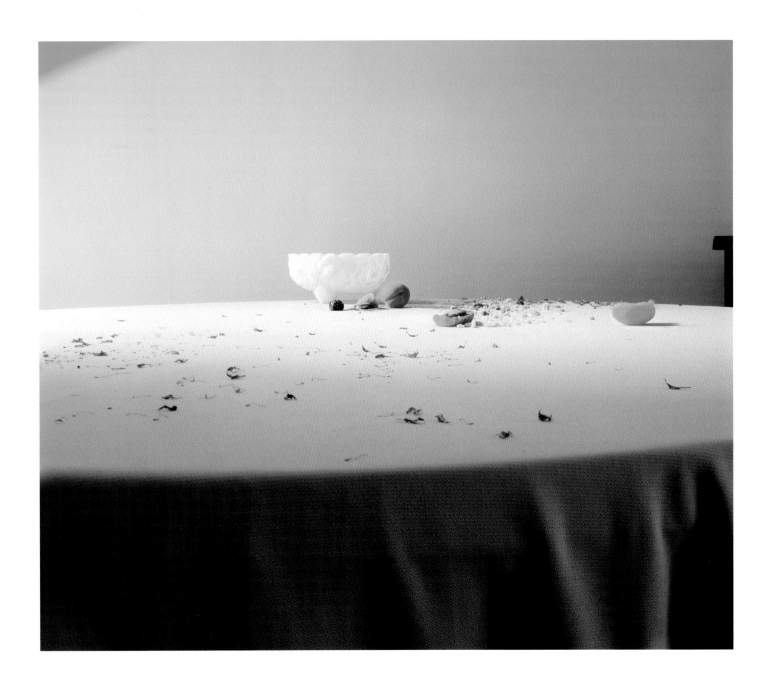

LAURA LETINSKY, I DID NOT REMEMBER I HAD
FORGOTTEN: UNTITLED #80, 2003
LETINSKY'S ENTIRE STILL-LIFE SERIES IS CALLED
HARDLY MORE THAN EVER, A PHRASE TAKEN FROM
GERTRUDE STEIN'S NOVEL *TENDER BUTTONS* (1914).
THE TITLE OF THE FIRST PART (1997–2001), *MORNING
AND MELANCHOLIA*, IS A PLAY ON FREUD'S ESSAY
'MOURNING AND MELANCHOLIA' AND THE LATER
IMAGES FALL UNDER THE TITLE *I DID NOT REMEMBER I
HAD FORGOTTEN*. THE IMAGES OSCILLATE BETWEEN
PASTEL AND ACID HUES, WITH THE LATER WORKS
BOLDER IN COMPOSITION.

INTRODUCTION

'The discovery of photography was announced in 1839. Quite optimistically, many artists held the view that it would "keep its place" and function primarily as a factotum *to art. But this was both presumptuous and futile.'* Aaron Scharf [1]

Photography is constantly changing and hard to define. Its discursive and somewhat promiscuous nature has tended to confuse many people as to its status and value as an art form. The trouble is that it lends itself to many varied uses. We see photography in newspapers, surveillance, advertising campaigns and art galleries, and as fashion shots or family snaps. Meanings can slip and slide depending on context, and the fact that photography lacks any kind of unity and seems to have no intrinsic character makes the insistent cry of 'but is it art?' a constant refrain throughout its relatively short but complex history.

What is more, photography's mechanical nature, its prolific use in the commercial sector, its ability to constantly reproduce itself and its apparent lack of 'artistic' skill have also fuelled criticisms that have dogged the medium since its invention in the 1830s. French poet and critic Charles Baudelaire's protestations against the display of the photographic portraits of Nadar (Gaspard-Félix Tournachon) in the Paris Salon of 1859 sum up persistent (though now somewhat redundant) feelings regarding the intrusion of the machine into the realm of fine art: 'We must see that photography is again confined to its real task, which consists in being the servant of science and art, but a very humble servant like typography and stenography, which have neither created nor improved literature.'[2]

And yet this 'humble servant' has now become the medium of choice for many artists, as contemporary art has become increasingly photographic. Indeed, the very fact that it has inextricable ties with other fields such as science or journalism is one of the reasons why it is so attractive to some. Artists have taken the criticisms, or ignored them altogether, and used photography to their own advantage to create work that smashes through definitions of what art is and what it is not. We are now at a point where challenges to photography's status have been exhausted, and it goes without saying that it *can* be art. Its high-profile presence in contemporary exhibitions at major international art museums signals its importance, as does its ever-increasing market value. And as more and more people – both individuals and institutions – collect photography, the traditional divisions between what comes under the domain of museums' photographic collections and what is the responsibility of contemporary art departments are being rethought. National art galleries, which in the past often held snobbish attitudes towards 'mere' photography, are now re-examining their collections and filling in gaps as the history of the medium is re-evaluated; museums that previously had no photography collections at all are now beginning to establish them.

This book does not distinguish between terms such as 'art photography' and 'artists using photography', but instead seeks to examine work that is interesting, regardless of who has made it.[3] Some of the image-makers here refer to themselves as artists; others call themselves photographers. Some show their work primarily in the pages of magazines or books; others operate purely in the gallery arena. Many work in other media too, such as film, video and installation. For these practitioners and others like them, such definitions and titles do not matter; what does count is that the work communicates intelligent ideas that are worthy of attention, appreciation and investigation.

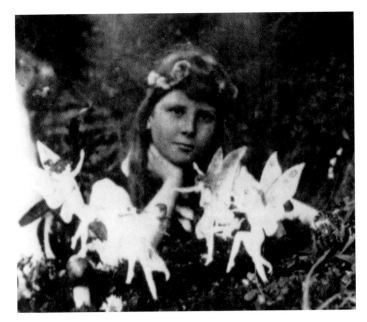

Interestingly, as we reach this stage in the acceptance of photography, new areas of confusion are emerging. Just as we think we are beginning to recognize the medium, or at least to characterize it, important technical changes see certainties slip through our fingers once again. Just as earlier technical breakthroughs, such as the use of colour, were once hurdles for some, photography has recently begun to mutate again, and not without controversy. The digital revolution has impacted in ways that would have been unimaginable only a few years ago, causing some to ask not 'Is this art?' but 'Is this photography?' However, this dynamism and volatility in photographic practice are not the final blows to the medium, as so many purists would claim, but vital developments that are important to its existence. The application of digital technology has helped open up debates, not only about photography's future, but also its past and its present.

Today we are a sophisticated audience, used to seeing cynical distortion of images in the media and body and head swaps on the internet, and software such as Photoshop has made photographic manipulation open to anyone with a computer. This demystification of process has made us aware of how easy it is to distrust a photograph. Digital techniques, from touch-up to total construction, are now as much a part of

ELSIE WRIGHT, FRANCES AND THE DANCING FAIRIES, 1917
THE ORIGINAL TITLE OF THIS PICTURE, *ALICE AND THE FAIRIES*, IS THOUGHT TO REFER TO THE NAME GIVEN TO FRANCES GRIFFITHS BY SIR ARTHUR CONAN DOYLE (THE CREATOR OF SHERLOCK HOLMES AND A STRONG PROPONENT OF SPIRITUALISM) IN AN ATTEMPT TO CONCEAL HER IDENTITY, ALONG WITH THAT OF ELSIE WRIGHT, WHEN HE PUBLISHED THE PHOTOGRAPHS AS 'PROOF' OF THE EXISTENCE OF FAIRIES IN *STRAND MAGAZINE* (1922).

photographic practice as the darkroom once was, and just another example of how technical advances affect photography's ever-changing identity. The impact of this digital technology has seen some theorists describe the current situation as being 'post-photographic'. But instead of employing one single overarching term that can never adequately cover the breadth and depth of the medium, it is probably better to think of there being several photograph*ies*.

One reason why digitalization makes many observers uncomfortable is that it takes us away from reality and into the realm of fantasy, an area which at first seems at odds with a seemingly objective and descriptive medium. However, the photograph's role as a conveyer of 'truth' or as a trace of reality has long been contested; and photographs have always been manipulated, whether in the taking or in the printing process. Tricks of the trade such as splicing and double-negative printing have been part and parcel of photography since the nineteenth century, and the contemporary urge to escape into a fantasy world through photography has parallels with the medium's early days. In the domestic sphere there are fine examples of family albums

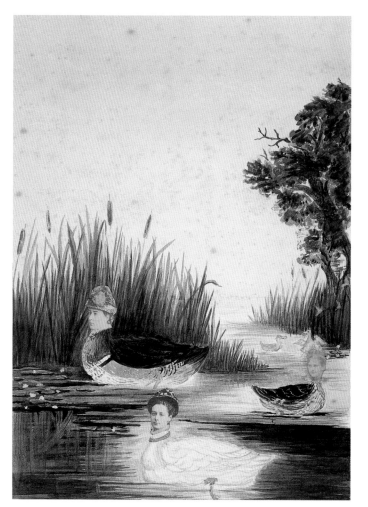

that were elaborately collaged and painted upon with fabulous pre-Surrealist narratives, quietly, and perhaps unconsciously, deconstructing the ideology of the Victorian family. Perhaps the most elaborate and amusing example is that compiled by the early British photographer Kate E. Gough in the 1860s, now held in the Victoria & Albert Museum in London. As critic Marina Warner put it, 'Her mixed-media treatment of family snaps has a wild wit that prefigures the collage novels of Max Ernst half a century later.'[4] Deflationary scenes of family members transformed into ducks and monkeys can be read as subversive and gentle protests against the order and categorization of regular carte-de-visite albums with their rigid display panels and sanctimonious Bible-like appearance. Also in the domestic realm, fantastical flights of fancy became public when, famously, in July 1917, fifteen-year-old Elsie Wright and her nine-year-old cousin Frances Griffiths produced five fairy photographs now known as the *Cottingley Fairies*. These charming images were believed to be proof of the existence of other-worldly creatures, although in fact the 'fairies' had been cut out of magazines and made to stand up with hatpins. The hoax was not uncovered until many years later. The collective disappointment showed the extent to which photography's role as 'evidence' was fundamental to the way it was understood as a medium.

While both examples might be written off as harmless child's play, the Victorians' use of photography in science (or, more accurately, the pseudo-sciences of physiognomy and phrenology) relied heavily on the photograph's role as evidence. And yet here, too, we find that manipulation existed very early on in the medium's life. By layering negatives on top of one another, scientists created composite portraits that were hailed as a method for parents to see what their future children might look like. More sinisterly, they were used as validations of Jewish 'identity' and other 'types' such as criminals and ethnic groups. The same method has been used, but with an enquiring postmodern approach, by contemporary artists such as Thomas Ruff in his *Other Portraits* (1994–5) and in the continuing work of Nancy Burson. Both use digital imaging to debunk ideas of archetypes and employ photography's supposed objectivity, if only to expose it as a fiction.

ATTRIBUTED TO KATE E. GOUGH, UNTITLED (DUCKS), c. 1870
THE PLAYFULNESS THAT CAN BE SEEN IN MANY, MAINLY BRITISH, NINETEENTH-CENTURY ALBUMS WAS SHORT-LIVED. THE DOMAIN OF THE FEMALE OF THE HOUSEHOLD, THE ALBUM MIXED PHOTOGRAPHY WITH THE SUPPOSEDLY 'FEMININE' ARTS OF WATERCOLOUR AND DRAWING. A WONDERFUL DISREGARD FOR THE FINAL IMAGE CONTRASTS WITH THE PRECIOUS, CHRONOLOGICAL APPROACH TO THE FAMILY ALBUM THAT AROSE IN THE TWENTIETH CENTURY.

Science, art and photography have long had close ties, especially in the field of psychoanalysis. Freudian concepts of the unconscious and phantasy reverberated through Surrealist photographic practice of the 1920s and 1930s, and continue to be influential in the making and interpretation of art photography. Not all Surrealist images used 'tricks' or manipulated photographs, however: writers such as André Breton employed 'straight' photographs in order to illustrate their texts and ideas. Perhaps the most influential piece of writing of the 1930s that addressed the nature of photography was 'The Work of Art in the Age of Mechanical Reproduction' (1936) by the German critic Walter Benjamin. In this famous essay, in which the late-nineteenth-century French photographer Eugène Atget is presented as a forerunner of Surrealism, Benjamin talks of the 'optical unconscious' and the ability of photography to open up spaces that previously existed only in dreams – things that had never been consciously seen, let alone reproduced: 'the camera introduces us to unconscious optics as does psychoanalysis to unconscious impulses'. [5]

The writing of Walter Benjamin was especially important to artists working in the late 1960s and 1970s, one of the richest periods of photographic history. The art of this moment grew out of a diversity of critical positions informed by a range of issues, ideas and theories such as Marxism, gender, race, postcolonialism, literary theory, anthropology, art history and social history, and aimed to strip photography of any supposed guarantees. Artists such as Andy Warhol, Robert Rauschenberg, Ed Ruscha, William Wegman, Dan Graham, Larry Sultan and Mike Mandel played with context and probed the belief in the photograph as evidence, questioning its relationship to realism and reality in provocative ways. They made the photograph a perfect means of redefining aesthetic experience and transgressing the medium-based categories and inherent elitism of modernism. In the words of the current Chief Curator of Photography at New York's Museum of Modern Art, Peter Galassi, 'Tinkering with the artless sincerity of the most banal photographs – passport portraits, real estate ads, textbook illustrations – these artists make a world of engaging mischief. The appealing wit of their pseudo-documents and photographic conundrums undermined the presumed reliability of photographic fact, showing that what we see always depends in part on what we expect to see.' [6]

This investigation into the multiple roles and contexts of the photograph rocked the very grounds on which photographic modernism had been built in the early decades of the twentieth century. The stylistic elegance of photographers such as Ansel Adams, Paul Strand, Imogen Cunningham and Edward Weston had an eloquence based on formal control and photographic 'purity', and they strove to have their work received and understood as art. Their status in photographic history has much to do with the earlier campaigning of photographer, gallery director, writer and editor Alfred Stieglitz. He fought to position photography as an equal with painting and at the polar opposite of what he considered crass commercial imaging. [7] By creating a specialist market for art photography and becoming a guiding spirit to Beaumont Newhall (MoMA's first curator of photography), Stieglitz was a crucially important advisor on what and whom MoMA should collect and display as photographic art and therefore was a major influence on photography's status in American art. [8]

Stieglitz held fast to the belief that art photography was special and had nothing to do with the commercial roles of the medium. It was somewhat paradoxical, therefore, that Pop artists such as Warhol and Rauschenberg and later Conceptualists such as Ruscha and Graham saw photography as a medium of anonymity and function, rather than considering photographs as beautifully crafted objects, and exploited this with their art. Both Warhol and Rauschenberg celebrated the vernacular and commercial representations of popular and capitalist culture. By adopting the mechanical, mass and lowly elements of photography, both artists would conspire to create an atmosphere in which hybrid practices of art and commercialism prevailed. Their use of photography as a tool to question and critique the medium itself, and to examine its place in society, paved the way for lens-based media to become a major part of contemporary art practice.

The questioning of the relationship between value and form was exacerbated later in the twentieth century in what became known as the era of postmodernism. Postmodernist art and theory asked questions about the place of images in our culture, who produces them and also who *re*produces them. Postmodernists considered form (in this case art, but also everyday language, literature, advertising, fashion, film) as the embodiment of the values of a given society, not as a transparent and neutral carrier of meaning, as pure modernists would have it. And since they also explored the question of who defines those values, postmodernists saw form as embodying the power relations at work in society – between classes, between genders, between races,

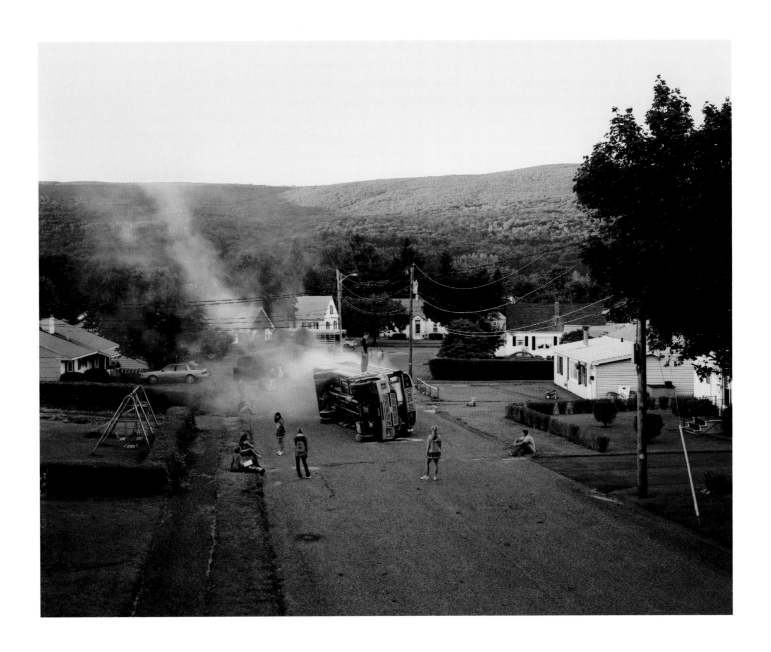

GREGORY CREWDSON, TWILIGHT: UNTITLED (OVERTURNED BUS), 2001–2
CREWDSON WORKS WITH A PRODUCTION TEAM OF UP TO SIXTY PEOPLE,
INCLUDING A CINEMATOGRAPHER AND DIRECTOR OF PHOTOGRAPHY.
THE TITLE *TWILIGHT* WAS CHOSEN BECAUSE OF A PRAGMATIC DECISION TO
PHOTOGRAPH AT THIS TIME – ARTIFICIAL AND AMBIENT LIGHT WORK WELL
TOGETHER – AND ALSO BECAUSE OF ITS MYSTERIOUS CONNOTATIONS.

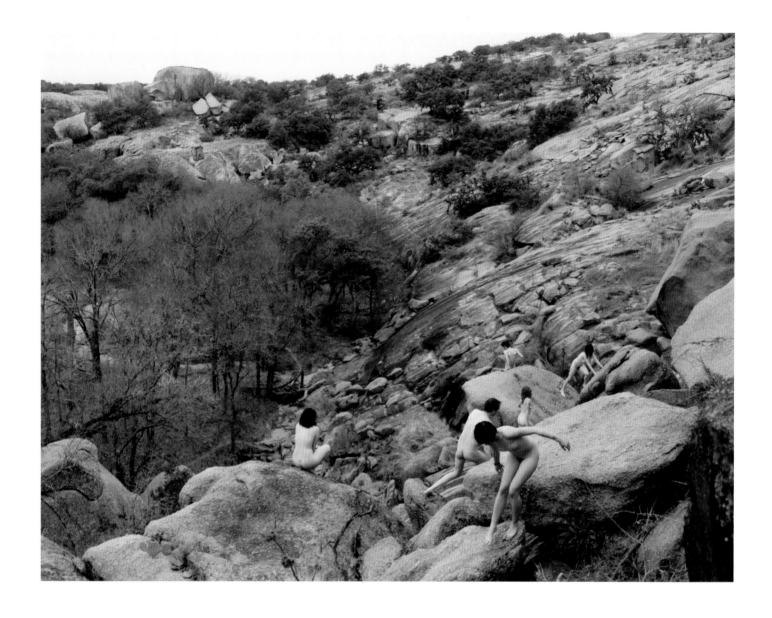

JUSTINE KURLAND, HOUSES OF THE HOLY, 2003
THIS IMAGE, THE TITLE OF WHICH REFERS TO THE
1972 LED ZEPPELIN ALBUM, COMES FROM A SERIES
PRODUCED DURING A SIX-MONTH ROAD TRIP IN 2003.
KURLAND'S WORK, IMBUED WITH A SENSE OF MYSTERY,
REFERENCES MYTHOLOGICAL BEINGS AND FAIRY
STORIES AND OFTEN FEATURES NAKED PEOPLE EXISTING
IN THE LANDSCAPE IN A PRIMAL OR EDENIC WAY.

and so on. Postmodernism impacted on art photography in vital ways. It exposed how photography was used and understood as a medium, as a material and as a message; and the study of 'great' masters became increasingly irrelevant and problematic, since a work was no longer seen as the creation of a single 'author' who retained the monopoly on its meaning but as the product of a certain context with a multiplicity of meanings. One group of artists in particular – among them Barbara Kruger, Richard Prince, Sherrie Levine, Martha Rosler and Cindy Sherman – were influenced greatly by postmodernist theory in the mid- to late 1970s and early 1980s. By mocking aspects of the mass media, both Kruger and Prince, for example, revisited codes of representation (especially of sexuality and gender) by appropriating images originally used in advertising and re-presenting them in the gallery space. This change of context and conceptual understanding exposed the images' multiple viewpoints and possible meanings.

So, as we search for a definition as to what photography actually is and the varied ways in which it has become accepted as art, we repeatedly see a collapsing of boundaries that may seem rather at odds with the more traditional genre-based way in which this book is structured. As with any project that aims to bring together a diversity of artists, some kind of categorization is needed. The decision to use traditional genres – document, narrative, landscape, etc. – was, on the one hand, a pragmatic one. But by placing what may seem like limitations on how we understand certain photographs, I have also attempted to show how these classic genres have been reinterpreted by contemporary artists, and how they often overlap. Much of the work in the book refuses to be pigeonholed and could easily sit in another chapter. With this in mind, one will find that less tangible themes – such as memory, time, space and, of course, identity (both of the medium itself and of the subject) – cut across the book's formal structure.

The portrait is without doubt the most popular form in contemporary art photography and there has been a rush of exhibitions on the theme over recent years. The human face has long been read as a 'window' onto the soul of a person, and early photographic portraits, like their painted equivalents, were certainly read in this way. But in the late twentieth century, with the debunking of the idea of essences (of both the photograph and the sitter) has come a sustained questioning of what a photographed portrait is. Is it all about surface appearance or can it communicate something more?

What remains true, however, is that the portrait continues to function as an index and a symbol, an icon and a metaphor, making claims about 'humankind'. As viewers, when we engage with another human face, we often feel moved to make comparisons with ourselves, to sympathize or empathize with the subject. At the same time, some of the work in this chapter taps into insecurities surrounding such problematic territories as cosmetic surgery, cloning, and issues of privacy. The self-portraits in this chapter are different. Addressing questions of personal identity more acutely, the artists who work with their own image show us that identity is fluid and interchangeable, depending on our surroundings and those around us. The use of the mask, and the play between what is revealed and what is disguised, is central to self-portraiture as artists offer different versions of themselves up to the camera. Gender, sex, age and personalities are all adopted and discarded for the camera and scenarios are performed in a process that continuously picks away at the 'self' of the self-portrait.

Strange as it may seem at first, investigations into personal identity can also be seen in the landscape chapter. The search for 'man's' place in the world and age-old questions of nature and culture are at the core of many of the artists' work here. As writer and theorist David Campany has pointed out, the camera and the land have had a long history together: 'As an invention of modernity, photography was central to the desire for a control and ordering of the natural world. It could map terrain topographically in preparation for urban expansion.'[9] It could document the huge changes to the land being wrought by industrialization, commenting upon – and, more often than not,

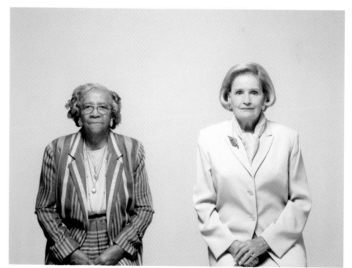

JULIE MOOS, DOMESTIC (MAE AND MARGARET), 2001
SOME PHOTOGRAPHERS QUESTION THE NATURE OF THE TRADITIONAL PORTRAIT FORMAT AS THEY EXPLORE ITS POSSIBILITIES. AMERICAN ARTIST MOOS ADDRESSES THE DELICATE POWER BALANCES OF RELATIONSHIPS. THESE RELATIONSHIPS MIGHT BE PERSONAL (*FRIENDS AND ENEMIES*, 1999–2000), BETWEEN EMPLOYER AND EMPLOYEE (*DOMESTICS*, 2001) OR GENERATIONAL (*MONSANTO*, 2001). THE PRESENTATION OF TWO PEOPLE ENCOURAGES THE VIEWER TO MAKE COMPARISONS BASED SOLELY ON APPEARANCES.

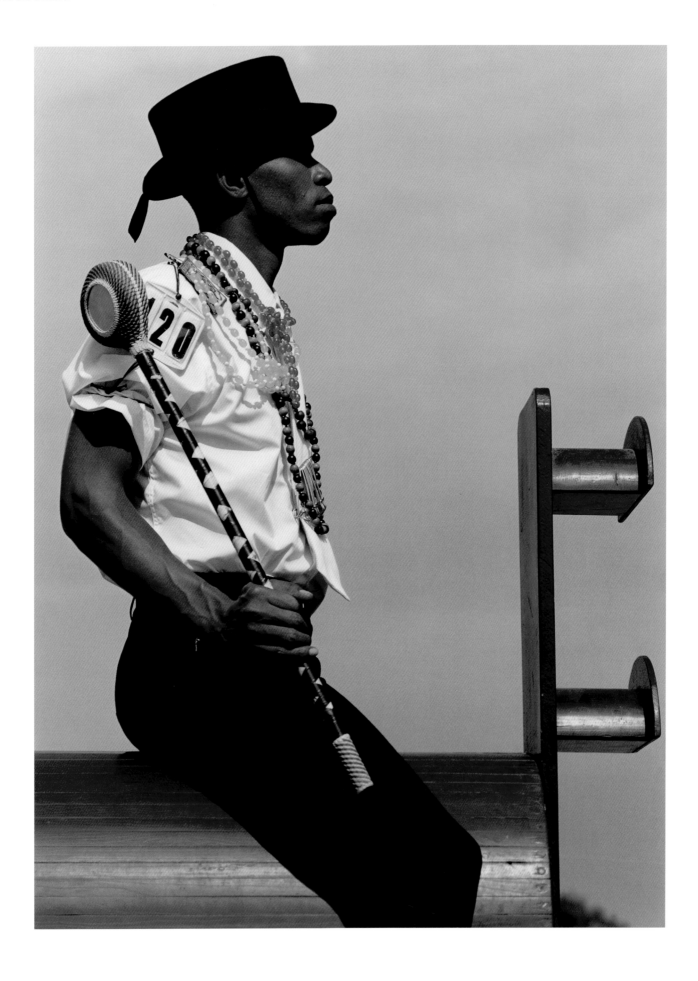

critiquing – so-called progress. As our relationship with the land became increasingly complex in the twentieth century, there was a horrific realization that in the battle between nature and culture, culture might actually be winning. The cost of human consumption remains a subject for many of the artists in this chapter, along with associated issues of preservation and alienation. At the same time, landscape – often following the example of painting – can also offer a form of escape, nostalgia and fantasy away from all that is man-made and 'unnatural'. Perhaps one of the most interesting aspects of the genre is that many contemporary photographers still take painting as their point of reference, whether to critique it explicitly or to borrow and make use of its aesthetic or metaphorical signs and symbols.

The works in the third chapter, 'Narrative', explore elements of fiction and the relationship of photography to reality and realism. Highly dramatized lighting, artificial and often unlikely settings and filmic sensibilities let the viewer know immediately that we are in the realm of fantasy and artifice. We are not fooled into believing that these are snatched moments from the 'real world'. Cherry-picking their aesthetics from a wide range of sources from figurative painting, cinema and literature, these images do not claim to document or witness 'reality' but to fabricate and present an invented world of make-believe. The work in this chapter ranges from subtle comments on society to bombastic digital tableaux that have more in common with computer games and science-fiction movies.

The physical act of photographing something can in turn change its meaning. This is crucial to the fourth chapter, 'Object', and it is here that we turn most acutely to questions of photographic identity. Dealing with still life, experimental or abstract photography, deadpan investigations of objects in loaded spaces, and the photographic object itself, the artists featured constantly deal with questions of subjectivity and objectivity, photographic truthfulness and manipulation, and what makes a photograph and, indeed, an art work. With no set style, shared politics or obvious identity, such work demonstrates the diversity of contemporary art photography, from its variety of processes – from large-plate cameras to digital technology – to its range of influences, from important artistic pioneers to the vernacular and the commercial. The crossovers between other artistic media such as sculpture and still-life painting are also apparent in this chapter.

Compared to such traditional genres as portrait, landscape and still life, fashion photography is a newcomer. It has enjoyed unprecedented success in the art arena over the last ten years. British curator and writer Charlotte Cotton has written extensively on the crossover between fashion photography and art and has commented, 'At its best, this cross-fertilisation proffered experimental access for fine art photographers to the working practices of commercial image-making, as well as offering magazines direct engagement with the perceived prestige of fine art.'[10] Exhibitions and books have allowed fashion photographers' work to be reassessed and understood in different contexts from the magazine; and for artists, working for fashion magazines has presented different freedoms, opportunities and challenges. The images in this chapter show a combination of work done by artists for the fashion world, 'personal' work by fashion photographers, and work that enjoys equal status in both sites.

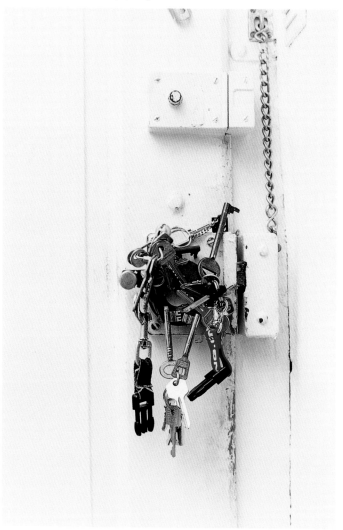

OPPOSITE KOTO BOLOFO, LESOTHO HORSEMEN, 2003
BOLOFO'S FASHION WORK IS BOLD, GRAPHIC AND STYLIZED. THIS SERIES, PRODUCED FOR ITALIAN *VOGUE*, MIXES AFRICAN ELEMENTS WITH THE UNIFORM OF SHOWJUMPING TO GIVE ITS SUBJECTS A DISTINCT NATIONAL IDENTITY.

ABOVE WOLFGANG TILLMANS, SCHLÜSSEL, 2002
TILLMANS' WORK REMOVES OBJECTS FROM THEIR BANAL, EVERYDAY FUNCTIONS. HERE A BUNCH OF KEYS IS TREATED ALMOST AS A STILL LIFE.

The sixth chapter, 'Document', is perhaps the most ambitious in its scope and brings together the widest range of practitioners. Documents have traditionally laid claim to certifiable truth. With traditional sites for 'documentary photography' such as photomagazines rapidly disappearing, there is an escalating presence in the gallery of work dealing with issues of the document. The decline of the supposed certainties of photography – such as authenticity and veracity – underpins much of the work in this chapter. It takes the term 'document' in its broadest sense and clearly challenges the more established view that a photograph is a way of recording and showing the social world. The latter reading assumes that photography is a 'neutral' medium that somehow bypasses subjectivity, prejudice and ideology and re-presents the world to us 'as it is'. New documentary strategies aim to get away from emotive photojournalism and social documentary that exposes some horrific human suffering, to find a slippery position somewhere between the traditional photographic document and the traditional art photograph. The documents in this chapter might be witnesses to a performative event, insights into intimate diaries usually kept private, or powerful political statements. We also see them function as anthropological tools or as a series of found images stripped from their original context, leaving the viewer to create imaginative narratives based on visual clues.

In many ways, it is the urban landscape that has perhaps become synonymous with photography, and it is to this that the final chapter turns. 'Street' photography evokes ideas of men snapshooting from the hip with 35-mm cameras, composing rhythmic and poetic images that capture the daily ebb and flow of humanity within the city. However, the increased use of large-plate cameras and the consequent slowing down of the photographic process have also had an important impact on how artists deal with the city. Panning out and taking a wider view causes one to see the city as a layering of moments in time, belonging to no one, more like an archaeological site – albeit one in which people live. Constantly changing, cities are both banal and beautiful, alienating and seductive. The mysterious spaces where cities stop and suburbia starts, or the sites one might hurry past in everyday life, are rich pickings for many of the artists in this final chapter. The act of photographing has the ability to turn what might be ignored into something much more profound. On another level, the increased threat of globalization and homogenization to the individuality of cities, and those who live in them, is a theme for some. The growing domination of Western culture and the apparent blending into one big global brand, where everyone looks the same and drinks the same coffee, is a very contemporary concern. Nowhere is this more vivid than in the cities of the Far East, which are undergoing redevelopment and transition faster than any other urban centres.

As all the work in this book testifies, photography is no longer a 'mortal enemy' or a 'humble servant' to art. It is currently enjoying significant re-evaluation in terms of its profile, acceptance and status. These developments mirror its exciting advances and shifts as a medium, and we can look forward to seeing more and more of it in contemporary art galleries and books, in whatever shape or form it may take.

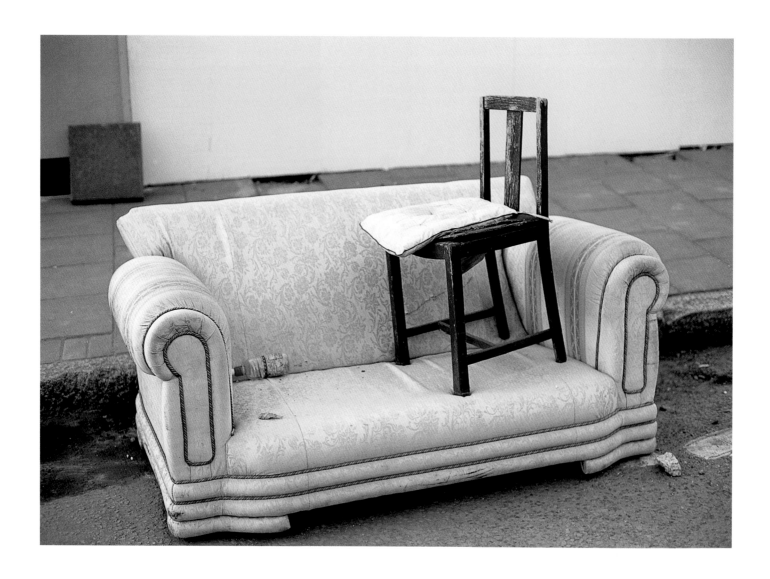

OPPOSITE BORIS MIKHAILOV, THE CITY (BERLIN), 2002–3
BORIS MIKHAILOV COVERS A WIDE RANGE OF
TOPICS AND USES A VARIETY OF APPROACHES,
FROM STAGED SCENARIOS TO DOCUMENTARY-STYLE
SHOTS OF THE CITIES IN WHICH HE TRAVELS AND WORKS.
RECENT WORK IN BERLIN, WHERE HE NOW LIVES, REVEALS
HUMOROUS JUXTAPOSITIONS, REPEATED THEMES AND
RHYTHMIC COMPOSITIONS.

ABOVE RICHARD WENTWORTH, KING'S CROSS, LONDON, 2001
DISREGARDED OR REDUNDANT OBJECTS – URBAN
FLOTSAM AND JETSAM – FORM THE SUBJECT MATTER
OF WENTWORTH'S PHOTOGRAPHIC WORK. BOTH
TENDER AND WITTY, HIS IMAGES CAPTURE THE
SUBTLE SURREALIST QUALITIES OF THE CITY
TO WHICH THE CITY DWELLER BECOMES IMMUNE.

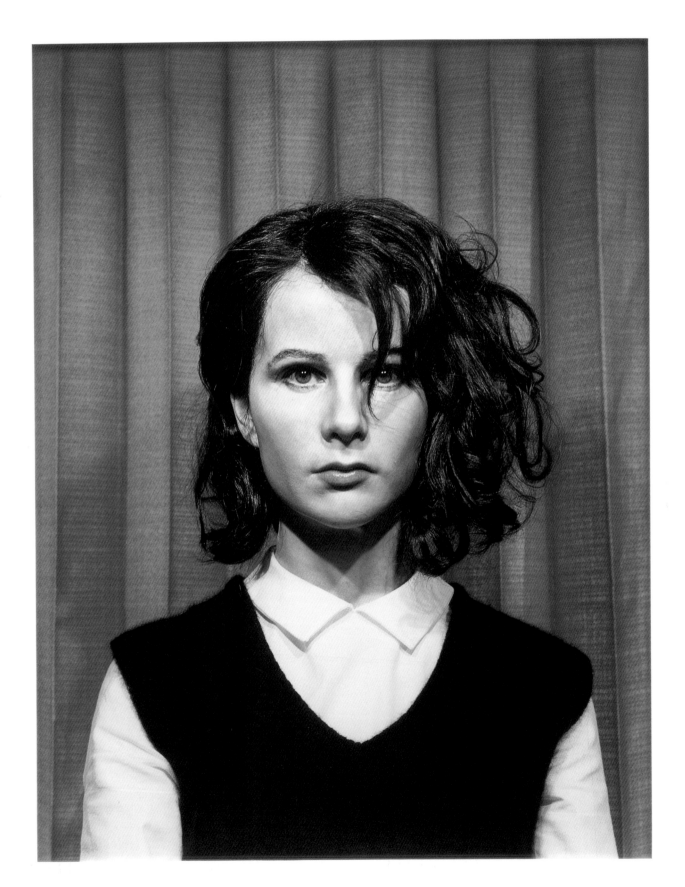

PORTRAIT

Laden with ambiguity and uncertainty, the portrait is perhaps the most complex area of artistic practice. Used by contemporary artists to explore issues of identity – national, personal or sexual the portrait has moved away from its commercial roots to become a powerful encounter or exchange between artist, sitter and spectator. Motivations and desires are never really clear and reactions to a portrait can vary enormously. To one it can be exploitative, engaging or ethically uncertain, and to another tender, informed and noble. These tensions make portraiture one of the most compelling of artistic genres and also one of the most popular.

Over the last ten years there has been a remarkable increase in the number of artists turning to the human figure (and more specifically the human face) and reworking the concepts behind photographic portraiture. Traditionally, the studio and the street have been the most established environments in which portraits have been made. Here there are recognized codes of conduct that result in portraits that we know how to read and understand. These codes and rituals are formed by a triangle of relationships between the sitter, photographer and spectator. On closer inspection the rituals between the three parties involved often become a complex interplay of power, positioning and performance.

Many photographers feel uncomfortable with the imbalance of control that a camera often offers and so question and play with the power exchanges at work. The dynamic approaches adopted by many artists are more interventionist, calling into question the nature of portraiture and representation and the very bedrocks of not only the painted, but also the photographic portrait.

A portrait is the questioning or exploration of self and identity through a literal representation of what somebody looks like. The paradox is that the inner workings of the complex human psyche can never really be understood by just looking at a picture. However much one is tempted to read a face subjectively for clues of someone's character, the many versions, and indeed the many selves, which can be fashioned in front of the camera can say anything the artist or the sitter wishes to say at that precise moment. Furthermore, the viewer of the photograph then adds his or her experience to it to create another version of its meaning. However much we want to capture a person's true personality with a camera, it just isn't possible. If you put a different caption under the image or change its context, the meaning will change with it. Identity can be changed in an instant.

This belief in a personal essence or soul, so deeply rooted in the tradition of painted portraiture, and carried over to the photograph, has been the subject matter of many twentieth-century artists and is the touchstone for Cindy Sherman. Her work is not concerned with finding an essential core but with debunking it. Her work focuses on the postmodern belief that our identities are made up of multiple selves dished up and adopted in a series of performances and masquerades in order to fit in with how culture has defined and determined us. Her work has been hugely influential and one can not really consider a contemporary self-portrait without first understanding what Sherman has done for the genre.

Her landmark *Untitled Film Stills* series (1977–82) is a series of sixty-nine small black-and-white images, which resemble publicity shots, not only as objects but also in their subject matter. The final art objects are cheap glossy 8x10 resin prints, a far cry from the mannered fine art prints associated with art photography before the 1970s. Taking her influence from post-war movies and the fictional femininity that was peddled through the media, Sherman adopts the roles of stereotypical and clichéd women familiar to us all through our knowledge of the cinema. She plays her roles with sincerity, and she is indeed an extraordinarily good actress. She is utterly believable in her own fantasy world. Throughout her career she has looked to other sites of presumed femininity including the centrefold, historical painting, the fashion photograph and, most recently, the vernacular studio portrait.

Her work has complicated the term self-portrait. Are we looking at Cindy Sherman or at a photograph of another person? It's never really clear. Similar

approaches to 'self-portraiture' and the consideration of multiple identities can also be seen in the work of a generation of artists who emerged in the 1990s. Nikki S. Lee, Samuel Fosso and Gillian Wearing engage with those theories and ideas now associated with Sherman's work and use them to investigate issues of identity central to their lives: class, race and gender. There is room for everyone but inevitable comparisons do make it hard for such work to be valued on its own terms.

This deliberately ambiguous strategy of 'performed' portraiture is just one of many approaches that artists have adopted to deconstruct and question what a portrait can do and how it functions. Traditionally portraits have used clues or props to tell the viewer more about the sitter's personality and to give the sitter a context in which to be understood. If one sees a photograph of a person with a violin we can make the assumption that the person is a musician. It's a simple device that is used most noticeably in the studio, where the person is taken out of context and stripped of any other visual clues that may inform the viewer about their character or profession. But these strategies are also deceptive as they are conscious decisions by either the photographer or sitter to show a public face. In many ways the very best portraits take on board the ambiguities and question what can't really be articulated or identified of a person in terms of an image.

Much of contemporary photographic portraiture sees a removal of clues and contexts and a highly formal, almost scientific and clinical approach which leaves the sitters with nothing to hide behind. The level of scrutiny involved is obvious, leaving the viewer less room to understand the function and meaning of the work since many frames of reference are removed. The strength of these works lies in the uncertainty, as it's not only the 'who' that fascinates us but the 'why'. Why would a person allow such interrogation – not only by the photographer but also by the audience?

The use of a large-plate camera to produce such portraits again slows the process down and enables a very different kind of relationship to be built. In a way it is a more collaborative technique, but such a large piece of apparatus demands a seriousness far removed from that of the casual snap. We do not know how to behave in front of such apparatus, as it is not our everyday experience of a camera, and so formality and awkwardness also become part of many of the portraits here. As the apparent demand for celebrity portraiture is on the rise, artists use the portrait to delve deeper into the ways in which we understand what has in the past been referred to as the 'human condition'. Artists take their inspiration not only from the grand traditions of portraiture but from the more vernacular and commercial uses of the medium. There are those who probe and question issues of identity by presenting to us the masquerade and falsehood of the photographic process of self-portraiture and those who shift the emphasis onto the viewer, forcing them to bring their assumptions and misconceptions to the work to inform the reading of the image.

HELLEN VAN MEENE

VAN MEENE IS BEST KNOWN FOR HER COMPELLING IMAGES OF GIRLS AND YOUNG WOMEN WHO HAVE THE TRANSITIONARY TRAITS OF PUBERTY. THE IMAGES OFTEN SHOW A COMBINATION OF CONTRADICTORY DEVELOPMENTS IN TEENAGERS SUCH AS AWKWARDNESS AND SENSUALITY, VULNERABILITY AND CONFIDENCE. THE AWKWARD POSES AND UNUSUAL POSTURES CREATE A CURIOUS UNDERLYING TENSION THAT CONTRASTS WITH THE NATURAL LIGHT WHICH BATHES THE IMAGES IN AN ALMOST ROMANTIC GLOW. THE PEOPLE WITH WHOM VAN MEENE WORKS OFTEN SEEM TOTALLY SELF-ABSORBED AND PREOCCUPIED IN PRIVATE THOUGHTS OR ACTIVITIES, AS IF THEY ARE UNAWARE OF THE ARTIST DIRECTING THEM IN CAREFULLY CONSTRUCTED MISES-EN-SCÈNE.

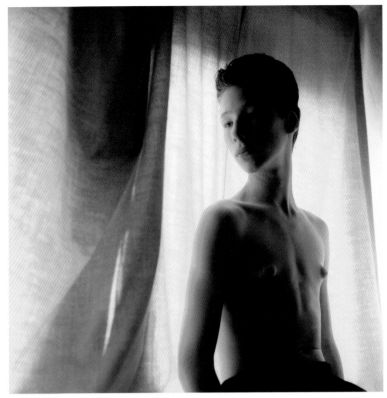

ABOVE HELLEN VAN MEENE, UNTITLED, 2000
RIGHT HELLEN VAN MEENE, UNTITLED, 2000

'I first started photographing boys in 1998, but I was unsure if I was ready for it. I didn't photograph any more boys until 2000, when I saw Laurence again. He is the brother of a girl who had modelled for me. He had that mixture of feminine and masculine qualities that some boys of that age can have. At a certain age boys have something very soft about their faces and gestures and I think it's that which attracts me.

I always direct my models but of course they put their own personality into the picture. I always have a fixed idea in my head but it can also be open to new things spontaneously happening, so it can evolve a bit like theatre. I present myself as the person who is in control and knows what they are doing in order to help my models relax and give them a hand with the situation, especially as they are not professionals. I ask them to do some quite unusual things, but they always trust me completely.'

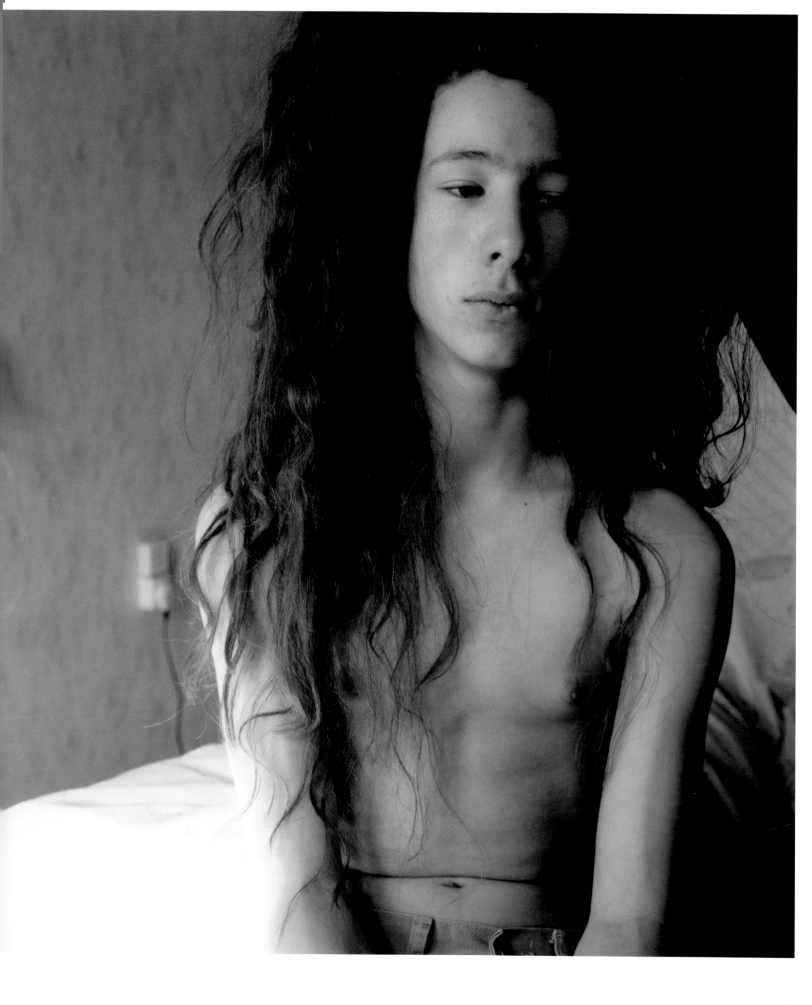

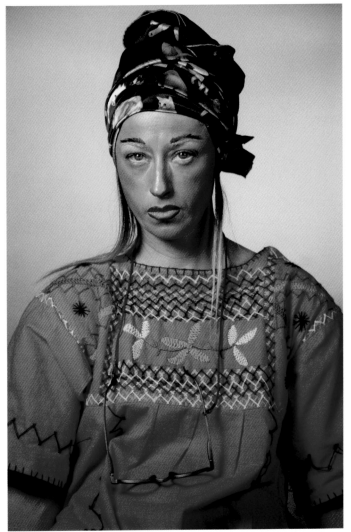

CINDY SHERMAN, UNTITLED #395, 2000

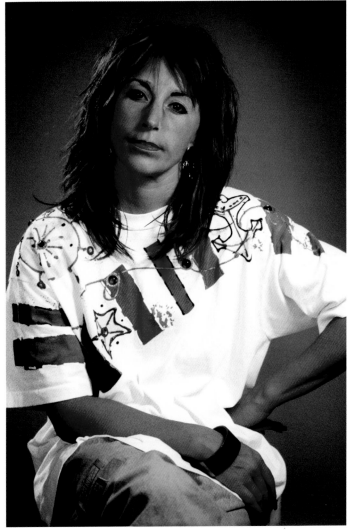

CINDY SHERMAN, UNTITLED #396, 2000

CINDY SHERMAN EXCLUSIVELY PHOTOGRAPHING HERSELF AND USING THE FORMULAIC APPEARANCE OF CERTAIN TYPES OF PHOTOGRAPHS, FROM THE PUBLICITY SHOT TO PORNOGRAPHY, SHERMAN HAS CONTINUOUSLY QUESTIONED THE CONSTRUCTION OF FEMININITY IN CONTEMPORARY SOCIETY. IN THIS SERIES, SHE LOOKS AT THE CONVENTIONS OF THE PROFESSIONAL STUDIO PORTRAIT. THESE IMAGES ARE TRADITIONALLY DESIGNED FOR DISPLAY IN THE HOME AND TO SHOW THE SITTER IN THEIR 'SUNDAY BEST'. THE STEREOTYPICAL FEMALE 'TYPES' THAT SHERMAN PASTICHES ARE MADE TO LOOK RIDICULOUS UNDER THE CAKED-ON MAKE-UP, WHICH ACTS AS ANOTHER MASK IN THE ARTIST'S GAME OF MASQUERADE.

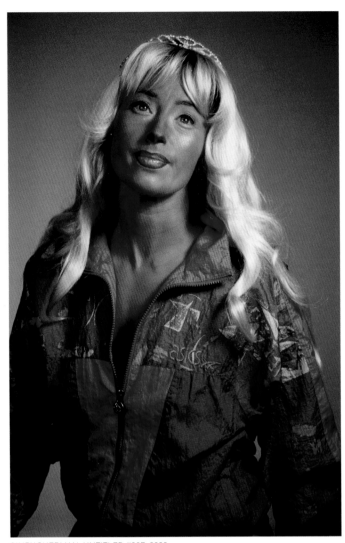

CINDY SHERMAN, UNTITLED #397, 2000

'I did once try using family members or friends, and once paid an assistant. But even when I was paying somebody, I still wanted to rush through and get them out of the studio. I felt like I was imposing on them. Also, I got the feeling that they were having fun, to a certain extent, thinking this was like Halloween, or playing dress-up. The levels I try to get to are not about the having-fun part.

I also realized that I myself don't know exactly what I want from a picture, so it's hard to articulate that to somebody else – anybody else. When I'm doing it myself, I'm really just using the mirror to summon something that I don't even know until I see.

I was feeling guilty in the beginning; it was frustrating to be successful when a lot of my friends weren't. Also, I was constantly being reminded of that by people in my family making jokes like, "Oh, yes, she's still just dressing up like she did when she was a kid," or "It doesn't take any brains to be doing what she's doing." So I guess I was thinking, maybe I am still just dressing up, because I don't theorize when I work. I would read theoretical stuff about my work and think, "What? Where did they get that?" The work was so intuitive for me, I didn't know where it was coming from. So I thought I had better not say anything or I'd blow it.'

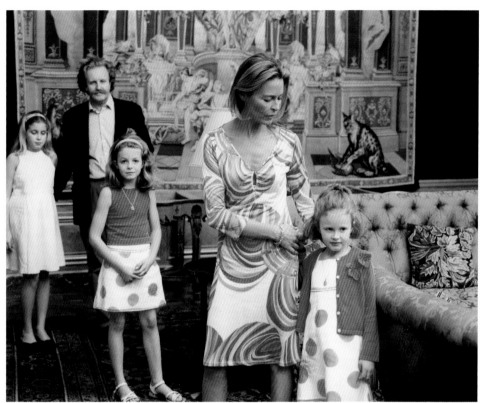

ABOVE TINA BARNEY, THE EUROPEANS: THE DAUGHTERS, 2002
RIGHT TINA BARNEY, THE EUROPEANS: THE TWO FRIENDS, 2002

TINA BARNEY *THEATRE OF MANNERS* (FIRST PUBLISHED IN 1997) WAS AN IN-DEPTH STUDY OF TINA BARNEY'S FAMILY AND FRIENDS IN MANHATTAN AND THE INTRICATE RITUALS OF THEIR EVERYDAY LIFE. BARNEY FIRST STARTED STUDYING HER FAMILY IN THE MID-1970S AND MOVED FROM A 35-MM CAMERA TO USING A LARGE-FORMAT 4x5 CAMERA IN THE 1980S. BY SLOWING THE PHOTOGRAPHIC PROCESS DOWN AND CREATING ELABORATE TABLEAUX, WHICH COMBINE THE FAMILIARITY OF A FAMILY SNAPSHOT WITH MORE FORMAL COMPOSITIONS, SHE WAS ABLE TO HONE IN ON THE TINY DETAILS AND ON THE TENSIONS AND RELATIONSHIPS BETWEEN THOSE CLOSE TO HER. THIS TECHNIQUE AND INTENTION CAN ALSO BE SEEN IN *THE EUROPEANS*, WHICH CONCENTRATES ON ASPECTS OF DOMESTICITY IN WEALTHY EUROPEAN FAMILIES.

'I have an anthropological and sociological fascination with looking at people. I don't make any assumptions about the people I photograph. I don't feel it's social commentary because I am not judging them; it's all instinct. For me, it's a great visual feast, and the houses are sets for taking the pictures.

For instance, in *The Sunday Dresses*, I had planned to photograph just one woman, but then she called her sister who joined us. The sister was completely unselfconscious and she had a little girl, which was such a gift. I knew the matching dresses would do something visual. I just like to see how people treat each other: the distance between them, their gestures and body language.

For me, the fascination of portraiture is in the relationship between the photographer and the subject. For my work to be successful there must be a play among several elements: what is subconsciously there; what sitters do for the camera; what happens when I am with them and the unplanned things that happen. I take a lot of pictures and when I am shooting, I almost go into a trance. It all happens so fast that not until afterwards can I see whether all of the elements coalesce. It's like magic.'

BELOW TINA BARNEY, THE EUROPEANS: THE SUNDAY DRESSES, 2004
RIGHT TINA BARNEY, THE EUROPEANS: THE HANDS, 2003

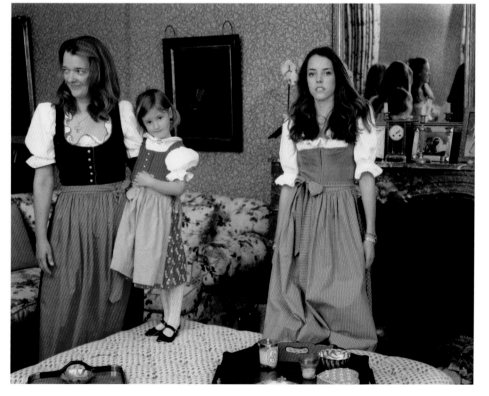

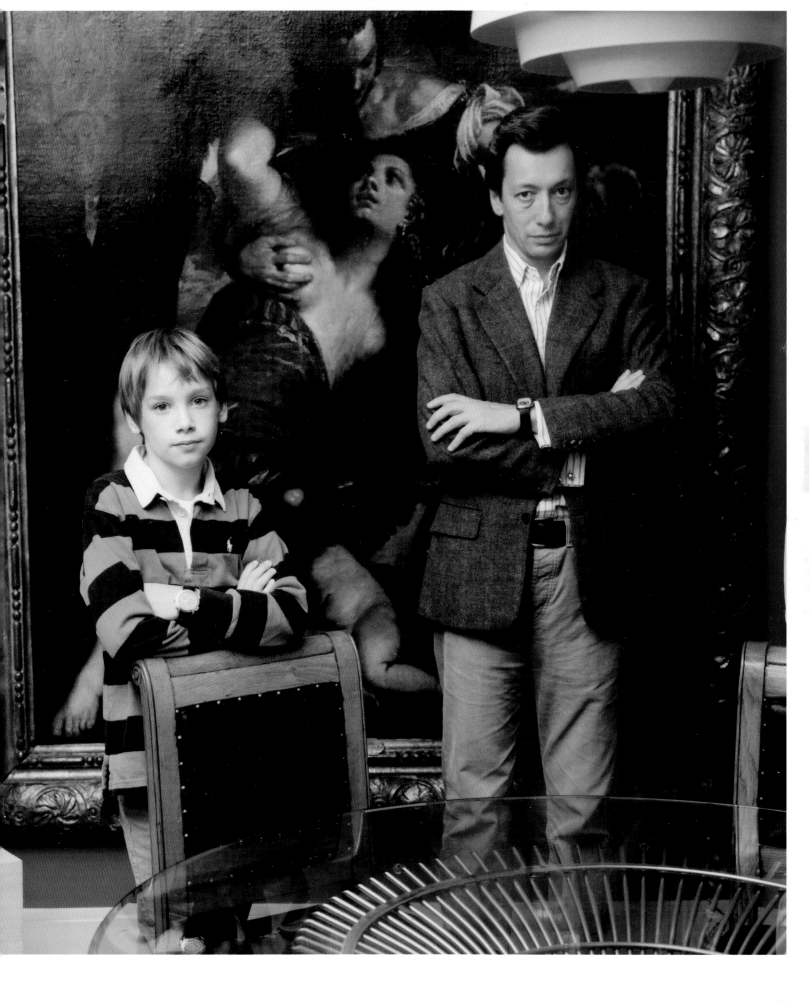

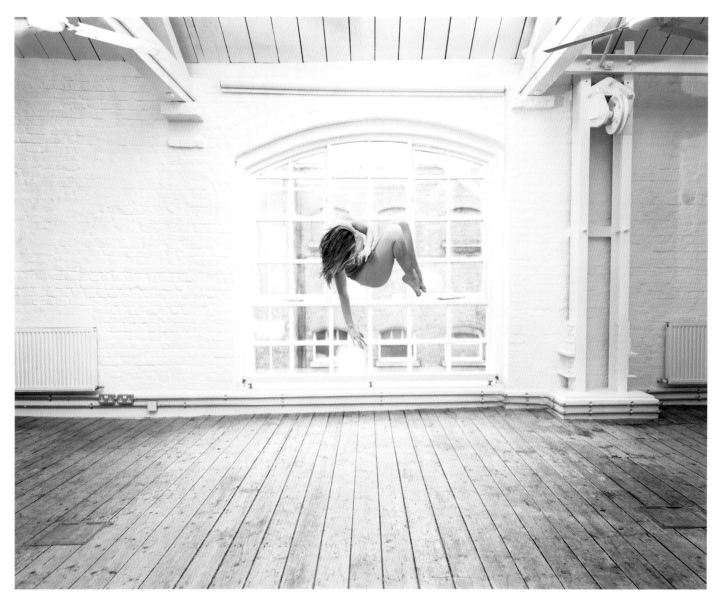

SAM TAYLOR-WOOD TAYLOR-WOOD'S SELF-PORTRAITS OFTEN REFLECT SIGNIFICANT CHAPTERS IN HER LIFE AND ARE MARKERS FOR CHANGE OR PROGRESSION. THEY FORM AN IMPORTANT AUTOBIOGRAPHICAL THREAD WHICH WEAVES THROUGH HER OVERALL PRACTICE. WITH PERSONAL AND OFTEN BRUTALLY HONEST IMAGES, SHE SHARES WITH THE AUDIENCE EMOTIONAL AND REVEALING NARRATIVES THAT TOUCH ON ISSUES SUCH AS HER ROLE AS AN ARTIST AND HER FEELINGS TOWARDS THE ART WORLD. MORE RECENT WORK SUCH AS *SELF-PORTRAIT AS TREE* (2000) AND *SELF-PORTRAIT IN SINGLE-BREASTED SUIT WITH HARE* (2001) ARE DEFIANT AND POWERFUL REFLECTIONS ON HER HEALTH.

'Moving into my studio I felt a wonderful sense of release and relief at having a space of my own. It was as though I could think, breathe and work and not feel like I was escaping or performing, which is how I felt in previous studios. I think this work reflects that, and was the starting-point for the portraits. I hired a bondage expert to tie me up and make me into different shapes. So I was in my studio in these twisted and contorted shapes.

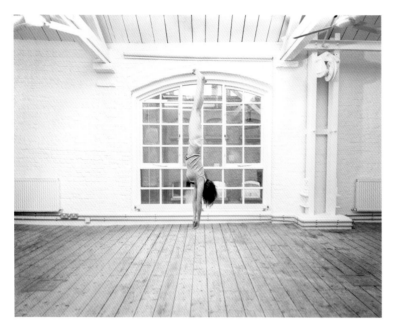

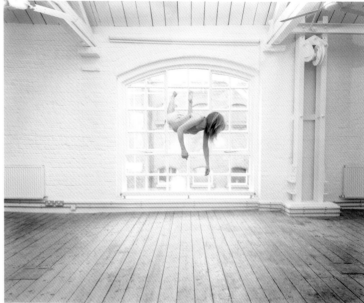

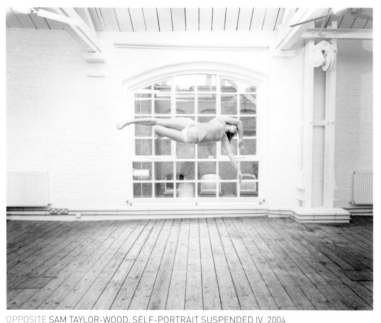

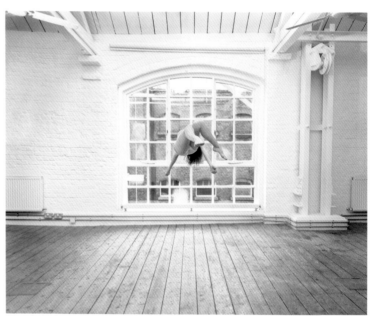

OPPOSITE SAM TAYLOR-WOOD, SELF-PORTRAIT SUSPENDED IV, 2004
TOP LEFT SAM TAYLOR-WOOD, SELF-PORTRAIT SUSPENDED VIII, 2004 TOP RIGHT SAM TAYLOR-WOOD, SELF-PORTRAIT SUSPENDED II, 2004
ABOVE LEFT SAM TAYLOR-WOOD, SELF-PORTRAIT SUSPENDED VII, 2004 ABOVE RIGHT SAM TAYLOR-WOOD, SELF-PORTRAIT SUSPENDED VI, 2004

I have done self-portraits throughout my career, but with these I didn't want them to be too recognizable as me. I have obscured my face in all of them, so that it leaves it slightly ambiguous. Deciding what to wear was a hard process. Initially I thought I wanted it to be naked but then that would have become the focus of the piece and they would have become something very different. I wanted to show limbs and wanted something with similar colours to the space. For me they seem kind of magical and I don't think the viewer thinks too much about how they were made. I'm not levitating or falling – I just exist in a kind of dance in the air.'

KATY GRANNAN *SUGAR CAMP ROAD* IS A CONTINUATION FROM TWO EARLIER SERIES ENTITLED *POUGHKEEPSIE JOURNALS* (1998) AND *DREAM AMERICA* (2000). GRANNAN'S WORK TAKES INSPIRATION FROM AREAS AROUND BOSTON WHERE SHE GREW UP. THE PORTRAITS MANAGE TO SIDESTEP BECOMING PURELY DECORATIVE AND PICTURESQUE AND OFTEN HAVE A SLIGHTLY UNCOMFORTABLE AND SEEDY AIR ABOUT THEM, SINCE THE LOCATIONS CHOSEN BY THE MODELS OFTEN HAVE DARK HISTORIES OR ARE SITES FOR ILLICIT ACTIVITIES. FEELING UNCOMFORTABLE ABOUT APPROACHING STRANGERS ON THE STREET AND ASKING TO PHOTOGRAPH THEM, GRANNAN HAS ADOPTED A STRATEGY OF PLACING ADVERTS IN LOCAL PAPERS TO FIND HER MODELS.

BELOW KATY GRANNAN, SUGAR CAMP ROAD: CHRISTOPHER AND ZACHARY, BAY FARM, DUXBURY, MA, 2002
RIGHT KATY GRANNAN, SUGAR CAMP ROAD: DANIELLE, VACANT LOT, BURLEIGH ROAD, NEW PALTZ, NY, 2003

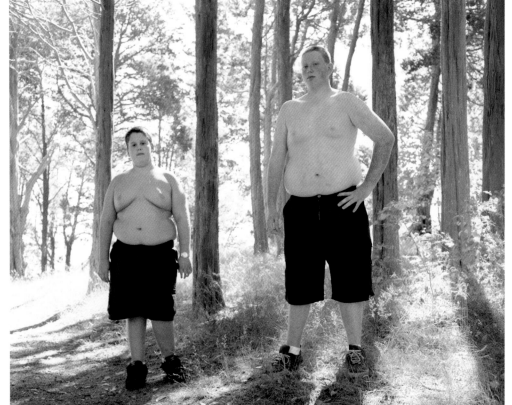

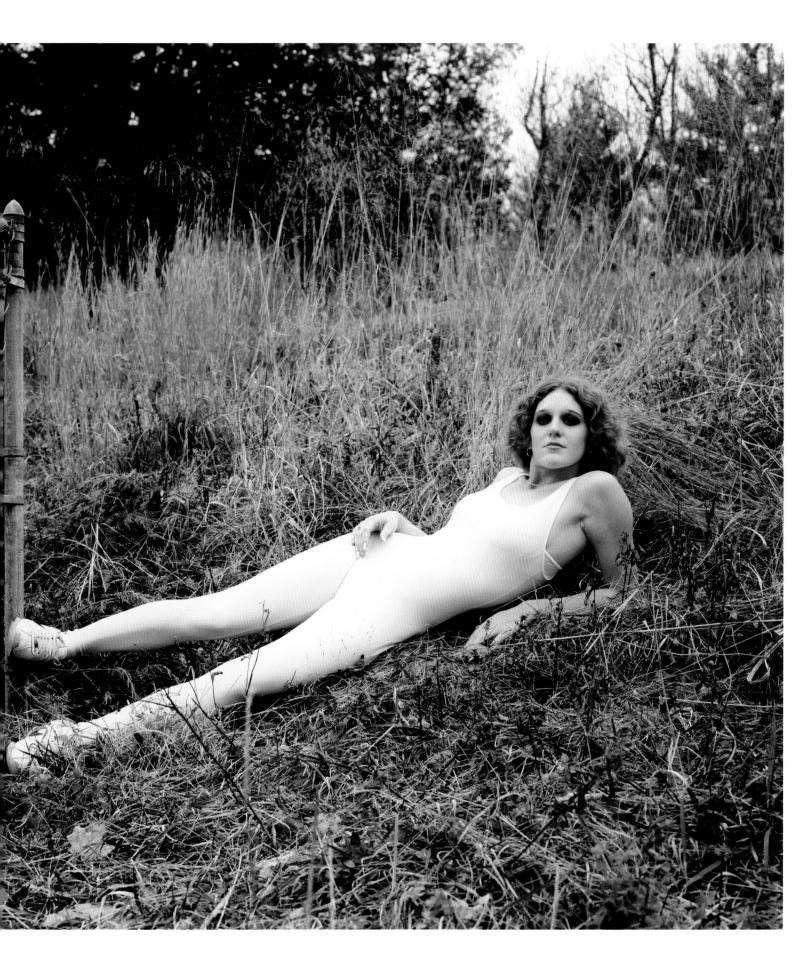

'It is important to me that I photograph people I don't really know. Often we are meeting for the first time. There is usually a lot of secrecy surrounding these shoots. Husbands and wives will pose for me without telling their spouse, and others comment on how friends and family would certainly disapprove. Posing for a portrait is quite a common thing, but it is another thing entirely to meet up with a stranger and walk together to a secluded location to make a photograph. There is a good deal of trust involved on both our parts.

KATY GRANNAN, SUGAR CAMP ROAD: ANGIE AND BETTY, SHOENECK CREEK, NAZARETH, PA, 2003

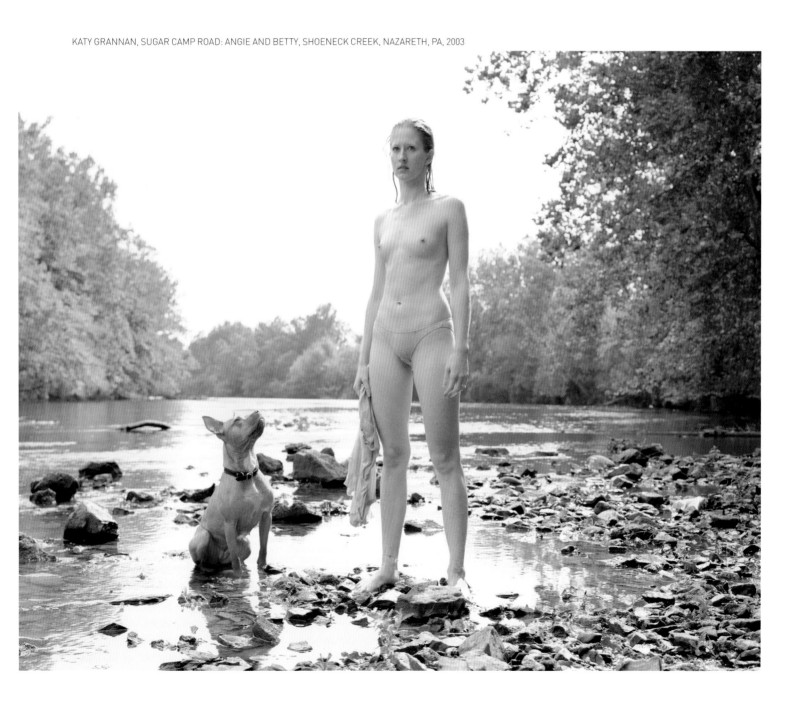

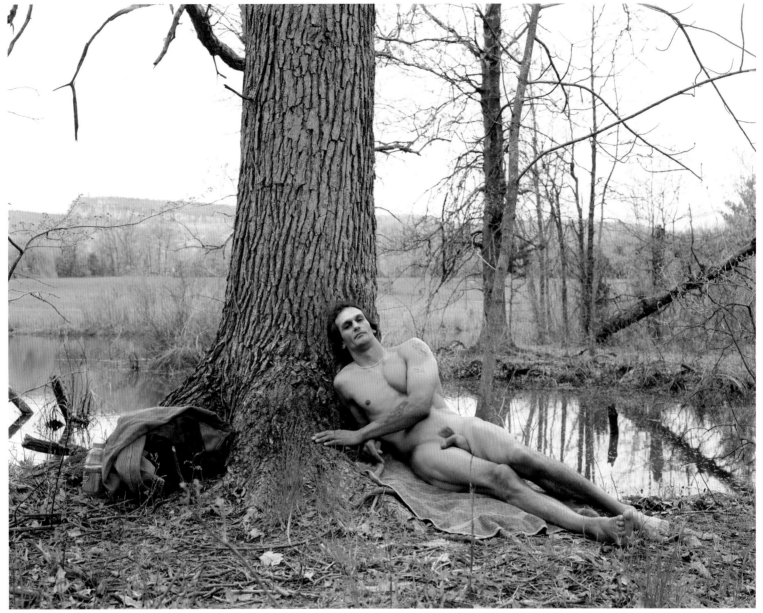

KATY GRANNAN, SUGAR CAMP ROAD: MIKE, PRIVATE PROPERTY, NEW PALTZ, NY, 2003

Of course, at their most basic level, they represent the desire to be seen and to be paid attention to. But, ultimately, their desire to be seen and my desire to photograph them are the ingredients of something larger. The portrait that remains represents neither accurately. Our intentions, whatever they were, are recorded and warped and reinvented into something entirely unique. Every scar is beautiful, every smile disturbing and in that moment the portrait becomes its own truth.

Sugar Camp Road is a dirt turn-off in rural Pennsylvania. The name, innocuous, almost sweet, was the site of the murder of a local high-school student. One of my subjects took me there to make her portrait. The way in which an ordinary landscape could suddenly become so charged and uncomfortable became representative of many of the locations I used. They were often on the edge of town, places that everyone avoided.'

RINEKE DIJKSTRA DIJKSTRA'S PORTRAITURE OFTEN TAKES PLACE OVER A LONG PERIOD OF TIME AND SHOWS THE TRANSFORMATIONS AND CHANGES THAT HAPPEN IN PEOPLE'S APPEARANCES. THIS IDEA OF TRANSITION IS OFTEN SEEN IN HER CHOICE OF SUBJECTS, FROM TEENAGERS AND BULLFIGHTERS TO NEW MOTHERS. HER PORTRAITS WORK IN A VERY CLASSICAL WAY: BECAUSE THE IMAGE IS STRIPPED OF CONFUSING PROPS OR CONTEXTUAL BACKGROUNDS, THE VIEWER HAS TO SCRUTINIZE THE TINY GESTURES AND FACIAL EXPRESSIONS FOR CLUES INTO THE PORTRAIT AND THE PERSON'S IDENTITY. THE KIND OF INTENSITY OF LOOKING DEMANDED OF THE VIEWER AND THE SOMEWHAT DETACHED APPROACH ARE REMINISCENT OF NINETEENTH-CENTURY PHOTOGRAPHY.

BELOW RINEKE DIJKSTRA, SHANY, PALMAHIM ISRAELI AIRFORCE BASE, ISRAEL, OCTOBER 8, 2002
OPPOSITE RINEKE DIJKSTRA, SHANY, HERZLIYA, ISRAEL, AUGUST 1, 2003

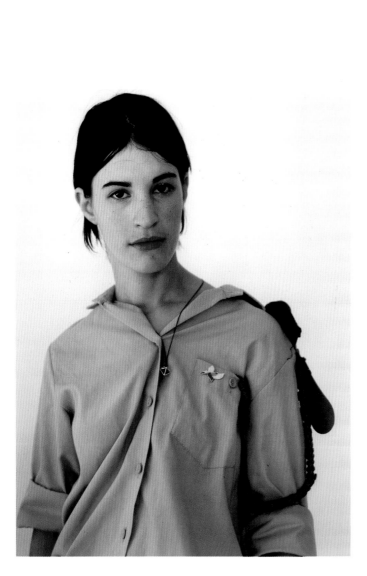

'I first started to photograph young women in Israel on their induction-day into the army. Later on I thought it could be interesting to follow them, and see how the army affects them. Military service implies that one has to submit to a collective identity, but I think there is always a tension between the values and desires of the individual and the values of the community. I have always been interested in ideas of uniformity and individuality; especially in a country like Israel where people don't have a choice about joining the army or not. Boys and girls have to do so as it's part of their society.

One thing I noticed was that the second time I photographed them, they all looked younger than the first time. They said that it might be because they had to submit to authority again. Just at a moment in their lives when they were becoming more independent they felt as if they were being thrown back into the first grade. I think that we transform ourselves all the time. But I also think that when people go through big changes in their lives, they are more confronted with themselves and the world around them.'

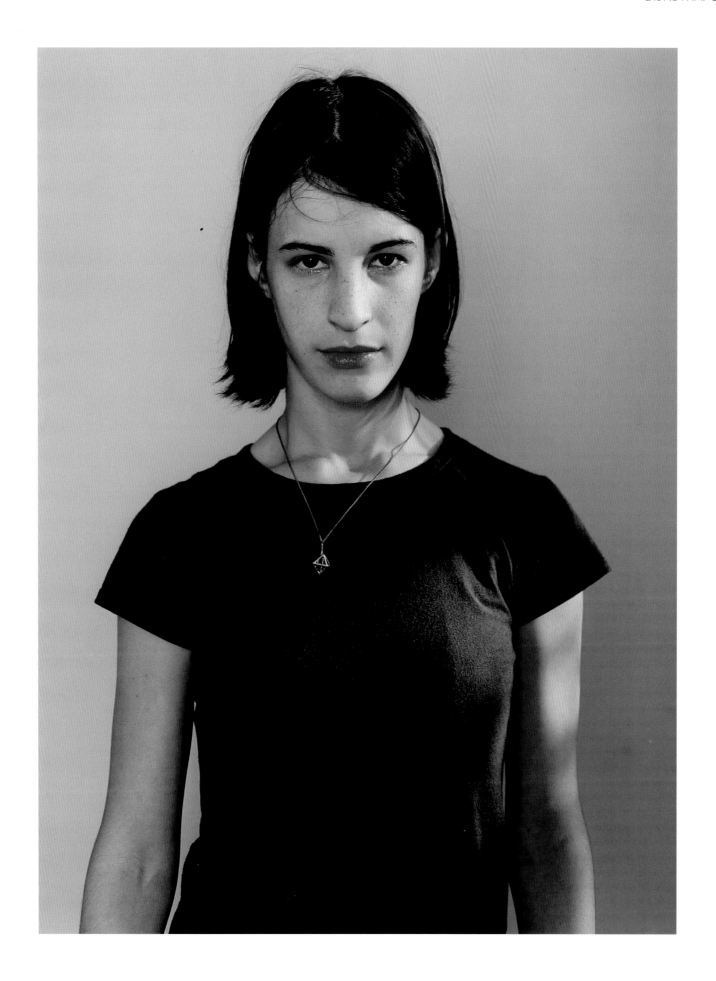

ZWELETHU MTHETHWA MTHETHWA BEGAN TO EXHIBIT HIS WORK IN THE MID-1980S. HE WORKS IN BOTH PHOTOGRAPHY AND PASTEL DRAWING. HIS PORTRAITS OFTEN REVOLVE AROUND SOUTH AFRICAN MIGRANTS' LIVING AND WORKING CONDITIONS AND THE CULTURAL DISORIENTATION THAT TAKES PLACE AFTER SUCH SHIFTS. HIS INTEREST LIES IN QUIETLY OBSERVING THE SPECIFICS OF EVERYDAY LIFE, OF WORK OR DOMESTIC LIVING, SCENES MORE FAMILIAR IN VERNACULAR PHOTOGRAPHY. HIS RELAXED PORTRAITS AND SKILLED USE OF COLOUR ARE FAR REMOVED FROM THE STEREOTYPICAL BLACK-AND-WHITE PHOTOJOURNALISTIC IMAGES OF RIOTS AND POVERTY THAT ARE USUALLY ASSOCIATED WITH TOWNSHIPS.

'I started to visit all the informal sections and homes. I was curious to look at the most attractive ones, simply because I just wanted to see what really makes people tick. What is a home to a person who doesn't have money? I would go about just peeking through windows, through open doors. I found that what attracted me in the house could be the wallpaper or the way colour was coordinated in the space. I would knock on the door, present my case and tell them that I was just looking at how they decorated their homes. 99% of the time they would let me in, and then I would ask if I could take photos of them inside their own spaces, and they would pose for me. I never really directed people or told them how to pose.

BELOW ZWELETHU MTHETHWA, UNTITLED, 2002 RIGHT ZWELETHU MTHETHWA, UNTITLED, 2003

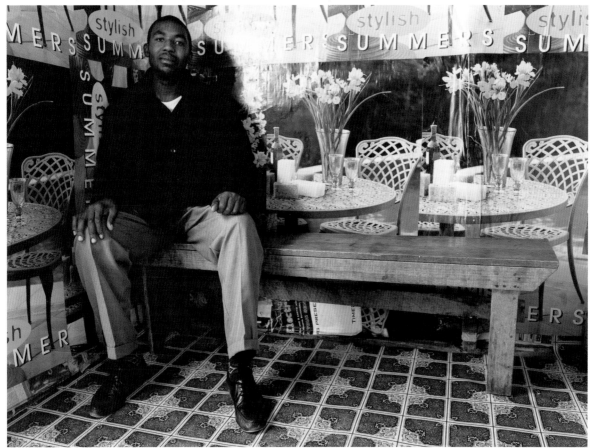

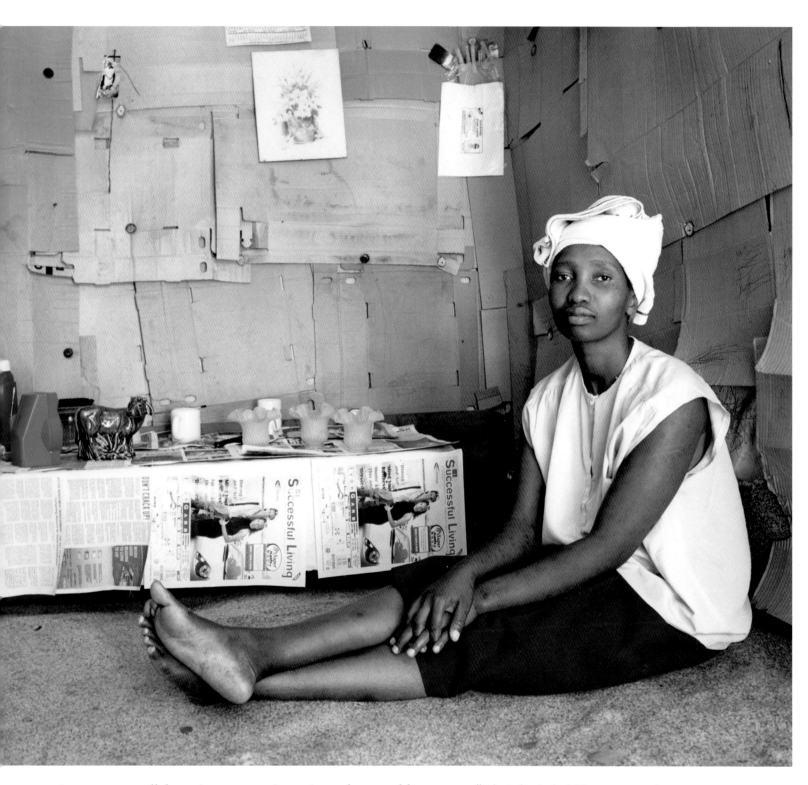

It was a very collaborative process. Sometimes they would say to me, "Oh, I don't feel like I want to be presented in this way and I don't want to be perceived like this, so come back in an hour. I'm going to take a bath and change into my best clothes." I would always adhere to that, because I wanted to take photos that would be approved of by the sitters. I wanted them to love the photographs of themselves. For me that was the primary objective, not to take photos that I would love, but to take photos that *they* would love.

It was such a surprise when these pictures became popular. I was just doing them for myself and I really didn't do them for an audience. I think it was because the philosophy behind them was so strong that they became popular. What was strange was how many people posed in ways that reflected traditional painting genres. This was very, very weird for me because these people knew nothing about the conventions of art.

NIKKI S. LEE ACTING DIFFERENTLY DEPENDING ON WHO IS WITH US IS SOMETHING THAT WE ALL DO. IN AN EARLIER SERIES, *PROJECTS* (2001), LEE TOOK THIS IDEA OF SHIFTING IDENTITIES FURTHER AND TRANSFORMED HERSELF INTO MEMBERS OF DIFFERENT SOCIAL AND ETHNIC GROUPS. TRANSCENDING AGE, CLASS, RACE AND GENDER, SHE PLAYS OUT VARIOUS ROLES. THE 'PROJECTS' INCLUDED HER BECOMING A YUPPIE, A LESBIAN, A SENIOR CITIZEN AND A HISPANIC. PART PERFORMANCE, PART DOCUMENTARY, THE PHOTOGRAPHS WERE TAKEN BY MEMBERS OF THE 'GROUP' LIKE SNAPSHOTS. THE USE OF THE SNAPSHOT CONTINUES IN *PARTS*, IN WHICH THE ARTIST EXPLORES THE WAY PHOTOGRAPHS REPRESENT OUR RELATIONSHIPS WITH OTHER PEOPLE.

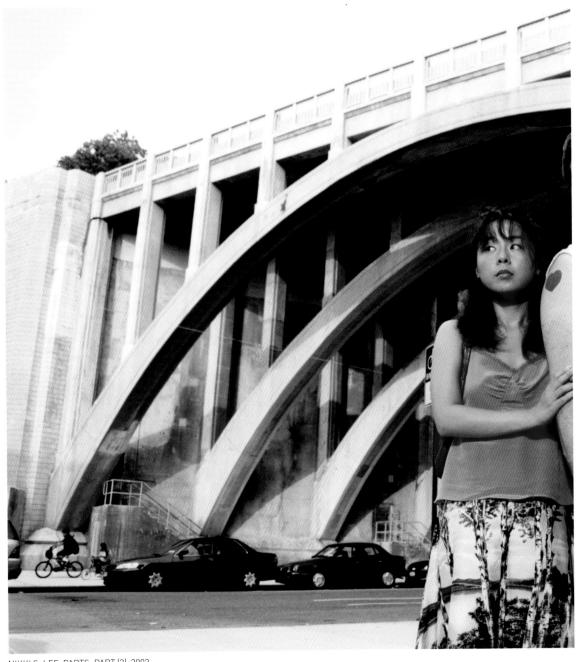

NIKKI S. LEE, PARTS: PART (3), 2003

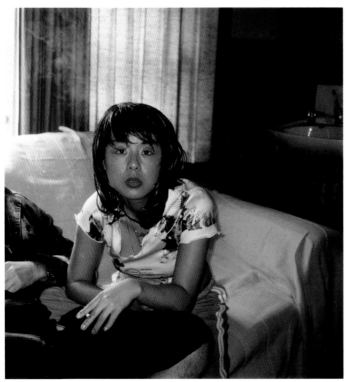

NIKKI S. LEE, PARTS: PART (37), 2003

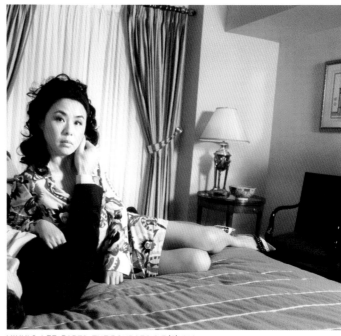

NIKKI S. LEE, PARTS: THE BOURGEOISIE (8), 2004

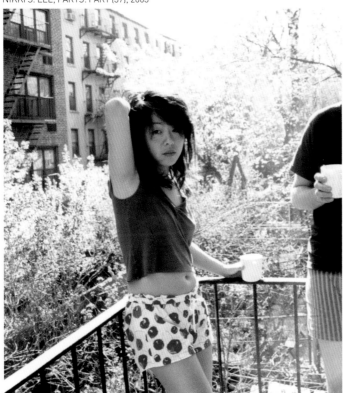

NIKKI S. LEE, PARTS: PART (18), 2003

'I started the *Parts* series in 2002. The pictures are not about me – they are just stories. After printing the entire image, I chop the man out but purposefully leave a trace of his presence – perhaps an arm or foot – so the viewer can guess things about him or make assumptions about who he is. Many people see these images as melancholic, thinking that they may be pictures after a break-up, but that was not my intention. I adopted the cliché of cutting pictures to show how personal identity is affected by other people and different kinds of relationships. My appearance is not dramatically different in each of the pictures, as it was in my past work. You can see that it is one person throughout and that her identity shifts and changes depending on whom she is with. They are all me of course, but are also my different personas. Sometimes I like to mix those things up, which may confuse people. Is that really Nikki? Or is she playing a part? I am very interested in the viewers' reactions. Having said that, I want my pictures to look real and easy to believe, which is why I use a documentary snapshot style rather than theatrical, structured photography.

Just because I use the photographic medium, that doesn't mean I am a photographer. I am not talking about a hierarchy between photography and art. I can be a photographer or an artist, whatever really. I use photography now, but that doesn't mean I will for ever. I can move on. I can be a film director. I can make videos. I don't want to be categorized by or limited to one medium.'

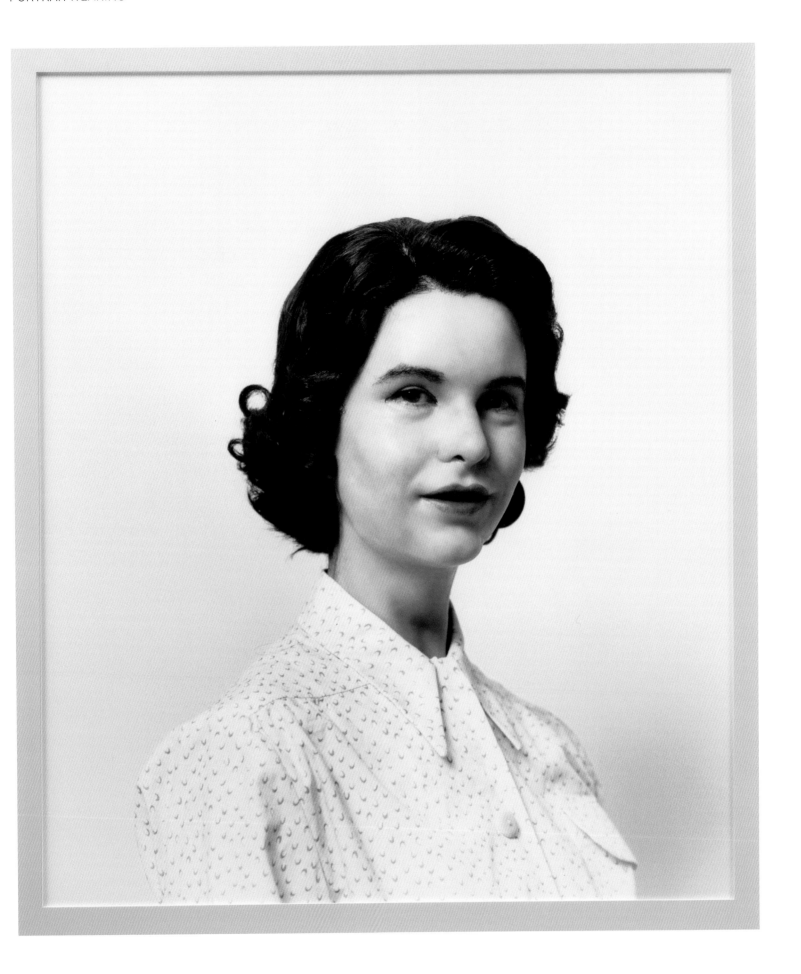

GILLIAN WEARING

WEARING IS ONE OF BRITAIN'S MOST INFLUENTIAL ARTISTS. HER WORK EXPLORES THE COMPLEXITIES OF HUMAN RELATIONSHIPS, AND SHE OFTEN USES REAL PEOPLE TO TALK ABOUT THEIR LIVES. THE CONCEPTS OF MEMORY AND REALITY UNDERPIN HER PRACTICE, AS DOES THE SLIPPAGE BETWEEN IDENTITIES. FOR *ALBUM*, SHE PHOTOGRAPHED HERSELF DISGUISED AS HER FAMILY. DISGUISE HAS APPEARED BEFORE IN HER WORK, FOR EXAMPLE IN THE VIDEO *CONFESS ALL ON VIDEO. DON'T WORRY YOU WILL BE IN DISGUISE. INTRIGUED? CALL GILLIAN* (1994). THE DISGUISE OFFERS A LIBERATING ESCAPE FROM THE 'SELF', AND THE MASKS AND THE SLIPPAGE OF IDENTITIES REVEAL THE THIN LINE BETWEEN REALITY AND FANTASY.

'*Album* came about when I was going through some old photographs and I came across an image of my mother as a twenty-three-year-old. I noticed that my memory of the photo was very different from what I was looking at when I rediscovered it in 2001. It was through this re-evaluation that I began to think about what I had projected onto the image of her and my consciousness of her age. There was something she possessed in that picture that had to do with innocence. I guess it was this quality that I hoped to capture. The mask I had made of her face was in many ways the opposite of innocent, but my hope was that I could internalize her state of being at that age and, mainly with my eyes, posture and bearing, convince the viewer that I was her.

I soon realized that I wanted to take the whole thing further and widen it to include the closest members of my family. Everyone, including myself, in the photographs I had selected, was a similar age. They were all young. They were all at an age where they seemed hopeful and in some way undefined by life's pressures. I mean with fewer responsibilities, a little more self-centred. They projected a more optimistic or idealized face to the world.

I was also looking at photography in general, and in particular the portrait genre tradition. In my parents' lifetime fewer cameras were available. In order to document oneself it was necessary to employ a studio photographer, and an air of formality as well as a standard convention of posing was expected. By the seventies, the whole photographic process had become more accessible, making a snapshot aesthetic more accepted. So this album is of my family, but I think it also represents a family album that can be recognized by everyone. It's about archetypes coming together, which gives each "self-portrait" a deeper meaning.'

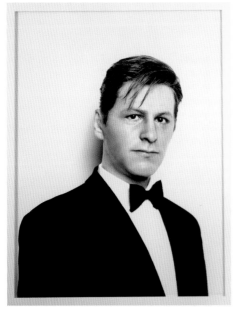

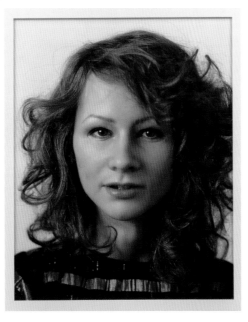

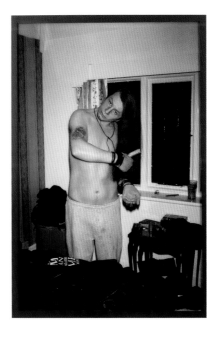

SAMUEL FOSSO FOSSO'S WORK PLAYS WITH DIFFERENT IDENTITIES AND HE REFUSES TO FULLY COMMIT TO ONE DEFINITE VERSION OF HIMSELF. RELISHING THE GAME OF HIDE-AND-SEEK WHICH MASQUERADE INITIATES, HIS PORTRAITS SHOW FABULOUS ROLE-PLAYING AND ARE CREATED IN HIS STUDIO IN BANGUI, THE CAPITAL OF THE CENTRAL AFRICAN REPUBLIC. USING A RANGE OF PROPS, BACKDROPS, COSTUMES AND HIS OWN BODY, FOSSO INFUSES POLITICAL INTENT AND LIGHTNESS OF TOUCH WITH A RESOLUTE 'AFRICAN-NESS' THAT TAPS INTO ISSUES, BOTH GLOBAL AND LOCAL, OF AFRICAN COLLECTIVE IDENTITY. HIS WORK IS OFTEN DISPLAYED IN SEQUENCE TO SHOW HOW STORIES UNFOLD.

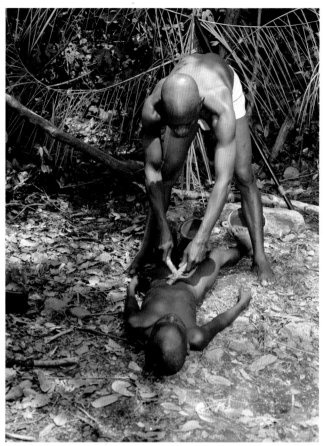

SAMUEL FOSSO, MY GRANDFATHER'S DREAM: SANS TITRE, 2003

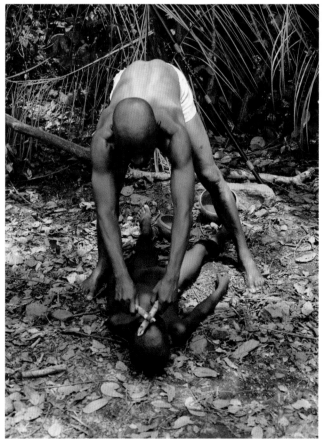

'When I was born in 1962 in Kumba, Cameroon, I was very sick. I could not walk for three years; my legs and arms were paralysed. My mother had taken me to doctors in Cameroon, where we lived, but nobody could cure me. When I was about four she took me to Edda, the village where she was born in Nigeria. My grandfather, Okoro Agwa, was both chief healer and village chief. He started to cure me. I don't remember being sick but I do remember being cured. After he cured me he wanted me to return to Cameroon to be with my mother, but it was hard because my grandparents were like parents to me and I stayed with them. He wanted me to follow in his footsteps and become a healer too.

When I became an artist I wanted to do something about my grandfather. I wanted to honour his memory. The pictures are about his life but I am also combining this with stories about myself. Through the photographs I interpreted what my grandfather wanted me to become: a healer and a village leader. I did it to pay homage to him. In this work, as in all my work, I am both character and director. I don't put myself in the photographs: my work is based on specific situations and people I am familiar with, things I desire, reworked in my imagination and afterwards interpreted. I borrow identities.'

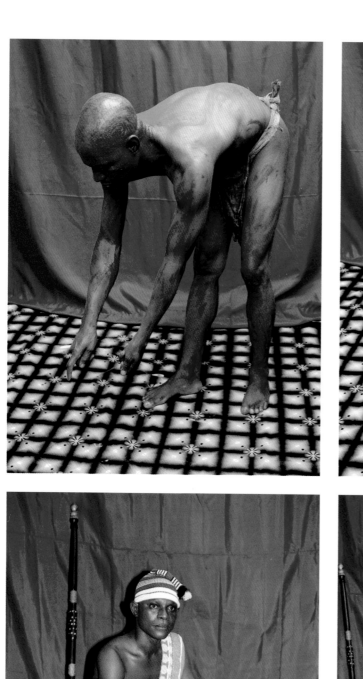
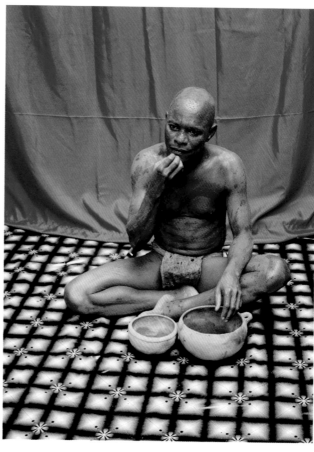
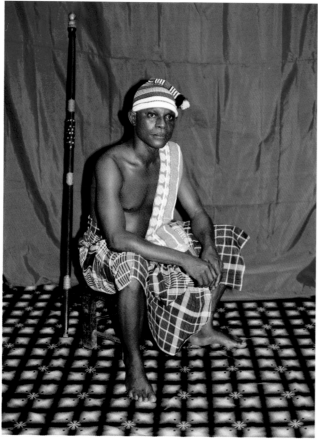
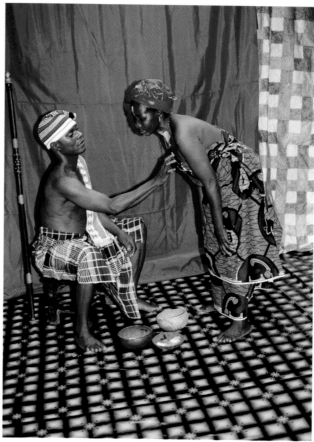

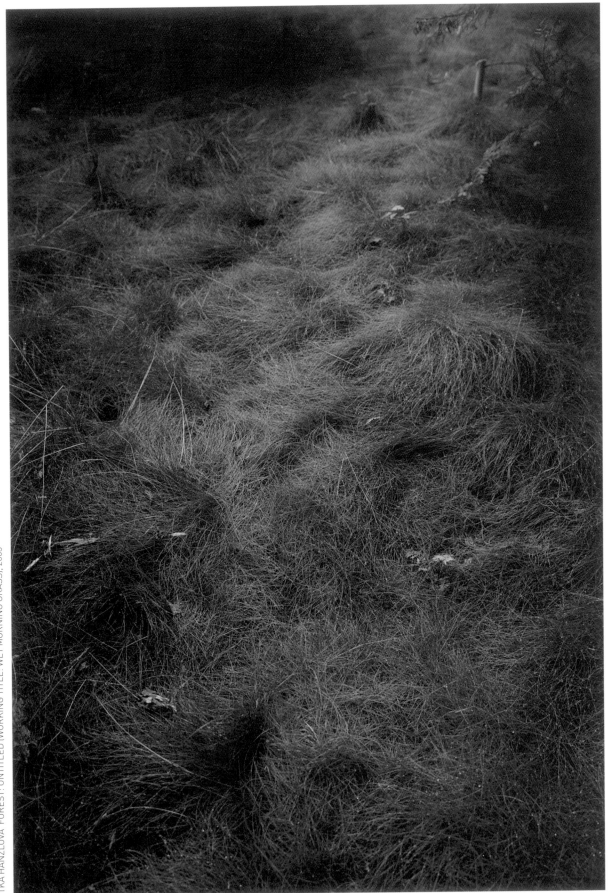

JITKA HANZLOVÁ FOREST: UNTITLED (WORKING TITLE: WET MORNING GRASS), 2003

LANDSCAPE

Photography emerged at a time of continuing and expanding exploration and travel, so in many respects the camera and landscape are intertwined. Coinciding with voyages, colonization, exploration and settlement, the camera enabled travellers to control the unknown visually so that sense could be made of it within terms of reference that were more easily understood. Voyagers could send back images of exotic lands, a vast and untamed Other, to thrill those at home.

The new invention of photography and the discovery of new lands proved to be a heady mixture, and a vast quantity of topographical 'views' were produced, collected and categorized. In Britain, such explorations coincided with the 'Picturesque' period which dominated aesthetic principles in painting at the time, taming and shaping the landscape into a frame, suggesting a rural idyll and Arcadian past. Many nineteenth-century photographers, whether they trained as painters or not, would have been aware of this style with its formulaic approaches and subjects and would have adhered to its stylistic conventions in composition in order to make the new photographic landscapes as 'picture perfect' as their painted counterparts.

Perhaps more so than with any other genre, it is important to understand the history of landscape, because it is such a major influence on contemporary work. Its influence appears, for instance, in the way artists mirror painterly devices in order to comment upon and update past artistic conventions. Looking at nineteenth-century landscape photographs now, we understand them to have been made, and set, within particular codes and assumptions of the time, which were embedded within the traditions of painting. Those Europeans who travelled (John Thompson to China, Francis Frith to Africa and the Near East, Felice Beato to Japan and Samuel Bourne to India, for example) took with them their Western visual taste and imperial anxieties so that when the pictures were returned home much of the 'foreignness' had been removed and they were safe for the Victorian viewer, exotic certainly, but not too threatening or difficult. Entrenched within a sense of superiority, similar attitudes can also be seen in much of the literature of the time.

In America, the scale of the land – and its extreme nature – was in many respects harder to control, so the somewhat genteel quaintness of the Picturesque was not appropriate. It also seemed to be an ever-expanding country, moving westward, and by the mid-nineteenth century there was massive rail expansion, and geological surveys were being conducted. Many photographers such as Timothy O'Sullivan, William Henry Jackson and, to a certain extent, Carleton Watkins, documented these man-made developments, recording the shifts and changes in the landscape. Not all landscape photographs were made with artistic intent, but the tendency to use natural detail to comment on something symbolic and universal carried on into landscape photography of the twentieth century.

Alfred Stieglitz, and then later Ansel Adams and Edward Weston, took American landscape photography to its formal conclusions. Technically outstanding, the modernist works of Adams and more specifically Weston are self-consciously photographic and self-assuredly declare themselves as art. They dazzle and seduce with technical and sensual qualities that aesthetically idealize the landscape. Here, as photography historian Graham Clarke describes, 'the play of light and pattern, of texture and contrast, expresses an almost metaphysical presence'.

Today our relationship with the land – and indeed with photography – is not so straightforward, and very few see it as unproblematic, natural or neutral

space. By the late 1960s and early 1970s, many artists, especially in America, were uncomfortable with this straightforward objectification of land and a growing body of work turned to exploring the human presence, and its – not always progressive – impact on the land.

Highly influenced by the work of conceptual artists, photographers grouped together under the title of the New Topographics began not only to question critically the tradition of photographing the landscape but also to comment upon growing political and social issues that were affecting it. These included the spread of suburbia; anonymous industrial sites; pollution and other environmental issues and the disappearance of once pristine land. Work by artists such as Robert Adams, Lewis Baltz and Stephen Shore flattened out the landscape so that the viewer was invited to see how changes were not necessarily for the good and that it was now impossible to look at landscape in a romantic and subjective way that did not engage critically with postmodern concerns and critiques.

Human intervention in the landscape, not as subject matter but as raw material, was to become apparent in 1970s America. The issues of controlling and moulding the landscape and man's relationship to it were central to land artists as they aimed to sympathize with their environment through intervention and experimentation set away from the gallery. The term 'land art' was conceived in the United States for the immense earthworks projects made by artists such as Robert Smithson. His now famous *Spiral Jetty* created in 1970 and located in the Great Salt Lake, Utah, defined an entirely original notion of landscape and relied on photography for documentation and as a tool of investigation rather than aesthetic reflection. British land artists such as Richard Long and Hamish Fulton used the photograph in a similar way in their less bombastic approach to landscape. Tying their work in with text and language, they welded together the artistic practices of sculpture, photography

and performance and took the photograph beyond the gallery and the frame and other modalities we so readily associate with art.

In contemporary landscape photography there is a trend, as there is in many of the other genres, to print work large. For images of the land this has a particular resonance and makes conceptual sense. To condense the experience of vast stretches of land into a series of small rectangles is not always appropriate. The land is experienced physically and so images of it tend to be as well. This phenomenological experience is also carried over into books, which tend to be beautiful, large-scale and almost fetishistic in their production standards. Perhaps in book form we can try to control the landscape again as we are unable to do with vast prints that aim to cause the same kind of awe and wonder as the original experience.

The complexities of landscape, which can at first seem the most straightforward of artistic genres, are not to be underestimated. The many different approaches to the land and the traditions so embedded within the genre are also tied into sensibilities very much associated with photography such as time, the nature of looking and issues of space. Contemporary artists respond to place and explore issues including national and cultural identity, migration, boundaries and borders, but perhaps most fundamentally, landscape photography offers the space to explore ever-present artistic and philosophical concerns about our place in the world.

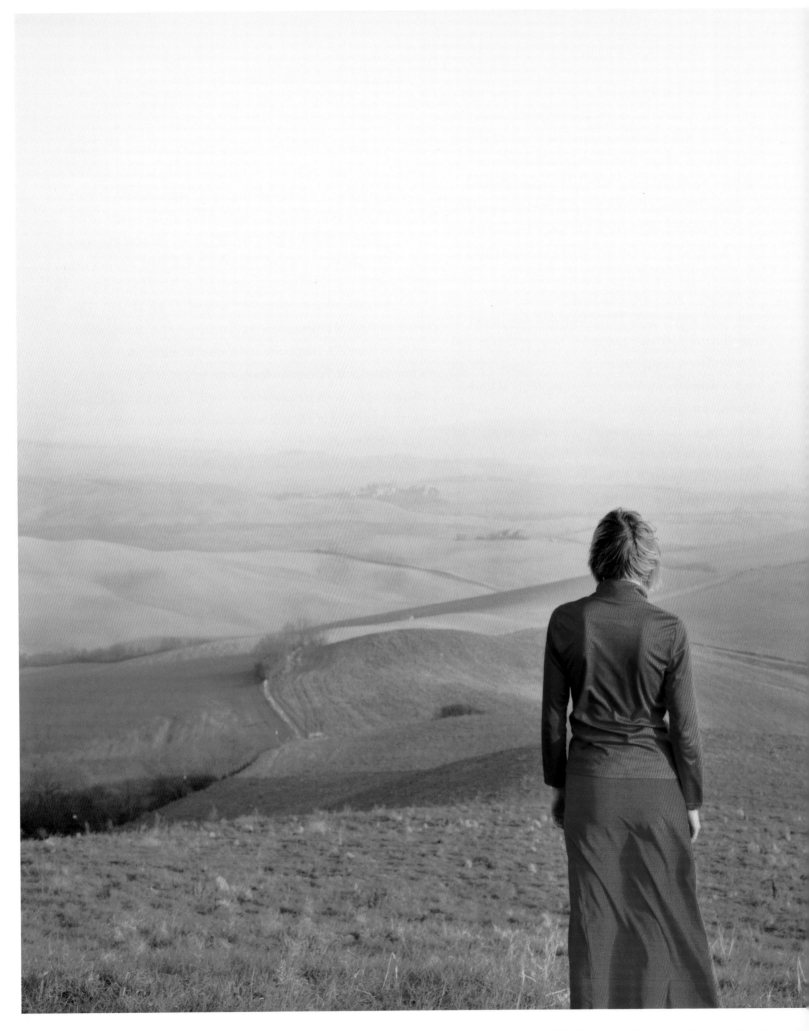

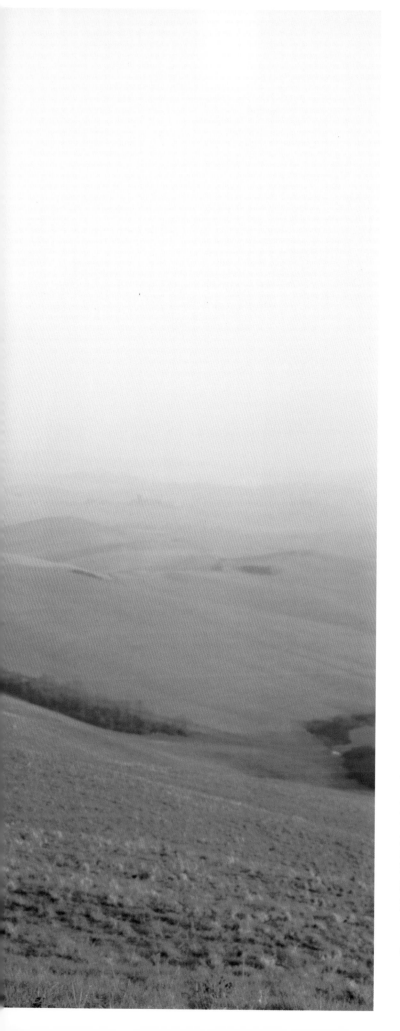

ELINA BROTHERUS THE GRANDEUR OF LANDSCAPE PAINTING REVERBERATES THROUGHOUT THIS SERIES BY FINNISH ARTIST BROTHERUS, WHOSE TITLE PLAYS ON THE RELATIONSHIP BETWEEN PHOTOGRAPHY AND PAINTING AND ON THE CHANGED STATUS THAT PHOTOGRAPHY NOW ENJOYS IN THE ART WORLD. BY USING HER CAMERA TO INVESTIGATE DILEMMAS THAT HAVE CHALLENGED PAINTERS FOR CENTURIES, BROTHERUS IS WIDENING HER PRACTICE AWAY FROM THE VERY PERSONAL, DIARISTIC SELF-PORTRAITS AROUND WHICH MUCH OF HER EARLY WORK CONCENTRATED. SHE STILL USES HERSELF AS A MODEL, BUT *THE NEW PAINTING* IS LESS AUTOBIOGRAPHICAL AND A MORE GENERIC COMMENT ON THE FIGURE AND ITS PLACE IN LANDSCAPE.

'I started this series in 2000 and I still don't see the end. This approach, or this way of seeing and photographing things, is still very important to me. *The New Painting* draws inspiration from art history, from the tradition of figurative painting. I am very humble when faced with the history of art, as I'm an artist, not an art historian. I therefore don't have an academic point of view or academic knowledge. I study on my own, go to museums and read books. This continuous self-educating process is something I cherish, and it of course affects and enriches the iconography of my work.

I consider that, as a contemporary photographer, I am approaching the same themes that have previously been the property of painting. This is why my series has this slightly provocative title *The New Painting*. But I don't mean to say that painting has been or should be replaced by photography. On the contrary – I love painting. But my medium is colour photography. With it, I treat themes that some might claim are old fashioned but that I still find completely relevant and interesting. I'm talking about the fundamental questions of visual art: light, colour, composition; presenting space and volume; the relation between figures in space.'

ELINA BROTHERUS, THE NEW PAINTING: DER WANDERER, 2003

JOEL STERNFELD THE HIGH LINE IS A DERELICT RAILTRACK RUNNING ALONG THE WEST SIDE OF NEW YORK CITY. CONSTRUCTED BETWEEN 1929 AND 1934, IT IS ABOUT 1.5 MILES LONG AND SEVEN ACRES IN TOTAL AREA AND USED TO BE AN IMPORTANT VEIN THROUGH THE CITY, TRANSPORTING GOODS FROM ALL OVER AMERICA INTO THE HEART OF COMMERCE AND INDUSTRY. A GROUP OF DEDICATED LOCALS HAVE COME TOGETHER TO FORM 'FRIENDS OF THE HIGHLINE', WHO ARE DEVOTED TO THE PRESERVATION AND REJUVENATION OF THE SPACE AND AIM TO CONVERT IT INTO A PUBLIC PATH SIMILAR TO THE PROMENADE PLANTÉE IN PARIS. AMERICAN ARTIST STERNFELD PHOTOGRAPHED THE SITE OVER A PERIOD OF EIGHT MONTHS, CAPTURING THE INTERSECTION BETWEEN LANDSCAPE AND THE CITY IN THIS UNTAMED OASIS HIDDEN AWAY AND UNKNOWN TO MOST.

JOEL STERNFELD, WALKING THE HIGH LINE: LOOKING SOUTH, 19TH STREET, LATE OCTOBER 2001, 2001

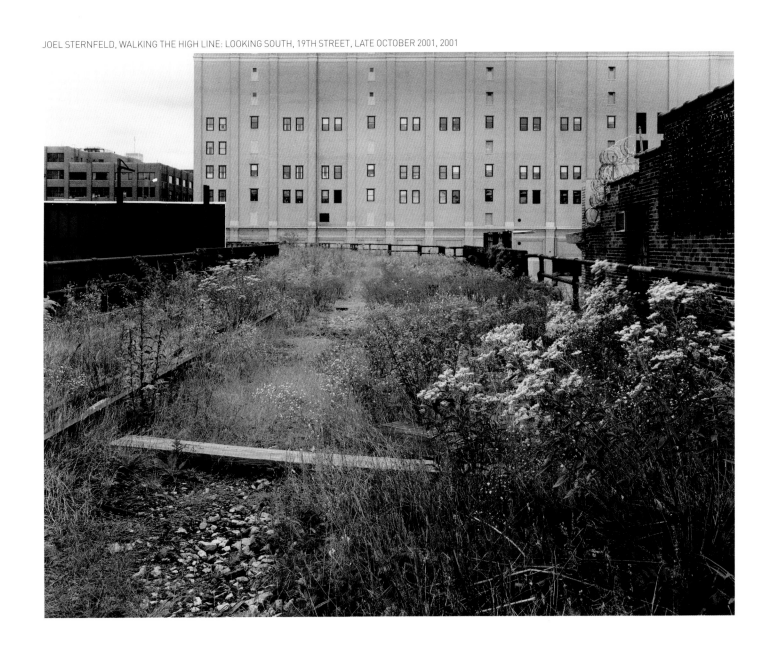

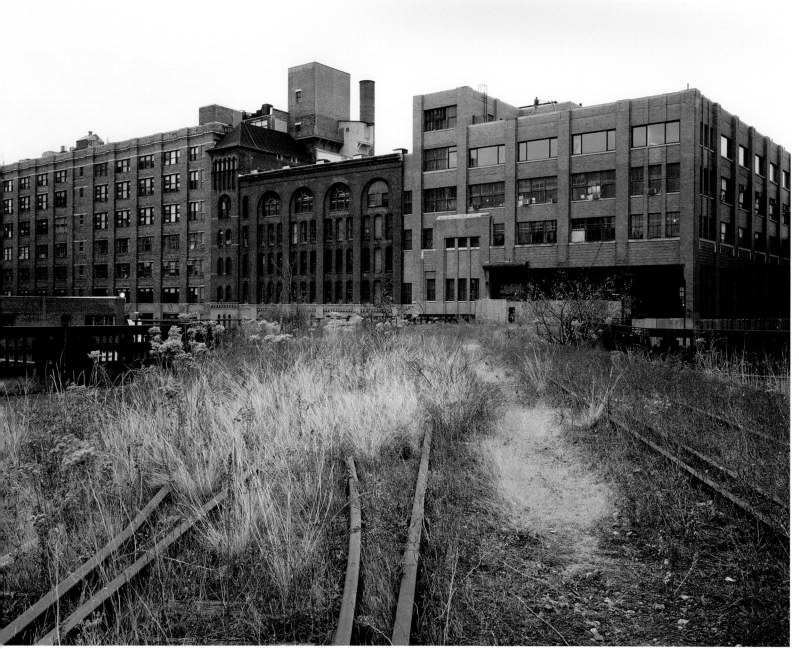

JOEL STERNFELD, WALKING THE HIGH LINE: LOOKING SOUTH TOWARDS CHELSEA MARKETS, DECEMBER 2000, 2000/1

'In the spring of 1978 I received a Guggenheim Fellowship to continue a series of street photographs. But the award and the possibilities it created encouraged a change in my work. All at once it seemed as if the entire continent, every region, every season, and every photographic means were within reach. In time the thematic structure of a new body of work emerged. Although I was only thirty-three years old, I had the sense of having been born in one era and surviving to another. The photographs which I made represent the efforts of someone who grew up with a vision of classical regional America and the order it seemed to contain, to find beauty and harmony in an increasingly uniform, technological and disturbing America.

This is a true time landscape, a railroad ruin. The abandoned place is the place where seasonality resides. These little shoots – see this! This is the real look of spring. Central Park is a construct in so many ways. A beautiful construct, but made for an effect. This is what spring in New York actually looks like when it's left up to spring.'

BELOW JOEL STERNFELD, WALKING THE HIGH LINE: KEN ROBSON'S CHRISTMAS TREE, JANUARY 2001, 2001
OPPOSITE JOEL STERNFELD, WALKING THE HIGH LINE: LOOKING SOUTH ON A MAY EVENING
(THE STARRETT-LEHIGH BUILDING), MAY 2000, 2000/1

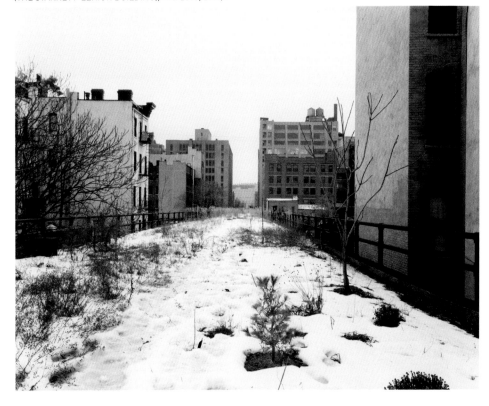

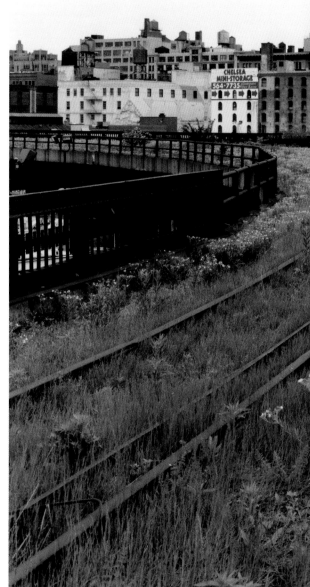

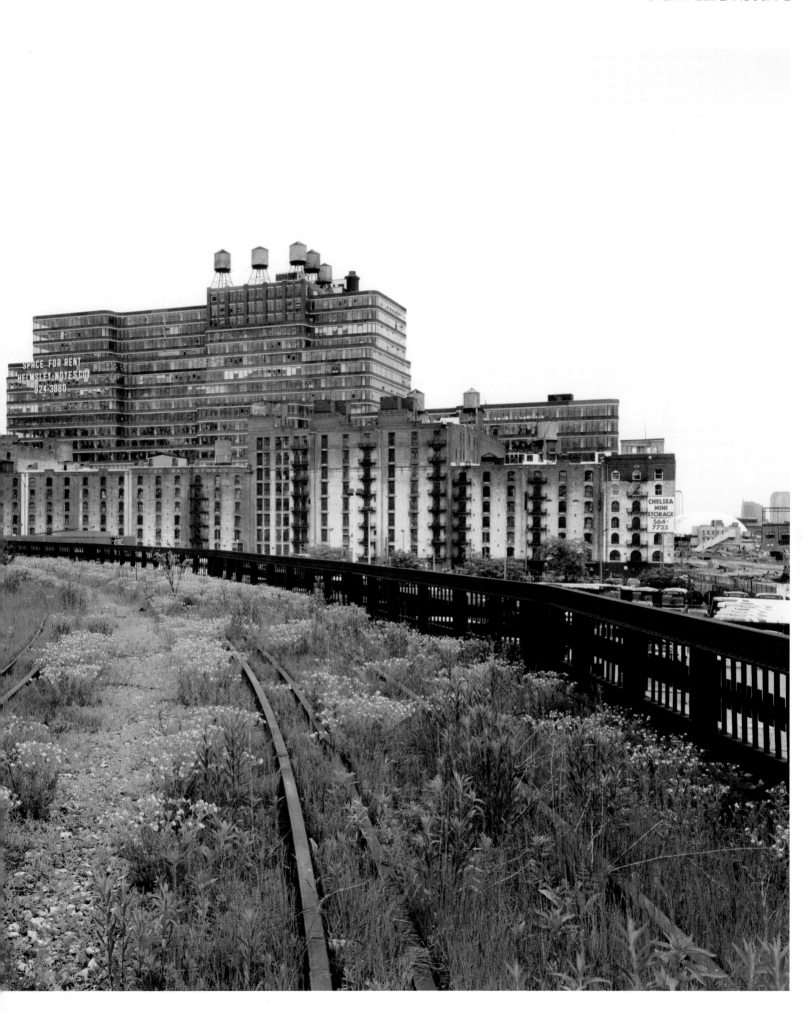

RICHARD MISRACH FOR MORE THAN THIRTY YEARS AMERICAN ARTIST MISRACH HAS BEEN PHOTOGRAPHING THE DESERT AND EXPLORING THE COMPLEX RELATIONSHIP THAT HUMANS HAVE WITH THIS FOREBODING LANDSCAPE. THE SUBLIME BEAUTY OF HIS EXTENSIVE *DESERT CANTOS* SERIES BECOMES ALL THE MORE POIGNANT WITH THE REALIZATION THAT MANY OF THE SITES ARE DUMPING GROUNDS FOR MILITARY WASTE OR TESTING GROUNDS FOR NUCLEAR WEAPONS. HIS MORE RECENT SERIES *ON THE BEACH* TAKES THE FRAGILE HUMAN'S INTERACTION WITH THE LAND TO ITS LIMITS.

'The title for the series, *On the Beach*, is a self-evident description of people indulging in the pleasures of beach-going. It is also a reference to the 1950s Cold War classic *On the Beach*, a film based on the eponymous Nevil Shute novel, which in turn was inspired by the 1926 T. S. Eliot poem "The Hollow Men". Both the film and the poem reflected "end of the world" paradigms for their respective eras.

RICHARD MISRACH, ON THE BEACH: #394-03, 2003

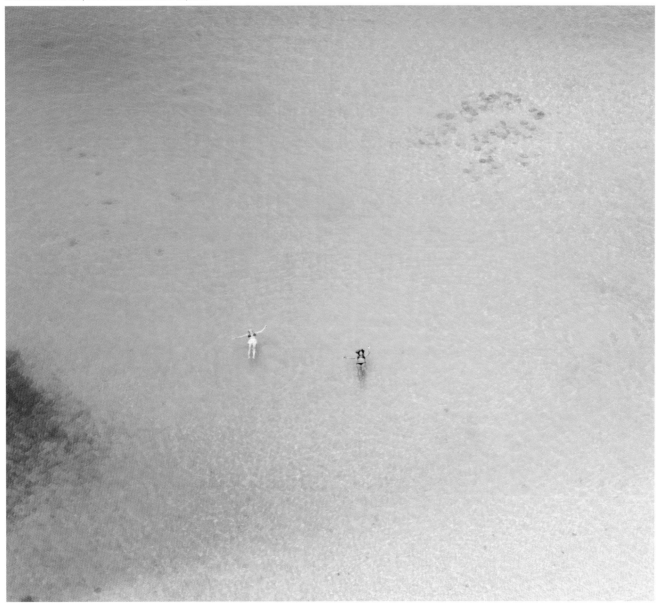

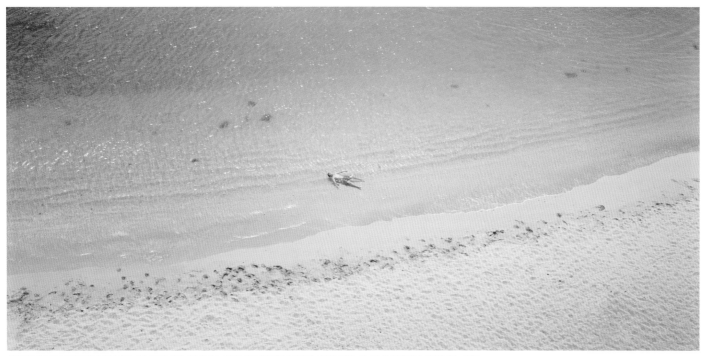

ABOVE RICHARD MISRACH, ON THE BEACH: #892-03, 2003 BELOW RICHARD MISRACH, ON THE BEACH: #192-02, 2002

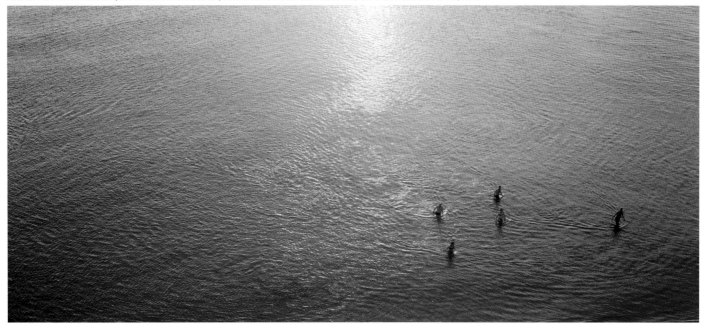

Some of the work has been carefully edited to foreground the vulnerability, ambiguity and unease of my subjects. I often catch swimmers who look like they're drowning, or fleeing some menace or are burying themselves alive in the sand. Another component of the work is its unusual perspective – literally – on a number of dynamics: group behaviour and social space; individual play and the performative; sensual pleasure and our fragility within the natural world. Informing the entire project is a sense of voyeurism and surveillance – the camera as the virtual panopticon of our time.

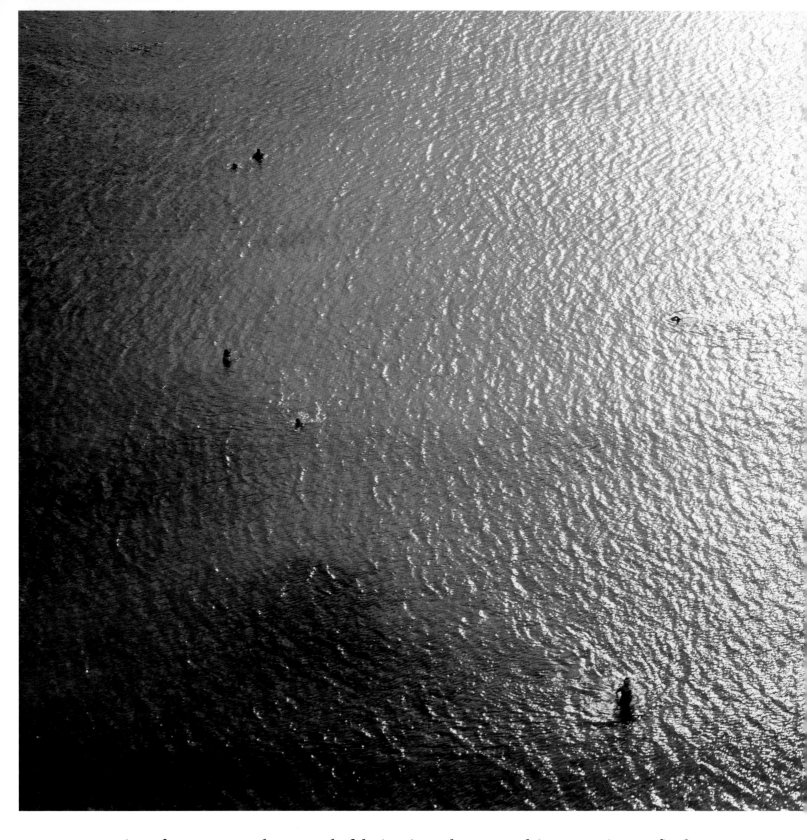

In spite of recent trends towards fabricating photographic narratives, I find, more than ever, traditional photographic capture – the "discovery" of found narratives – deeply compelling. It's astonishing that I can still find, in the commonplace, images that speak so directly to broader themes of culture, literature and history. I am not unaware that I have the mindset, as contradictory as it may sound, to discover in the world what I am in fact looking for. Perhaps the best pictures are a seamless hybrid of discovery and construction.'

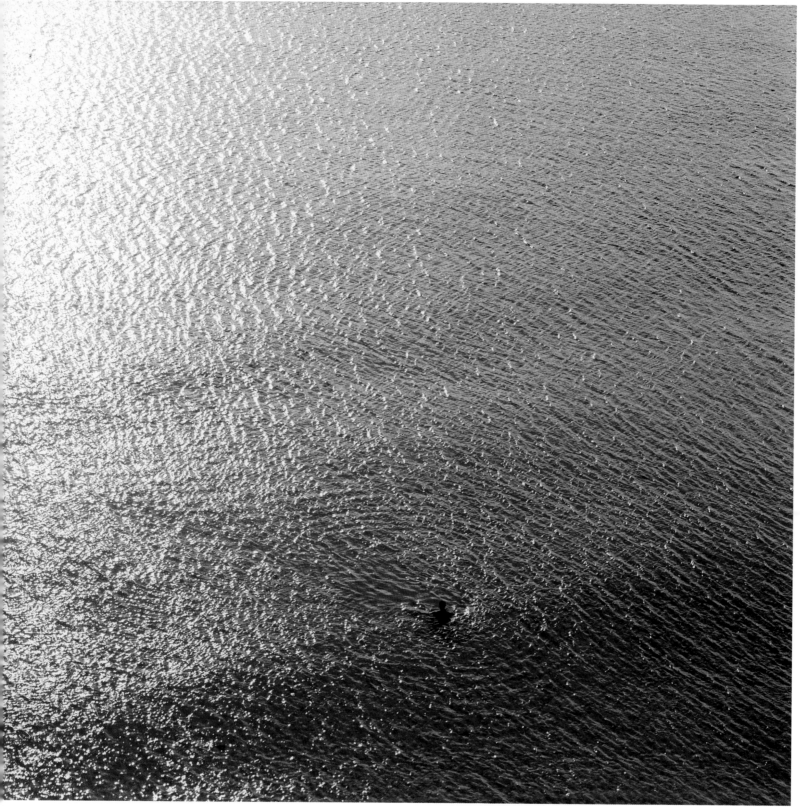

RICHARD MISRACH, ON THE BEACH: #136-02, 2002

JITKÁ HANZLOVÁ HANZLOVÁ MOVED TO GERMANY FROM HER NATIVE CZECHOSLOVAKIA AS A SMALL CHILD IN 1983 AND WAS ABLE TO RETURN ONLY IN 1990, AFTER THE VELVET REVOLUTION. *ROKYTNÍK* (1990–6), HER FIRST BODY OF WORK BACK IN HER OWN COUNTRY, WAS A TENDER LOOK AT THE VILLAGE OF TWO HUNDRED INHABITANTS IN NORTHERN BOHEMIA WHERE SHE GREW UP. *FOREST* IS SIMILAR IN THAT THE ARTIST HAS A VERY PERSONAL ATTACHMENT TO THE PLACE REPRESENTED, THIS TIME THE VILLAGE OF HER BIRTH IN THE NOW CZECH REPUBLIC. BY EXPLORING THE LANDSCAPE OF HER CHILDHOOD IT IS AS IF SHE IS ALSO INVESTIGATING HERSELF AND HER OWN IDENTITY. THE TWO SERIES ALSO SHARE 'FAIRY TALE' CONNOTATIONS AND A RICH PALETTE OF COLOURS.

'In the autumn of 2000, I felt I had to take some time off from doing portraits and look for a different subject. The idea of working on the forest had been growing inside me for many years. In December of that year I went to a forest near my native village in the Czech Republic and started to work there for the first time. Forests have a long and important place in the history of European culture, in our fairy tales and old legends. The very personal connection to this particular forest, to the place, and the need to find out more about myself, as well as to think about the "collective" self and our archaic roots, are the bases for my photographs.

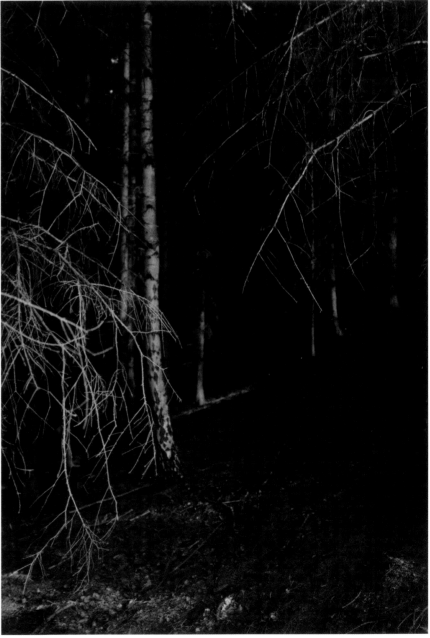

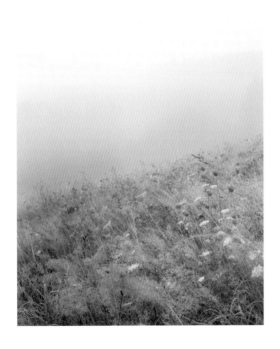

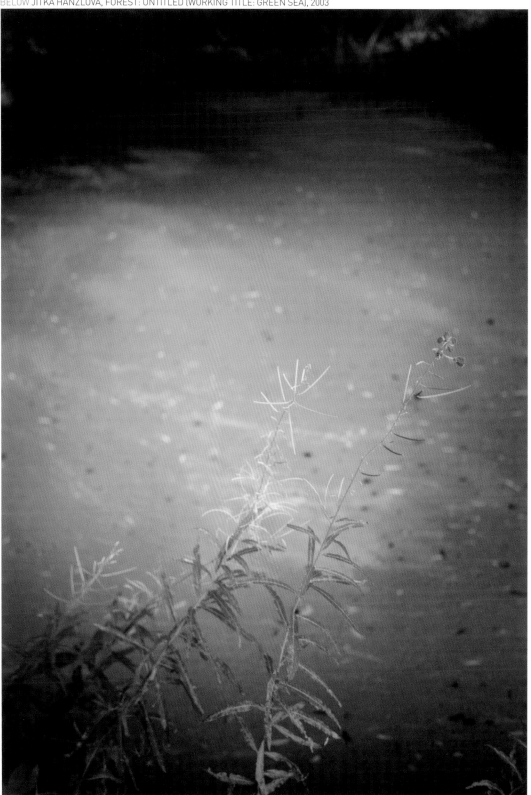

I took the first trips during each season and brought back different pictures. When I looked at them I realized that many of them were of single trees, as if I had made portraits without eyes. Later I made some different, darker pictures. This was new for me, because nearly all of my pictures until this time were light. I wanted to find my own way – to see, to visualize the subject and to try to find my own subject in it. This led to a process of self-reflection and to a different kind of perception from the one I have with portraits. There was nobody looking at me, or communicating with me directly, so I had to look more and more into myself.'

DOUG AITKEN AMERICAN ARTIST AITKEN IS PROBABLY BEST KNOWN FOR HIS WORK WITH VIDEO, AND THE CHARACTERISTICS THAT DEFINE THAT MEDIUM ARE APPARENT WITHIN *NEW OPPOSITION*. THE PHOTOGRAPHS DO NOT WORK AS SELF-SUFFICIENT ONE-OFF FRAMES BUT RELY ON EACH OTHER FOR MEANING. THE OPTICAL TRICKS THAT THE LANDSCAPES FORM WHEN PLACED TOGETHER GIVE THE IMPRESSION TO THE VIEWER THAT THEY ARE EITHER FALLING INTO THE CENTRE OF THE EARTH OR ARE ON TOP OF IT LOOKING DOWN AS IF FROM THE APEX OF A PYRAMID. THIS ACTIVE INVOLVEMENT BY THE VIEWER AND THE THREE-DIMENSIONAL SCULPTURAL SENSATIONS OF THE PHOTOGRAPHS CAN ALSO BE SEEN IN THE ELABORATE INSTALLATIONS THAT OFTEN ACCOMPANY HIS VIDEOS.

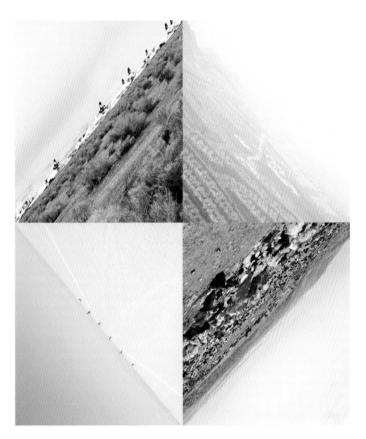 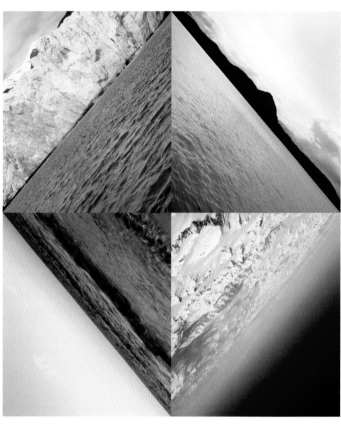

'The series *New Opposition* consists of three pieces and was started in 2001. I was interested in the fragmentation of the image. I wanted to formulate an image that was whole but also broken apart. So these are multiple images working as one. I wanted to find a way to blend together different moments in time, different spaces and different locations. I wanted to bring them together in a central unifying image. They are not portraits or cityscapes but more an entropic progression. As the series progresses it becomes increasingly abstracted and denser and you get a sense of motion. The elements in the last image are ones you might just walk past in daily life – there is nothing special about the land. You can imagine someone who is surveying the land taking them. I really like the idea of banality and repetition being used to generate the images, which are simple and unobstructed and not captivated by composition.

The images create a cycle of different places, but they can all be tied together through the central unifying theme of the horizon, which cuts, perpendicular, through them. I was after a three-dimensional quality. Working as well are the ideas of montage and editing, basically filmic concepts, as is repetition. I wanted the eyes to constantly search for the horizon. When the images are brought together they collapse and create a feeling of retreating or expanding.'

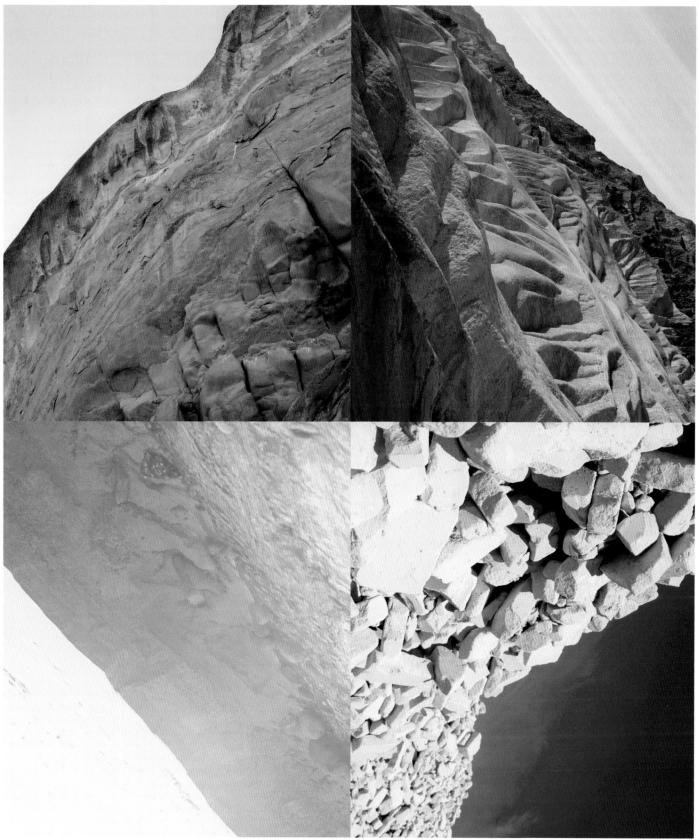

OPPOSITE LEFT DOUG AITKEN, NEW OPPOSITION IV, 2003 OPPOSITE RIGHT DOUG AITKEN, NEW OPPOSITION II, 2001 ABOVE DOUG AITKEN, NEW OPPOSITION III, 2003

UTA BARTH FAVOURING THE EFFECTS OF LOOKING OVER DEPICTION AND CLARITY OF SUBJECT MATTER, GERMAN ARTIST BARTH CREATES IMAGES THAT WORK IN VERY DIFFERENT WAYS FROM TRADITIONAL LANDSCAPE PHOTOGRAPHY AND QUESTION THE FUNCTION OF AND OUR EXPECTATIONS ABOUT PHOTOGRAPHS. SUGGESTIVE RATHER THAN DESCRIPTIVE, HER WORK IS CONCERNED WITH ISSUES OF SPACE AND WITH HOW HUMANS REACT TO LOOKING AT AND ENCOUNTERING A CERTAIN VIEW. IT FOCUSES ON BOTH INTERIORS AND LANDSCAPES BUT REFUSES TO FIT NEATLY INTO TRADITIONAL GENRES AND PIGEONHOLES. THE AMBIGUITY, SO CRUCIAL TO HER WORK, ALSO HAS THE EFFECT OF MAKING THE BANAL BEAUTIFUL, WHICH IN TURN MAKES US RECONSIDER WHAT WE SPEND OUR TIME LOOKING AT AND WHY.

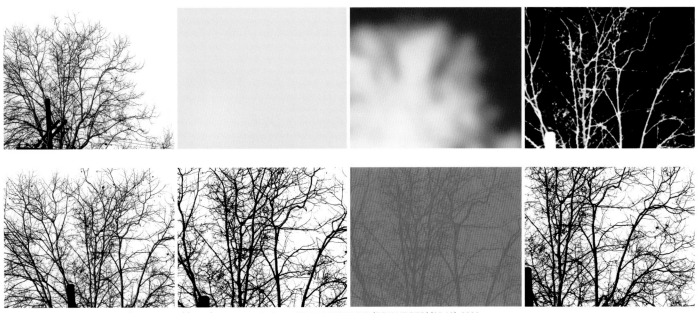

TOP UTA BARTH, WHITE BLIND (BRIGHT RED) (02.12), 2002 ABOVE UTA BARTH, WHITE BLIND (BRIGHT RED) (02.13), 2002

'This project, like all of my work, foregrounds the activity of looking over that which is being looked at. My work never directly addresses the literal subject-matter of the photograph, but attempts to asks questions about vision itself. This particular project traces the long look. They are images of duration, of visual fatigue, of optical overexposure. What happens when you stare into the sky? What happens when you look into blinding light and then close your eyes? What is the image held in place while now in the dark? The work looks at optical afterimages, which invert the view and then drift and fade slowly, only to be replaced by the original scene, once your eyes open again. The work describes these afterimages and blinding events, describes what the eye sees, that the camera cannot.'

SIMONE NIEWEG FOR MORE THAN TEN YEARS, NIEWEG HAS BEEN PRODUCING COLOUR PRINTS OF SEMI-RURAL OR CULTIVATED LANDSCAPES NEAR HER HOMETOWN OF BIELEFELD IN GERMANY. HER SYSTEMATIC CHOICE OF SUBJECT MATTER AND ALMOST FORENSIC APPROACH TO LANDSCAPES SUCH AS GARDENS, ALLOTMENTS AND FIELDS SHOW THE INFLUENCE OF GERMAN PHOTOGRAPHERS INCLUDING AUGUST SANDER AND ALBERT RENGER-PATSZCH, WHO WORKED AT THE BEGINNING OF THE TWENTIETH CENTURY. THE SIMPLICITY OF GROWING ONE'S OWN VEGETABLES AND THE ANCIENT DISCIPLINE OF PLANTING IN REGIMENTED ROWS CONTRAST GENTLY WITH MODERN-DAY MAKESHIFT GARDENING APPARATUS SUCH AS PLASTIC BOTTLES AND BUCKETS.

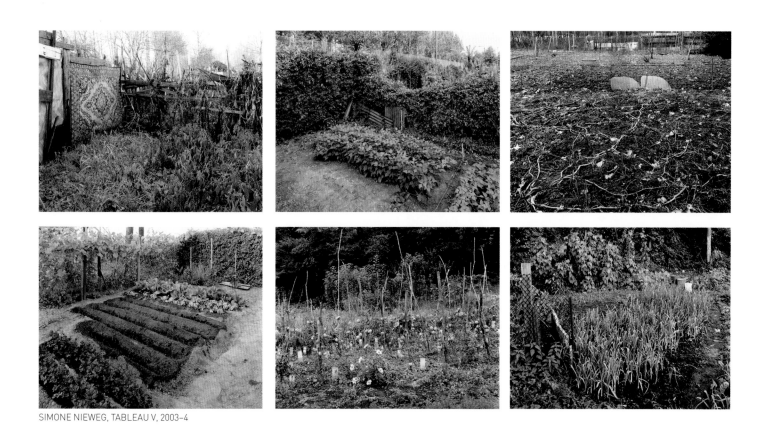

SIMONE NIEWEG, TABLEAU V, 2003–4

'Since my student days I have dealt with the cultivated landscape in its different manifestations. It all started with a series about vegetable gardens, which I have been adding to since 2002. In 1990 I turned to pictures of fields and woods, most of which were in the immediate vicinity of my home town.

It is the interplay between man and nature, between purposeful human planning on the one hand and unpredictable instinctive growth on the other, that I find visually exciting. In some respects, I am reassured to see the degree to which nature protects its incalculable dynamic and atmospheric power, despite all the human interventions and transformations.'

ANDREAS GURSKY SCALE IS VITAL TO GURSKY'S WORK – NOT ONLY IN HIS CHOICE OF SUBJECT AND THE WAY HE DEPICTS THE SCENE BUT ALSO IN THE USE OF GIANT-FORMAT PRINTS. THESE ALLOW THE VIEWER ALMOST TO FALL INTO THE SCENE AND TO EXPERIENCE IT AS THE ARTIST DID WHEN HE PHOTOGRAPHED IT. RECENTLY GURSKY'S WORK HAS TAKEN ON A MORE CRITICAL EDGE BY LOOKING AT HUMAN CONSUMPTION AND CONSUMERISM AND THE EFFECTS THESE HAVE ON THE LAND. BY USING SUCH HIGH AND DISTANT VIEWPOINTS, HE OFFERS US A VIEW OF SOCIETY THAT WE COULD NOT OTHERWISE EXPERIENCE.

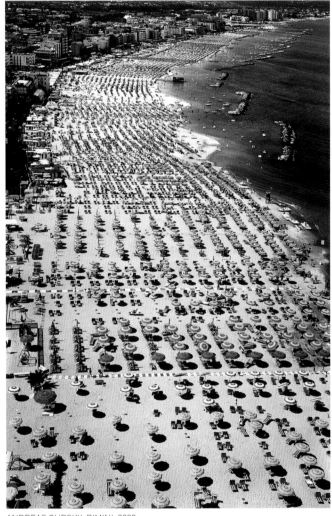

ANDREAS GURSKY, RIMINI, 2003

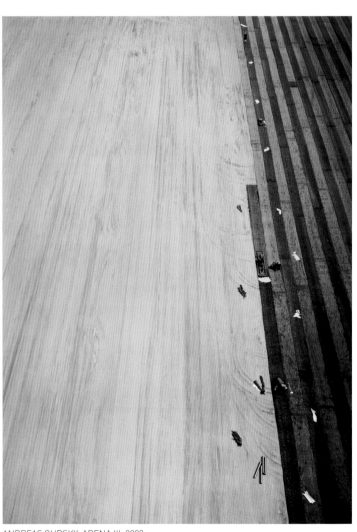

ANDREAS GURSKY, ARENA III, 2003

'As a person who primarily experiences his environment visually, I am always observing my immediate surroundings. Consequently, I am constantly putting things in order, sorting them out, until they become a whole. My preference for clear structures is the result of my desire, perhaps illusory, to keep track of things and maintain my grip on the world.'

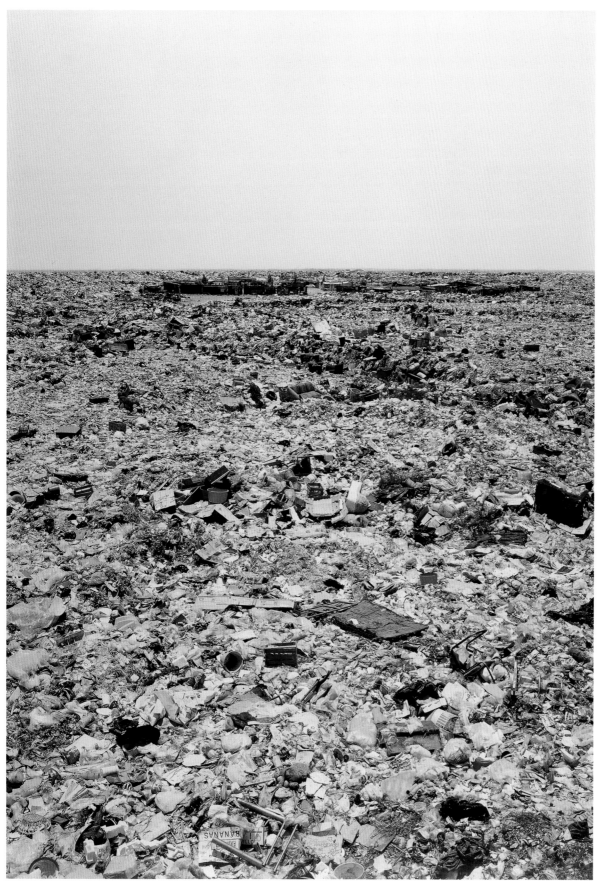

ANDREAS GURSKY, UNTITLED XIII (MEXICO), 2002

DAN HOLDSWORTH BRITISH ARTIST HOLDSWORTH FIRST CAME TO INTERNATIONAL ATTENTION WITH A SERIES OF PHOTOGRAPHS THAT EXPLORED SPACES AND LOCATIONS ON THE EDGES OF URBAN ENVIRONMENTS, SUCH AS SERVICE STATIONS AND OUT-OF-TOWN MALLS. NEITHER RURAL LANDSCAPES NOR CITYSCAPES, THEY PORTRAYED THE BOUNDARIES OF MODERN LIVING WITH A BEGUILING AND MYSTERIOUS BEAUTY. *THE WORLD IN ITSELF* AND *BLACK MOUNTAINS* TURN TO MORE EXTREME ENVIRONMENTS, BUT AT THE CORE OF BOTH SERIES IS THE SAME THEME AND EXPLORATION: THE AGE-OLD DIALECTICAL RELATIONSHIP BETWEEN NATURE AND MAN.

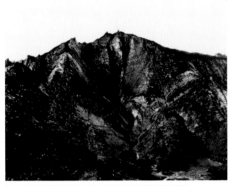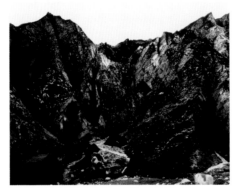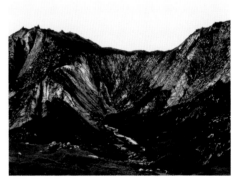

DAN HOLDSWORTH, BLACK MOUNTAINS, 2001

'*Black Mountains* was taken on the south coast of Iceland. It is the edge of a glacier and there's a volcano underneath. It's at the edge of the world's third largest ice cap, and because of the volcanic debris in the ice you have oozing soot. The day it was taken was very still, and because it hadn't rained for a couple of days there were panicles of soot on the ice which made it look sharp even though it's soft and fragile. I was attracted to it physically as it felt so intimidating. It almost looked unnatural – like it was an overspill from mining activity. The area that runs off this to the sea is an area of black desert, which in itself seems upside down. It makes the desert more bleak and less familiar. I made it into a triptych, as I wanted to have a certain scale to the piece and occupy the space in a very physical way. It doesn't mimic the experience of walking along it, but I did want people to be confronted by this slab of nature.

Black Mountains followed on from *The World in Itself*. Both series are like alien landscapes and I am interested in extreme environments where there is nothing to distract you. Your mind and body become very focused. I try to make images that are open compositionally so I'm not interested in very familiar photographic forms. I shot these with the smallest aperture so that they look very flat, which is important.

I am interested in abstraction, and working with the landscape is a very personal experience; it is also about exploring how we, as a species, occupy the Earth. As soon as I discovered the pools in *The World in Itself* I knew immediately what I wanted to do with them. I didn't want them to reflect the sky or to be romantic or domesticated in any way. I wanted them to be quite unfamiliar and a bit difficult, to reflect my experience of being there. I overexposed the pools and the sky so in fact the pools don't reflect anything. They become holes in the surface. I have always been very interested in taking out information in photographs, as a kind of visual editing. You could do that digitally but I have just done it through exposure. I like the fact that there isn't anything there, that the pools become like cut-outs.'

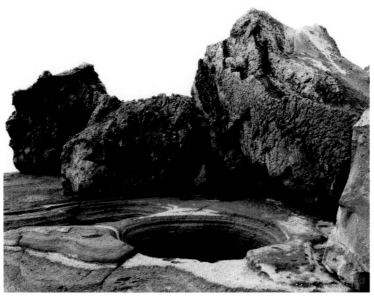

DAN HOLDSWORTH, UNTITLED (THE WORLD IN ITSELF NO. 3), 2000

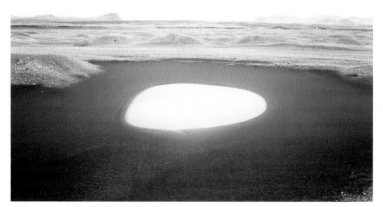

DAN HOLDSWORTH, UNTITLED (THE WORLD IN ITSELF NO. 2), 2000

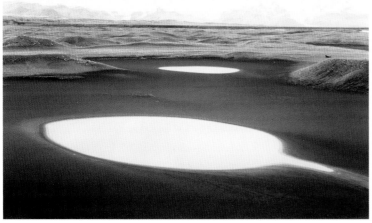

DAN HOLDSWORTH, UNTITLED (THE WORLD IN ITSELF NO. 5), 2000

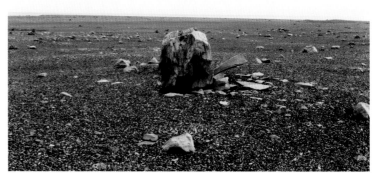

DAN HOLDSWORTH, UNTITLED (THE WORLD IN ITSELF NO. 1), 2000

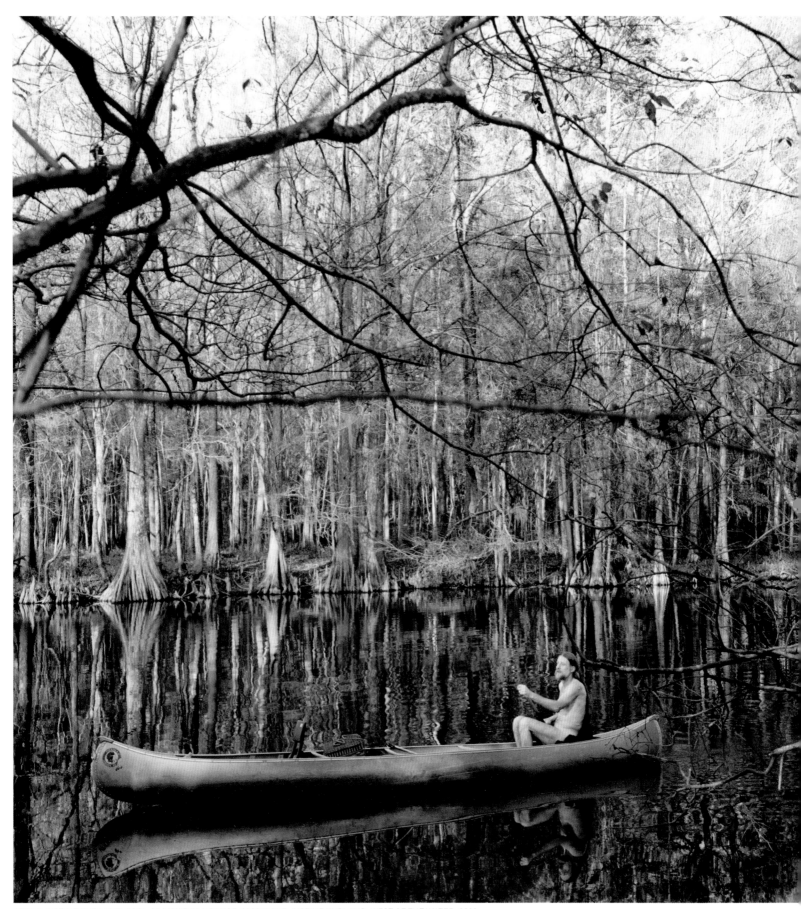

ABOVE JUSTINE KURLAND, FOOL OF MOXIE IN A CANOE, 2003 RIGHT JUSTINE KURLAND, WEST OF THE WATER, 2003

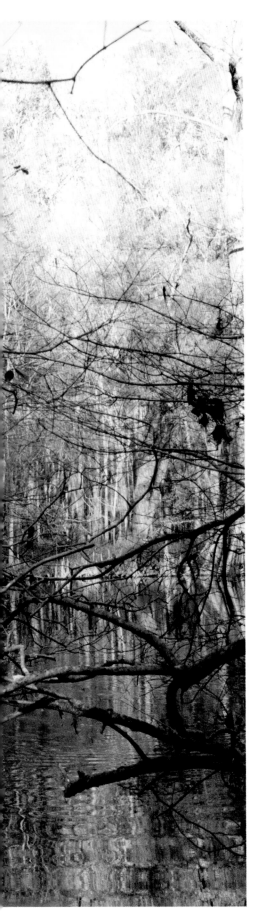

JUSTINE KURLAND AMERICAN ARTIST KURLAND WAS
INCLUDED IN THE 1999 EXHIBITION 'ANOTHER GIRL,
ANOTHER PLANET', CURATED BY THE ARTIST GREGORY
CREWDSON. THIS INFLUENTIAL SHOW, WHICH INCLUDED
SIXTEEN WOMEN PHOTOGRAPHERS, LOOKED AT THE
STAGED NARRATIVE STYLE SO DOMINANT IN ART
PHOTOGRAPHY OF THE 1990S. KURLAND OFTEN CHOOSES
ALLEGORICAL TITLES TO ENHANCE NARRATIVE READINGS
IN HER WORK, JUST AS VICTORIAN FAIRY PAINTINGS WERE
SOMETIMES TITLED AFTER A SENTENCE FROM A STORY.

'The naked figures in the photographs have willingly undressed for my camera. They are either perfect beings heroically occupying their Edens, or else they are gardeners after the Fall, lost and exposed to both the elements and the lens. In other cases quasi-biblical narratives or ritual acts are performed by the subjects as they elaborate fantasies of communal living and communion with nature. And sometimes it is the natural landscape that dominates, swelling to engulf the figures who inhabit it. The photographs are a shared act of faith, a romantic gesture impelling us towards a transcendental experience of being human in the world.

These photographs were made during extended road trips, while visiting and living among "hippie" communes across America. Early nineteenth-century photography rendered the colonization of the American landscape in epic expanses, aestheticizing the wilderness as a receptacle for a new, self-made civilization and its utopian impulses. The communities I visited are a continuation or remnant of the pioneer dream, and these photographs operate inside the American tradition of picturing a more perfect world. These communes are remote pockets of extreme idealism, sustained by an ethic of living stoically and with a bare minimum. Their members, usually transient, are tied to each other and to the land for that moment through shared social, political, and spiritual beliefs, and through the desire to live in harmony with nature.'

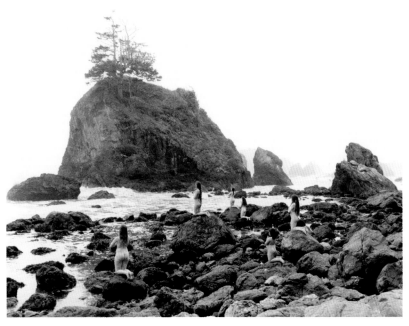

WALTER NIEDERMAYR NIEDERMAYR'S INTEREST IN PHOTOGRAPHING THE LANDSCAPE BEGAN IN 1987. HIS INTEREST IS IN HOW HUMANS INTERACT WITH THE LAND AND WHAT SPACES REPRESENT BOTH CULTURALLY AND SOCIOLOGICALLY. LIKE THE SEASIDE, ALPINE RETREATS ARE AREAS OF ESCAPE AND FANTASY – PLACES FOR FUN AND HOLIDAYS. HOWEVER, NIEDERMAYR'S PHOTOGRAPHS QUESTION WHAT WE ARE ESCAPING TO, AND BY SURVEYING THE SCENES FROM A GREAT DISTANCE HE MAKES THE TOURIST INDUSTRY, AND OUR DESIRE, LOOK SLIGHTLY RIDICULOUS. THESE IMAGES FORM PART OF A LARGE-SCALE PHOTOGRAPHIC BOOK ENTITLED *CIVIL OPERATIONS* (2003), WHICH ALSO FEATURES INVESTIGATIONS INTO SPACE IN INSTITUTIONS SUCH AS PRISONS AND OFFICES.

'I have no particular connection with the mountains, except that generally they form my immediate habitat – hence for me it was the most natural thing in which to absorb myself, something I knew a bit about…. No landscape interests me purely as a landscape. I'm interested in the landscape in which man is present. The works focus on the presence of human beings in the landscape. In order for me to turn this "picture" into a picture, however, there must be a certain intensity to the human presence. In the photographic transformation the signs and examples of interaction become apparent. There is definitely an aesthetic interest behind the observations: naturally, aesthetic questions are tied in with the contact with the landscape or the awareness of space.'

LEFT WALTER NIEDERMAYR, NIGARDSBREEN I, 2002
OPPOSITE WALTER NIEDERMAYR, FRANZ-JOSEFS-HÖHE V, 2002

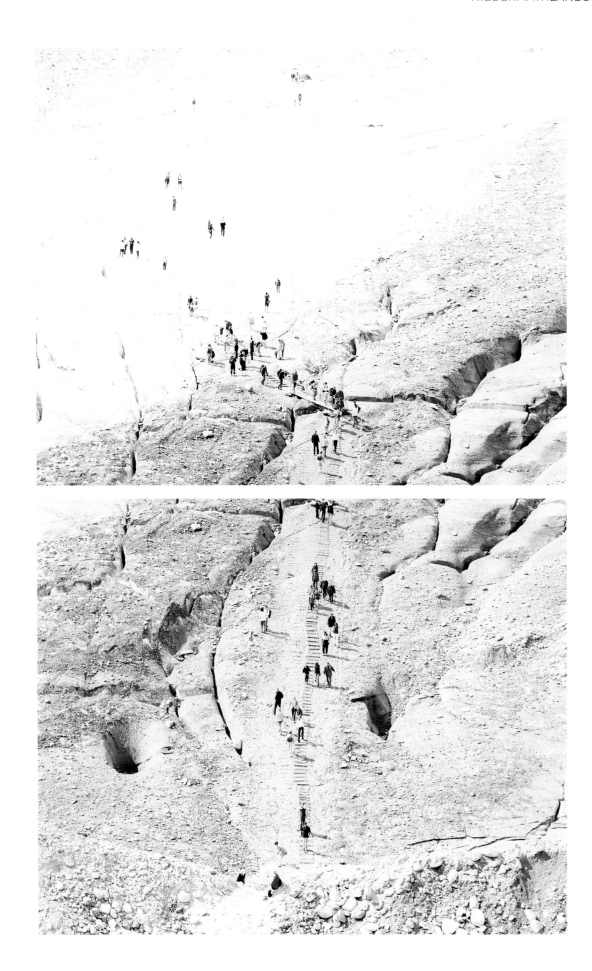

JEAN-MARC BUSTAMANTE THESE LARGE-SCALE IMAGES FORM PART OF A SERIES THAT CARRIES ON FROM A BODY OF WORK PRODUCED IN 2000 SHOWING LAKES IN SWITZERLAND. THE LATTER WAS SIMPLY ENTITLED *L.P.*, WHICH CAN STAND FOR 'LAKES PHOTOGRAPHS', 'LOST PARADISE' OR 'LONG PLAYING'. THE GENERIC LAKE, HISTORICALLY AS WELL AS FOR THE PURPOSES OF TOURISM, HAS OFTEN BEEN PICTURED AS A PARADISIACAL PLACE, PURE, PICTURESQUE AND ABOVE ALL INVITING. THE CAREFUL COMPOSITION OF FRENCH ARTIST BUSTAMANTE'S WORK OFTEN OBSCURES VIEWS AND REMOVES THE POSSIBILITY OF STEREOTYPICAL READINGS, FORCING US TO LOOK DIFFERENTLY AT PLACES WE THINK WE KNOW. THE 'NATURAL' ENVIRONMENT IS OFTEN SHOWN AT ITS MOST BANAL, WITH HUMAN HABITATION FORMING THE FOREGROUND OF THE PICTURE.

'In 2000 I began a new series of monumental photographs of lakes in Switzerland. The idea was to photograph lakes and to elaborate the idea of landscape photographs as mental spaces. The presence of the lakes as blue monochrome surfaces divided the spaces, from very sophisticated areas to the wilderness, giving these images a peculiar atmosphere.

BELOW JEAN-MARC BUSTAMANTE, S.I.M.1.04, 2004 OPPOSITE JEAN-MARC BUSTAMANTE, T.7.01, 2001

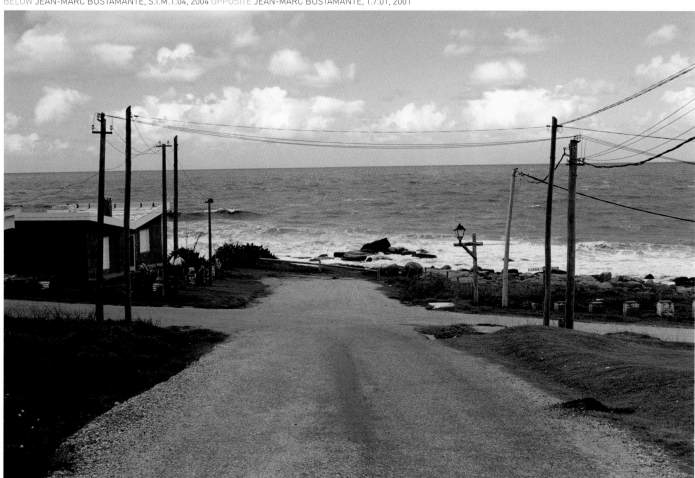

74

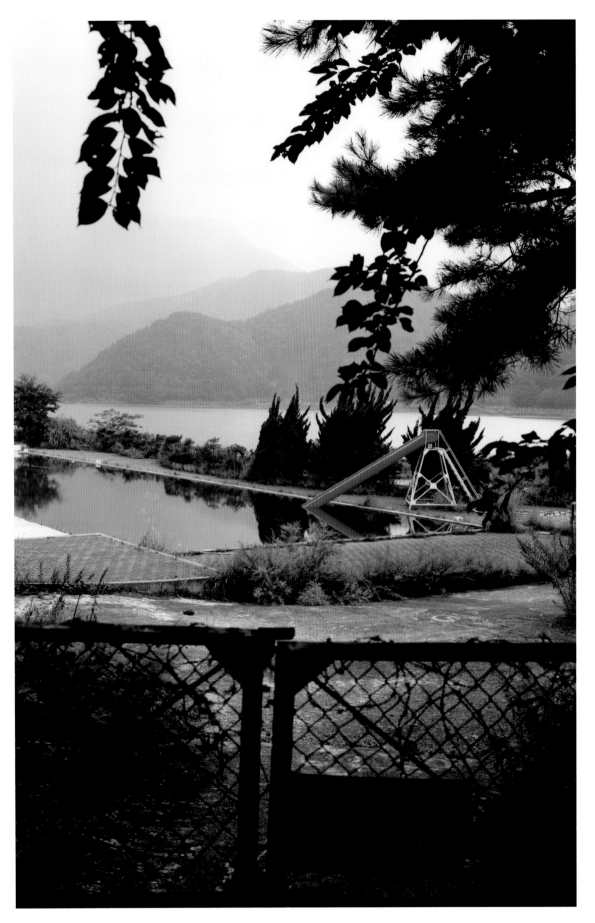

I have decided to continue this series through Japan, where I am confronted with the specific properties of Japanese landscapes, which have strange similarities with Switzerland. At the same time I am also taking photographs in very far-off, "lost" countries in an ongoing series called *Something is Missing*. Sort of dead ends which face towards the sea as ultimate limits.'

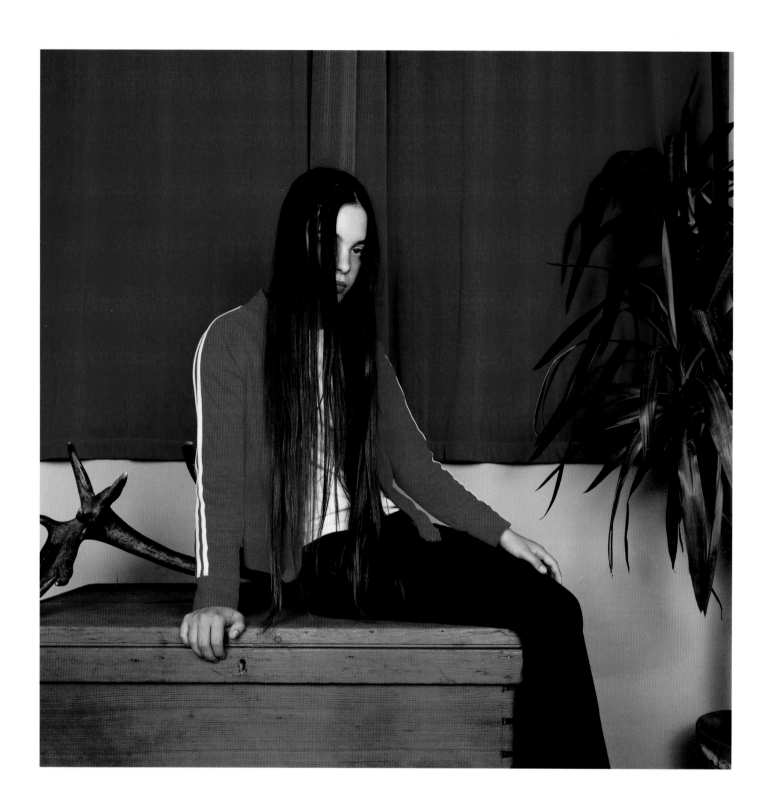

SARAH JONES, THE LIVING ROOM (CURTAIN) (I), 2003

NARRATIVE

To try to follow the threads of influence that feed into contemporary art photography is an almost impossible task. It is too wide and varied, contradictory and elusive. Sucking its references from many rich springs, photography is the magpie of all artistic mediums, cherry-picking styles and theories from the other arts and turning them into something resolutely its own. These rich pickings are nowhere more apparent than in 'staged photography'. This term is the most commonly used for photography which relies on a narrative for its reading. Of all the genres featured in this book it is perhaps this that has become most synonymous with contemporary art photography.

One of the most exciting moments in very recent photographic practice emerged with a generation of artists in the 1990s. Understanding and relishing the complexities of the medium, as outlined by a previous generation of theorists and photographers, these artists incorporated elements of fantasy, artifice and make-believe into their work. By scrupulously staging events and working with their subject matter in a similar way to that of a film director, artists created often sumptuous and seductive fictitious tableaux in which narrative elements came to the fore. Carefully choreographed, performative and elaborately conceived, photography that deals with narrative owes much to the language and look of cinema.

The term 'narrative' suggests a story, and therefore movement. A story needs to progress in order to be told. At first this seems at odds with the singularity of a photographic still, but 'staged' photography distils stories into one-off images, packed full of multi-layered information. Such images function densely rather than chronologically, as experienced in a photo story. Although many of the artists featured do work in series, each of their images also stands alone in the same way as a painting or a film still does.

Narrative photography demands time from the viewer, peeling off the layers to get to the next instalment which might (or, more likely, might not) fill in the blanks. The language of film and the cultural understanding of how we engage with cinema is vital. The pregnant pauses, the mises-en-scène and the dramatic lighting all borrow from the filmic tradition and share the seductive qualities of the silver screen. Artists in the 1980s such as Laurie Simmons and Cindy Sherman employed similar strategies in their work, but referenced specific cinematic tropes in order to parody and pastiche them. Cinema has influenced contemporary art in a variety of ways as can be seen in the work of artists such as John Divola, John Stezaker, Douglas Gordon, John Baldessari, Matthew Barney and Robert Altman to name but a few. Andy Warhol's obsessive fascination with the icons of the screen and his work in film perhaps make him the grandfather of the cinema/photography crossover. As ways of looking, cinema and photography have much in common and it is not surprising that they influence and support one another so profoundly.

However, narrative photography relies on many other vital sources apart from cinema. Painting, fashion, theatre and literature all have equally important parts to play. Victorian photographers such as Julia Margaret Cameron turned to popular poems and literature and re-enacted them photographically in elaborate 'tableaux vivants'. Surrealists such as Claude Cahun produced theatrical portraits that literally used the backdrop of the stage to exaggerate their artifice and to think about roles and performances for the camera. It could also be argued that self-consciously staged narratives have also always been commonplace in fashion photography, portraiture and in the family snapshot. Narrative is crucial to photography, as is artifice, and contemporary artists realize this and use these as strategies to tell stories. But these images often tap into wider social issues, and to see them as only functioning as fantasy is to ignore the other very real issues that lie behind this kind of work. Nor can one think about this way of working as copying. The references for each image are eclectic and cannot be traced from a particular painting or moment of cinema. The artist's hand is very much apparent in staged photography and autobiographical glimpses often add yet another layer, or story, to the final image.

For many of the artists here, it is the work of Canadian artist Jeff Wall that has been the most direct source of inspiration, and his influence cannot be overestimated. For a period of over twenty years, Wall has developed an outstanding body of work in which he places images in back-lit boxes more generally associated with the display of adverts. Through his carefully constructed work he explores a range of social and political themes. A constant dialogue with nineteenth-

century genre paintings is blended with a seemingly casual snapshot style to show moments of everyday life that may well have gone unacknowledged. At times he digitally manipulates his work to confuse the viewer further, so that they have to look harder at his work and think more deeply about the role of the photograph itself. It is the doubt about what is actually being represented, and the deconstruction of what a photograph essentially is and how it functions, that are core to his work and to the work of others of his generation. His background in art history (he studied the subject at the Courtauld Institute of Art in London) reveals a sophisticated knowledge of painting and the stylistic and compositional devices of art. Indeed his comments on art history are equally explanatory of his own practice:

'The Western Picture is, of course, a tableau, that independently beautiful depiction and composition that derives from the institutionalisation of perspective and dramatic figuration at the origins of modern Western art, with Raphael, Dürer, Bellini and the other familiar maestri. It is known as a product of divine gift, high skill, deep emotion, and crafty planning.'

The energy, time and skill needed to create such a constructed photograph is common to all the artists featured in this chapter, but they do have different approaches to narrative. The subtle mixture of the everyday and the staged in the work of Wall can also be seen in work by artists such as Sarah Jones, Hannah Starkey, Sharon Lockhart, Collier Schorr and Bill Henson. Weaving documentary issues and styles into their work, the ambiguity between what is staged and what is 'real' gives these images their power. In a careful balancing act between reality and fantasy, the viewer is unsettled and does not really know on what terms to take the photograph. Part document, part fantasy, such images produce a tension that is often echoed by their subject matter and composition. The very 'stillness' that

occurs in such constructs often has a claustrophobic or uncanny effect which is reminiscent of Victorian photography with its slow shutter speeds. The stillness creates an atmosphere of expectation. It can be seen as the pregnant pause, or in many cases the calm before the storm. By lingering on figures they become as compelling as portraits and, as when watching a film, the viewer forms allegiances with the characters involved.

This feeling of the uncanny or of impending doom can be seen acutely in much staged photography and is often extenuated by the use of children and the presence of slightly dangerous situations. The push and pull between the beautifully constructed image and the fear of something dreadful about to happen has become something of a cliché within the genre and there has been a shift recently to quieter, more ambiguous work, almost documentary in style. The predominance of female practitioners and subject matter is also changing and the genre is generally becoming more diverse.

The noticeable use of a stage set with obvious 'actors' is another common device in narrative work. Artists such as Tracey Moffat and Wang Qingsong make no claims to be dealing in the realms of reality, although many of the themes that they touch on are grounded in the real world and have serious implications. The playful, slightly kitsch approach makes their work accessible and then leads the viewer to think more deeply about the messages the actors are presenting. The 'over the top' costumes and 'ham acting' inject humour into a genre that is often associated with horror (even if that horror is just around the corner, unseen).

Finally, it is here that the use of the digital perhaps has the freest reign. Although artists such AES&F deal completely in the realm of fantasy, the ramifications of human behaviour underpin their work. The complex layers built into narrative photography show the many twists and turns and variations that exist in the telling of stories. As with all photography, the deeper you delve, the more you get.

GREGORY CREWDSON THE SINISTER AND
SEETHING UNDERBELLY OF SUBURBIA
HAS LONG BEEN A SOURCE OF INSPIRATION
FOR ARTISTS. BUILT AS ASPIRATIONAL
AND ALMOST PARADISIACAL HABITATS
FOR THE MIDDLE CLASSES, THESE AREAS
OUTSIDE THE CITY CENTRE BECOME,
FOR AMERICAN ARTIST CREWDSON,
SITES FOR BIZARRE AND UNEXPLAINABLE
HAPPENINGS. TAPPING INTO A HOST OF
PARANOID FEARS, IT IS AS IF THE LID HAS
BEEN LIFTED TO EXPOSE THE FANTASIES
AND ANXIETIES OF THOSE LIVING THERE.
THE ALMOST CLAUSTROPHOBIC CALMNESS
OF THE INHABITANTS IN HIS TABLEAUX
CONTRADICTS THE ACTIVITIES AROUND
THEM, CAUSING AN UNCANNY TENSION
THAT WE, AS VIEWERS, UNDERSTAND AND
REACT TO LIKE THE MOMENT BEFORE A
CATASTROPHE IN A SCIENCE-FICTION FILM.

'My first impulse is to make the most
beautiful picture I can. But then I'm
always interested in this idea of a kind
of undercurrent in the work. I think of
that completely in psychological terms.
The perfect façade and what's beneath
the surface of that façade. I'm very
interested in the uncanny and a way
of looking to find something mysterious
or terrible within everyday life. For better
or worse, a lot of my newer pictures seem
less dark. The uncanniness is less explicit
and more poetic in feel.

GREGORY CREWDSON, UNTITLED (PREGNANT WOMAN/POOL), 1999

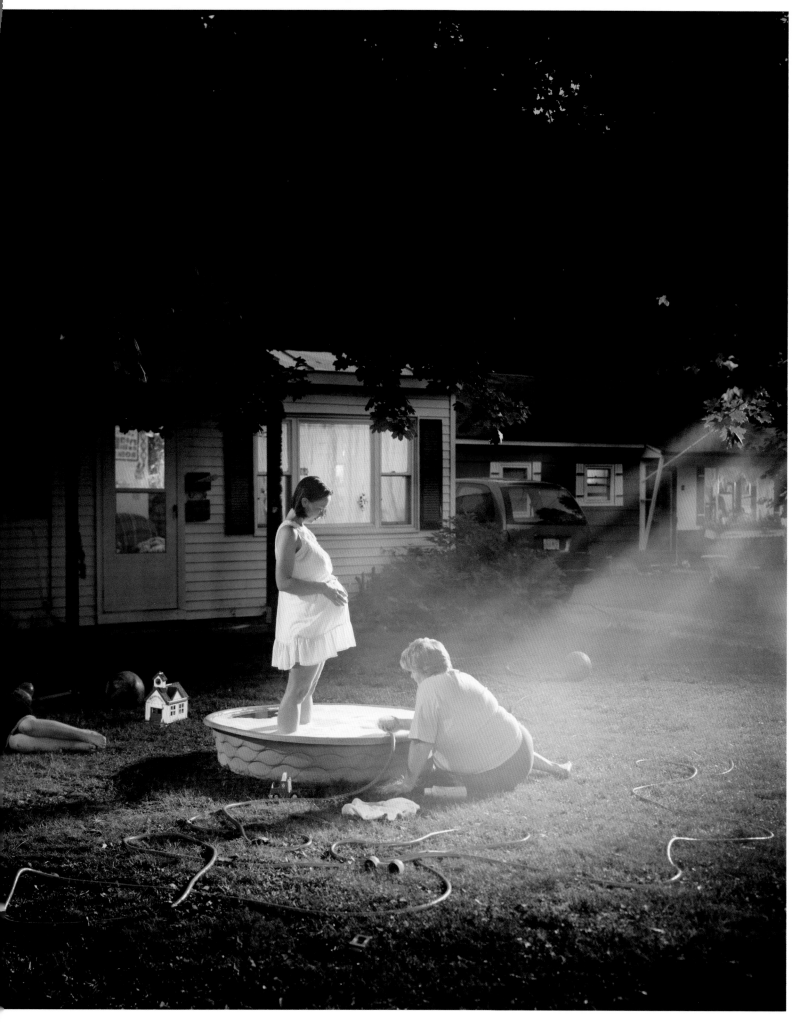

I have always been very interested in the idea of telling a story, in narrative and the limitations of photographs. Where other more traditional modes of story-telling such as film and literature move forward in time the photograph is still and frozen. From day one, I have been interested in taking that limitation and trying to find the strength in it – like a story that is forever frozen in between moments, before and after and always left as a kind of unresolved question.

Even though my work is primarily influenced by film, I consider myself first and foremost a photographer. I like the idea that I am able to instil, in a single moment, every imaginable kind of production technique to make a perfect image. I work with a production crew of about sixty people. Almost every one of them comes out of a film background. There are two essential ways in which we work. One is on a sound-stage in a big studio. We build everything up from nothing. The second is on location. On location it's pretty much like a film crew coming to town and

BELOW GREGORY CREWDSON, UNTITLED (BUD MAN/ COYOTES), 1999 OPPOSITE GREGORY CREWDSON, UNTITLED (RAY OF LIGHT), 2001

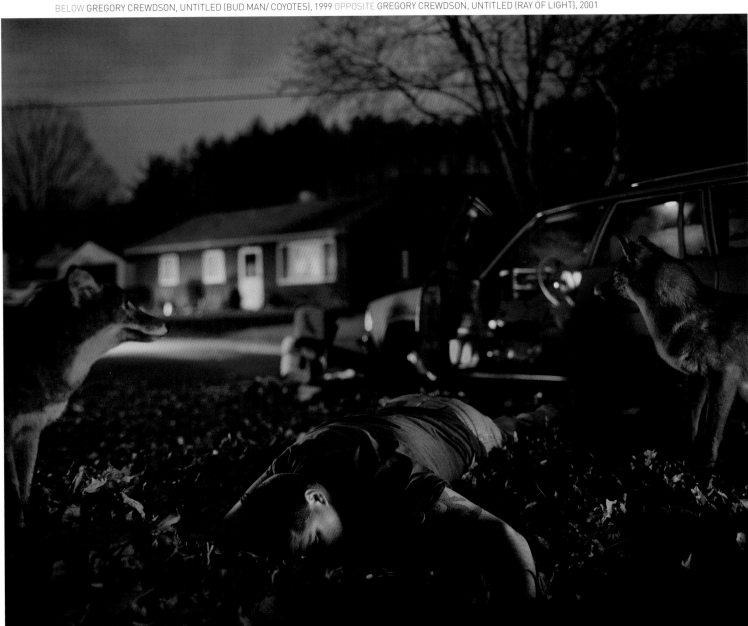

there's a huge amount of interaction between the crew and the town and the people who live there. There are also months of planning. The big difference is with a film crew there is a rush to get many different scenes or shots done over the course of a day, whereas we usually spend two or three days working towards making a single image. It's exciting but also painful. Ultimately, despite all that enormous production and so many people working on the pictures, the pictures themselves are very quiet, very still and emptied out in a certain sense.

I think my pictures are really about a kind of tension between my need to make a perfect picture and the impossibility of doing so. Something always fails, there's always a problem, and photography fails in a certain sense. It's so limited. Despite the fact we work enormously in post-production, reproduction is reproduction and it will always, one way or another, fail you. This is what drives you to the next picture.'

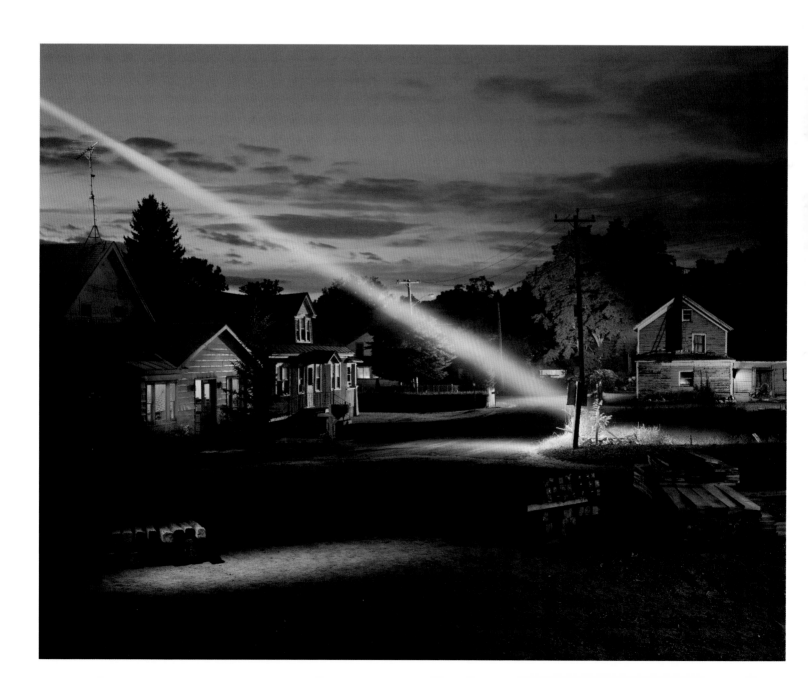

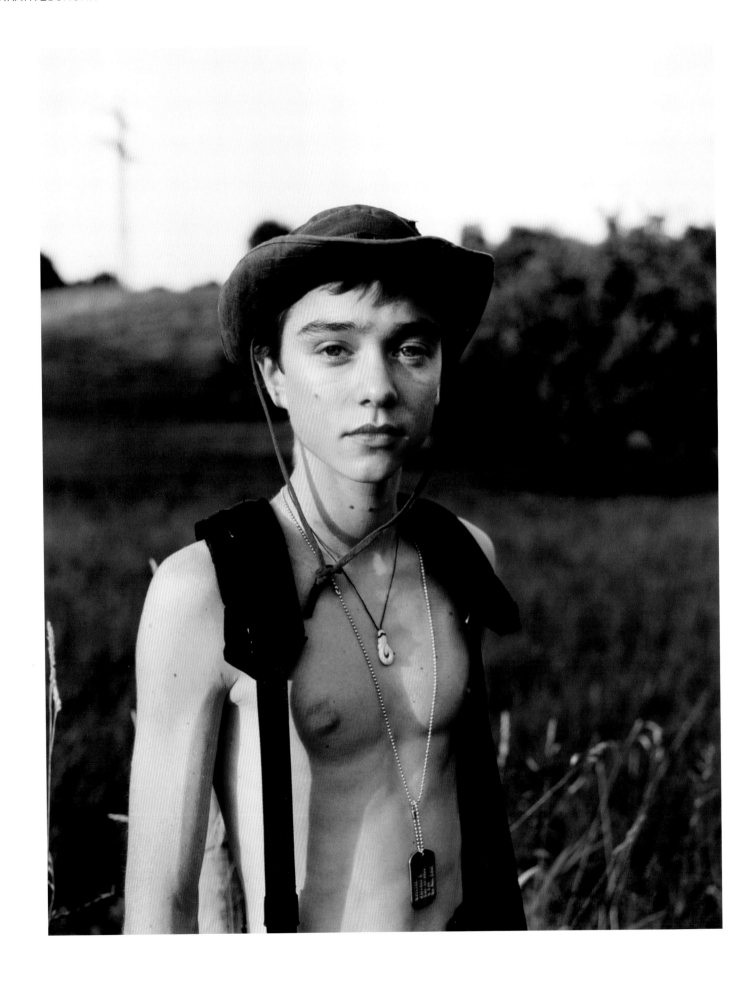

COLLIER SCHORR THE NARRATIVES IN SCHORR'S WORK ARE SUBTLE AND BURIED IN COMPLEX HISTORIES AND CONNECTIONS BETWEEN THE PAST AND PRESENT, FANTASY AND MEMORY. *FOREST AND FIELDS* TOUCHES ON SCHORR'S RELATIONSHIP WITH GERMANY, ITS LANDSCAPE AND HISTORICAL TABOOS, AND HER OWN POSITION AS A GERMAN JEW AND AS A LESBIAN. REVERBERATING THROUGHOUT THIS DOCUMENTARY-STYLE SERIES ARE QUESTIONS OF IDENTITY AND MASCULINITY. THE GENTLENESS OF MANY OF THE MEN'S POSES AND THE VULNERABILITY OF THEIR NAKED FLESH CONTRASTS WITH THE COSTUMES AND UNIFORMS AND THE VIOLENT ASSOCIATIONS OF SOLDIERS AND WAR, AS WELL AS WITH THE CONVENTIONAL ATTITUDES OF MASCULINITY.

'This is from the series *Forests and Fields*. The series is about nature and war, but more specifically the landscape of war: the intersection between youth and land; how war is connected to desirable land; how land changes nationality due to violence. It is also about how in Germany so much memory is buried. Many soldiers at the end of World War II burned their uniforms and medals in the woods. So for me, these pictures are about those memories rising to the surface. Also, Germany's strict environmental land-protection programmes were started by the Nazis who wanted to preserve the Germanic Arcadian myth of the forests and warrior strength.

OPPOSITE COLLIER SCHORR, DOMINIK FIRST TOUR BACKNANG, 2000
BELOW COLLIER SCHORR, STEFFEN CAUGHT, 2003

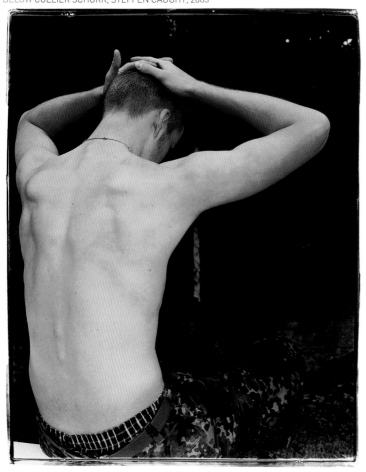

I have always been interested in internationality. The idea that we have potentially multiple identities and allegiances. I always feel something for the people I shoot. I choose them because there is the suggestion of some intrinsic connection – a feeling of sympathy or attraction or even fear on my part. I want the audience to be both drawn to and confused by that attraction to the characters. It doesn't have to be specifically sexual. It could be a maternal or fraternal attraction as well.

I'm sure working with the military will always be there for me but perhaps in less obvious ways. It becomes more complicated in a time of war. Pictures of static service (downtime in the military) seem less potent. When I took the picture of Steffen, he was in the air force but was in no danger of going to war. That might be different today.'

AES&F THE PROVOCATIVE RUSSIAN COLLECTIVE AES&F (TATIANA ARZAMASOVA, LEV EVZOVICH, EVGENY SVYATSKY AND VLADIMIR FRIDKES) WORKS IN THE REALMS OF FANTASY. IN *ACTION HALF LIFE*, DIGITALLY ENHANCED SCENES REFERENCE SCIENCE FICTION, VIDEO GAMES AND FASHION TO PORTRAY A FUTURE IN WHICH WAR, BEAUTY AND DEATH COINCIDE. VIOLENCE IS EXPLICITLY EXAMINED IN ALL OF THEIR WORK, WHICH THEY OFTEN EXAGGERATE TO PUSH BOUNDARIES AND TO QUESTION ASSUMPTIONS. AES FORMED AS AN ARTISTS' COLLECTIVE IN 1987 AND WERE JOINED BY FRIDKES IN 1995 FOR CERTAIN PROJECTS.

'The title of this piece comes from a well-known computer game. The plot of the game is different, but we liked the title very much. It sounds half-dead, half-live, half-robotic, half-human – in some ways similar to current civilization, where the virtual and reality are mixed.

BELOW AES&F, ACTION HALF LIFE: EPISODE 2, 2003 OPPOSITE AES&F, ACTION HALF LIFE: EPISODE 2, 2003

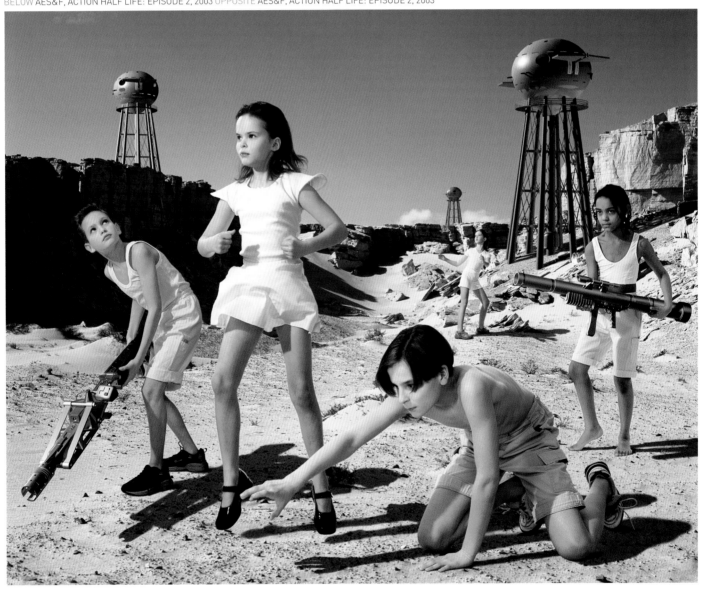

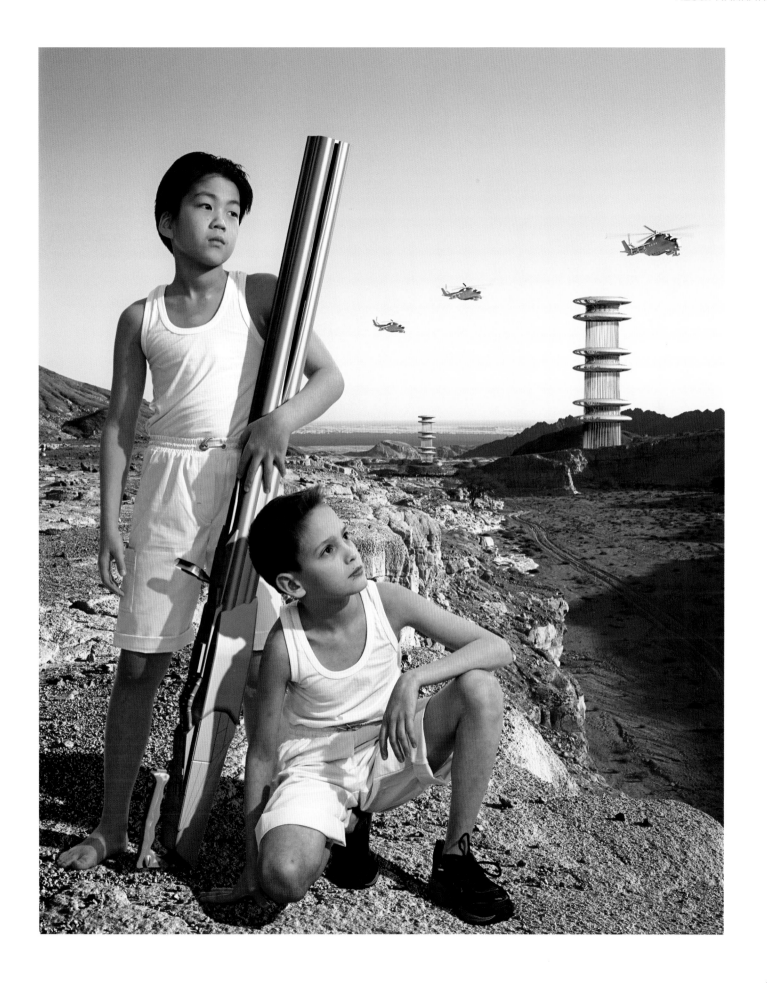

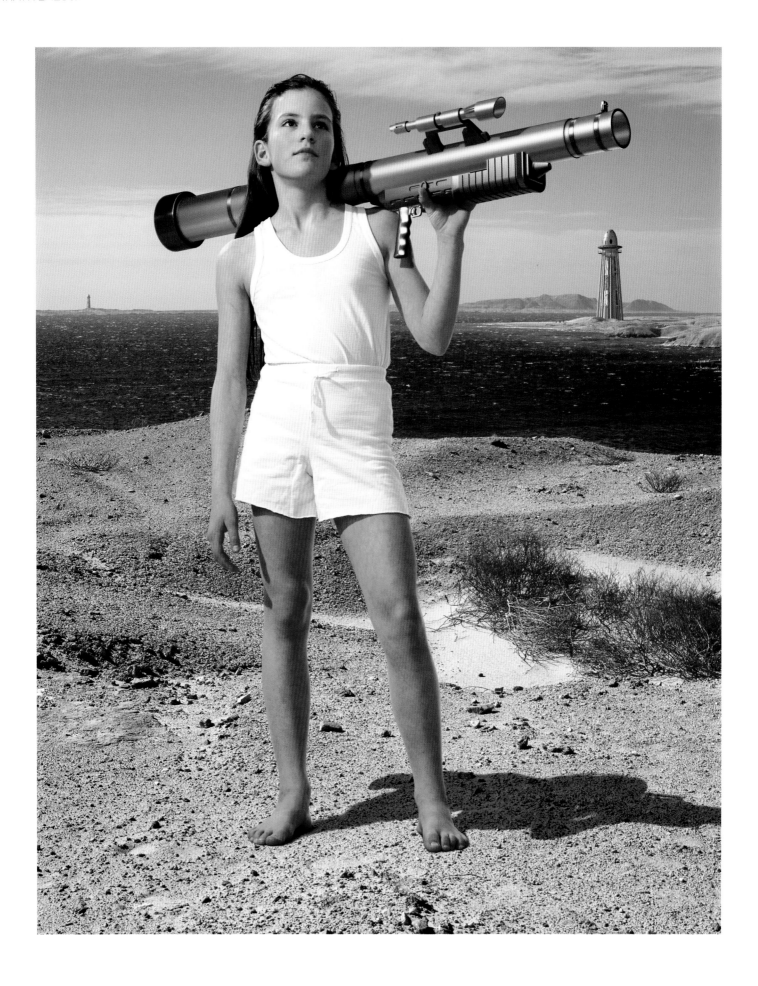

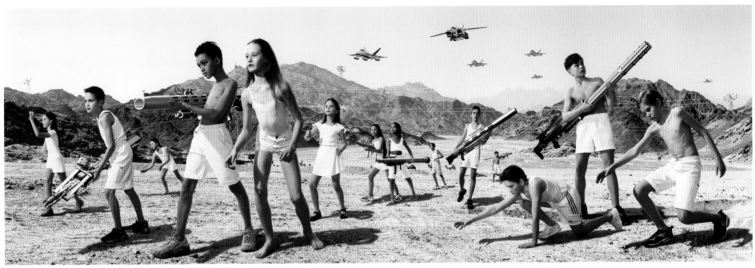

OPPOSITE AES&F, ACTION HALF LIFE: EPISODE 2, 2003 ABOVE, BELOW LEFT, BELOW RIGHT AES&F, ACTION HALF LIFE: EPISODE 3, 2003

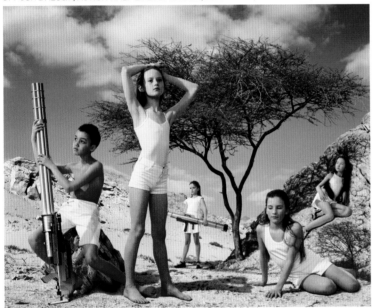
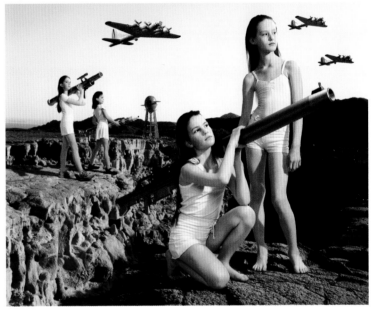

This project is a parody on *Star Wars* by George Lucas, so we started from *Episode 3* and *Episode 1* is in process. We wanted the development of the images to look like Old Master paintings, and be versions of one theme. The Old Masters did sketches and cartoons before the final painting and in a similar way we made sketches after our "digital paintings". We use the visual reference to the drawings of the Renaissance and early Baroque masters in an ironic way and to elevate the reconstruction of trashy computer games to "high art".

The photographs are of the landscapes of the Sinai Desert but the weapons and the architecture were generated in 3D Max. In some ways we used the production methods of a Hollywood blockbuster. The interesting question is: with whom are the children fighting? The answer is another question: with whom is the contemporary warrior fighting? Take a modern pilot, looking at the display and pushing the buttons of high-tech weapons; he is totally isolated from the real enemy, the blood and dirtiness of the war. People react emotionally to the use of children in our work, but at the same time are ignorant of adults acting in the same way.'

SARAH JONES BRITISH ARTIST JONES IS BEST KNOWN FOR HER *FRANCIS PLACE* SERIES (1997), IN WHICH ADOLESCENT GIRLS SEEM TO SUFFOCATE WITH BOREDOM IN BOURGEOIS DOMESTIC INTERIORS. REFERENCES TO THE HISTORY OF PORTRAIT PAINTING ARE IMPLICIT IN HER WORK, AND WE MAY RECOGNIZE CERTAIN FAMILIAR POSTURES OR BACKDROPS, ALTHOUGH THESE ARE HARD TO RELATE TO SPECIFIC MASTERPIECES. THE STIFLING INTERIORS HAVE GIVEN WAY HERE TO BEDROOMS, WOODLAND OR GARDENS BUT THE IMPLIED FEMININITY OF SUCH SETTINGS IS FAR FROM STRAIGHTFORWARD, AS IT WAS IN MUCH NINETEENTH-CENTURY PAINTING.

'With these works I am looking at our complex relationship to representing nature, at the idea of beauty versus (or at odds with) the abject. My work sets out to examine the conventions of portraiture couched within a kind of ongoing filmic narrative, set up by how the figures or locations may relate to each other. How we may or may not relate ourselves to both the pictured figure and the pictured experience. It slides between the authentic and the imagined.

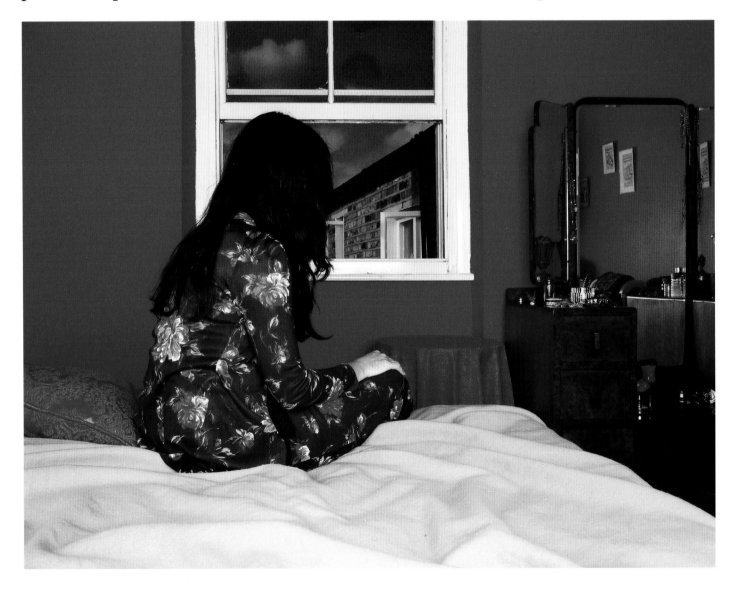

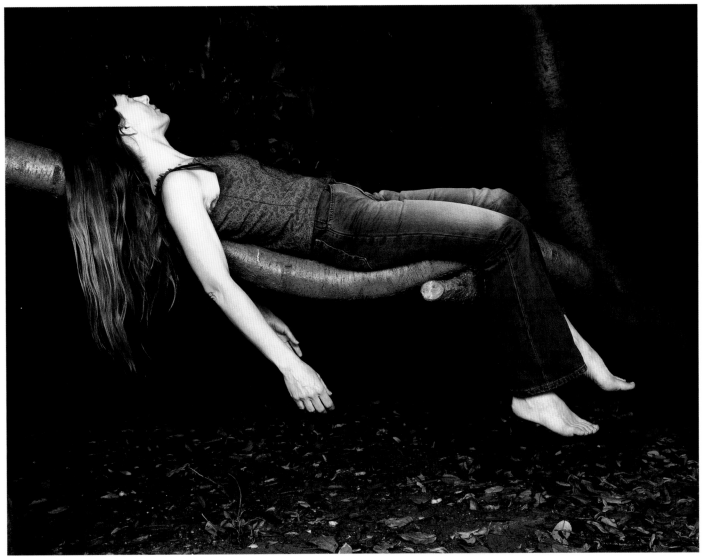

OPPOSITE SARAH JONES, THE BEDROOM (1), 2002 ABOVE SARAH JONES, THE PARK (2), 2002

'The photograph allows us to look at someone we don't know for what would normally be an unacceptable length of time. It allows us a certain kind of intimacy and it's also reliant on memory, on the personal. I'm interested in how this might be represented, how exteriority collides with interiority. Female figures are depicted both in interiors – their own homes or found, more transient locations – and in domestic gardens or areas on the edges of municipal parks. They might be seemingly self-possessed or preoccupied.

I regularly photograph the same group of people over an extended period of time. They often exchange gestures in the work or come to the foreground or recede. The outside and the inside blur and are cross-referenced throughout, perhaps by the particular colouring of a room, or a pattern on a bed cover or sofa, or item of clothing. Nature and ideas of naturalistic gesture are represented as being at once resonant with a kind of cultural, emotional power and impotent – picturing at once utopia and dystopia.'

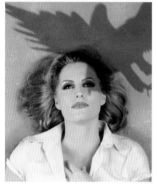

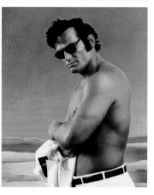

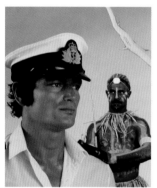

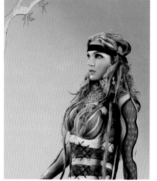

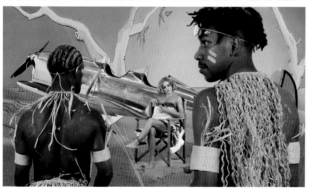

TOP TRACEY MOFFATT, ADVENTURE SERIES 3, 2004
ABOVE TRACEY MOFFATT, ADVENTURE SERIES 7, 2004
OPPOSITE TRACEY MOFFATT, ADVENTURE SERIES 5, 2004

TRACEY MOFFATT STEREOTYPES AND ARCHETYPES UNDERPIN MOFFATT'S *ADVENTURE SERIES*. PRESENTED IN COMIC-BOOK STYLE, IT PLAYS WITH IDEAS OF ARTIFICE, PERFORMANCE AND FANTASY. MOFFATT'S WORK OFTEN HITS HARD IN DEALING WITH ISSUES SUCH AS HOMOPHOBIA, COLONIALISM, RACISM AND SEXISM IN HER NATIVE AUSTRALIA. VISUALLY SEDUCTIVE, A TENSION IS CAUSED BETWEEN THE IMAGE AND THE SUBJECT MATTER. MOFFATT EMPLOYS THIS STRATEGY TO PRESENT CHILLING MESSAGES IN AN ASSERTIVE WAY. HER WORK ENCOMPASSES A DIVERSE RANGE OF PHOTOGRAPHIC TECHNIQUES AND MATERIALS, FROM PHOTOGRAVURES TO COMMERCIAL STOCK IMAGERY, GIVING THEM EQUAL STATUS.

'As an art piece, *Adventure Series* hangs together according to colour, yet each piece with the three images is an individual story. Sometimes the same characters appear more than once. The viewer can weave together different scenarios. All the characters are "types": there is the blond-gal type, a handsome brown guy type, a gorgeous Asian girl type, and a rugged outdoors type. I appear as "dark and intense". I shot this work in my hometown of Brisbane, Australia. The locations can be read as Australian but this wasn't important, more that they read as "fantastical".

I like constructing narratives in the studio with model-actors and props and painted backdrops. The 1960s Disney film palette has inspired me from the very beginning. I have always liked "artifice". I adore the "fake". I recently went into a historical museum in Stockholm, Sweden. I spent hours gawking at the historical diorama displays of re-created street scenes and rural farmhouses. They had a "poverty" scene with a begging blond child in rags. There were painted canvas backdrops of forests and snow-covered hills. All of this was heaven.

I wanted to make something glossy that looked comic strip and pop. I love early 1970s modern adventure stories in comics and movies, especially low-budget American and Australian television dramas. In these productions, "adventure" meant jumping into a speedboat or a small plane to catch a "poacher" and the stories were always set in great locations. Fashion-wise, people were still "coiffed" – it wasn't yet "casual" – and you'd see characters in pilot or park-ranger uniforms or scuba-diving suits. I was a teenager at the time and I aspired to look like that. All the men and women looked "professional" as if they were doing something "important", yet at the same time eyeing each other up. To me it was all so sexual and hot.'

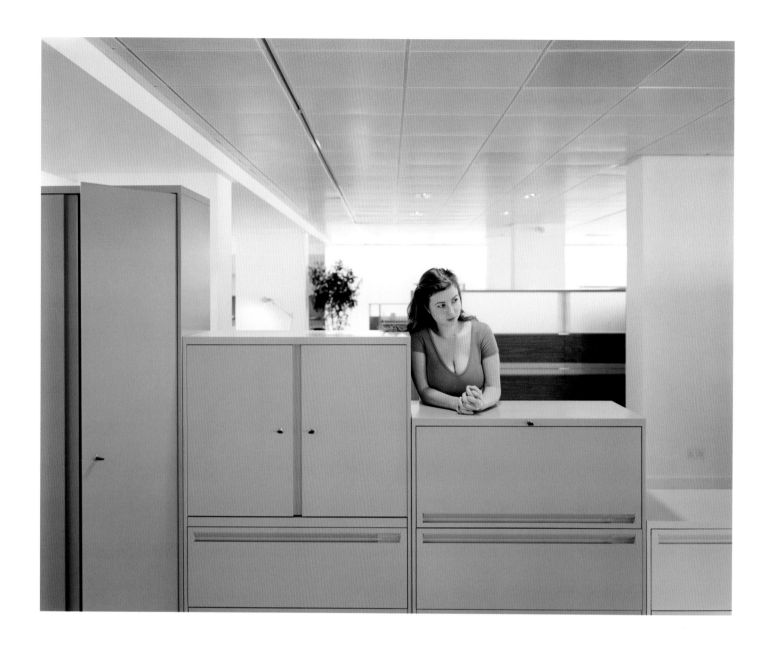

HANNAH STARKEY RECENT WORK BY BRITISH ARTIST STARKEY HAS SHIFTED FROM LOOKING DIRECTLY AT WOMEN'S EXPERIENCE TO MORE GENERAL OBSERVATIONS ABOUT CONTEMPORARY SPACE, AND HOW THE CONTROLLING URBAN ENVIRONMENTS WE ASPIRE TO OFFER LITTLE APART FROM ARTIFICE AND FAÇADE. STRONGLY INFLUENCED BY TRADITIONAL DOCUMENTARY PHOTOGRAPHERS, STARKEY CHOOSES MORE FICTIONAL TABLEAUX WITH WHICH TO MAKE SOCIAL COMMENT. THIS WORK INTRODUCES A DIGITAL ELEMENT THAT ALLOWS HER TO PLAY WITH PRECONCEIVED NOTIONS OF SPACE. PART AUTOBIOGRAPHY, PART DOCUMENTARY, PART FICTION, STARKEY'S WORK PLAYS WITH OUR EXPECTATIONS OF PHOTOGRAPHY AS A STRAIGHTFORWARD, OBJECTIVE MEDIUM.

'Photography has an endless potential to explore questions about ourselves in relation to the world around us. It is a medium of both expression and communication, which is omnipresent in our society and accessible to everyone.

These photographs explore the psychological and physical space of an individual in contemporary western society, during a climate of uncertainty. The complexities of the society are reflected in the contradictions that the photographs reveal: the gulf between reality and its pictorial reproduction. The photographs are set in highly designed urban interiors – an office, a dentist, a cake shop and a penthouse – that allude to an aspiration for order, control and exclusivity, all of which are modes of lifestyle that are likely to be unobtainable or unsustainable. The characters portrayed in each location seem to be at odds with these environments, appearing dislocated and isolated.

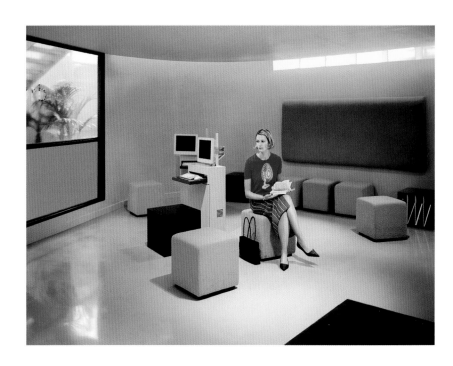

OPPOSITE HANNAH STARKEY, APRIL 2004, 2004 ABOVE HANNAH STARKEY, THE DENTIST, 2003 BELOW HANNAH STARKEY, MARCH 2004, 2004

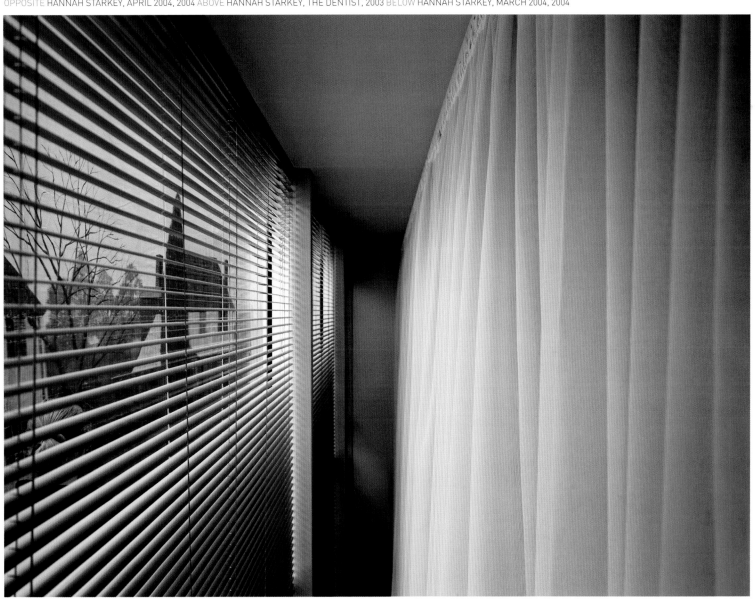

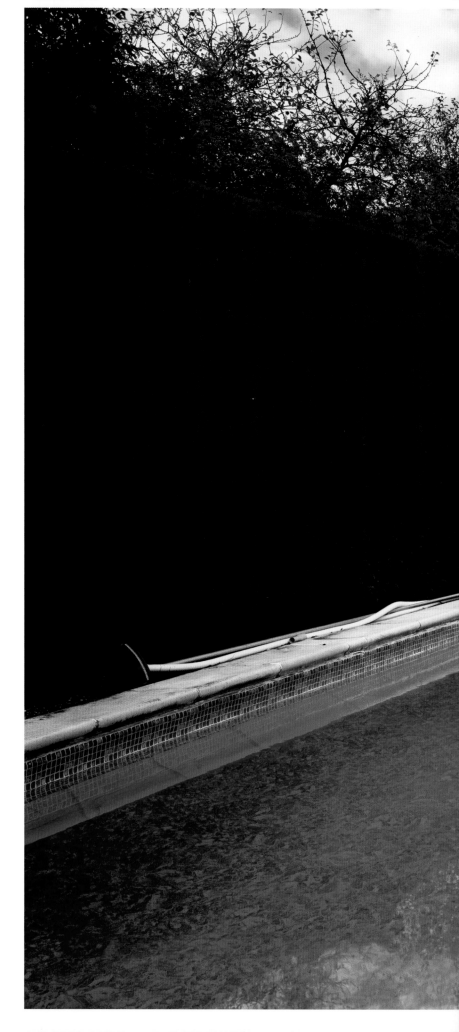

By carefully constructing my photographs and controlling all elements within the image, I can express to others how I view the world around me. Also by collaborating with the people that I cast for my characters and working with them I find out how others view the world. By working like this, the process of making work becomes magical and enables my photography to continue to mutate and develop at every stage; cementing the characters' and my accumulated history together. I then use this history, both cultural and personal, as the framework for the work.'

HANNAH STARKEY, SEPTEMBER 2003, 2003

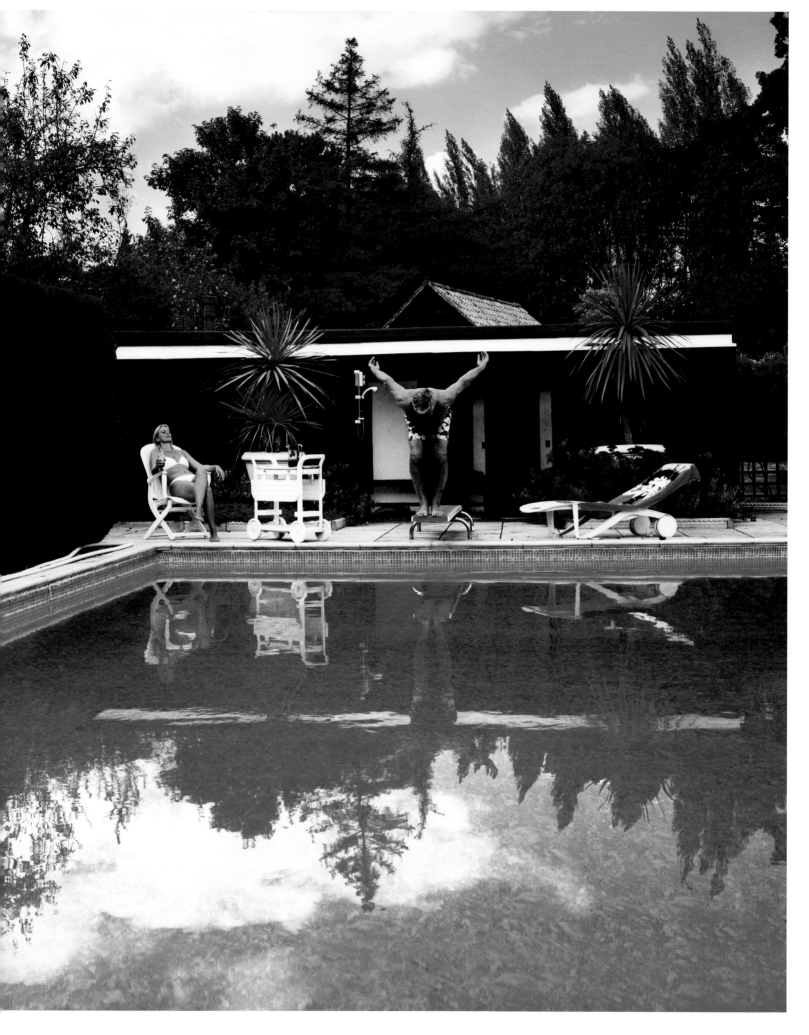

BILL HENSON THE CITY ACTS AS A SEDUCTIVE BUT ALSO MELANCHOLIC BACKDROP TO THE CRUISING TEENAGERS IN HENSON'S IMAGES. SINCE THE 1980S HENSON HAS BEEN WORKING WITH TEENAGERS AND THE ANONYMITY THAT THE CITY OFFERS THEM AS THEY ENJOY ESCAPIST ACTIVITIES LONG ASSOCIATED WITH VULNERABLE AND ALIENATED YOUTHS. IN DARKNESS THEY CAN INDULGE IN WHAT WOULD SEEM FORBIDDEN IN DAYLIGHT. THE IMAGES ARE SHOT THROUGH WITH SENSUALITY AND SEXUALITY, AND THE CITY LIGHTS ILLUMINATE A CLOSENESS BETWEEN THE YOUTHS THAT SEEMS IMPENETRABLE TO OUTSIDERS.

'Adolescents have this all-pervading sense of uncertainty and this is riveting for me: they are in such a state of transition. They have this sweet, dark, tumultuous sense of who they might be and how the world might be. I find the best way of trying to describe it in the pictures is through stillness, silence and a sense of these people just being. I've always felt that our relationship to photography was conditioned by an underlying sense of loss. That there was always this feeling of "otherness" or

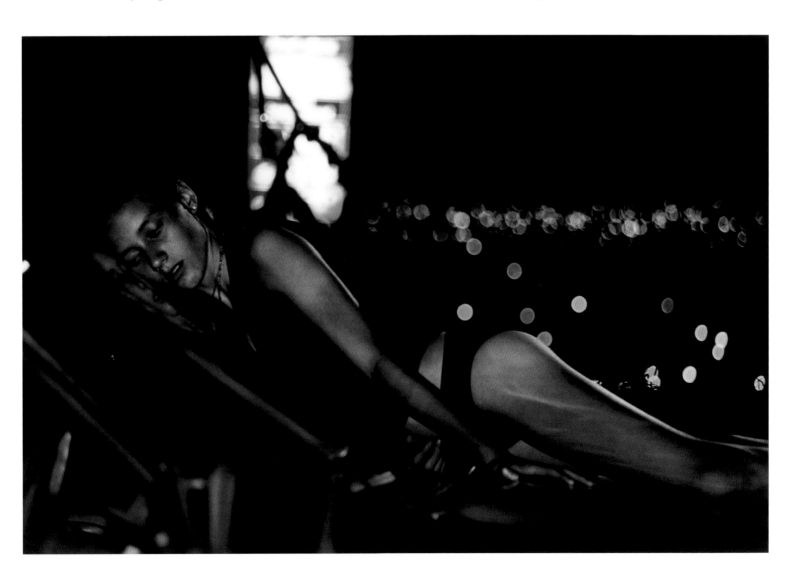

"elsewhere" seemed to me perfectly natural and to be largely where the real potential for the medium lay. Trying to understand the nature of that distance seems central to my need to make photographs. I suppose the apprehension of distance evokes a sense of loss in us – a sense of longing and I think it's longing that animates contemplation.

I think my interest in the urban edges and the feeling of being on the brink or edge of something probably stems from the way in which the unknown stimulates speculation. Everyone naturally finds themselves drawn into a more interesting relationship with a subject when that subject is not entirely familiar, when that subject suggests a multitude of possibilities without having clear definition. We find often in the most interesting art (as in life) that we can have an acute sense of something – if you like, something is powerfully apprehended – and yet it is not fully understood. This suggests, for me, a link between the nature of adolescence and an ambiguous and only partially defined environment. These things naturally animate our speculative capacity.'

OPPOSITE BILL HENSON, UNTITLED #52, 2000–3 BELOW BILL HENSON, UNTITLED #63, 2000–3

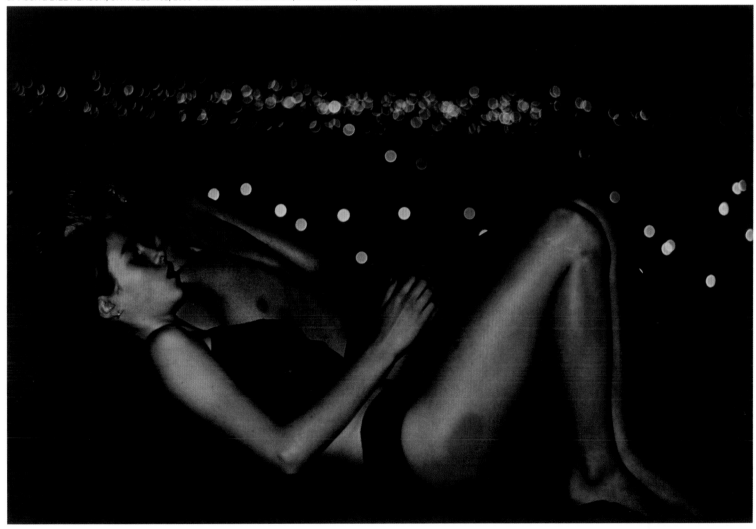

WANG QINGSONG CHINESE ARTIST WANG EMPLOYS PHOTOGRAPHY, COMPUTER-GENERATED IMAGES, SCULPTURE AND PAINTING. CRITIQUING CHINA'S CONSUMERIST SOCIETY AND THE 'AMERICANIZATION' OF HIS COUNTRY, HIS IRONIC AND PLAYFUL STYLE OFTEN REFERENCES THE PATRIOTIC PAINTINGS AND PROPAGANDA SO DOMINANT DURING THE MAOIST ERA. THIS IRONY IS DOUBLE EDGED HOWEVER: HE IS EQUALLY CRITICAL OF REGRESSIVE TRADITIONAL VALUES. HIS WORK CAPTURES THE PARADOXES AND CONFUSION OF A CULTURE IN TRANSITION.

'China, a country with a five-thousand-year-old history, looks back with pride over its cultural achievements. Yet, as a consequence of unbridled growth in the past two decades, China has undergone extraordinary destruction – both material (buildings) and immaterial (ideas). In their striving for success and wealth (the highest goals in Chinese society today), people are developing a rampant yearning for happiness and recognition. There have been corresponding changes of a dramatic nature in the urban and mental landscape.

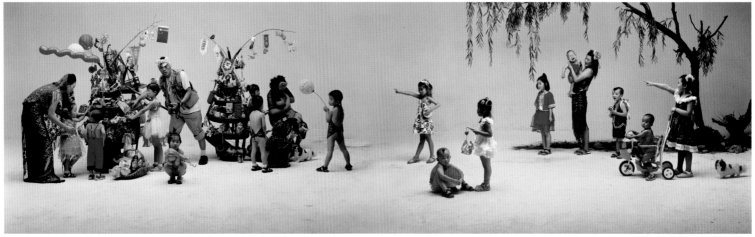

ABOVE WANG QINGSONG, KNICKKNACK PEDLAR, 2002

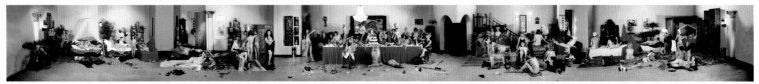

ABOVE WANG QINGSONG, CHINA MANSION, 2003 BELOW WANG QINGSONG, FOLLOW ME, 2003

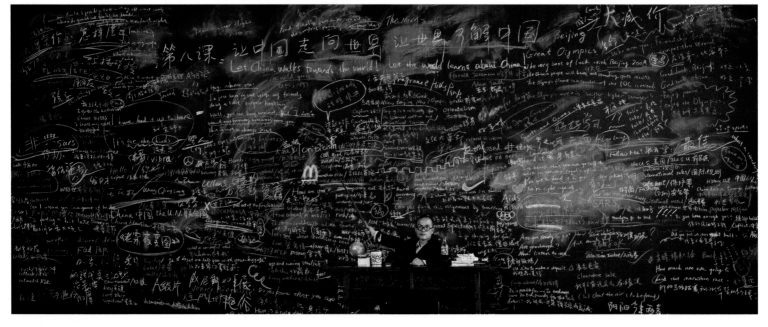

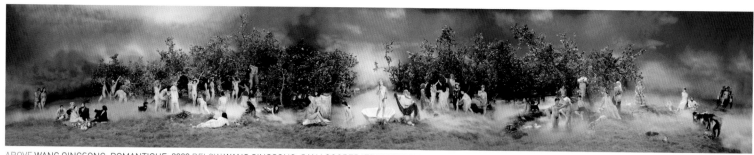

ABOVE WANG QINGSONG, ROMANTIQUE, 2003 BELOW WANG QINGSONG, CAN I COOPERATE WITH YOU?, 2000

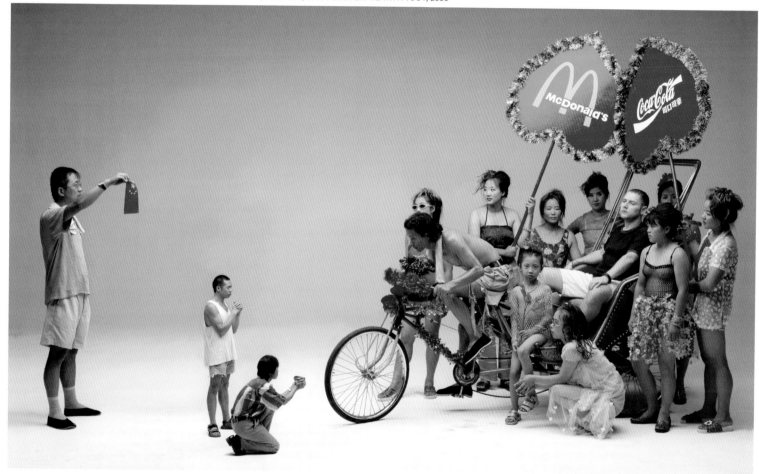

The countless contradictions I see around me and the ever-present crisis of modernization are what determine my photographic work. My photographs mainly select interesting and contradictory episodes from reality, to tell the ongoing "real stories" of the high-geared development of modernizing China. Applying documentary photography and parody and satire, I direct some familiar and typical scenes from our history. For me art evolves from reality. Looking around the changes in our lives, one can easily understand the stories I put together with staged theatrics.

In *Knickknack Pedlar*, I am portrayed as a pedlar that sells all sorts of foreign goods. Both in art and economics we see so much impact from foreign cultures and residual influence from our own traditions. In my work I address the Chinese endeavour for modernization and the conflicts that occur when we encounter foreign cultures, tastes, and influences.'

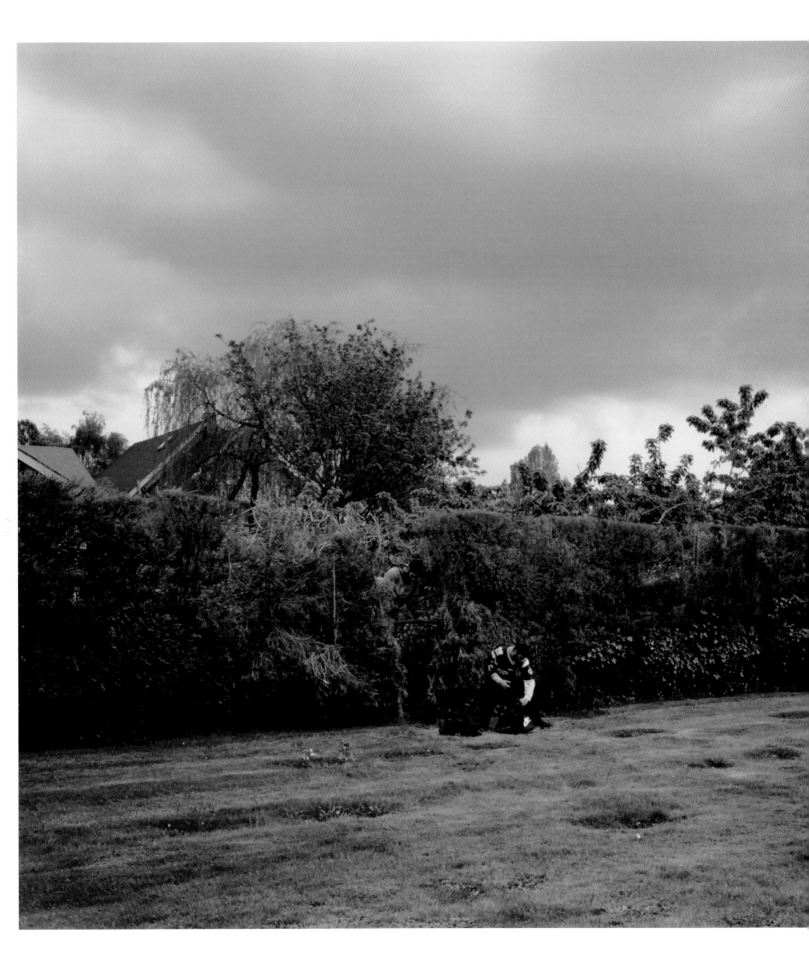

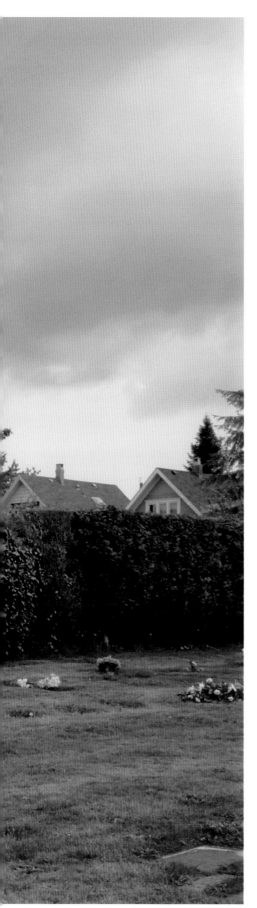

JEFF WALL IN 1977, WALL BEGAN MAKING CAREFULLY COMPOSED CIBACHROME TRANSPARENCIES, WHICH WERE DISPLAYED ON LIGHTBOXES AND MIMICKED THE DISPLAY OF MORE COMMERCIAL PHOTOGRAPHS. SINCE THEN HE HAS INCORPORATED DIGITAL TECHNOLOGY TO PRODUCE LARGE-SCALE STAND-ALONE PHOTOGRAPHS, SOME OF WHICH ARE OBVIOUSLY AND ELABORATELY STAGED AND OTHERS MORE SUBTLE, CONFUSING IDEAS ABOUT DOCUMENTARY, AS CAN BE SEEN IN THIS LATER WORK. COMING FROM A BACKGROUND IN ART HISTORY, WALL REFERENCES WELL-KNOWN WORKS OF ART AND SHOWS AN ACUTE UNDERSTANDING OF HOW IMAGES ARE PUT TOGETHER AND RECEIVED.

'Artists need to have as much authority and control over their as work as they can. The essential model, for me, is still the painter, the artisan who has all the tools and materials they need right at hand, and who knows how to make the object he or she is making from start to finish. With photography this is almost possible. You could say that the photographer purchases unexposed film the way a painter purchases new canvas or paper; chemicals for development are analogues to paints. The camera and the enlarger are new technologies and not parallel to anything but, using those machines, the photographer can expose that film and produce a final print all in one in-house activity. Any extension of that, into collaboration with other technical people, or into having aspects of the work done outside the studio, can be thought of as just circumstantial events that don't disturb the basic structure. I always thought working in labs was just a temporary situation.

JEFF WALL, BOYS CUTTING THROUGH A HEDGE, VANCOUVER, 2003

 If we photographers extended the work process outside the studio, we could feel confident that we could bring it back there when necessary. Even though, now, many would never even consider doing that, the thing we call "photography" still retains that potential – the capacity to be done at the highest artistic levels on a very modest technical scale.'

JEFF WALL, A WOMAN WITH A COVERED TRAY, 2003

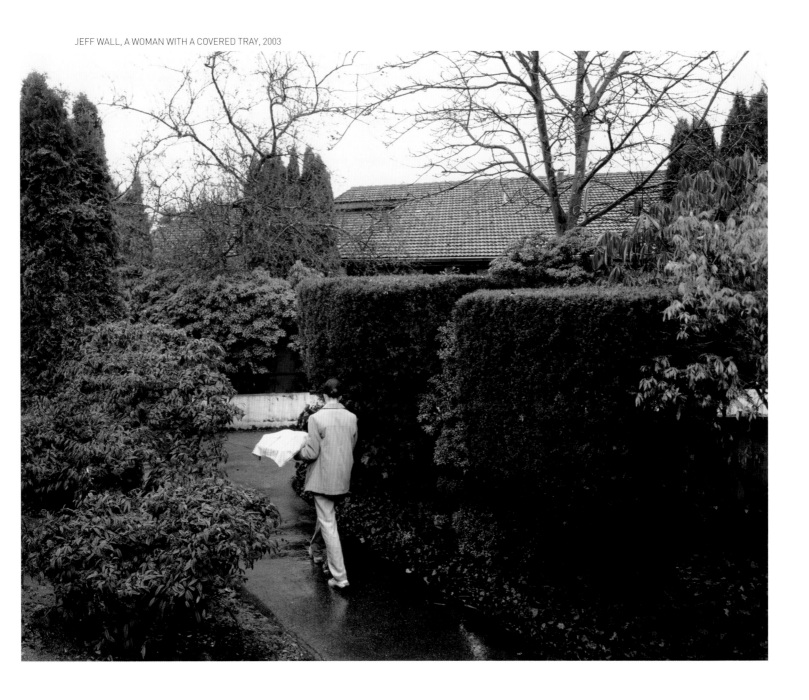

SHARON LOCKHART AMERICAN ARTIST LOCKHART'S WORK, WHICH OFTEN ENCOMPASSES VIDEO, DEALS WITH ISSUES OF TIME AND SEQUENCING, BOTH VITAL TO PHOTOGRAPHY. EXPLORING THESE GIVENS, HER PRACTICE CONSTANTLY INVESTIGATES HOW PHOTOGRAPHS WORK WITH REGARDS TO THE SPECTATOR AND AS OBJECTS IN THEMSELVES. FOCUSING HERE ON THE SUBJECT OF THE WORKER, SHE CONTINUES A LONG TRADITION OF LOOKING AT MANUAL LABOUR, BUT IN A CONTEXT IN WHICH THE VIEWER IS ALSO FORCED TO ASK QUESTIONS ABOUT SKILL AND AUTHORSHIP IN RELATION TO ART WORKS.

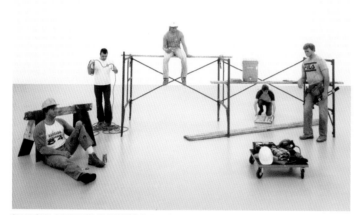 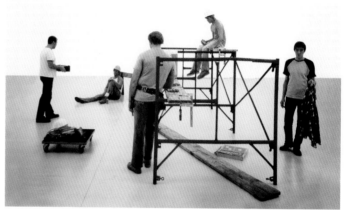

SHARON LOCKHART, LUNCHBREAK INSTALLATION, 'DUANE HANSON: SCULPTURES OF LIFE', 14/12/02–23/02/03, SCOTTISH NATIONAL GALLERY OF MODERN ART, 2003

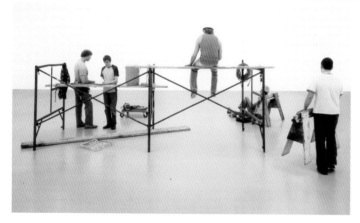 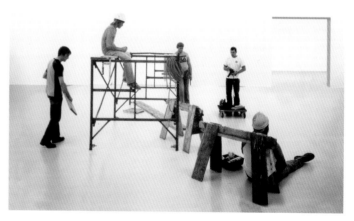

'This project started with the idea of representing the difference between sculptural and photographic representation. I spent a long time looking for the right sculptural work. The photographs show the installation of *Lunchbreak* by the American sculptor Duane Hanson during a retrospective exhibition of his work in 2002–3.

Sculpture is really a time-based medium, especially with a large sculpture like this one. It takes time to walk around it and to discover all its facets. In a photograph you are linked to a specific moment and a single perspective. We photographed the sculpture from four perspectives, travelling counter-clockwise. As we photographed, the preparators – the unsung heroes of the art world – added smaller items from the cart. The photographs present both this movement around the sculpture and the movement in time towards completion. I wanted the work to address the way photographs attach our viewpoints to specific moments as opposed to the infinite perspectives afforded by the constant flow of time. It was meant to do, on a photographic level, what happens with the sculpture. You cannot view them in a singular moment but must move from picture to picture.'

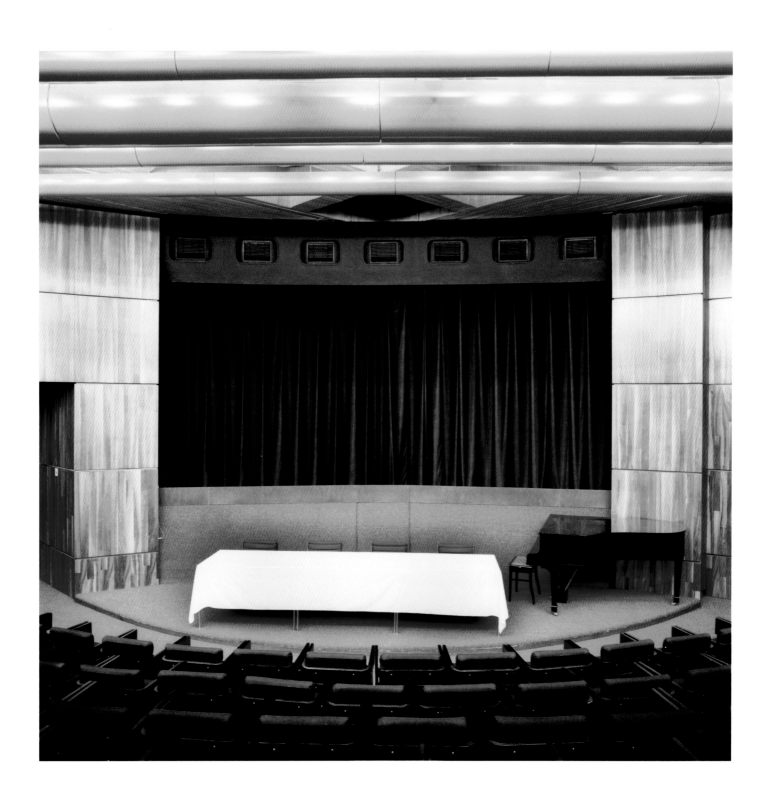

CANDIDA HÖFER, BOTSCHAFT DER TSCHECHISCHEN REPUBLIK BERLIN VII, 2001

OBJECT

The photographic object – be that the book or print – is a thing to be treasured, looked at, cared for or even fetishized. Think how precious our family snaps are, how we collect postcards or carry images of loved ones in our wallets. This obsession also carries over into subject matter as artists focus on objects, relishing detail and elevating the status of 'things' to the extraordinary. The very act of photographing something makes it special and indeed its significance and our understanding of it can change dramatically once it is turned into a subject.

Some of the work in this chapter deals with the actual act of photographing, and it includes the more experimental or diverse approaches to photography. It is important to note that many of the images are less successful as 'one-offs' and need to be seen in sequence or in series in order to make comparisons between them, or to delight in the tiny differences that a camera can capture. The range of techniques seen here are particular to photography and embrace the object with respect. The range of photographic processes and techniques include making objects purely to be photographed, camera-less techniques, still life, archive retrieval and 'straight', seemingly objective approaches with regard to space, in which objects gain in importance or significance.

Photography's rich and experimental history paves the way for many to think about objects – both as subject matter and as finished products – in provocative ways. The photomontages of modernist Europe, and digitized imagery with its contemporary equivalent of cut and paste, have allowed imaginative narratives and fantastical aesthetics to enter into the photographic lexicon. However, beyond these approaches to subverting the referentiality of photography, more direct experiments which embrace all kinds of photography, including negative prints, aerial views, x-rays, direct contact printing of objects placed on photographic plates, solarization, double exposures, and composite pictures made by darkroom masking, have been present throughout its history. Such processes push the point of the photographic object and delight in the untapped potential of the medium. This freedom has produced some of the

most dynamic work of the twentieth century, which has addressed the question of what photography is and how we understand it. The stunningly complex photomontages of Hannah Höch, Man Ray's cameraless technique of photograms (or rayograms), and László Moholy-Nagy's disregard for traditional limitations are all seen as giving license to artistic experiment with the object and, more crucially, with objectivity.

In the very early stages of photography's existence, artists such as William Fox Talbot and Anna Atkins experimented with contact printing of flowers, leaves and ferns, placing them directly onto photographic plates to produce photograms. Technical advancements and the incorporation of the computer into the creative process of photography, together with 'off the shelf' software packages, have allowed artists to return to such simple working methods and the conceptual ideas of the early Victorian pioneers, all be it with a scanner and the aid of Photoshop. Here the very thing becomes both the subject and the object, blurring boundaries between reality and representation.

However, it is not just the more experimental side of photography that is important here. The 'straight' photograph, coolly analysing, disciplined and objectifying, is also crucial. The work and teachings of Bernd and Hilla Becher have had enormous repercussions on contemporary art photography. As teachers at the Düsseldorf Art Academy they tutored many artists featured in this book including Thomas Ruff, Candida Höfer, Andreas Gursky, Thomas Demand, Simone Nieweg and Thomas Struth. As artists, their sphere of influence and impact is even wider.

Their earliest publication *Anonyme Skulpturen: Eine Typologie technischer Bauten (Anonymous Sculpture: A Typology of Technical Buildings)*, published in 1970, featured several different types of buildings and structures including power stations, high-tension pylons, radio telescopes, oil pumps, drilling towers, refineries,

milling works, factory halls and washeries. Their black-and-white prints avoided craft-like aesthetics and chance encounters. Interestingly, their objective stance, and the publication's telling title, aimed to distance the object from its function and turned it, in representation, into something completely different. As engineering and industry have changed so significantly, their moribund images have become tinged with the subjective emotion of melancholy. Their work is becoming increasingly important to historians and engineers as a record or document of a disappearing industrial fabric. For a new generation of artists the images are beginning to be understood in terms of the photographic givens of memory, loss and time, and contemplated as well through the conceptual references of banality, repetition, vernacular and the everyday.

Photography's relationship with sculpture is also dealt with in this chapter. Creating objects, or sculptures, that exist purely for the camera questions the status of the art work. Is it the photograph or the object itself that is the art? This use of photography to make something permanent, as seen in other artistic practices such as performance or land art, is one of the many ways that the photograph has become embedded within art. However, in more contemporary practices, photographs enjoy a far higher status than mere documentation and are desirable objects in themselves, editioned and beautifully produced. The photograph's function as a simple document is complicated, as it can show or suggest elements of the sculpture that are not revealed by the naked eye.

Metaphor and allegory and the hint of something bigger run through much of the work in this chapter and are intrinsic to still life, the oldest study of objects through art and the most traditional of genres. The artists in this chapter all have an interest in and an understanding of still life but revise it and move beyond its established conventions. The artists give the genre, so

prevalent in painting, its own place and methodology in photography. In painting, iconography associated with the genre has significant and symbolic meaning known to those familiar with the language of art history. Contemporary art photography tends to avoid the weight of such history, its connotations and its baggage, and instead turns to those ordinary and everyday objects that might be passed by, ignored or not considered worthy of becoming the subject of art. Such contemplation makes us as viewers think about everyday objects differently, possibly as art objects rather than as merely functional ones.

LAURA LETINSKY A PROFESSOR OF PHOTOGRAPHY AT THE UNIVERSITY OF CHICAGO, LETINSKY WORKS PREDOMINANTLY IN STILL LIFE BUT ALSO CONCENTRATES ON INTIMATE PORTRAITS OF HETEROSEXUAL COUPLES. WORKING IN THE CLASSIC STILL-LIFE GENRE, LETINSKY'S IMAGES REVERBERATE WITH THE TRADITIONS OF SEVENTEENTH-CENTURY DUTCH PAINTING BUT REMAIN RESOUNDINGLY PHOTOGRAPHIC BECAUSE OF THE DISTINCTIVE ANGLES AT WHICH THE IMAGES ARE TAKEN. THE FRUIT IN HER IMAGES IS NOT LADEN WITH THE SYMBOLIC MEANINGS OF PAINTING, BUT ACT IN A MORE METAPHORICAL WAY, HINTING AT THE DELICACY AND FRAILNESS OF DOMESTICITY.

'Initially, when I began this series, I worked from leftover meals and preparations. I was interested in the narrative end-point of the leftover, of what remains, what resists, not as a depressing or sad place, but as all that we ever really have, what has been handed to us. Art, aesthetic sensibilities, ideas about love, family, all those so-called individual feelings that are so heavily mediated in our culture.

LAURA LETINSKY, I DID NOT REMEMBER I HAD FORGOTTEN: UNTITLED #58, 2002

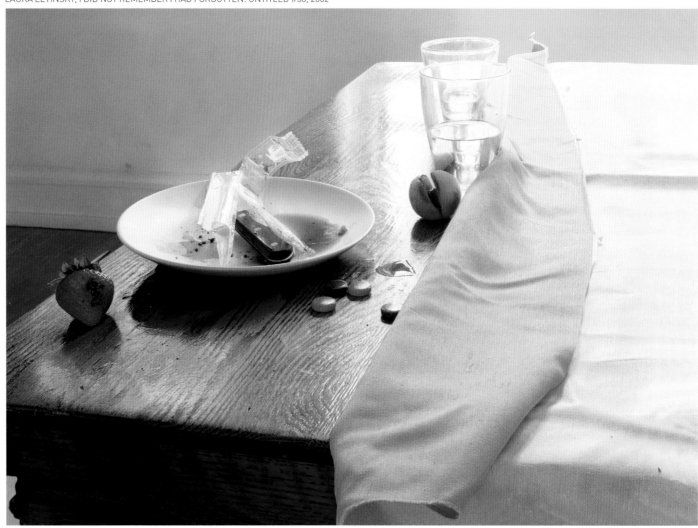

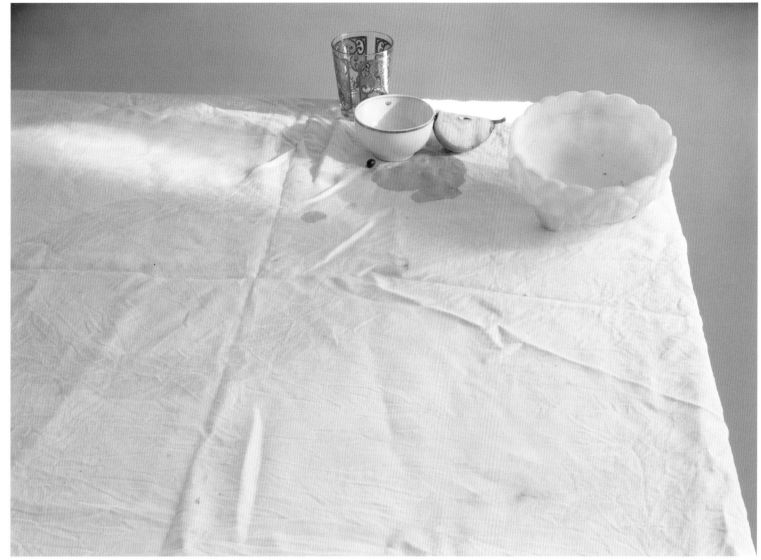

LAURA LETINSKY, I DID NOT REMEMBER I HAD FORGOTTEN: UNTITLED #63, 2002

When I first began working on the series I was interested in trying to figure out how, and why, Dutch seventeenth-century society was the site for so much still life work. I felt a little bit like I was groping about, trying to understand their formal and descriptive language. As I worked, the similarities in cultures (our appreciation for material goods, our multi-ethnic and class-based economies, the attitudes towards the home as a space of intimate display) began to dawn on me.

I am also interested in how the still life is the 'supporting cast' in Renaissance and Baroque religious paintings, as well as in the more recent attentions of Chardin, Cézanne and Morandi. I feel that I learn from these works and want to engage with them as part of a dialogue. For example, in one of my photographs I have a bowl of peaches that references a Chardin painting. I had come home from peach-picking with way too many peaches that quickly began to rot. I was interested in how I could depict my love of Chardin's painting while also responding to, and communicating, my experience, both literally and emotionally. I think that while I reference the genre at different historical stages, my work also clearly reflects my approach, in this contemporary context, from a position of intimacy, ambivalence and tenderness. Never would I want to re-create a painting. Again, I see my work as a dialogue, a conversation between what was and what is.'

GABRIEL OROZCO MEXICAN ARTIST OROZCO WORKS WITH A WIDE RANGE OF MEDIA AND IS PERHAPS BEST KNOWN AS A SCULPTOR. HE WORKS WITH OBJECTS, BOTH FOUND AND MADE, AND OFTEN CREATES MODEST SCULPTURES OUT OF THE THINGS AROUND HIM. HE USES PHOTOGRAPHS AS ART WORKS IN THEIR OWN RIGHT AND ALSO TO DOCUMENT HIS INTERVENTIONIST SCULPTURES AND PERFORMANCES. HIS WORK HAS A PLAYFUL AND TOUCHING ELEGANCE AND BY PHOTOGRAPHING OFTEN UNASSUMING SUBJECT MATTER HE ELEVATES IT INTO SOMETHING WORTH INVESTIGATING. HE COMMENTS POETICALLY ON THE RELATIONSHIPS BETWEEN OBJECTS AND HUMANS IN BEAUTIFUL AND ALLUSIVE IMAGERY.

'You see what you understand. You have to be prepared to see the world. The moment of clicking the camera is almost irrelevant. What is really important is what happens before and after you take the picture.

You put things in a box when you want to keep them, to think about them. Photography is more than a window for me. Photography is more like a "space" that tries to capture situations.

My photographs are not just about the instant of movement that you capture in the camera. It's much more total, about constant movement that becomes static.

What is important is not so much what people see in the gallery or the museum but what people see after looking at these things, how they confront reality again. Really great art regenerates the perception of reality; the reality becomes richer, better or not, just different.'

GABRIEL OROZCO, ISADORA'S NECKLACE, 2003

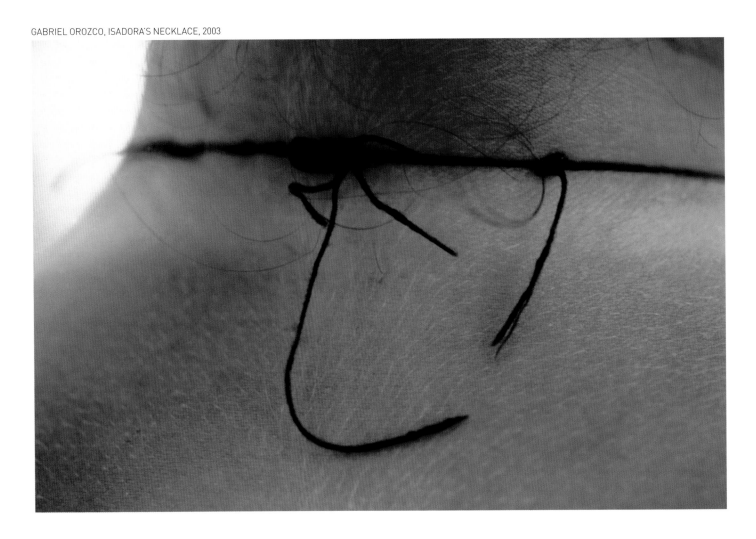

ABOVE GABRIEL OROZCO, ROLLING LIFE'S HAND LINE, 2003 BELOW GABRIEL OROZCO, BUBBLE ON FOOT, 2004

CANDIDA HÖFER HÖFER'S WORK IS MOST COMMONLY DISCUSSED IN RELATION TO SPACE AND THE INSTITUTIONS THAT SHE CHOOSES TO PHOTOGRAPH. HER WORK HAS TENDED TO CONCENTRATE ON SITES FOR ARCHIVING AND COLLECTING, SUCH AS LIBRARIES AND MUSEUMS, BUT ALSO ENCOMPASSES SEMI-PUBLIC SPACES SUCH AS LOBBIES, HOSPITALS AND THEATRES, ALL PLACES WHICH THE ARTIST ENCOUNTERS IN HER DAILY LIFE. HER IMMACULATE RENDERINGS OF INTERIORS FORCE US TO NOTICE THE OBJECTS AND DETAILS WITHIN THE SPACES AND HOW THEY WORK IN TANDEM WITH THE ARCHITECTURE OR JAR WITH IT. OBJECTS SUCH AS CHAIRS AND TABLES GIVE THE VIEWER CLUES AS TO THE FUNCTIONS OF THE SPACES.

'I can to some extent describe the way in which I work but I feel awkward when talking about intentions or effects. Spaces may or may not invite the image – if they do, they mostly do it with their spatial layers of time. Such qualities of spaces may create typologies over time but there is no intention to make typologies out of spaces. It is then the image which takes the place of the space; the image in its own right. It is the images with which I work, and images are planes, and colours, and relations of order and disorder.'

BELOW CANDIDA HÖFER, ANATOMISCHES INSTITUT DER UNIVERSITÄT BASEL I, 2002
RIGHT CANDIDA HÖFER, BIBLIOTECA SEMINARIO PATRIARCALE VENEZIA I, 2003

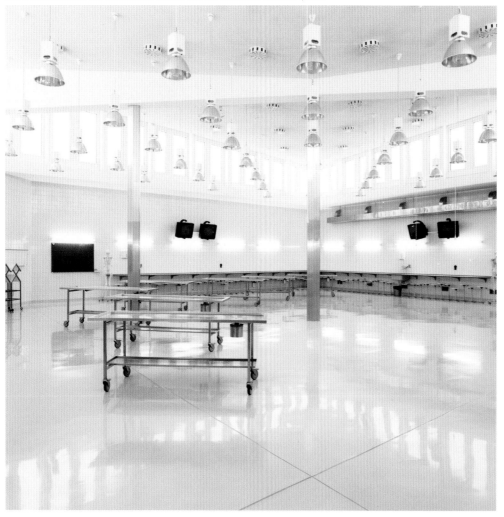

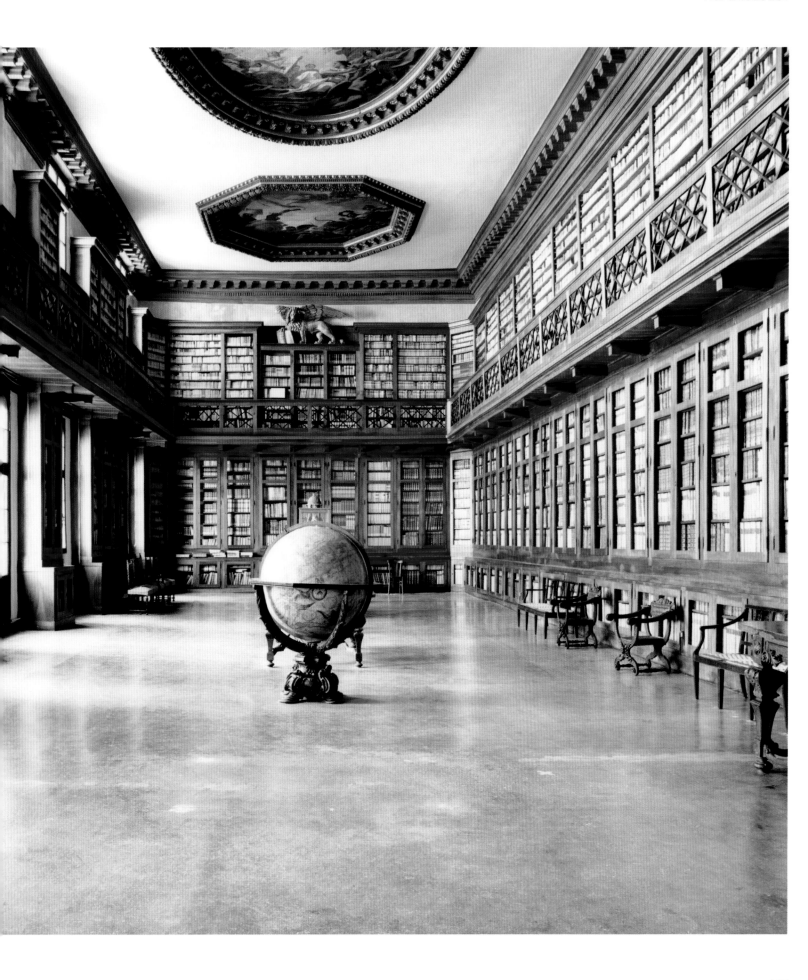

WOLFGANG TILLMANS GERMAN ARTIST TILLMANS WORKS ACROSS ALL GENRES OF PHOTOGRAPHIC PRACTICE AND WAS ONE OF THE MOST INFLUENTIAL PHOTOGRAPHERS TO EMERGE IN THE 1990S. MANY OF HIS IMAGES INVITE US TO DELIGHT IN THE BEAUTY OF OBJECTS THAT ARE OFTEN OVERLOOKED OR THOUGHT OF AS UNIMPORTANT, UGLY OR BANAL. THE 'OBJECTNESS' OF THE ACTUAL PHOTOGRAPH IS ALSO CRUCIAL TO HIS PRACTICE AND HIS GALLERY INSTALLATIONS EMPHASIZE THE PAPER HE HAS USED, OFTEN BY PINNING THEM ONTO THE WALL. BY NOT FRAMING HIS WORK IN A CONVENTIONAL MANNER OR SURROUNDING IT WITH THE TRADITIONAL TRAPPINGS OF DISPLAY, TILLMANS QUESTIONS THE HIERARCHIES AND MODES OF ANALYSIS WITHIN WHICH WE UNDERSTAND AND APPRECIATE ART.

'I know when I am onto a good thing when an interest resurfaces over several years. For example, the unobvious subject matter of socks has triggered my attention for a long time. I realized that socks are not just socks but can also be viewed as "significant" things. They are pathetic and full of imperfection. They slip and they sometimes slip down into your shoe – which is so annoying. They look like graphic signs. In 1994 I laid them out to dry and realized they looked like chromosomes. They always lose their partner, however wise or old we get we always look for the matching sock. Then again it's a little delight of the day to find a clean matching pair. They are such an unstable device which we need to live our lives. That's what I always have the greatest interest in. The things that humans choose and make and do in order to deal with their lives. That's the connection that I look for. I am not interested in divisive things but more in overcoming division and trying to see if other people can also relate to a specific observation or point of view.

WOLFGANG TILLMANS, FALTENWURF (SHINY), 2001

WOLFGANG TILLMANS, MUSKEL, 2001

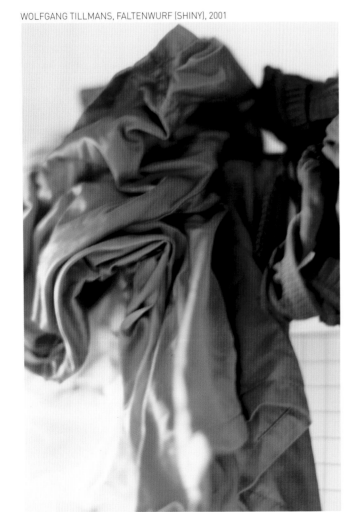

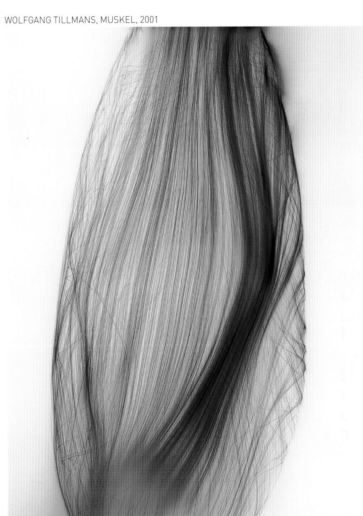

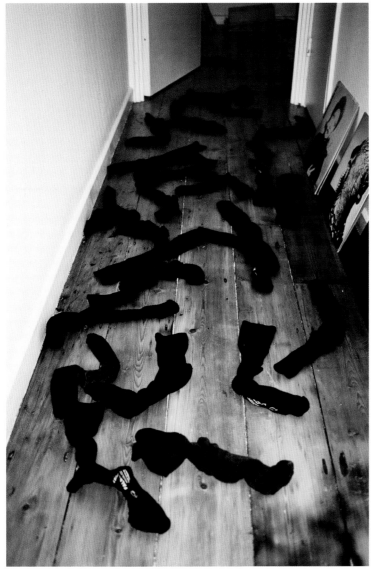

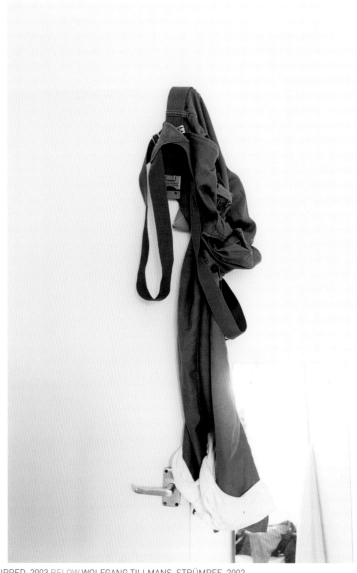

ABOVE LEFT WOLFGANG TILLMANS, GENOM, 2002 ABOVE RIGHT WOLFGANG TILLMANS, STRIPPED, 2003 BELOW WOLFGANG TILLMANS, STRÜMPFE, 2002

I want the pictures to look like the way I see things, which is not to be confused with standard notions of authenticity. I use my photography and my technical skills to achieve the impression of what it felt like to me in real life, to reflect a subjective observation or staged scenario. The true authenticity of photographs for me is that they usually manipulate and lie about what is in front of the camera but never lie about the intentions behind the camera.'

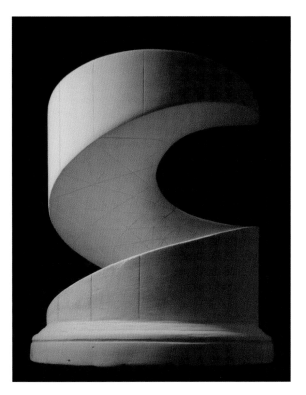

JAPANESE ARTIST SUGIMOTO STUDIED PHOTOGRAPHY IN THE EARLY 1970S AND WAS STRONGLY INFLUENCED BY MINIMALISM, ESPECIALLY THE WORK OF SCULPTORS DAN FLAVIN AND CARL ANDRE. USING PHOTOGRAPHY WITH TECHNICAL ELEGANCE AND CONCEPTUAL INTEGRITY, HE ALWAYS WORKS IN SERIES. THE USE OF LONG EXPOSURES AND STRICT COMPOSITIONAL RULES MAKES HIS PHOTOGRAPHIC PROCESS SLOW AND MEDITATIVE. THIS PRODUCES IMAGES THAT MAY AT FIRST SEEM TIMELESS BUT ARE INSTEAD EXPLORATIONS OF TIME AND HOW IT AFFECTS OUR UNDERSTANDING OF CONTEMPORARY LIVING. HIS SERIES INCLUDE *DIORAMAS AND WAX MUSEUMS* (FROM 1976), *THEATRES* (FROM 1978), *SEASCAPES* (FROM 1980) AND *ARCHITECTURE* (FROM 1997).

'*Conceptual Forms* consists of two parts, *Mathematical Forms* and *Mechanical Forms*. *Mathematical Forms* is subdivided into *Surfaces* and *Curves*. *Mathematical Forms* are photographs of stereometric plaster models that were used to provide a visual understanding of complex trigonometric functions. They were made in Germany in the late nineteenth and early twentieth centuries. *Mechanical Forms* are photographs of mechanical models used to demonstrate basic movements of modern machines. They were made in England during the late nineteenth century. These machines and models were created without any artistic motivation. This is what motivated me to produce this series of photographs and entitle them *Conceptual Forms*. Art is possible without artistic motivation and can be better without it.'

ABOVE HIROSHI SUGIMOTO, CONCEPTUAL FORMS, MATHEMATICAL FORMS 0001: HELICOID: MINIMAL SURFACE, 2004
RIGHT HIROSHI SUGIMOTO, CONCEPTUAL FORMS, MATHEMATICAL FORMS 0004: ONDULOID: A SURFACE OF REVOLUTION WITH CONSTANT NON-ZERO MEAN CURVATURE, 2004
OPPOSITE HIROSHI SUGIMOTO, CONCEPTUAL FORMS, MATHEMATICAL FORMS 0003: DINI'S SURFACE: A SURFACE OF CONSTANT NEGATIVE CURVATURE OBTAINED BY TWISTING A PSEUDOSPHERE, 2004

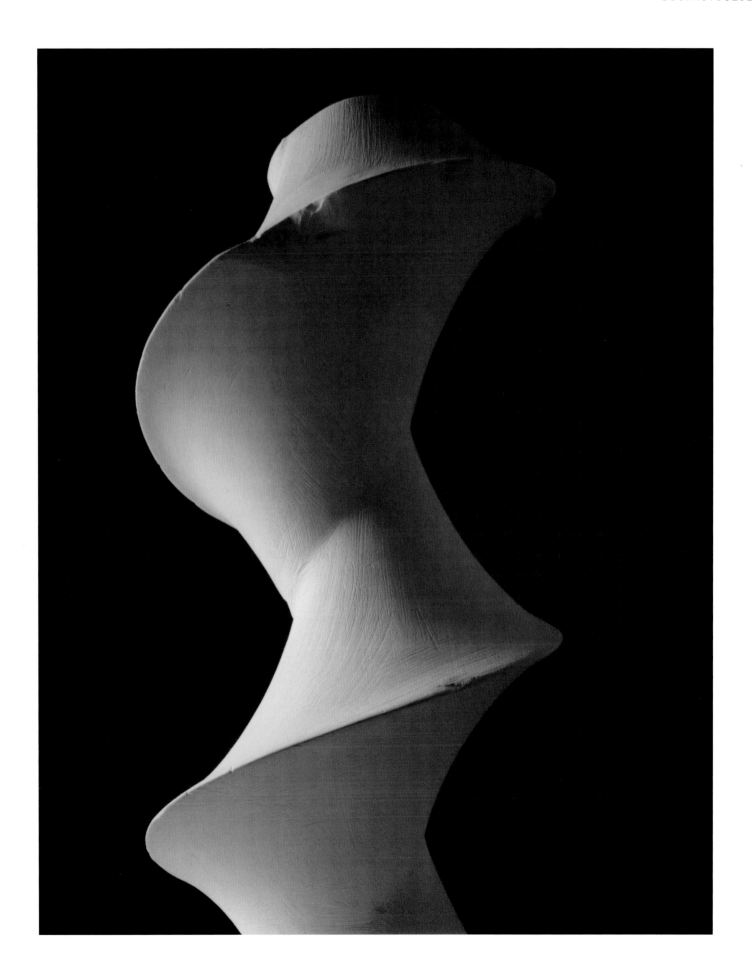

THOMAS DEMAND GERMAN ARTIST DEMAND MAKES MODELS OF ARCHITECTURAL SPACES AND THEN PHOTOGRAPHS THEM. THE SPACES, WHICH HE MODELS FROM WELL-KNOWN MASS-MEDIA PHOTOGRAPHS, OFTEN HAVE A LOADED OR TROUBLED HISTORY, BUT SINCE HIS IMAGES ARE TITLED GENERICALLY THIS HISTORY IS NOT GIVEN TO THE VIEWER. PLAYING WITH THE TRADITIONAL UNDERSTANDING OF A PHOTOGRAPH AS A FAITHFUL TRANSCRIPTION OF THE WORLD, DEMAND CREATES A TENSION BETWEEN THE ARTIFICIAL AND THE REAL.

'I build environments on a scale which enables me to take them seriously: in lifesize. This is as much a method as painting in acrylic is a method or making drawings with a pencil is a method. You might just call it a little more eccentric. I start with sculptures made out of very temporary materials, which would be widely accessible and not precious at all. The 3D work and its representation in 2D are different stages, which in combination become in fact quite complex constructions. To do this they need to be valid in their own right, that's why I spend so much energy on things you might not see in the end but are needed for that sculpture. Obviously, they counteract each other too. Sometimes they get filmed, animated or photographed. Then they are displayed mounted in plexiglas so they appear like windows – to employ a very old analogy. I want them to have a physical presence as things, not as framed flatware.

 I am always trying to construct a concept of an image, sometimes in a more narrative way, sometimes with a more philosophical or associative syntax. An image is always only showing what's necessary for a thought, not the thought itself.'

THOMAS DEMAND, KITCHEN, 2004

HONG HAO COLLECTING, ARCHIVING, MAPPING AND CATEGORIZING ARE CRUCIAL ELEMENTS IN HAO'S WORK. IN HIS EXTENSIVE SERIES *SCRIPTURES – FAKE MAP SERIES* (1992–6) HAO REWORKED MAPS AND RESHAPED THE WORLD ACCORDING TO DIFFERENT MILITARY, CORPORATE, ECONOMIC OR GEOGRAPHICAL POWERS. THIS DARKLY HUMOROUS AND SOMEWHAT ANXIOUS INTERPRETATION OF THE FORCES THAT GOVERN THE WORLD CAN BE READ IN DRAMATIC OPPOSITION TO THE MICROWORLD PRESENTED IN *MY THINGS*. HERE HIS FASCINATION WITH ORDER IS PERSONAL AND NOT POLITICAL AND HE INVITES THE VIEWER TO SPECULATE ON WHAT YOU CAN REALLY TELL ABOUT A PERSON JUST BY THEIR BELONGINGS.

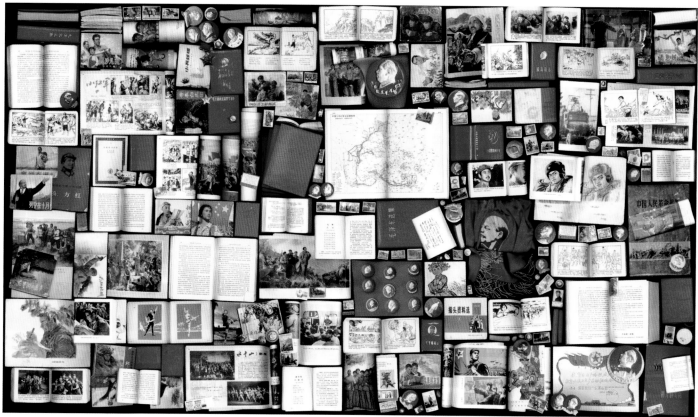

HONG HAO, MY THINGS NO. 6 – THE HANGOVER OF THE REVOLUTION IN MY HOME, 2002

'I represent the daily pieces of my life where no one thing is more important or more expensive than the other; they just form the daily "waste book" of my life. All the things presented in my works are used on a daily basis or are leftovers – things we don't pay much attention to. The things in the images are all the same size as the original objects. They are directly scanned and then individually arranged on a computer. The objects do not become more valuable to me after I have made the art work. They are simply the things which my life consists of, they have their destinations – some are used, some are thrown away and some are collected. I do not disturb or change their destinations. I have finished scanning most of my things now but maybe I will make more when I have something new, or I might present them in another way.

The selection is not subjective, it's more like a selection by a machine and most works are categorized randomly. They are unfocused in their arrangement, apart from "My Things No. 5", which is arranged by size and shape. "My Things No. 6" is the memory of my childhood – things that were used at that time which I kept. They are more like my collections, or a record or document of my personal history, including the beginning of my study of art.'

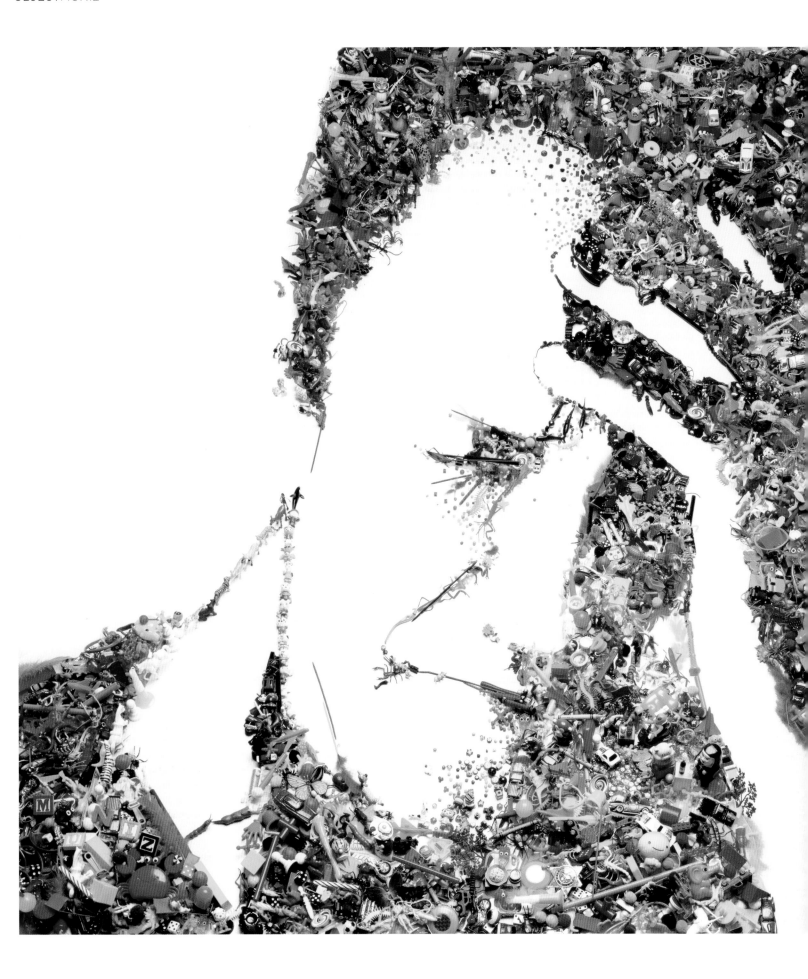

VIK MUNIZ BRAZILIAN ARTIST MUNIZ'S BACKGROUND IN ADVERTISING EXPLAINS HIS UNDERSTANDING OF HOW POWERFUL AN ICONIC IMAGE CAN BE AND HOW WITTY AND IRONIC MANIPULATION CAN HELP AN AUDIENCE INTO NEW WAYS OF THINKING. HIS BLENDING OF SCULPTURE, PAINTING AND PHOTOGRAPHY PERFECTLY MATCH THE MATERIAL TO THE SUBJECT MATTER, ALLOWING FOR LINKS WHICH GO BEYOND SIMPLE REPRESENTATION. THE OBJECTS WHICH HE CREATES AND THEN PHOTOGRAPHS – ALL RE-CREATIONS OF OTHER ARTISTS' IMAGES – ARE MADE WITH A WIDE RANGE OF SUBSTANCES INCLUDING SUGAR, SOIL, WIRE, STRING, CHOCOLATE SYRUP, DIAMONDS AND CAVIAR AND OFTEN DISINTEGRATE SHORTLY AFTER THE PHOTOGRAPH HAS BEEN TAKEN.

'The late Dutch artist Bas Jan Ader died while attempting an ocean crossing for a performance piece. I had always admired him. He has a piece called *I'm Too Sad to Tell You* which he did in the early 1970s. It's a film in which he goes from being completely satisfied to being distraught and desperate and crying. I've always thought it is very strange. Would he do that, if the camera weren't there? It's not just acting, it's something right in between. That kind of playing or pretending has something to do with the idea of toys. I didn't want to do a picture of him. I tried the same thing in front of a stills camera, and by the time I got to the point that I thought he was at, I was pretty sad too. When I reached the point he's at in the famous still of him, I could then start the piece.'

LEFT VIK MUNIZ, REBUS, SELF-PORTRAIT (I AM TOO SAD TO TELL YOU, AFTER BAS JAN ADER), 2003
RIGHT VIK MUNIZ, PICTURES OF CHOCOLATE, MEDUSA, AFTER BERNINI, 2004

ZOE LEONARD BOTH THE OBJECT REPRESENTED IN THE IMAGE AND THE PHOTOGRAPHIC OBJECT ITSELF INTEREST AMERICAN ARTIST LEONARD. THIS DUAL FASCINATION IS A THREAD WITHIN HER WORK AND CAN ALSO BE SEEN IN THE *FAE RICHARDS PHOTO ARCHIVE* (1993–6), WHICH SHE PRODUCED IN CONJUNCTION WITH THE FILMMAKER CHERYL DUNYE. IN THIS FICTIONAL ARCHIVE THEY CREATED PHOTOGRAPHS THAT MIMICKED 'REAL' PHOTOGRAPHS, FROM PUBLICITY SHOTS TO VERNACULAR SNAPSHOTS, TO RECONSTRUCT A NARRATIVE ABOUT A BLACK AMERICAN ACTOR LIVING IN THE FIRST HALF OF THE TWENTIETH CENTURY. WORKING BOTH AS A PHOTOGRAPH ALBUM AND AS AN EXHIBITION OF 'ARCHIVE' PRINTS THE CONSTANT PLAY BETWEEN REPRESENTATION AND PHOTOGRAPHIC OBJECT WAS CRUCIAL TO THE VIEWER'S UNDERSTANDING OF IT.

'Much of my work deals with the re-construction and repositioning of common objects. I'm interested in how we fetishize objects, communicate through them, and project meaning onto them. And, as a photographer, I am interested in the uneasy connection between sculpture and photography. I'm also interested in the gap between reality and representation, objective evidence versus subjective fiction. This piece was all of those things: an installation, a group of objects, and a series of pictures.

In 2003, I was invited by Mass MoCA, who were doing a show in collaboration with the Society for the Preservation of New England Antiquities, to go through SPNEA's collections and archives and make a work. The title is from the Pledge of Allegiance: "I pledge allegiance to the flag of the United States of America, and to the republic for which it stands …". I chose this phrase for several reasons. Part of it was timing. While I was working, the US government was gearing up towards war with Iraq, and there was a lot of talk about patriotism and the homeland.

I chose these objects because they all seemed American in some way, all mundane, un-dramatic, but somehow all also touch on some kind of symbolism. I was interested in the inherent instability of symbolism; these objects could mean different things to different people, at different times.'

ZOE LEONARD, FOR WHICH IT STANDS, 2003

THOMAS RUFF DRAWN FROM AN ARCHIVE OF GLASS NEGATIVES, *MASCHINEN* RECONTEXTUALIZES IMAGES ORIGINALLY TAKEN FROM AN INDUSTRIAL PATTERN BOOK. RUFF REWORKS THE IMAGES SO THAT THE END RESULT IS A HYBRID OF PRE-EXISTING PHOTOGRAPHS AND DIGITAL RETOUCHING. THIS RETURNING TO (AND SUBVERTING OF) TRADITIONAL PHOTOGRAPHIC GENRES CAN BE SEEN THROUGHOUT HIS WORK. RUFF QUESTIONS THE SUPPOSED OBJECTIVITY AND TRUTHFULNESS OF PHOTOGRAPHS BY CONCEPTUALLY CHALLENGING THE TRUST PLACED IN IMAGES.

'Photography has been used for all kinds of reasons over the past 150 years. Most of the photos we come across today are no longer really authentic – they have the authenticity of a manipulated, prearranged reality. You have to know the conditions in which a photograph was taken in order to understand it properly because the camera just copes with what is in front of it.'

BELOW THOMAS RUFF, MASCHINEN 0821, 2003 OPPOSITE THOMAS RUFF, MASCHINEN 1301, 2003

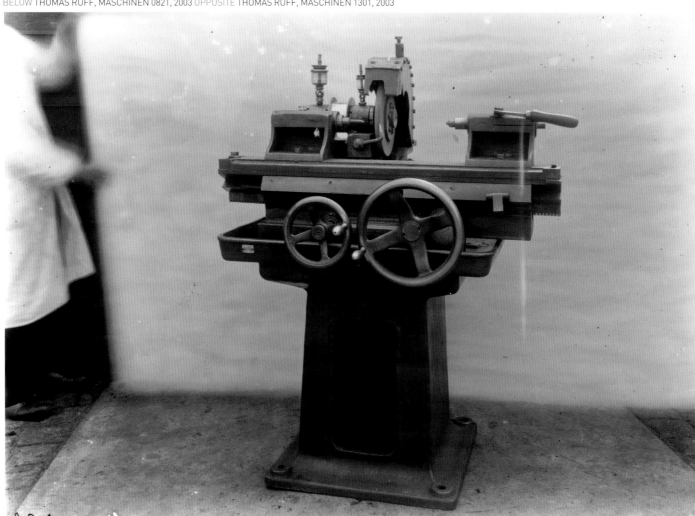

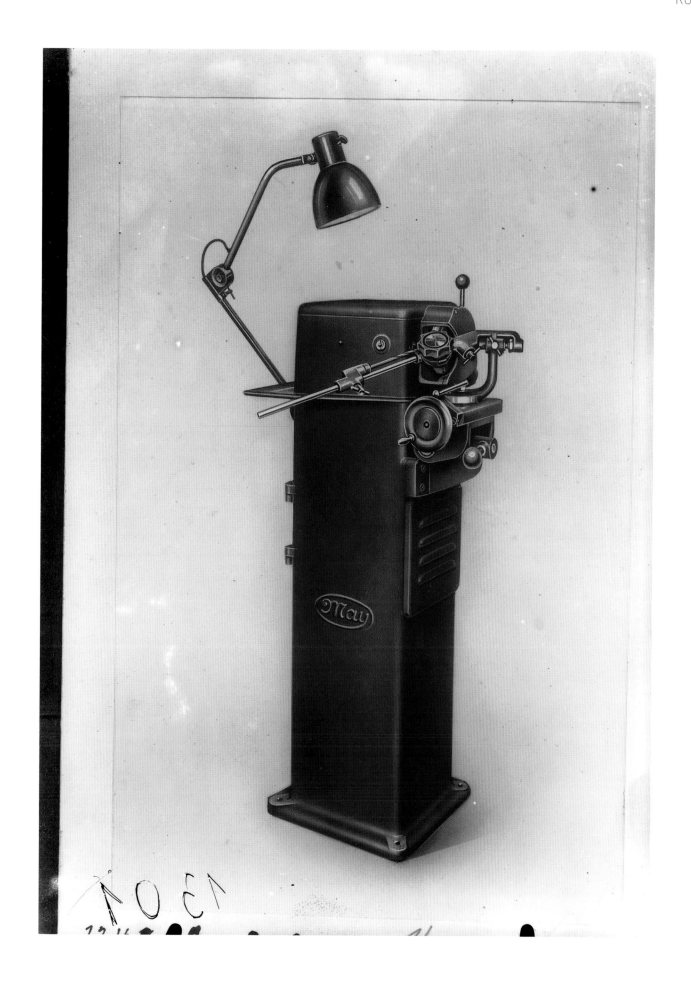

JAMES WELLING SINCE THE LATE 1970S AND EARLY 1980S AMERICAN ARTIST WELLING HAS BEEN DECONSTRUCTING AND EXAMINING THE PHOTOGRAPHIC PROCESS. HE IS PERHAPS BEST KNOWN FOR HIS MINIMAL IMAGES IN THE 1980S OF FOIL AND FABRIC. THIS WORK HAS OFTEN BEEN READ AS A POSTMODERN CRITIQUE OF REPRESENTATION, A CRITIQUE THAT WAS CENTRAL TO MUCH ART AND CRITICISM OF THE TIME. IT WAS IN MANY WAYS THE BEGINNING OF A LONG-STANDING EXAMINATION OF THE EFFECTS AND PRESENCE OF LIGHT, BE THAT IN HIS ABSTRACTIONS OR IN HIS SEEMINGLY STRAIGHTFORWARD DOCUMENTARY IMAGES.

BELOW JAMES WELLING, NEW ABSTRACTIONS, #22, 1998
OPPOSITE JAMES WELLING, NEW ABSTRACTIONS, #23, 1998

'Although I came out of an abstract painting background, I was very strongly influenced by conceptual art in the early 1970s. I use both conceptual and pictorial ways of thinking in my photographs and over the years I've had to deal with the tension between these two conflicting sets of ideas. I made abstract photographs by photographing things which looked "abstract" like drapes or aluminum foil and I made conceptual images by taking pictures that looked "documentary", photographing things like railroads or architecture. There is a degree of instability between these two directions and I seem to alternate between the two. In the mid-1990s I began to make pictures which held both these ideas in equilibrium. The photographs in that series, which I called *Light Sources*, were extremely varied in terms of subject matter and combined both abstract and documentary elements in the same pictures. I printed these works as large inkjet prints.

When I begin a new project, I often explore a frustrating series of dead ends. With the *New Abstractions* I started off photographing bobbins of thread unfurled on backdrop paper. Then, I photographed large pieces of seaweed. Next, I photographed surfaces covered with elevator grease. Finally, one afternoon, I impulsively cut up some strips of paper and made two photograms on high-contrast film. I printed these two negatives and studied them. There was something here and I began to make more photograms on photographic paper. Since I'd begun on film, I decided I wanted to make "positive" photograms – black shapes on a white field rather than the traditional white forms on black.'

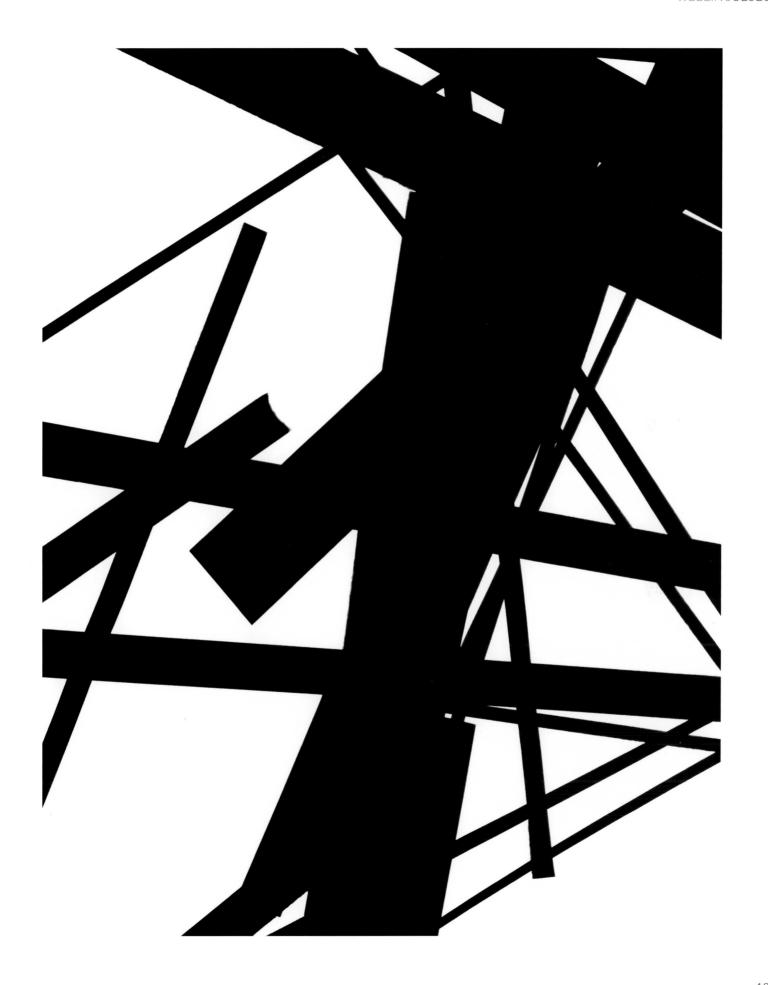

JEAN-LUC MOULÈNE FRENCH ARTIST MOULÈNE TAKES POLITICAL SUBJECTS SUCH AS PRODUCTION AND LABOUR, TRADITIONALLY REPRESENTED IN PHOTOGRAPHY THROUGH FIGURATIVE, HUMANISTIC APPROACHES, AND COMES AT THEM MORE OBLIQUELY. IN *DOCUMENTS/PALESTINIAN PRODUCTS* HE EXPLORES THE SEPARATION OF AN OCCUPIED TERRITORY BY ISOLATING THE PRODUCTS PRODUCED THERE AND TREATING THEM AS STILL LIFES WITHOUT CONTEXT. THE UNFAMILIAR BAR CODES SHOW THAT THE GOODS HAVE NO ACCESS TO A GLOBAL MARKET – THEY ARE BLACK-MARKET FAKES OF SORTS. THE ONLY WAY THEY CAN FUNCTION OUTSIDE OF PALESTINE IS BY BEING TURNED INTO IMAGES AND OPERATING AS ART.

BELOW JEAN-LUC MOULÈNE, DOCUMENTS/PALESTINIAN PRODUCTS: COLOURED SWEETS, PARIS 2002 09 26, 2002/5
OPPOSITE JEAN-LUC MOULÈNE, DOCUMENTS/PALESTINIAN PRODUCTS: BEANS, PARIS 2002 08 11, 2002/5

'Following on from *Strike Objects* (1999–2000), this new series, as rooted in real life as the earlier series, addresses an ongoing conflict. Made in Palestine, imported and displayed as evidence, these products are proofs of current-day consumerism (bottles of olive oil, chewing gum) shown as supreme examples of a developed economy, despite the fact that the state they come from no longer exists. I didn't select the products in advance: the choice was made for me when I decided to photograph products made in Palestine. I imported pre-existing products with all the difficulties caused by the export ban. I used various channels to do this: fair-trade organizations (Oxfam in association with PARC, the Palestinian Agricultural Relief Committees), Arafat's cabinet department, or the International Civil Campaign for the Protection of the Palestinian People, which sends missions to Palestine.

Conflict is a basic condition of the work. This conflict comes through in the geometry and rhetoric of the images themselves. Products such as cans of oil, wafer biscuits, packets of couscous or other items recall gun barrels, surveillance systems, sand bags or concrete walls.'

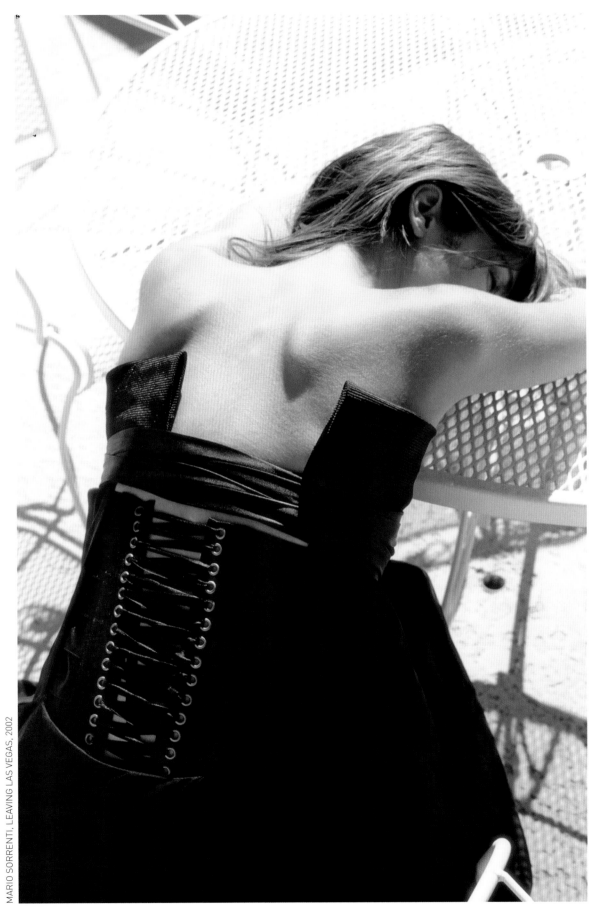

FASHION

Art and fashion have often been seen as surviving independently of one another at opposite ends of a hierarchical scale. Art has always traditionally enjoyed top billing with its lofty values and perceived 'purity' unsullied by burdens such as commercialization, briefs and clients, with which fashion has to contend in order to function.

But this simplistic understanding does not take into account the grey areas that always occur between fields, nor does it look at the constant re-evaluation of fashion imagery and the 'business' of the art world. The commercial element which drives fashion photography has meant that there has always been a perceived 'muckiness' surrounding it. It also demystifies itself as it is so obviously part of a process and belongs so visibly to an industry. But cross-fertilization between the two genres has always existed and the strange 'mating ritual' between fashion and the art world has become much more common in recent years.

Despite this, art museums continue to have a fraught relationship with fashion. It is often thought that fashion photographs are shown extensively in museums and galleries but this is simply not the case. When they are, they attract very large youth audiences, have larger marketing budgets and generate much wider publicity than 'fine art' exhibitions and thus enjoy a higher profile. This, however, is not to be confused with regularity or indeed clarity of display.

The relationship between art institutions and fashion is complex, for a number of reasons. One is that, because fashion has always traditionally been marginalized, it throws open questions about the history of art, and of photography, perceived as a series of 'great masters', in accordance with more museological understandings of history. Museums are wary of critiquing their own history, of showing gaps in their collecting policy or of complicating their fastidious categorizing systems. So when fashion is shown it is often displayed as existing outside the mainstream. The notion of the 'master' in art sits uncomfortably with fashion photography in that the production of a fashion image is a collaborative effort between a team that includes stylists, art directors, assistants and, sitting quietly in the background, the client. Fashion photography does not fit into the inflexible system that governs many museums and galleries, and so there have evolved galleries dedicated to the display and marketing of fashion photographs, raising the profile of work by photographers such as Irving Penn and Helmut Newton. These galleries tend to work commercially rather than as public institutions, but are vital for a fuller understanding of the trends within the genre.

The gallery or museum also tends to show art works as individual, polished pieces. Fashion photography can work like this, but is often more successful when viewed as part of a story, full of sequence and narrative, jostling for attention in amongst adverts, editorial and dynamic graphics. Magazines have an energy which institutions can never really rival and in a way fashion does not really need the museum or gallery as much as the gallery system increasingly needs fashion to bring in the numbers. So unlike other genres in this book it is not to the art institutions that we look in order to gain an understanding of its history but to the more ephemeral outlets. The magazine is not fashion photography's only currency – there are also music videos, lookbooks, catalogues, advertising and catwalk photography. Context is everything with a fashion photograph.

The most recent exhibition to try to come to terms with the increased crossover between fashion and art was 'Fashioning Fiction in Photography since 1990', curated by Susan Kismaric and Eva Respini for MoMA in 2004. With very little serious writing and few curatorial initiatives dedicated to fashion photography, it was refreshing. However, in the traditional manner of showing fashion in art museums, it did not relate the work to the industry in which it operates but understood it

only by placing it in the context of art. In this case it explored recent trends in art photography, such as staged tableaux, diarist approaches and the influence of cinema – examples of all of which can be seen in the pages of this book. It was a valid, if partial, welcoming of commercial practice into the art gallery, but it seemed only to accept it on its own terms. It was a greatly missed opportunity to show the diversity and energy so apparent in contemporary fashion photography.

While most commercial fashion photography cannot be considered art, some, like that occasionally produced for the higher-end labels and magazines such as *W*, certainly can. As outlined previously, the fashion spread can sit awkwardly in the gallery space so, increasingly, artists are coming to the magazine instead. Publications such as *Vogue, W, Another Magazine* and *Tank* are increasingly employing celebrated artists for shoots, such as Tina Barney, Nan Goldin, Larry Sultan, Philip-Lorca diCorcia, Sam Taylor-Wood, Collier Schorr and Justine Kurland. Where in the past artists might have kept fashion assignments quite separate from their 'personal' work or done them purely for the money, this is now changing and artists can wear the fashion spreads like a badge of pride, as a little of the street credibility and glamour rubs off on them.

In return, eminent fashion photographers are now increasingly represented by commercial art galleries, and some can operate in the two fields with equal respect on both sides. This is still quite rare but it is a changing trend as photography generally gains prominence in contemporary art. Added to this, the use of the computer and of digital manipulation, long accepted in fashion photography, is also becoming increasingly accepted in the gallery. As many magazines become pressured into being 'safe' at the mercy of their advertisers, the gallery can step in and offer space that does not threaten or curtail what is being represented or how. These shifts and changes in status will even out the long-held hierarchies and museums will have to readjust the way they collect and display fashion photographs.

The images in this chapter vary enormously. Many of these photographers gained prominence at the end of the 1980s and in the early 1990s when there were huge changes within the fashion industry and ground-breaking developments in how fashion imagery was made and understood. The huge growth in magazine culture and the need for art directors, photographers and stylists to seek alternative modes of portraying their work away from the high-gloss magazines of the 1980s resulted in new and influential magazines such as *Purple* in France and *I-D* and *The Face* in Britain, which blended music, documentary and 'street style' genres. This gave fashion photography a new credibility, and editorial fashion stories (as opposed to commercial advertising) allowed space for image-makers to construct narratives that had more personal meaning.

Some of the work shown in this chapter is 'personal work' made separately from commissioned assignments. Some of it cuts across both. Some was done originally for a fashion shoot and then transferred to the gallery, and some was created purely to be seen in book form. It is a mixture of editorial, advertising, personal work and art, all of which reflect highly individual styles and approaches and challenge traditional definitions and hierarchies.

JONATHAN DE VILLIERS TAKING ADVANTAGE OF THE MASS MARKETS OF FASHION AND STYLE MAGAZINES, BRITISH ARTIST DE VILLIERS INFUSES HIS WORK WITH A MORE CRITICAL OR POLITICAL EDGE THAN IS USUALLY ASSOCIATED WITH FASHION PHOTOGRAPHY. HIS WORK IS RECEIVING INCREASED ATTENTION IN THE ART WORLD. AWARE OF THE DIFFERENT VALUES PLACED ON WORK THAT APPEARS IN A GALLERY AS OPPOSED TO A MAGAZINE, DE VILLIERS RECENTLY PUT HIS WORK IN A SITE THAT WAS SOMEWHERE BETWEEN THE TWO. HE PRODUCED A FAKE MAGAZINE THAT WAS PINNED TO THE GALLERY WALL IN THE SAME WAY THAT A FLATPLAN WOULD BE PINNED TO THE WALL OF A MAGAZINE OFFICE.

BELOW JONATHAN DE VILLIERS, WAITING, 2003, 2004
RIGHT JONATHAN DE VILLIERS, WAITING, 2003, 2004

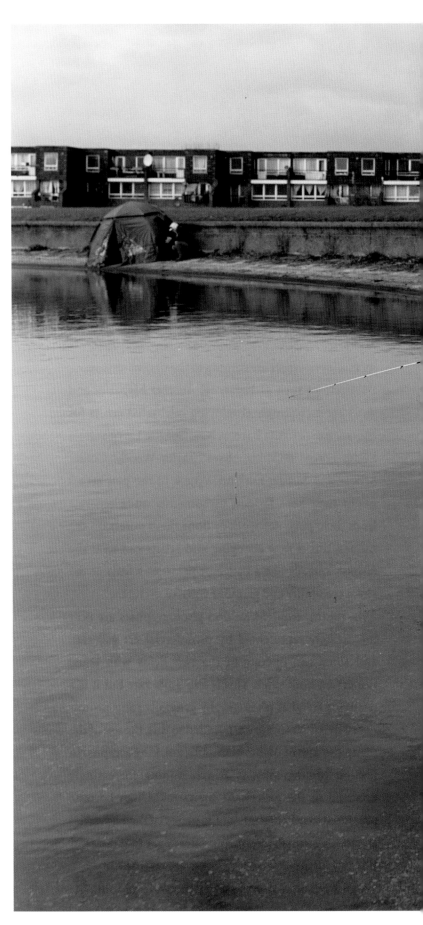

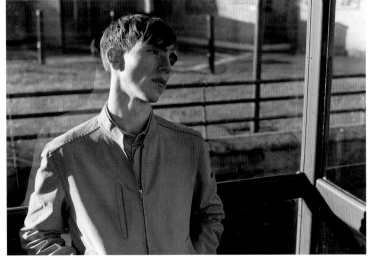

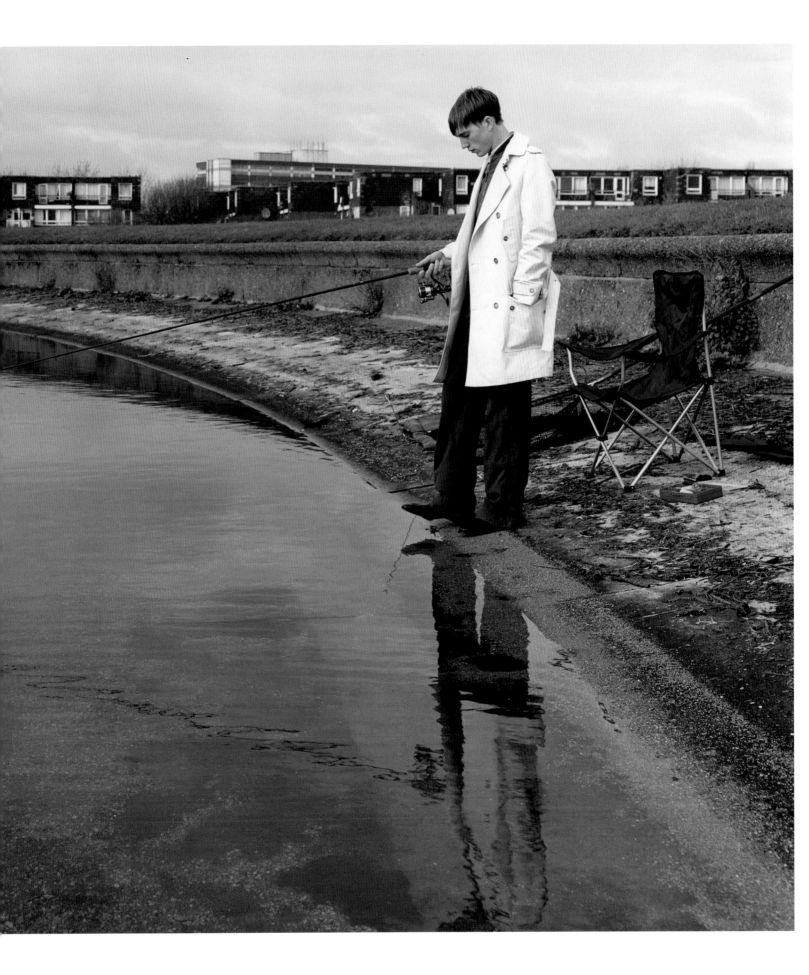

'*Waiting* was commissioned by *Roma Vogue*. When you're working in that kind of space you do have a different audience and there's less liberty in many ways because they're actually paying for the cost of shooting it to some degree. There's a lot more commercial pressure in some ways than the small magazines. So, it's a tighter box to work in and you've got to try and do what you can in that space. In a way, the tighter the box you make for yourself, the more exciting it is when you feel like you've done something interesting with it. Restrictions tend to make for interesting work, potentially, rather than self-indulgence. So, I have different directions for things that I've done but sometimes I just try and do things with a very slight idea, with a sort of element of banality to it and this is one of them. I just felt that fashion stories a lot of the time, and I've done this myself, are often about trying to put a spectacle on the page and to be terribly exciting. I thought it would be interesting to do something that was really flat and was all about a figure really just waiting, hanging around and pausing. I thought it would be interesting to try and think what I could do with that.'

JONATHAN DE VILLIERS, WAITING, 2003, 2004

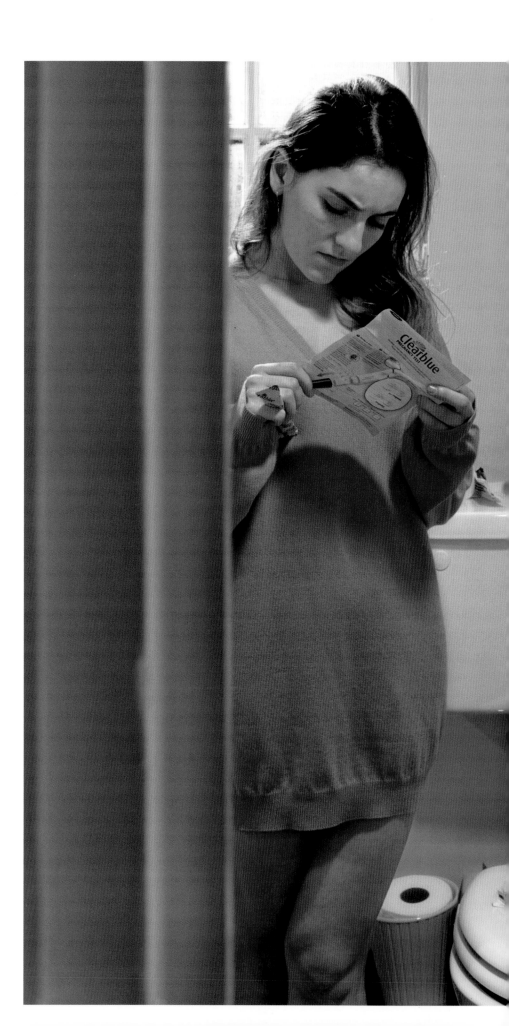

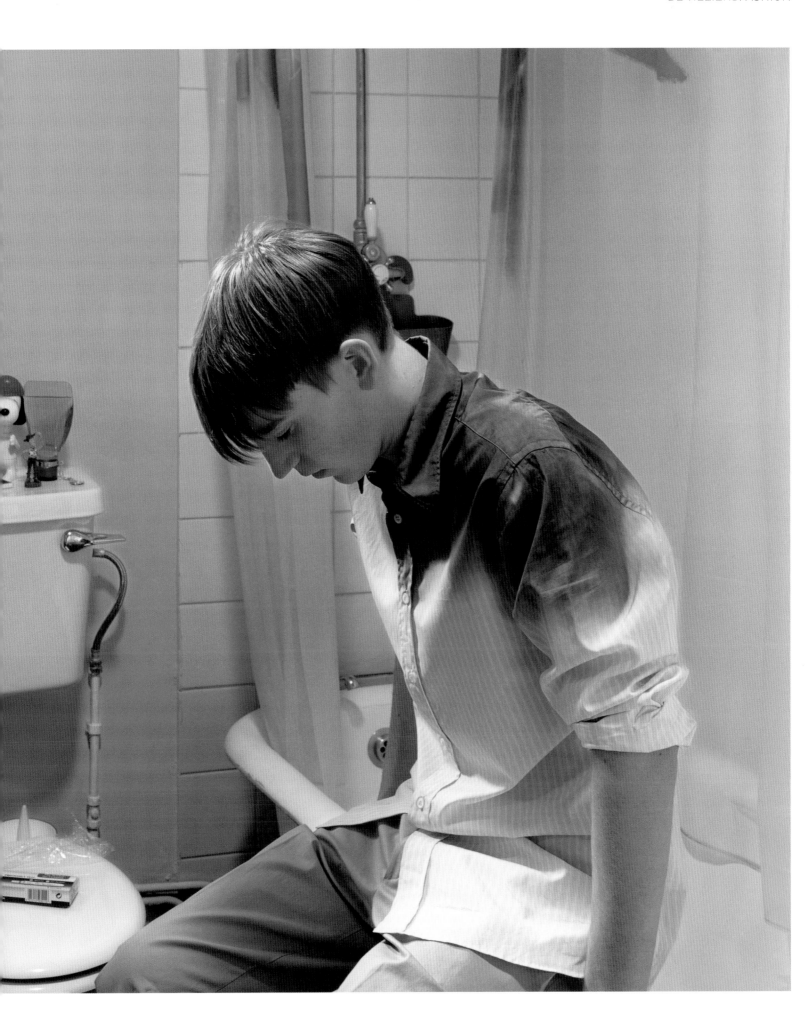

NICK KNIGHT
KNIGHT IS ONE OF BRITAIN'S MOST INFLUENTIAL AND INNOVATIVE FASHION PHOTOGRAPHERS. OFTEN USING THE PLATFORM OF FASHION TO COMMUNICATE MORE POLITICAL MESSAGES TO LARGE AUDIENCES, HIS WORK HAS TOUCHED ON ISSUES OF AGEISM, SIZE ACCEPTABILITY AND VISIBILITY FOR THE PHYSICALLY CHALLENGED. HE HAS CONSTANTLY PUSHED THE BOUNDARIES IN BOTH HIS ADVERTISING AND EDITORIAL WORK AND HAS COLLABORATED WITH LEADING ARTISTS AND CREATIVES IN THE FIELDS OF MUSIC, ART AND DESIGN.

BELOW AND BELOW RIGHT NICK KNIGHT, W SHOOT: W COUTURE S/S 2003, 2003

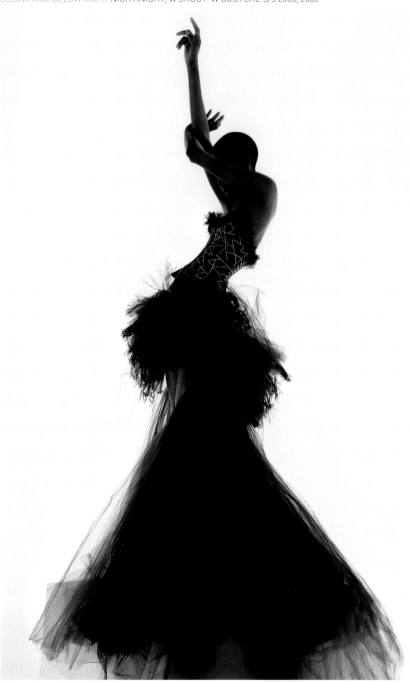

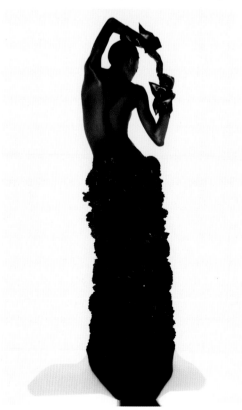

'Photography for me is a means of communication – and that's all. I don't have any love for the medium; for me it's just a way of expressing myself. The desire to communicate is what fuels my work. We perceive art as a finished product. It is presented as a final closed statement. But the creative process is a long one. When I am working the most exciting or painful parts of this process are the moments when I am struggling to resolve things. As it stands the public are quite wrongly excluded from this.

People criticize fashion for being superficial but I think that can work to its advantage. I like its fickleness and the fact it can change all its values. I've always thought that stills photography was not necessarily the best way to show it, as it seems to go against the product, which is about movement, line and fluidity.

NICK KNIGHT, SHOOT, 2003

With *Shoot*, I was producing fashion imagery for *W* magazine, one of the best-selling fashion magazines in the world, and at the same time I was trying to contextulize the images I was producing. The easiest way to explain this is the use of the horse. We had professional tanners skin a horse, but the idea wasn't simply to shock but to make people think about where their designer pony-skin boots come from, it was a way to force people to make that connection. The 48-hour performance was live and broadcast globally, then three months later the fashion pictures were printed in *W*, and then we condensed the live footage down to a three-minute film which is on my SHOWstudio website.'

CRAIG MCDEAN HAVING ASSISTED NICK KNIGHT, MCDEAN MOVED INTO HAVING HIS OWN WORK PUBLISHED THROUGH MAGAZINES SUCH AS *I-D* AND *THE FACE*. AT THE END OF THE 1980S, MCDEAN WAS ONE OF A NUMBER OF BRITISH PHOTOGRAPHERS REACTING AGAINST THE HIGH GLOSS AND GLAMOUR OF THE FASHION INDUSTRY. IN 1999 HE PUBLISHED *I LOVE FAST CARS*, A HOMAGE TO THE WORLD OF THE SOMEWHAT RETRO SPORT OF DRAG RACING AND ITS COMMUNITY. HIS LOVE OF AMERICAN POPULAR ICONOGRAPHY CAN ALSO BE SEEN IN *LIFESCAPES*, WHICH DIGITALLY LAYERS AND BLENDS LANDSCAPES TAKEN FROM ROAD TRIPS WITH PERSONAL NARRATIVES.

CRAIG MCDEAN, LIFESCAPES: VACATION, 2004

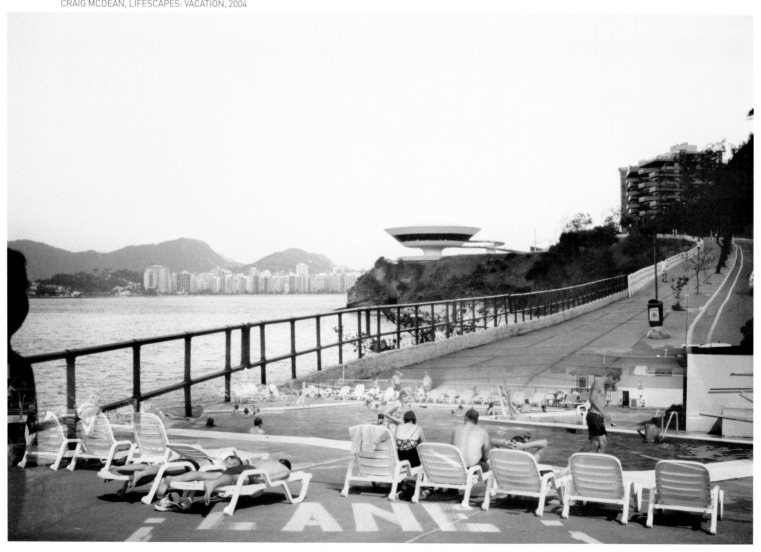

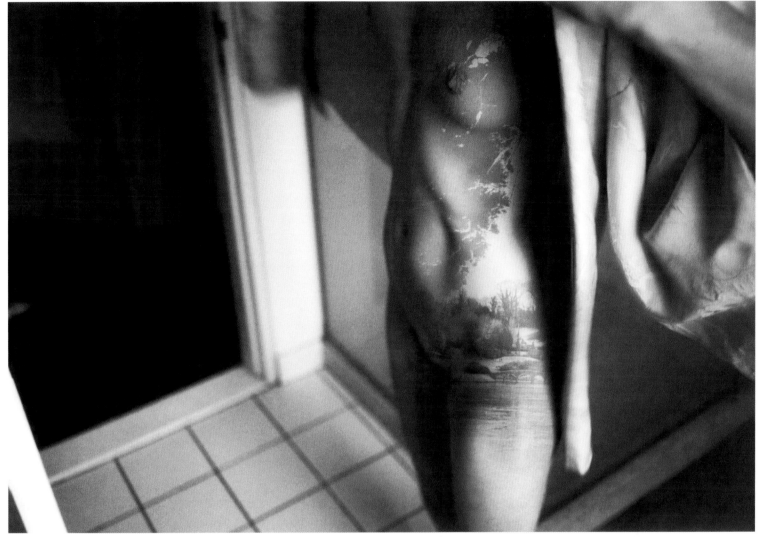

ABOVE CRAIG MCDEAN, LIFESCAPES: BOND STREET, 2004 BELOW CRAIG MCDEAN, LIFESCAPES: TATTOO, 2004

'I wanted to avoid genres. What's exciting for me is their particularity. Like the first image in the book – I wasn't so interested in the people because when they came out, I just photographed their tattoos, so in the end I didn't want it to look like a person. I didn't want to do their portraits. It wasn't about that. I wanted to dismantle the surface as much as possible. I just wanted their tattooed arms or legs. So in the end, I dehumanized them and allowed the pictures to come together subconsciously.

To me it's like going into the studio and writing a new song. But you don't have to write the album with the same guitar riff. You have to find elements and create some other kind of music. It's exciting to go in there and work on one image each day and then forget it and come back. Its really like an adrenaline rush.'

MERT AND MARCUS THE INFLUENCES OF FRENCH FASHION PHOTOGRAPHER GUY BOURDIN AND SURREALIST ARTISTS SUCH AS HANS BELLMER ARE APPARENT THROUGHOUT MUCH OF MERT AND MARCUS'S WORK. OFTEN LADEN WITH LATENT SEXUALITY AND TAUT PSYCHOLOGICAL UNDERCURRENTS, THEIR WORK UPDATES MANY SURREALIST FASCINATIONS WITH THE UNCANNY AND FEMALE SEXUALITY. HERE KATE MOSS IS A MUSE WHO IS BOTH KNOWING AND FEMININE. SITUATED IN A CLASSIC STUDIO SETTING, THESE ARE IMAGES OF AN INTIMATE RELATIONSHIP BETWEEN PHOTOGRAPHER AND MODEL, WHERE THE AUDIENCE IS INVITED IN TO MAKE A PRIVATE SITTING PUBLIC.

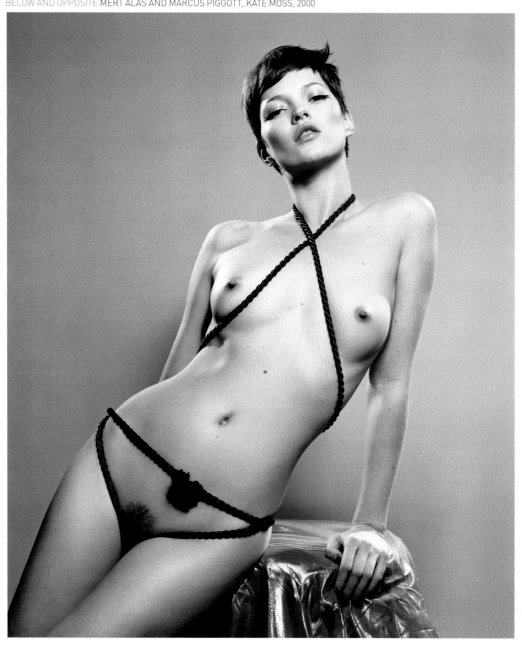

'We started doing art pictures before we started doing fashion and don't really see much difference between the two. We start with a character. Sometimes that could be inspired by an art work or sometimes by a person. You choose the right person for that outfit or the right outfit for that person. It's about seeing and understanding the message of what you want to photograph and how you want your imagination and your fantasy to be on a piece of paper. Sometimes you may have to sell a bag or a shoe. When this happens you may have to go onto a different level but in the end, when we are working, we're interested in making photographs and don't really label them as fashion photographs or art photographs. It's the same feeling that's put into both forms of photography – same sort of effort, same sort of thought, and same sort of environment.

Working collaboratively, it's hard to say what each person brings to the partnership. We are both very hands on during the making process. We get involved with every stage of the image. That could mean the lighting, the clothes, the set, the model, the hair, the look and the make-up.

We admire a great deal of artists but we don't use them as references. It's more about people that we really respect and love. They're people who make us think about taking pictures. So, we relate to them in a certain way, but they're not our references. Life is a reference.'

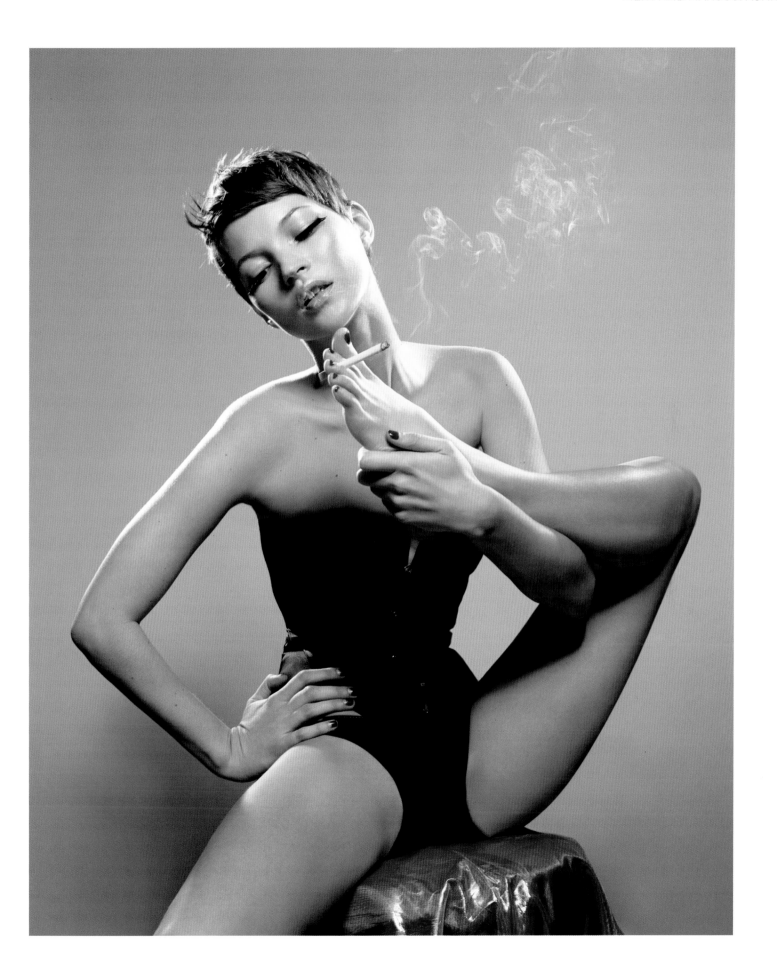

KOTO BOLOFO BOLOFO IS PROBABLY BEST KNOWN OUTSIDE OF THE FASHION WORLD FOR HIS FILM AND SUBSEQUENT BOOK *SIBUSISO MBHELE* AND HIS *FISH HELICOPTER*, FIRST SHOWN AT MOMA, NEW YORK, IN 2000. HIS INSTANTLY RECOGNIZABLE STYLE BLENDS THE TRADITION OF AFRICAN COMMERCIAL STUDIO PORTRAITURE WITH AN ALMOST SURREALIST HUMOUR AND PLAYFULNESS. THE RICH USE OF COLOUR IS REMINISCENT OF 1970S CINÉ FILM AND CUTS ACROSS BOTH HIS COMMERCIAL AND ARTISTIC PRACTICE.

'In the image of the man in the red jacket, he is holding a *koto* – a fighting weapon made out of one piece of wood. I wanted a sense of identification to show that the man is African and to celebrate the pride in that. I tried to glorify them. The motifs and designs on the blankets, which had been left behind, are from England. The placing of objects on the blankets is very much part of the tradition of studio portraiture in Lesotho where the props are used as symbols to show your status.

BELOW AND OPPOSITE KOTO BOLOFO, LESOTHO HORSEMEN, 2003

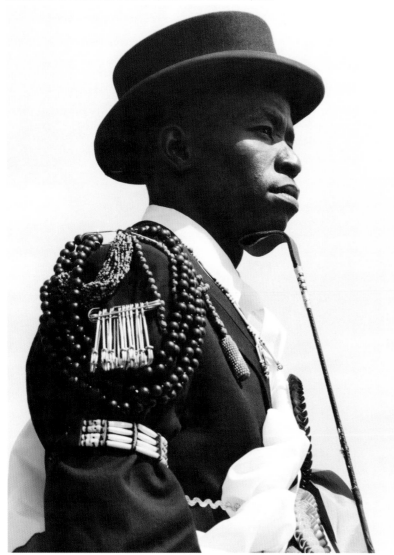

The project is about two men from Lesotho, the mountain kingdom in Southern Africa, where I am from. They are training for the Equestrian Olympics, and have been accepted to represent the Kingdom of Lesotho in the 2008 Olympics. I was approached to photograph them and to help raise awareness of them. I rang Italian *Vogue* and said that this was an incredible story – it has nothing to do with fashion really. They were training in Germany with the finest horses, and it was great to talk my native tongue. Show-jumping is usually thought of as a sport for the elite, so to have Lesotho represented was so important – it put Lesotho up there and made people look at the country. One of the men was a police officer and he wanted to return and start a show-jumping school. The other, a tracker, wants to make a museum of Lesotho culture. What I wanted to do with these images was to stylize the pictures, so there was an integration of Lesotho references like the blankets and pins as a celebration of the culture. They could just be two black riders so I wanted to give them a sense of identity and the viewer an insight into Lesotho.'

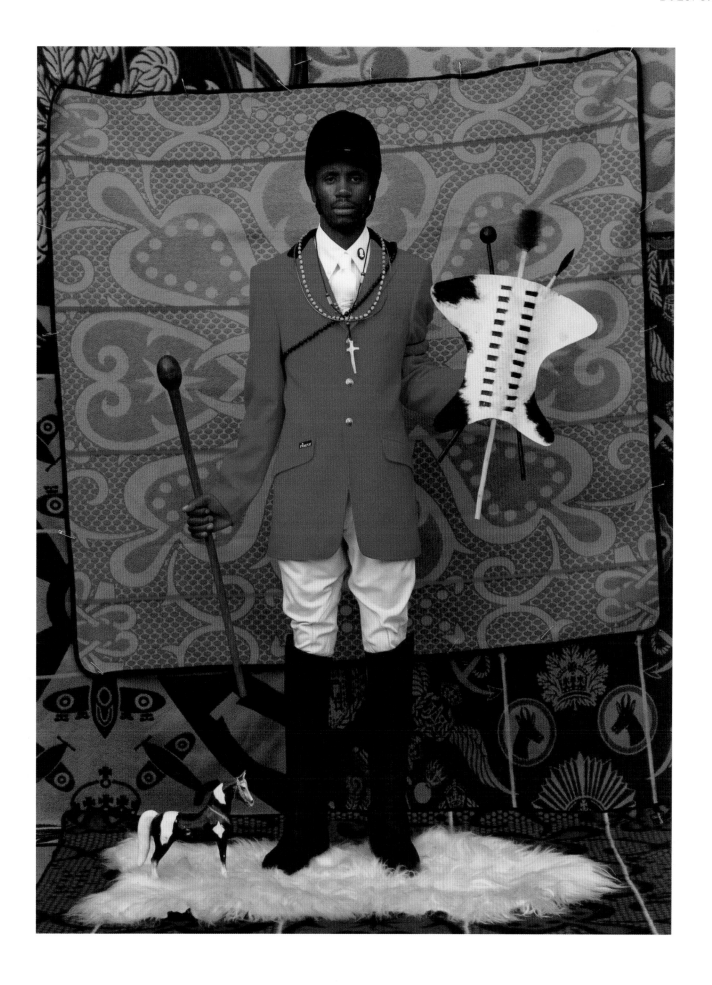

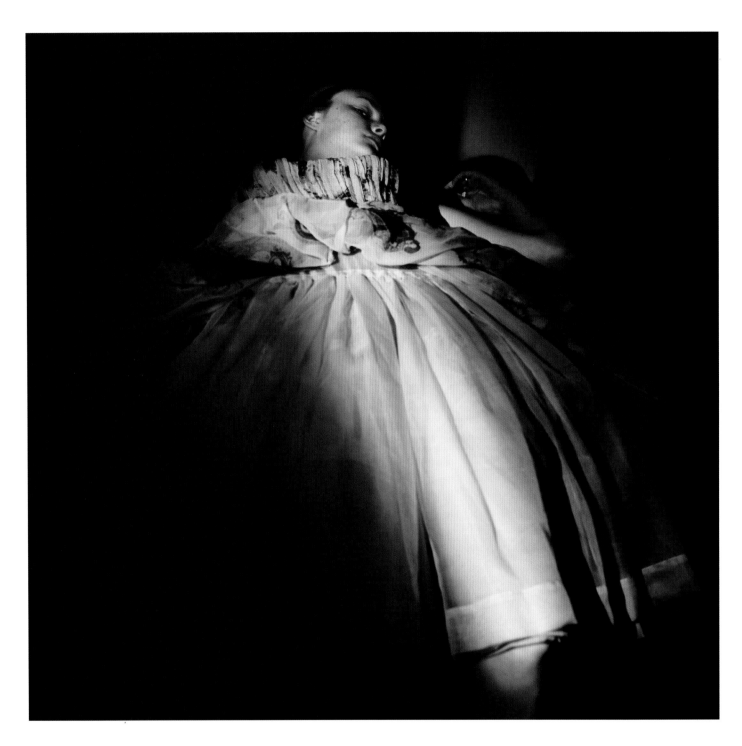

CAMILLE VIVIER VIVIER IS AN ARTIST AND FILMMAKER WHO WORKS IN FASHION. SHE STUDIED PRINTMAKING AND PHOTOMEDIA AT ST MARTIN'S COLLEGE OF ART AND DESIGN IN LONDON, AND IS ONE OF A YOUNGER GENERATION OF FRENCH IMAGE-MAKERS WHO CAME TO PROMINENCE THROUGH EXPOSURE IN STYLE MAGAZINES SUCH AS *PURPLE*. HIGHLY INFLUENCED BY THE AESTHETICS OF CINEMA, HER WORK HAS A TAUT AND PSYCHOLOGICAL EDGE THAT CONTRASTS WITH THE BEAUTY OF THE SUBJECT MATTER. SHE WORKS EQUALLY IN THE FASHION AND THE GALLERY SECTORS.

'My work is very influenced by cinema. Taking a fashion photograph is about creating a mise-en-scène where each detail must serve the image. When everything functions, then one can bring together a likely quirky, nearly magical situation. There are so many films that have influenced me … there are those that have inspired me in the detail, with certain styles and colours. Hitchcock, for example, with all the Freudian references, this overstatement in the detail; and the atmospheres in Lynch, though I am not looking to create worrying climates, quite the opposite.

The use of narrative is important to my work as it is what allows you to see beyond representation, and the idea is certainly to allow for different interpretations and for imagination. I try to create a meeting point between the subject, my intention and collective imagery. I try to show things not as they are, but as seen through a filter, as they can be in a vision. To give a face to things, a spirit, whilst at the same time allowing them to have an opaqueness and an element of enigma. What really interests me is how a mental image can take form in a real one.

I differentiate between my art and my fashion work less and less, because the difference between the two depends more on the context and process of realization than the intention. In the two cases, I want, above all, to take beautiful images. The ideal would be to take one and the same work in an undifferentiated context, but perhaps this is not very realistic.'

OPPOSITE CAMILLE VIVIER, UNTITLED, CAROLINE, 2003 (DETAIL) BELOW CAMILLE VIVIER, UNTITLED, CAROLINE II, 2003

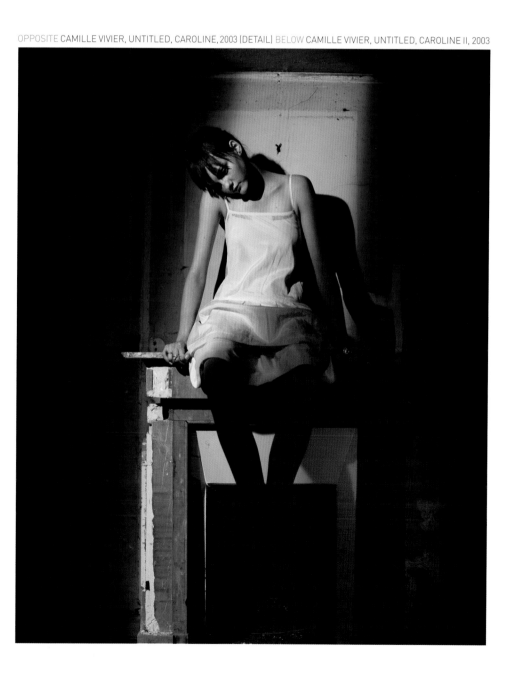

MARIO SORRENTI WITH NO FORMAL TRAINING, ITALIAN SORRENTI BEGAN TO SHOW WORK IN THE EARLY 1990S. HE BECAME AWARE OF FASHION PHOTOGRAPHY THROUGH BEING A MODEL. TAPPING INTO THE FRESHNESS OF FASHION PHOTOGRAPHY OF THE TIME, HIS SPONTANEOUS AND EXPERIMENTAL APPROACH OFTEN HAS AN AUTOBIOGRAPHICAL ELEMENT, WHICH CAN BE MOST OBVIOUSLY SEEN IN HIS DIARIES. THESE DIARIES OFTEN INFLUENCE THE DESIGN AND CONTENT OF MANY OF HIS FASHION SPREADS. FORMING VERY CLOSE RELATIONSHIPS WITH THOSE HE WORKS WITH, SORRENTI PRODUCES IMAGES THAT HAVE AN INTIMACY OFTEN MISSING FROM POLISHED HIGH-END FASHION PHOTOGRAPHS.

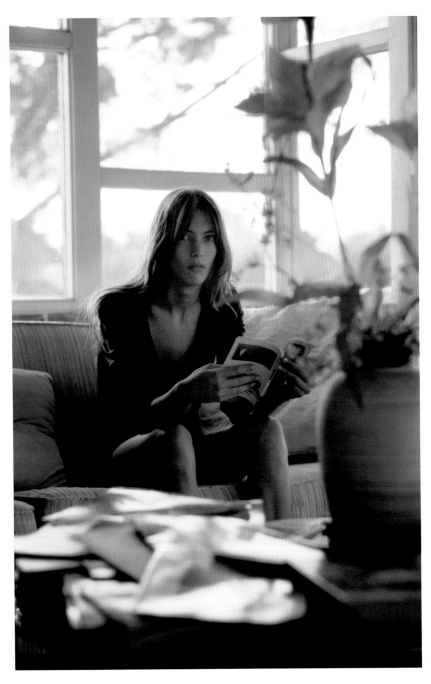

'I didn't have a sense of what a career as a photographer would be like when I started out. Then it was just a passion. I started modelling, travelling around Europe, earning a little bit of money, and that's what introduced me to fashion photography. Before then, I was just taking photographs of my family, friends and things on the street. I was taking photographs for myself for about four years. I couldn't afford to print everything so I cut up my contact sheets and stuck them in my diary. I was also going out with Kate Moss then. We were both very young and it all happened for us at the same time. All of a sudden, the ingredients were right for things to happen. Within six months I was shooting for *Harper's Bazaar* and Calvin Klein. It was a lot for a twenty-year-old to handle. It was like being in a race, working all the time. Luckily, I was totally inexhaustible then. It was probably one of the most exciting moments of my life.'

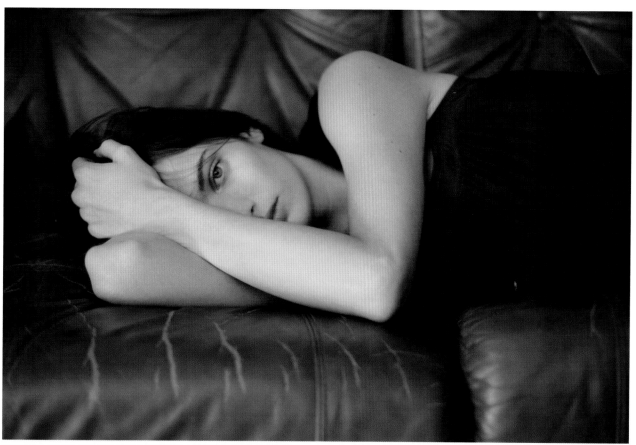

OPPOSITE, ABOVE, BELOW MARIO SORRENTI, LEAVING LAS VEGAS, 2002

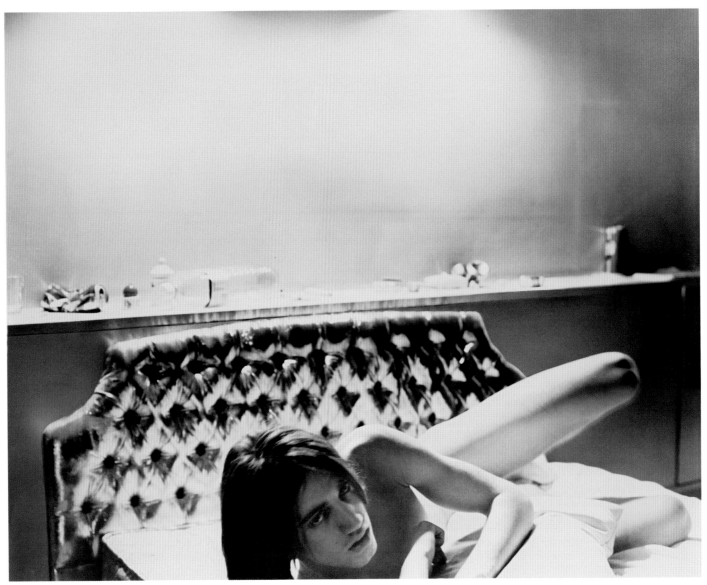

CORINNE DAY, DIARY: GEORGE LYING ON THE BED 1995, 2000

CORINNE DAY DAY BECAME KNOWN OUTSIDE THE FASHION WORLD WITH AN IMAGE SHE TOOK OF KATE MOSS FOR BRITISH *VOGUE* IN 1993. THIS IMAGE WAS A CATALYST FOR MEDIA FASCINATION WITH FASHION IMAGERY AND SHE BECAME CLOSELY ASSOCIATED WITH HOUSEHOLD TERMS SUCH AS 'HEROIN CHIC'. ONE OF THE PHOTOGRAPHERS MOST CLOSELY ALLIED WITH 'GRUNGE', SHE WAS HUGELY INFLUENTIAL TO A GENERATION OF YOUNG PHOTOGRAPHERS WHO OFTEN COMBINE THEIR PERSONAL LIVES AND FASHION. DAY TOOK SEVEN YEARS OUT OF THE FASHION INDUSTRY WHEN SHE WAS PRODUCING *DIARY*, AN INTENSE AND CANDID ACCOUNT OF HER LIFE AND FRIENDSHIPS.

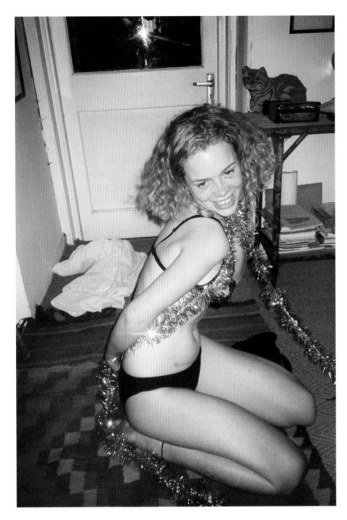

'I just got up one morning and took a snap and forgot about it. And then *Dazed and Confused* magazine asked me if I wanted to put some pictures in their "Art" issue and I remembered that one and I thought it would be really funny seeing it in a fashion magazine. I thought it would be great in that context. I don't really know if I like that picture to be honest, but I do think life should be photographed in every way.

ABOVE LEFT CORINNE DAY, DIARY: TARA WALES 1997, 2000
ABOVE CORINNE DAY, DIARY: YANK AT HOME 1999, 2000
LEFT CORINNE DAY, DIARY: MY BLOODY KNICKERS 1994, 2000

My life has changed. I don't take drugs like I used to – none of us take drugs like we used to. I guess that was just a particular time in our life. I'm still taking pictures for myself. I don't have any idea how a body of work will come from it. I didn't have any idea how *Diary* was going to be or look. It's kind of a hobby really.'

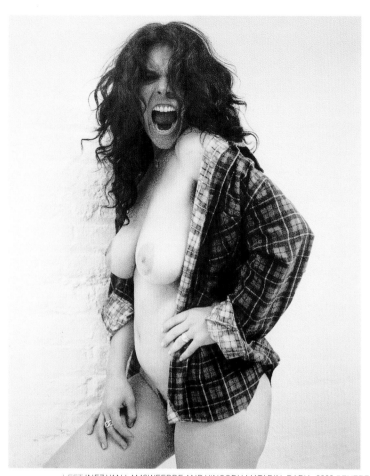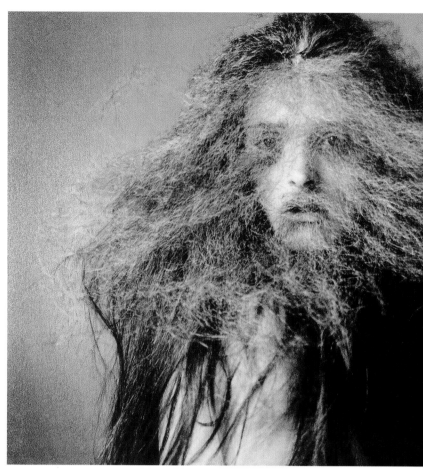

LEFT INEZ VAN LAMSWEERDE AND VINOODH MATADIN, DARIA, 2003 CENTRE INEZ VAN LAMSWEERDE AND VINOODH MATADIN, GOD, 2003

INEZ VAN LAMSWEERDE AND VINOODH MATADIN DUTCH ARTISTS VAN LAMSWEERDE AND MATADIN USED COMPUTERS AND DIGITAL IMAGING AT AN EARLY STAGE IN THEIR CAREER TO PRODUCE A PIONEERING BODY OF WORK ENTITLED *FINAL FANTASY* (1993), WHICH FEATURED FREE-FLOATING HYBRID HUMANS MORPHED TOGETHER FROM IMAGES OF CHILDREN AND ADULTS. THE LACK OF A CONTEXT FOR THE CREATURES AND THEIR UNCANNY AND DISTURBING APPEARANCE TAPPED INTO VERY REAL CULTURAL ANXIETIES ABOUT CLONING AND INTO THE ETHICAL DEBATES IN SCIENCE TAKING PLACE IN THE EARLY 1990S.

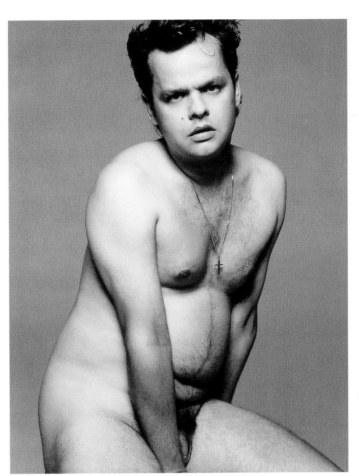

RIGHT INEZ VAN LAMSWEERDE AND VINOODH MATADIN, FRANK, 2003

'The images shown here belong together. They are pictures of God, Adam and Eve. They will be part of a bigger series and, in a way, they are a work in progress. One of the main things we are concerned with is how to avoid clothing as opposed to how to show nakedness. We want to have nudity that isn't too sexually suggestive or too arty, in the conventional parlance. We thought it was important to show people's nudity as a reference to everything that's going on in the world right now. We wanted strength and humour in the series. These images are really a preview of something bigger we will be doing later. We were also thinking a lot about how to incorporate text into photographs, like on posters or record sleeves, or fliers for clubs or bands; how youth culture has a certain language and a certain look about it. We wanted to appeal to people who are, let's say, underground and who could maybe rebel against the system and against all the damage that's being done. We wanted to have, as the first point, quite formidable human beings that are protesting. These are Daria and Frank. They've taken control and are going against something too. The thing we would like to achieve is to combine the political with the spiritual either by using text over, or in, the pictures, and by combining them with sculpture or three-dimensional pieces that will come from the silk-screened photographs. We would like to make spirituality cool again, using the visual language of pop culture to convey a different message of love and wonder.'

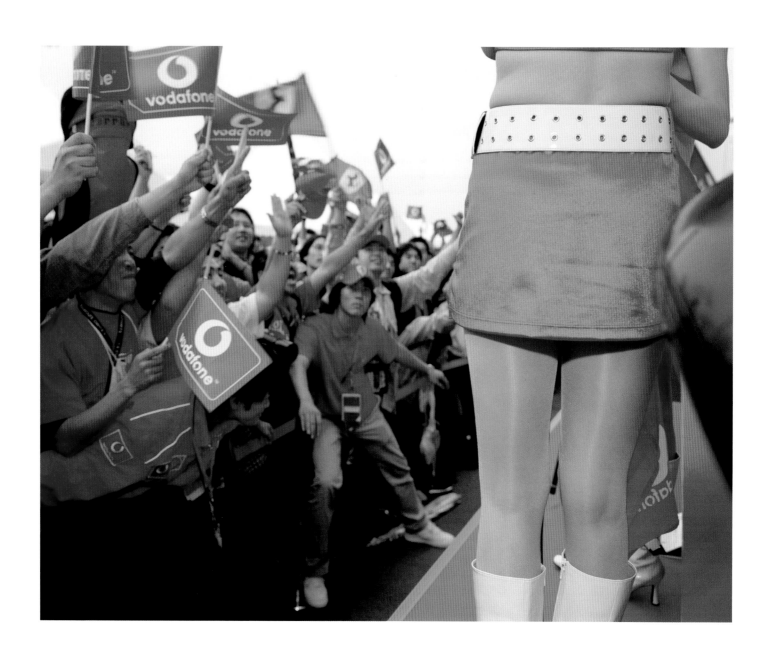

MARTIN PARR, JAPAN FORMULA 1 GRAND PRIX CHAMPIONSHIP, SUZUKA RACE TRACK, 2003

DOCUMENT

The term 'document' is virtually synonymous with the medium of photography itself. Indeed, it could be said that every photograph is in one sense or another a document, since it is always a record *of* something, a document of an occurrence. Traditionally, photography's power has resided in its referentiality and indexicality, making it the perfect vehicle with which to deal with 'real' life. But to think of contemporary art photography in these terms is limiting. The artists in this chapter use a wide range of approaches to think about how the document functions and how people respond to it. Many question its assumed authority, while at the same time undermining the supposed 'truth' inherent in photography.

Others approach documentary photography from more curatorial, archival or anthropological starting-points, sometimes turning to other text and image sources to draw a broader picture. Such an approach grows from a suspicion of the ability of a singular one-off photograph to be able to fully explain the complexities of any given subject and its histories.

There are some in this chapter whose work was first seen as a commissioned 'story' for a magazine, but this is becoming increasingly rare and the majority of artists here produce work primarily for the gallery or for books. There are also those who use the photograph to document performances or who turn to found photography to create elusive fictional stories. And of course there are those who use digital manipulation, which is perhaps at odds with our understanding of the nature of the document.

The actual term 'documentary' was originally used by the English philosopher Jeremy Bentham in the early nineteenth century, but as far as a visual understanding of the word is concerned it was almost certainly first used by John Grierson in 1926 in a review of Robert Flaherty's films. The term was employed to distinguish between Hollywood fiction films, which were seen as artificial and superficial, and those which aimed to be realistic, and most importantly, truthful. In this respect documentary could be seen as a kind of proof or witness. It was understood that a document could be authenticated and that it lays claim to truth.

When this term was first used with reference to photography, it reflected humanistic or social reformist connotations as can be seen in the work of Jacob Riis in the nineteenth century, in his project *How the Other Half Lives* (1890), or in the pioneering work of Lewis Hine, whose contributions to the National Child Labour Committee and *Survey* magazine did much to heighten awareness of children's abominable working conditions. These examples, along with work by those now most traditionally associated with the genre such as Walker Evans and Dorothea Lange who worked in the 1930s and 1940s, have shaped how we understand its past and what it is that artists now, to a certain extent, try to question and critique as they avoid recurring visual tropes and clichés and undermine the belief in a photograph's ability to deliver objective truth. Like all genres, it is easier to think of it in the plural rather than as one overarching term. The different approaches to documenting and the documents used by contemporary artists often look nothing like the black-and-white images mentioned, and a range of new documentary strategies not only take their reference from photography's history but also from art history and in particular the role of performance.

Contemporary documentary has not lost its power to convey information as it did in the past; it has just moved on. Images are now more open to interpretation from the viewer, using ambiguity as their strength rather than an authorial voice dictating meaning. The gallery and the book allow contemporary artists to deal with the term in more fluid ways and as a genre it has come to mean something much more amorphous and wide reaching. The slippage between the photographic document and the art photograph is expanding and the gallery (as well as the book) remains one of the few environments where the approach is not threatened, as magazines become increasingly fascinated with celebrity and space for 'stories' decreases. This means that that they have become less central to the distribution of documentary work and galleries more prominent. Indeed there has been a noticeable increase in documentary practices and exhibitions in the last five years. This is not only due to the changing landscape of the illustrated magazine but is also a reaction to the more elaborately staged colour tableaux that have come to take over the contemporary art scene during the last ten years. This return to documentary practices can also be seen in a rise in younger artists returning to black and white, a welcome respite from the large-scale colour images which have dominated, and continue to dominate, the gallery.

The document within art has enjoyed many manifestations and uses, perhaps most radically to create works that privilege art-as-activity over art-as-product. This can be seen most prominently in the work of performance and land artists of the late 1960s and 1970s. As a document that offered 'proof' or 'evidence' of performances or events, the photograph became crucial to the art of the time. With such work the photograph became secondary to the performance: a remnant or trace of what had gone before. The irony in this apparent disregard for photography, seen as a mechanical recorder of art, is that in time it is all that remains and so in turn *it* becomes the art object rather than the intervention, as originally intended.

The use of the photograph as a record did much to raise its profile within the contemporary art scene of the 1970s and it was around this time that phrases such as 'art photography' and 'artists using photography' began to be employed to categorize art that favoured photography as documentary evidence over artistic expression. As mentioned in the introduction, these differentiations are helpful when looking back but the lines are now too blurred for such tight categorizations to remain useful.

One of the most vital and engaging of the genres, documentary photography is currently enjoying a high profile, which is also mirrored in the huge influx of documentary films being shown at the cinema over the last few years. It is a much-needed return to 'true' stories, spurred on by the scale of events in the 'real' world.

LARRY SULTAN *THE VALLEY* ADDRESSES THE USE OF ORDINARY MIDDLE-CLASS SUBURBAN HOMES HIRED OUT AS SETS FOR PORNOGRAPHIC FILMS IN THE SAN FERNANDO VALLEY, LOS ANGELES, WHERE SULTAN GREW UP AND CONTINUES TO LIVE AND WORK. IT LOOKS AT THE BLURRED LINES BETWEEN REALITY AND FANTASY AND AT PHOTOGRAPHY'S ROLE BOTH AS CRITICAL TOOL AND PEDLAR OF FICTION AND ARTIFICE. FIRST PUBLISHED IN 2003, IT ENGAGES WITH MANY OF THE THEMES FOUND IN PICTURES FROM *HOME* (1992). THIS EARLIER SERIES IS AN INTENSE AND TOUCHING PORTRAYAL OF HIS PARENTS' RELATIONSHIP, ASPIRATIONS, AND REALITIES. USING A WIDE RANGE OF PHOTOGRAPHIC MATERIAL, IT SHOWED HOW POST-WAR AMERICA FAILED TO DELIVER THE PROMISES OF A MYTHICAL 'AMERICAN DREAM'.

'The cast and crew of a porn film have gathered in the front yard of a ranch house, a few blocks from where I went to high school in the San Fernando Valley. Women in six-inch heels sink into the lawn; men push around lights and cameras, anxious about losing the light. They are preparing to film a scene in which four blonde housewives in a convertible are pursued and overtaken by two men in an appliance-repair van. The neighbours have all come out to water their lawns and witness the scene, and in the late evening light it feels as if Fellini has come to make an updated version of *Amarcord*.

 The house was rented for the two or three days that it takes to make a porn film. It is common for adult-film companies to shoot on location in tract houses in the heart of the valley – the homes of dentists and attorneys and day traders whose photographs and mementoes can be seen in the backgrounds of these films, and whose decorating tastes give the films their particular "look". It's as if one family went on vacation leaving everything in the house intact, and another family, an odd assembly of very horny adults, has temporarily taken up residence.

LARRY SULTAN, THE VALLEY: SUBURBAN STREET IN STUDIO, 2000

Throughout the day the event of filming creates a sexualized zone in which the gestures, rituals and scenes of suburban domestic life take on a peculiar weight and density. The roll of paper towels on the living-room table, the bed linens in a pile by the door, the shoes under the bed all lose their mundane character and are transformed into props or a residue of unseen but very imaginable actions. Even the piece of half-eaten pie on the kitchen counter seems suspicious. While the film crew and "talent" are hard at work in the living room I wander through the rest of the house peering into the lives of the people who suddenly left home. I feel like a forensic photographer searching out evidence in a crime scene. But what is the crime?

BELOW LEFT LARRY SULTAN, THE VALLEY: TOPANGA SKYLINE DRIVE #1, 1999 BELOW RIGHT LARRY SULTAN, THE VALLEY: TASHA'S THIRD FILM, 1998

Lazy afternoons are interrupted not by noisy children but by the uncontrollable desires of delivery boys, baby-sitters, coeds and cops. They crowd in the master bedrooms and spill out onto the kitchen floors and onto the patios and into the pools that look just like our neighbours' pools, like our pool. And by photographing this I'm planted squarely in the terrain of my own ambivalence – that rich and fertile field that stretches out between fascination and repulsion, desire and loss. I'm home again.'

ERWIN WURM SINCE THE 1980S, AUSTRIAN ARTIST WURM HAS QUESTIONED THE STATUS OF ART WORKS AND POKED FUN AT THE SNOBBISH VALUES PUT ON CERTAIN MEDIA SUCH AS SCULPTURE. MIXING PERFORMANCE, SCULPTURE, PHOTOGRAPHY AND DOCUMENT, THIS SERIES CONTINUES HIS DESIRE TO TURN EVERYDAY ACTIVITIES INTO ART AND TO PROBE BOTH WHAT IS CONSIDERED ART AND THE ROLE OF THE PHOTOGRAPH. TAPPING INTO INTERNATIONAL FEARS AND PARANOIAS AND PRESCRIBED CODES OF BEHAVIOUR, THE SERIES *HOW TO BE POLITICALLY INCORRECT* DEBUNKS SANCTIMONIOUS ATTITUDES USING HUMOUR TO TACKLE SERIOUS UNDERLYING ISSUES.

'When I have an exhibition I ask the curator or organizer to put an advert in the paper calling for volunteers. Very often lots of people respond and I meet with them and chose with whom to work. The models also come up with ideas, so it can be a very collaborative process. Then we create situations – either psychological or political – for the volunteers to realize. They find themselves in odd situations in public places acting in strange, sometimes politically incorrect ways, knowing that they are doing something wrong, but also knowing that it's only an art work so the meaning turns around and makes a critical and funny comment on this concept of "political correctness".'

LEFT ERWIN WURM, INSTRUCTIONS ON HOW TO BE POLITICALLY INCORRECT: SPIT IN SOMEONE'S SOUP, 2003
BELOW ERWIN WURM, INSTRUCTIONS ON HOW TO BE POLITICALLY INCORRECT: INSPECTION, 2003

ERWIN WURM, INSTRUCTIONS ON HOW TO BE POLITICALLY INCORRECT: LOOKING FOR A BOMB 1, 2003

What interests me is that at first glance the images look funny and ridiculous, and for me humour is a way to seduce people and get them to come closer to really look. When they read the title, they come to a different aspect of the work. I lead them into thinking about something deeper. The title and image work in a circular fashion, bringing you back to one another.

These works are both documents of performances and questions about sculptural issues. I am interested in when something is a sculpture and when it becomes an action. When I started to work I realized that my art pieces lasted only as long as an exhibition. Then they became shorter and shorter and so I started to document them. At first the photographs were purely documents of actions. After a time, when I started with the outdoor sculptures, photography became more and more important.'

SUSAN MEISELAS THE CURATORIAL STRATEGY THAT AMERICAN ARTIST MEISELAS ADOPTED FOR *ENCOUNTERS WITH THE DANI* WAS FIRST SEEN IN 1991 IN HER HUGELY AMBITIOUS PROJECT *KURDISTAN: IN THE SHADOW OF HISTORY*. HERE MEISELAS GATHERED A RANGE OF DIFFERENT DOCUMENTS, FROM FAMILY PHOTOGRAPHS TO GOVERNMENT PAPERS, AND BROUGHT THEM TOGETHER IN A SYMBOLIC REGROUPING OF THE DIASPORAC KURDISH COMMUNITY. LOOKING AT THE IMAGING AND TREATMENT OF HISTORY, MEISELAS PRESENTED THE PROJECT AS A BOOK AND EXHIBITION. THERE IS ALSO A CONTINUING INTERACTIVE WEB-BASED ELEMENT, A SITE FOR 'COLLECTIVE MEMORY AND CULTURAL EXCHANGE', WHICH FORMS AN EVER-GROWING ARCHIVE OF NATIONAL IDENTITY.

'*Encounters with the Dani* draws on a concept I developed earlier when producing the book *Kurdistan: In the Shadow of History*. The approach is similar in that both projects began with my making my own photographs and then expanded into a curatorial process. My emphasis shifted from looking at the photograph as an aesthetic object to seeing it as an artefact, with its own history. This led me to find a visual language that could contextualize the present within the past.

SUSAN MEISELAS, ENCOUNTERS WITH THE DANI: ROBERT GARDNER GREETED BY HIS OLD FRIEND, ALORO, 1988, 2003

This strategy evolved when I sensed that I couldn't work with a single image, even with a series of images, as I had done before. The complexities were not going to be seen through my images alone. I'm deeply interested in the photograph as a record of an encounter and enjoy putting myself in a timeline of image-makers, alongside other travellers, such as anthropologists, colonists, missionaries, and even tourists. I do that to emphasize subjectivity, rather than privilege any single perspective – I see myself as only one of many storytellers.'

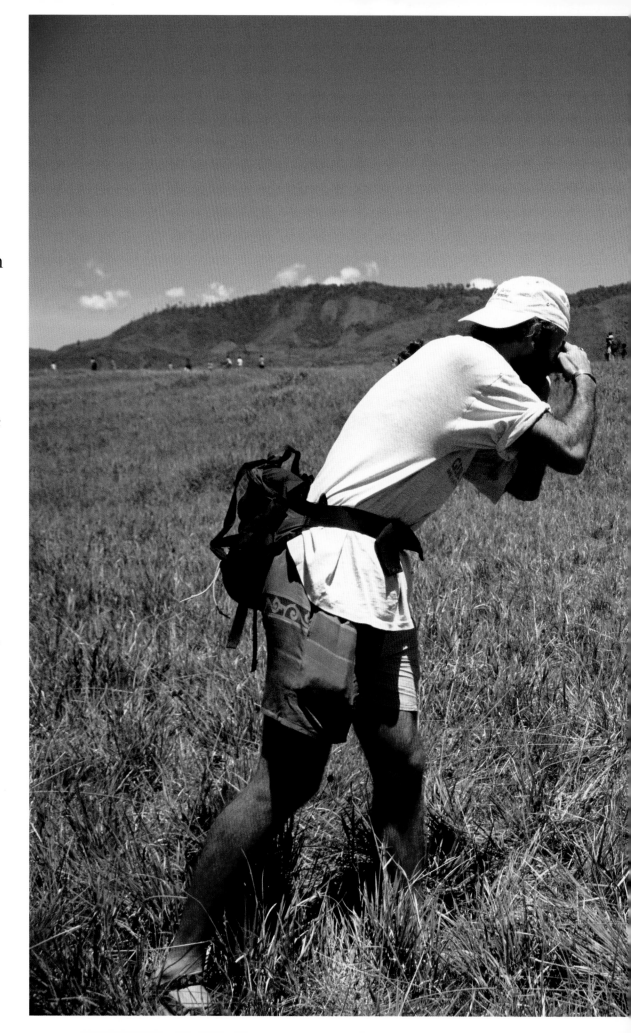

SUSAN MEISELAS, ENCOUNTERS
WITH THE DANI: CULTURAL FESTIVAL
AND WAR REENACTMENT IN PYRAMID,
1996, 2003

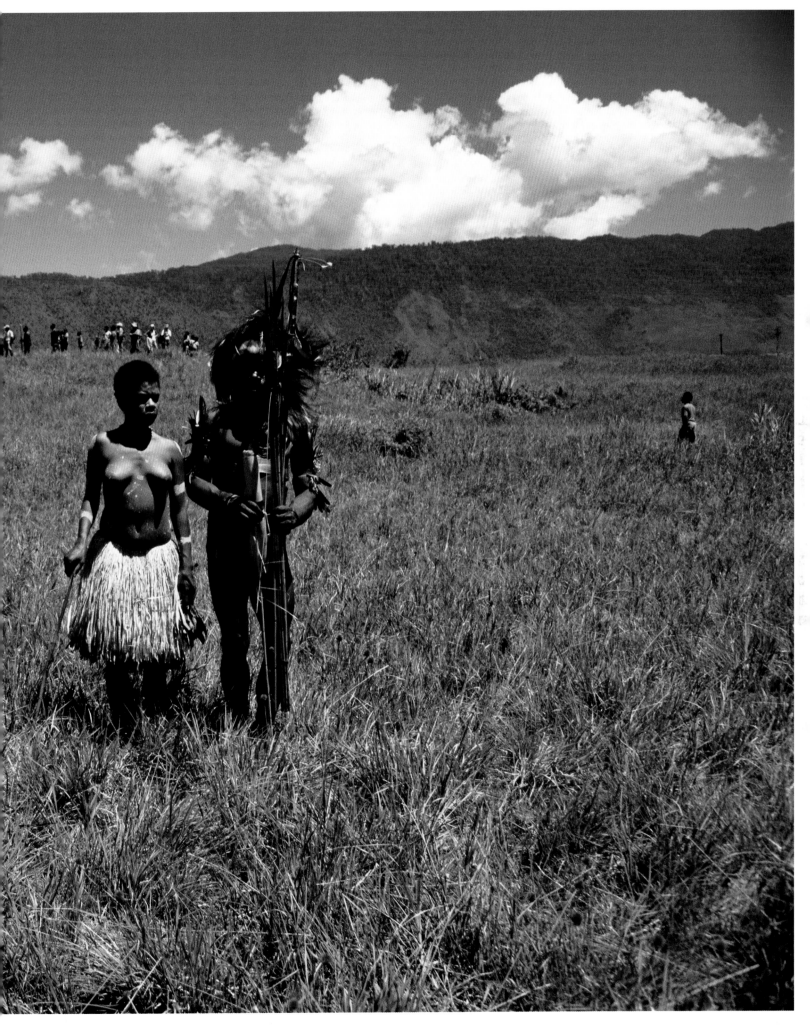

MARTIN PARR PROBABLY BRITAIN'S BEST-KNOWN AND MOST INFLUENTIAL PHOTOGRAPHER, PARR TURNS SOCIAL DOCUMENTARY INTO SOMETHING HUMOROUS AND PROVOCATIVE. HIS DISTINCTIVE STYLE, USE OF COLOUR AND LOVE OF THE IDIOSYNCRATIC TRADITIONS OF THE EVERYDAY IS BEST EXPRESSED IN THE FORM OF BOOKS, OF WHICH HE IS ALSO A PROLIFIC COLLECTOR AND EDITOR. A SELF-STYLED 'PROMISCUOUS PHOTOGRAPHER', HE WORKS ACROSS ADVERTISING, MERCHANDISE, EDITORIAL AND ART, BETWEEN WHICH HE DOES NOT DISTINGUISH WITH HIERARCHIES OF STATUS AND VALUE. IN 1994 HE WAS INVITED TO JOIN THE PRESTIGIOUS PHOTO AGENCY MAGNUM, TO MUCH CONTROVERSY.

'This piece was commissioned for *Intermission* magazine and financed by Jaguar Racing. I was given access to the garage and the pits, but the first thing I was interested in was the crowd, which is usually ignored by other photographers. I was fascinated by the obsessive Japanese fans. It was the hybrid of Japanese culture and racing culture that I found so enthralling.

MARTIN PARR, JAPAN FORMULA 1 GRAND PRIX CHAMPIONSHIP, SUZUKA RACE TRACK, 2003

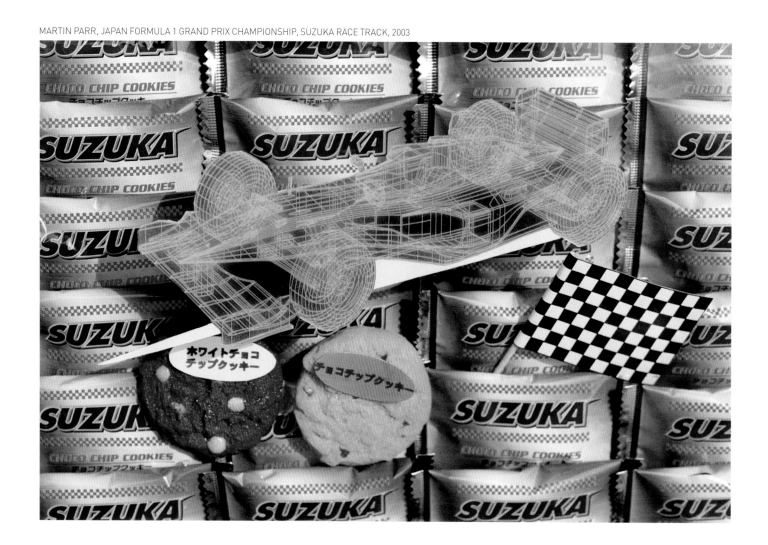

LEFT MARTIN PARR, JAPAN FORMULA 1 GRAND PRIX CHAMPIONSHIP, SUZUKA RACE TRACK, 2003
RIGHT MARTIN PARR, JAPAN FORMULA 1 GRAND PRIX CHAMPIONSHIP, SUZUKA RACE TRACK, 2003

I first went to Japan about ten years ago. I am fascinated by Japanese photographic culture. I am inspired by the brashness of it because it is not totally institutionalized. They understand how to make photography books, a big obsession for me, so it was obviously a place I would connect to.

I try to make pictures that work on many different levels. Part of my strategy now is to tap into the constantly increasing circles of dissemination and to try to encapsulate and embrace all of these. It is part of my agenda to take photos that can fit into all the outlets for photography, from the gallery wall to the magazine or newspaper page. That, to me, is using photography at its best.'

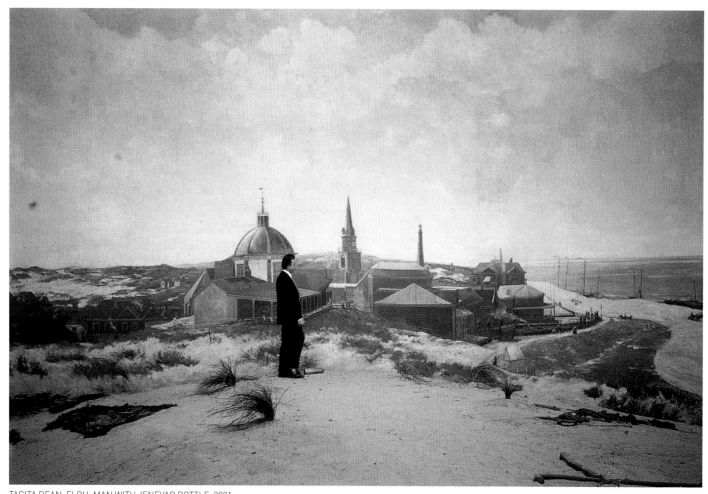

TACITA DEAN, FLOH: MAN WITH JENEVAR BOTTLE, 2001

TACITA DEAN BRITISH ARTIST DEAN TRAINED AS A PAINTER AND NOW WORKS IN A VARIETY OF MEDIA. SHE IS PROBABLY BEST KNOWN FOR HER 16-MM FILMS BUT SHE ALSO WORKS WITH SOUND, VIDEO, PHOTOGRAPHY, DRAWINGS AND OBJECTS. CONSTANT THEMES IN HER WORK ARE THE RELATIONSHIPS BETWEEN PAST AND PRESENT, FACT AND FICTION AND THE EVER-BLURRING LINES BETWEEN THEM. THESE CAN BE SEEN IN *FLOH*, WHICH TAKES PHOTOGRAPHS OUT OF THEIR ORIGINAL CONTEXT AND PLACES THEM TOGETHER IN BOOK FORM. BY BEING PRESENTED IN A NEW CONTEXT, THE IMAGES BECOME INTERCONNECTED AND WOVEN TOGETHER THOUGH AN ALLUSIVE NARRATIVE. DEAN TELLS A NEW FICTIONAL STORY THROUGH IMAGES THAT ONCE RECORDED NOW FORGOTTEN 'FACTS'.

'I do not want to give these images explanations – descriptions by the finder about how and where they were found, or guesses as to what stories they might or might not tell. I want them to keep the silence of the fleamarket; the silence they had when I found them; the silence of the lost object. Suffice it to say, that all the images were found over the last six or so years in fleamarkets in Europe and America. Only at a certain point did I realize I was making a collection, and nothing is more worrying to the collector than the prospect of closure; the realization that there will be a final version and a potential end to the collection. I have stopped going to fleamarkets for fear of finding an image that should have been in the book, or have distractedly turned my attention to collecting postcards: postcards that show frozen fountains or four-leaf clovers, or have seagulls in them, or have been scribbled on by someone. But now I have resolved to believe that there is not, and can never be, a final version to this collection; that *Floh* exists in the continuum and will one day, I hope, return, ownerless and silent, to its origins in the fleamarket.'

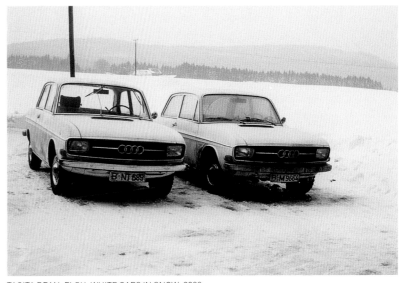

TACITA DEAN, FLOH: WHITE CARS IN SNOW, 2000

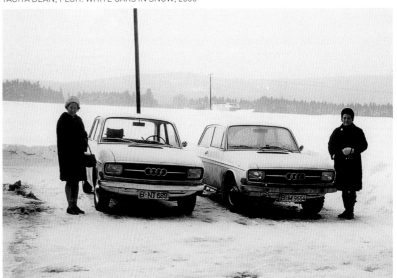

TACITA DEAN FLOH: WHITE CARS IN SNOW, 2001

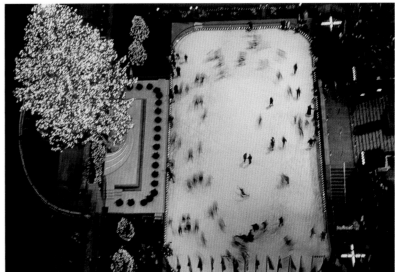

TACITA DEAN FLOH: ICE RINK, 2001

NAN GOLDIN AMERICAN ARTIST GOLDIN'S INTIMATE PORTRAYALS OF THOSE CLOSE TO HER HAVE BEEN HUGELY INFLUENTIAL ON A GENERATION OF ARTISTS WHO USE A SIMILAR DIARIST APPROACH IN THEIR WORK. THE SNAPSHOT STYLE IS REMINISCENT OF PHOTOGRAPHS TRADITIONALLY FOUND IN THE FAMILY ALBUM, BUT INSTEAD OF CONCENTRATING ON FORMULAIC CELEBRATIONS SUCH AS WEDDINGS AND HOLIDAYS, GOLDIN'S SHOW A MORE HONEST STORY OF WHAT A CONTEMPORARY FAMILY CAN BE. NARRATIVES OF ABUSE, ADDICTION AND ARGUMENT INTERTWINE WITH THE HAPPIER MOMENTS OF HER EXTENDED 'FAMILY'. GOLDIN FIRST SHOWED HER WORK IN CLUBS TO THOSE FEATURED IN THE PHOTOGRAPHS AND SET IT TO SPECIALLY SELECTED MUSIC. SHE STILL DOCUMENTS THOSE AROUND HER AND HER OWN LIFE BUT HAS ALSO RECENTLY EXTENDED HER OEUVRE TO INCLUDE LANDSCAPE AND RELIGIOUS ICONOGRAPHY.

'Clemens is one of my closest friends. I met him in Berlin in 1996 when he was a waiter in a restaurant. I slipped him a note – which was the only time I have ever done that – as he was absolutely one of the most beautiful people I had ever seen. He responded and we met and made a date. He came over that night but I was asleep so the following night we had a date. He had gone out and bought a suit and that night we had sex. I wanted to continue the relationship but I found out he was gay. Usually I can tell, but I guess I was so obsessed with him, I hadn't even thought it was an option. He made excuses not to see me and then one night he told me he was living with a Turkish boy.

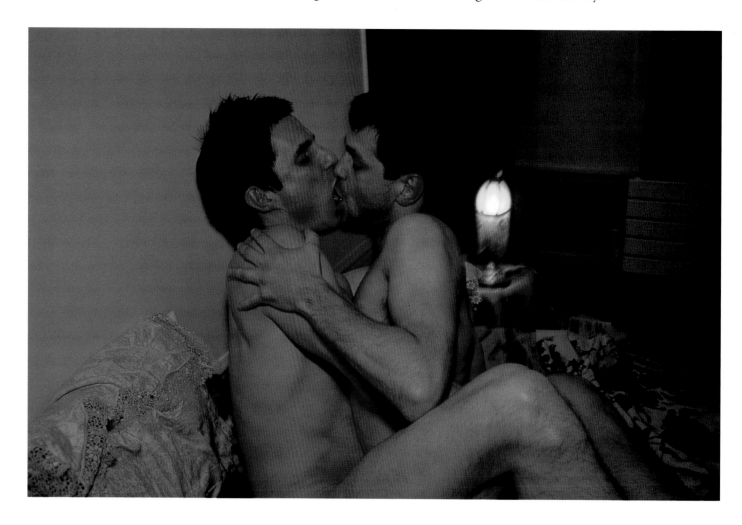

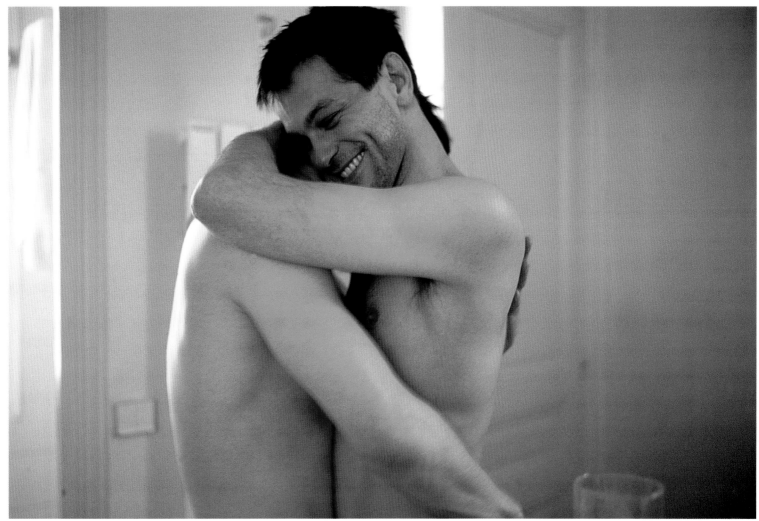

OPPOSITE NAN GOLDIN, SWEAT: JENS AND CLEMENS KISSING, PARIS, 2001, 2001 ABOVE NAN GOLDIN, SWEAT: CLEMENS AND JENS EMBRACED IN MY HALL, PARIS, 2001, 2001

We are still really, really close friends. I am the only woman he has ever had sex with, which explains a lot about the closeness of our relationship. I ran into him in the summer of 1999 when we were in the south of France. He was on holiday with his new boyfriend Jens and so the three of us started hanging out. I was the witness to their wedding and then in 2001 they came to Paris.

These pictures are taken in my apartment…. For twenty-five years, people have thought that I must be faking it and that I must set up my pictures, but none of that happens. They wanted to have sex, and they wanted me to photograph them. In a way it was me being a part of it. It was a threesome. I found it extremely erotic. I don't consider it voyeuristic but maybe scopophilic, as there was definitely sexual pleasure in looking. I am not a voyeur, as voyeurs photograph through closed windows and with me the window is always wide open. I am in the space and the person knows I am there. I never take a picture if the person doesn't know that I am photographing them. Photographing became my tool for expressing my excitement.

I titled the work *Sweat*, which I feel doesn't take away from the intimacy or the tenderness of it. It's just about the body and how visceral an experience of looking at two people having sex can be. I always want to make pictures where people can smell the sweat of another human being. They can feel what the other people are feeling – that's what I do in my pictures.

I am particularly proud of these pictures, and when I work I never think about other artists or filmmakers but I am deeply influenced by Caravaggio. I never set things up to look like something but during the editing I notice the connection between my influences and the pictures. It is in the editing and through the choices I make that my voice is really heard.'

BRUNO SERRALONGUE THE GATHERING OF CROWDS, BE THAT IN PROTEST OR CELEBRATION, IS A CONSTANT THEME IN FRENCH ARTIST SERRALONGUE'S WORK. AVOIDING THE DRAMATIC CLICHÉS OF PRESS PHOTOGRAPHY, WHICH TEND TO FOCUS ON THE SELF-SUFFICIENT, ONE-OFF IMAGE TO ENCAPSULATE THE WHOLE EVENT, THE SOMEWHAT BANAL AND SNAPSHOT APPROACH SEEN HERE AVOIDS THE SENSATIONALISM TRADITIONALLY ASSOCIATED WITH HIGH-PROFILE EVENTS. HERE IT IS THE REPETITION AND THE BANALITY OF THE IMAGES THAT MOST DRAMATICALLY HIGHLIGHT THE RELATIONSHIP BETWEEN THE PERSISTENT PROTESTORS AND THE UNYIELDING AUTHORITIES IN A SITUATION THAT SEEMS TO HAVE REACHED STALEMATE.

BRUNO SERRALONGUE, MANIFESTATIONS DU COLLECTIF DE SANS PAPIERS DE LA MAISONS DES ENSEMBLES: PLACE DU CHÂTELET, PARIS, SAMEDI 08 SEPTEMBRE 2001, 2001–3

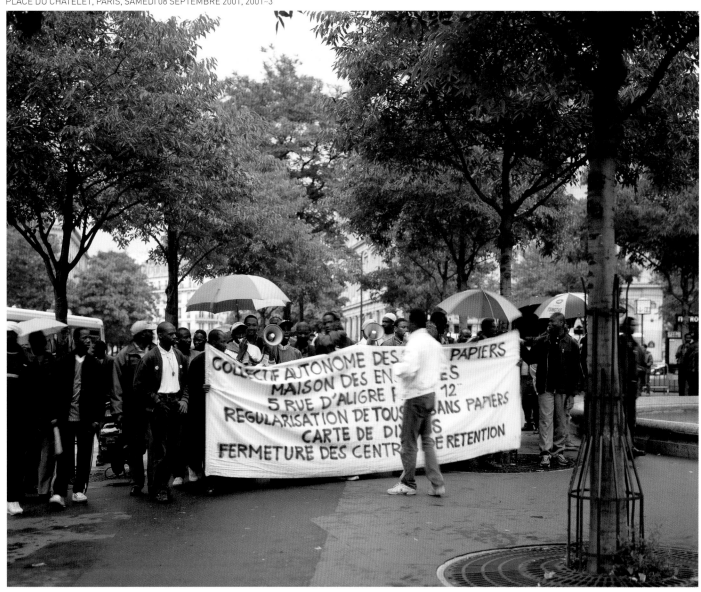

'Demonstrations by the Maison des Ensembles group of immigrants who are denied proper legal recognition began in 1999. Since then, every Thursday and Saturday from 17.00 to 19.00, they march around the fountain on the Place du Châtelet, with a banner calling for regularization of all immigrants in their position. I heard about this demonstration only recently. The first photo is dated 8 September 2001. It was the starting-point for a series that I planned to continue over a year, taking one photograph at each demo. Paradoxically, the best thing would have been for this series to be cut short, since the end of the demonstrations could be taken to signify definitive regularization. It didn't happen and I gave an end to the series. As on 11 January 2003, the series comprised 45 photographs.'

BRUNO SERRALONGUE, MANIFESTATIONS DU COLLECTIF DE SANS PAPIERS DE LA MAISONS DES ENSEMBLES:
PLACE DU CHÂTELET, PARIS, SAMEDI 02 FÉVRIER 2002, 2001–3

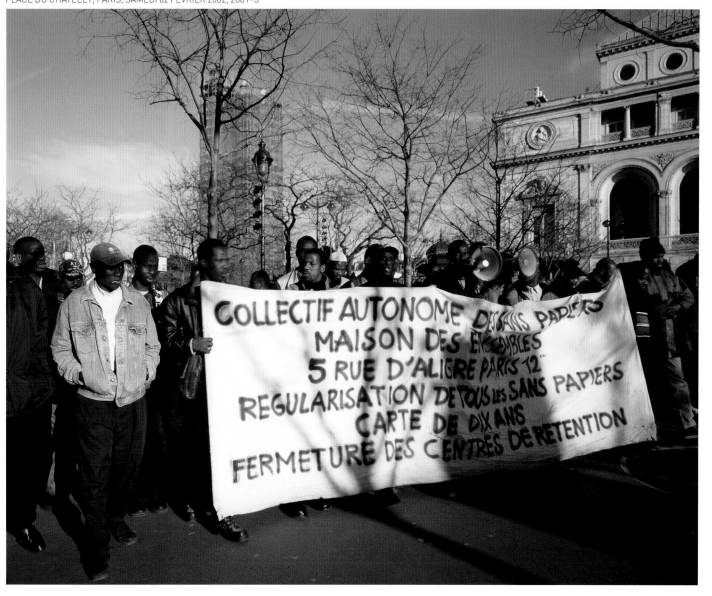

ALEXANDER APOSTÓL APOSTÓL IS ONE OF A YOUNGER GENERATION OF LATIN AMERICAN ARTISTS EXAMINING CULTURAL CLICHÉS AND ISSUES OF NATIONAL IDENTITY. THE PHALLIC FOUNTAINS HERE REFER TO THE BOOM IN THE VENEZUELAN ECONOMY DUE TO OIL IN THE 1950S, WHICH BROUGHT ABOUT HUGE CHANGES TO THE COUNTRY. THEY ALSO ACT AS METAPHORS FOR STEREOTYPICAL LATIN AMERICAN MACHISMO CULTURE, A THEME THAT IS ALSO TAKEN UP IN APOSTÓL'S OTHER SERIES *PASATIEMPOS* (1998) AND *RESIDENTE PULIDO* (2002).

'Just after the end of the dictatorial government led by Juan Vicente Gomez in 1935, Venezuela went through a very interesting period socially, economically, culturally and politically. This break with past history and the shifting mentality in Venezuela, specifically in Caracas, is the inspiration for my work. In *Fontainebleau*, the fountains, originally ornamental waters, are converted digitally into large monolithic sculptures that become more important than the surrounding buildings. I am asking about the fragility of architectural developments and the human wishes, dreams and impulses that drove them to be built. I think of the fountain as an ironic metaphor. Where the water grows, it's like a monolith, a power tower, but just as quickly as it rises, it also falls. The fragility of power.

The pictures are taken from a propagandist government book from the 1950s. It was aimed at new investors for the country and showed the fountains just after they had been constructed. The original pictures are implanted in the collective memory of the Venezuelan people.'

OPPOSITE LEFT, ALEXANDER APOSTÓL, FONTAINEBLEAU: LOS PROCERES, 2003 OPPOSITE RIGHT ALEXANDER APOSTÓL, FONTAINEBLEAU: PLAZA VENEZUELA, 2003 ABOVE ALEXANDER APOSTÓL, FONTAINEBLEAU: LAS TONINAS II (AFTER ALFREDO BOULTON), 2003

LUC DELAHAYE REVERBERATING WITH THE TRADITIONS OF HISTORY PAINTING, DELAHAYE'S LARGE-SCALE PANORAMAS GIVE US A CONTEMPLATIVE AND LONG-DISTANCE VIEW OF EVENTS AND SITUATIONS LINKED TO INTERNATIONAL NEWS. IT IS A TOTAL REPRESENTATION, RICH IN DETAIL AND RICH IN ALLUSION, WHICH BRINGS DENSITY AND GRAVITAS TO THE SCENES THAT ARE PICTURED. THE EXPERIENCE OF STANDING BEFORE HIS WORK NEITHER OPPRESSES THE VIEWER NOR REDUCES THE IMAGE TO A SPECTACLE OF PHOTOGRAPHIC VIRTUOSITY. RATHER A FREER AND MORE EXPANSIVE SPACE OF ENGAGEMENT IS GENERATED, A SPACE THROUGH WHICH THE IMAGE SLOWLY ARTICULATES ITS INFORMATION.

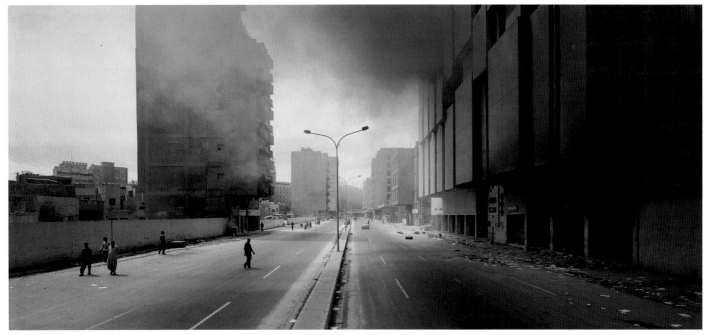

ABOVE LUC DELAHAYE, BAGHDAD IV, 2003 BELOW LUC DELAHAYE, MUSENYI, 2004

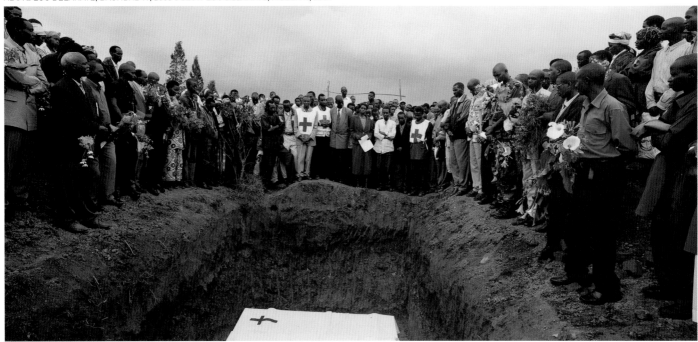

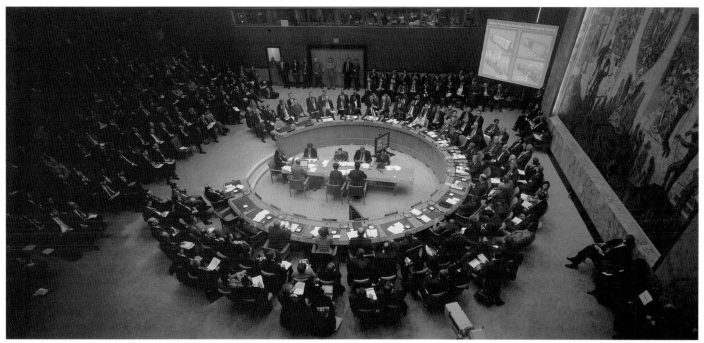

ABOVE LUC DELAHAYE, SECURITY COUNCIL, 2003 BELOW LUC DELAHAYE, TALIBAN, 2001

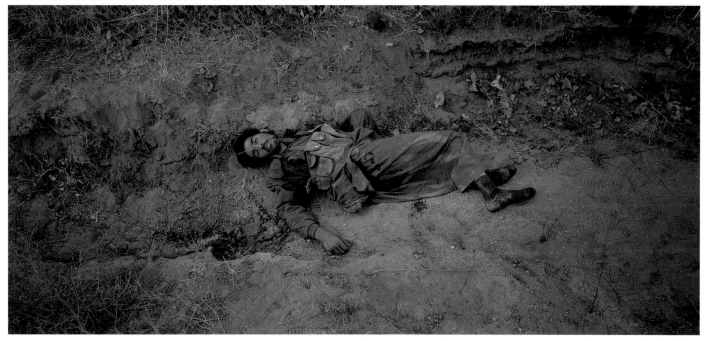

'What you want is to be a poet. You articulate sounds that are still formless, you invent what looks like a possible route. And yet the fundamentals are already there: you just translate an attitude and rationalize an intuition, using first of all what is specific to photography. There is the refusal of style and the refusal of sentimentalism, there is the desire for clarity, and there is the measuring of the distance that separates me from what I see. There is also the will to be like a servant of the image, of its rigorous demands: to take the camera where it needs to be and to make an image that is subservient neither to the real nor to an intention – for the intention of the moment will always fall short of what you're really looking for. You have to record as many details as possible and achieve an order, without taking away the complexity of the real. To voice the real and at the same time to create an image that is a world in itself, with its own coherence, its autonomy and sovereignty; an image that thinks.'

SOPHIE CALLE OVER THE LAST TWO DECADES FRENCH ARTIST CALLE HAS INVESTIGATED THE ROLE OF THE PHOTOGRAPHIC DOCUMENT AND HOW IT FUNCTIONS AS SOMETHING PERSONAL AND ALSO ARTISTIC. THE CROSSOVER BETWEEN WHAT IS PUBLIC AND WHAT IS PRIVATE AND THE BLURRING OF THE BOUNDARIES BETWEEN THEM ARE CONSTANT THEMES IN HER WORK AND HER APPROACH IS OFTEN AUTOBIOGRAPHICAL. *EXQUISITE PAIN* (2004) GATHERS TOGETHER IMAGES OF EPHEMERA COLLECTED FROM A JOURNEY SHE TOOK IN THE 1980S, WHICH SHE LATER RUBBERSTAMPED WITH A DAILY COUNTDOWN TO THE FATEFUL DAY SHE WAS REJECTED BY HER THEN LOVER. SMALL DIARY ENTRIES OR THOUGHTS ACCOMPANY SOME OF THE IMAGES. FROM THE LONG DELAY IN PUBLISHING THE WORK, WE CAN ASSUME THAT HER HEART HAS NOW MENDED.

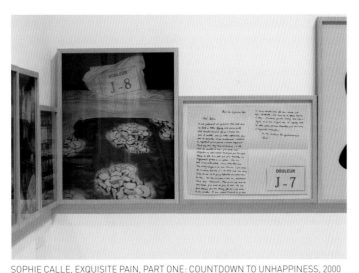
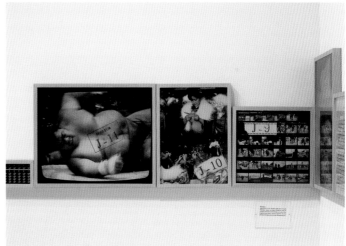

SOPHIE CALLE, EXQUISITE PAIN, PART ONE: COUNTDOWN TO UNHAPPINESS, 2000

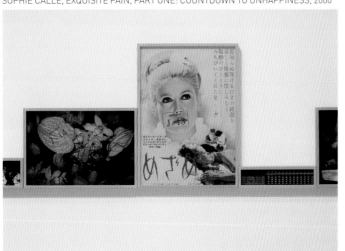
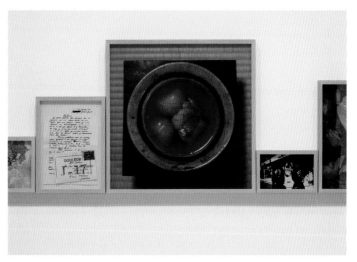

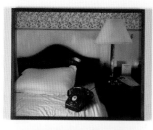

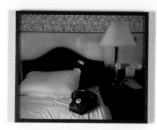

SOPHIE CALLE, EXQUISITE PAIN, PART TWO: COUNTUP TO HAPPINESS, 2000

'In 1984 the French Ministry of Foreign Affairs awarded me a grant for a three-month scholarship to Japan. I left on October 25, not suspecting that this date would mark the beginning of a 92-day countdown to the end of a love affair. Nothing extraordinary – but to me, at the time, the unhappiest moment of my life, and one for which I blamed the trip itself.

I got back to France on January 28, 1985. From that moment, whenever people asked me about the trip, I chose to skip the Far East bit and tell about my suffering instead. In return I started asking both friends and chance encounters: "When did you suffer most?" I decided to continue such exchanges until I had got over my pain by comparing it with other people's, or had worn out my own story through repetition. The method proved radically effective. In three months I had cured myself. Yet, while the exorcism had worked, I feared a possible relapse, and so I decided not to exploit this experiment artistically. By the time I had returned to it, fifteen years had passed.'

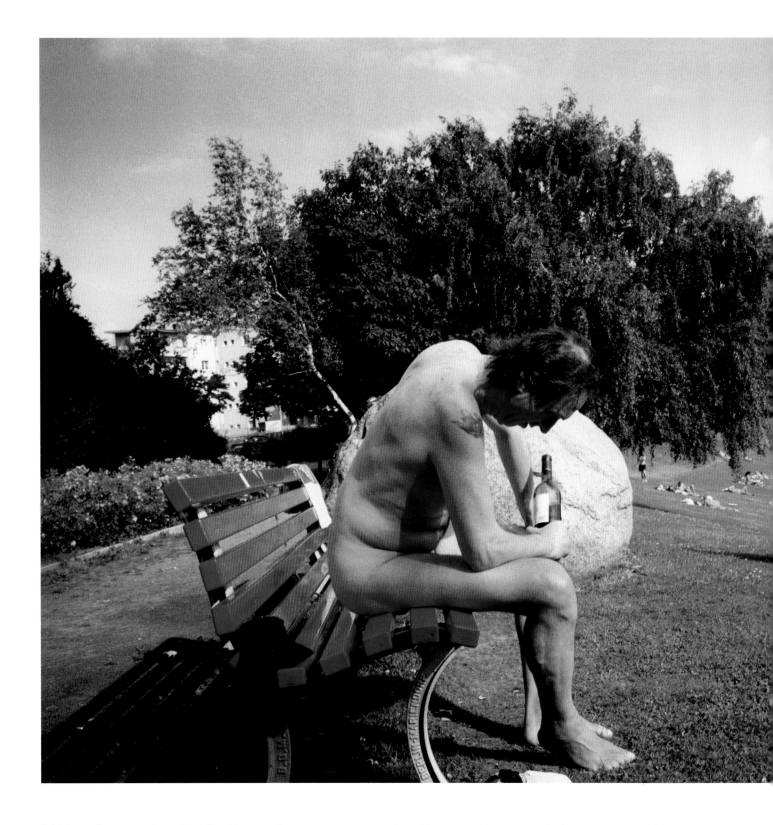

'Taking photographs of Berlin, I wanted to try to capture what Germany is, to try to bring out some of its singularity. I looked for romantic situations, connected with past traditions. I shot the tired faces of people who had lived through the war and who had endured the humiliating period after the war. "The Old" became a theme for me, maybe because I had got old myself. I walk and I get tired, and all around me I see a lot of tired, sick and old people. They rest or take a break before continuing on their way. Then suddenly I saw something new and brilliant to me: a few young guys were running, laughing and all at once plunged together into the water. It was for me both the continuation of some collective mind and something I had never witnessed before.'

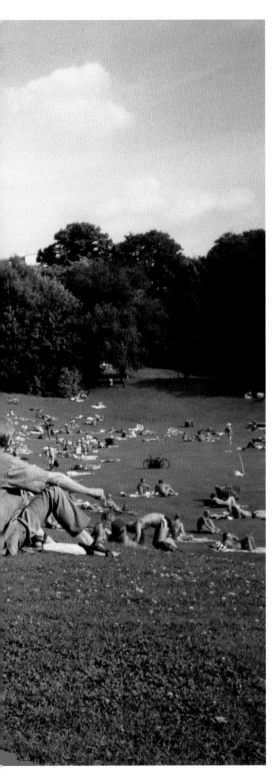

BORIS MIKHAILOV MIKHAILOV'S SATIRICAL CRITICISM DURING THE 1970S AND 1980S OF THE SOVIET REGIME AND CLASS SYSTEM DEVELOPED INTO DOCUMENTING THE POVERTY AND SOCIAL COLLAPSE THAT HAD BECOME EVIDENT IN HIS NATIVE UKRAINE IN THE 1990S. THE MOST CONTROVERSIAL OF THESE DOCUMENTS WAS THE EXTENSIVE SERIES OF OVER FIVE HUNDRED PHOTOGRAPHS ENTITLED *CASE HISTORY* (1997–8). FOCUSING ON THE HOMELESS OF KHARKOV, THE WORK BECAME NOTORIOUS DUE TO THE FACT THAT HE PAID THE SUBJECTS AND THAT THEY WERE OFTEN DEPICTED NAKED. HIS HARSH REALISTIC APPROACH CAUSED MUCH CONTROVERSY AROUND ISSUES OF ETHICS AND EXPLOITATION. HE CURRENTLY LIVES AND WORKS IN BERLIN, WHERE HE CONTINUES TO QUESTION THE BEHAVIOUR OF THOSE AROUND HIM WITH UNFAILING CURIOSITY.

OPPOSITE AND BELOW BORIS MIKHAILOV, THE CITY (BERLIN), 2002–3

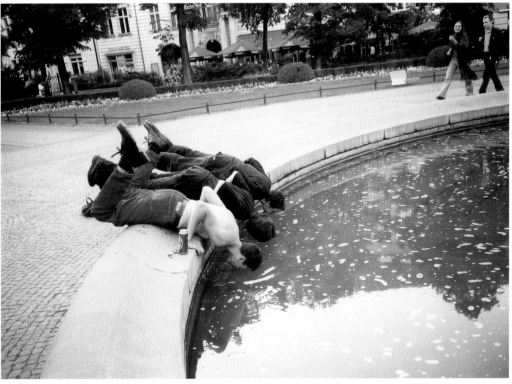

ALLAN SEKULA EQUALLY WELL KNOWN FOR HIS ART AND HIS THEORETICAL WRITINGS, AMERICAN ARTIST SEKULA JOINS DOCUMENTARY PHOTOGRAPHY WITH CRITICAL TEXTS TO GIVE A CONCEPTUAL DENSITY AND WIDER CONTEXT TO THE POLITICAL TOPICS HE COVERS. THE TEXTS ARE OF EQUAL IMPORTANCE TO THE IMAGES AS REGARDS INTERPRETATION OF THE WORK. BY SHIFTING THE READING AWAY FROM THE SINGLE-FRAME PHOTOGRAPH, AND COMBINING IMAGE AND INFORMATION, HIS WORK REPRESENTS AN IMPORTANT CHANGE IN DOCUMENTARY TECHNIQUE, PLACING LANGUAGE AND CONTEXT AT THE HEART OF A PHOTOGRAPH'S SIGNIFICANCE. THE SERIES *BLACK TIDE* (2002–3) DOCUMENTS THE EFFORTS MADE TO CLEAN UP ONE OF THE WORST OIL SPILLS IN HISTORY AFTER THE TANKER *PRESTIGE* SUNK OFF THE GALICIAN COAST OF SPAIN. IT ALSO DEALS INDIRECTLY WITH THE THEN RIGHT-WING GOVERNMENT'S COMPLACENCY ABOUT THE DISASTER.

ALLAN SEKULA, BLACK TIDE: VOLUNTEER ON THE EDGE (ISLAS CÍES, 12-20-02), 2002-3

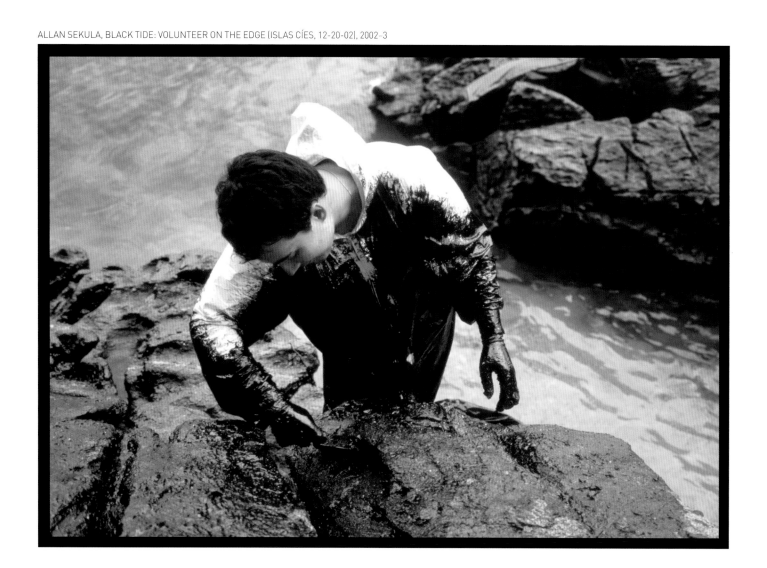

BLACK TIDE: FRAGMENTS FOR AN OPERA

To be performed in the village of Muxia, in the Galician language, on the 19th of November, 2032, a date imagined by many dwellers of that rocky coast to be set in a distant future free from the ravages of the black tide.[1]

We begin with a Galician fable. A milk cow crosses the stage, a lantern suspended from its horns. Lights dim until only the lantern is visible, bobbing as if cast upon the waves. The wind rises. A lookout peers intently from a precarious crow's nest on stage left and a title descends on a billowing canvas sail:

LAND OR SEA?

The Chorus is dressed in white: hooded in waterproof, sweat-retaining Tyvek suits, taped at the cuffs with transparent package tape. They seal each other into their suits, stooping to bite at the tape with their teeth. This preparation is performed with ritual solemnity, in silence. A Fisherman, enters, stage right, and gestures toward the chorus:

"These are the astronauts."

At first the scene has the look of an airplane crash or a terror-bombing, the carnage viewed from a distance, from behind a barrier of yellow tape. Voices rise with the wind: the swelling mask-muffled dirge of a collective Sisyphus, the chorus trailing across the dark beach in a ragged line, passing unwelcome cargo from hand to hand up the steep slope of the raking stage.

THE SONG OF THE COLLECTIVE SISYPHUS

The refrain is a chant in Gallego:

O prestixio do Sisifo
nunca máis
unha vez máis
nunca máis
unha vez máis[2]

Implements are scarce. The work we see here is more primitive and less industrial than that of the engine room stokers and chorus hall dancers of the age of coal. Publicity photographs are deceptive. These pictures, the product of photography's witless passion for uniforms and uniformity, give us the optimistic illusion of an artful array of disciplined, industrialized bodies in coordinated action, seen from the highest seats in the balcony. Or they give us the baroque agony of single bodies, isolated by the opera glass, twisted and mired in tragic poses.

These are uniformed homunculi of disaster, battling entropy itself. All distinctions – between soldiers and civilians, between those working for free and those working for a low wage, between *xente do mar* and sympathetic dwellers of the shore – are shrouded by the ghostly white suits. These darken and stain over the course of the performance, until the wearers come to resemble befouled sea mammals, greasy with oil more ancient than their own fat. The hands, once capable of grasping delicately at suffering crustaceans, are now crude shovels, stabbing bluntly into the viscous folds of fuel.

The King appears, stage right, surrounded by his retainers and a clutch of photographers. The chorus continues its Sisyphean labor, largely oblivious to the royal retinue. The King suddenly twists backward, awkwardly balanced on one leg to inspect the bottom of his shoe. The photographers turn away in unison from this forbidden gesture.

SONG OF THE PENGUINS AT THE SAN FRANCISCO ZOO

*"The photographer
descendent of the augurs and
haruspices…"*[3]
"It's endless swimming to nowhere…"[4]

A banner descends:

ONE MONTH LATER.

The Prime Minister and his retinue enter, stage left, in a well-appointed rolling watchtower that has replaced the flimsy mast of the lookout. The photographers abandon the King and rush to the base of the tower. The Prime Minister observes the chorus through opera glasses. A courtier appears and reads a press release:

"At that frigid depth, the oil will congeal to the consistency of heavy tar."

"Furthermore, the pressure of the deep, although equally exerted on all matter, will miraculously thwart the buoyancy of oil."

"Should these predictions prove wrong, we can promise without fear of error that the ship will stop leaking on the 15th of January, 2003."

The Prime Minister is distracted by a disturbance at the far corner of the stage. Dark-complexioned travelers are disembarking from a rowboat. Officials confer and a squad of sailors is dispatched to arrest the interlopers.

The courtier continues:

"We had hoped that the ship could have been towed south…out of harm's way"

A nautical map appears with details of the French, Spanish, Portuguese and West African coasts.

THE EUROPA SONG[5]

A news photograph is projected. The Secretary of Defense of the United States at a press briefing, viewed incongruously from a camera position just below the tip of his shoe. An offstage Texas-accented voice repeats the phrase "Nunca máis" to appropriately upbeat and "Western" musical accompaniment, mingled with the rumble of marine diesels followed by the roar of high performance jet engines. The refrain is taken up more convincingly by the chorus and then dropped, leading to:

SONG OF NECESSITY OF OIL[6]

Whatever else might become of the lyrics of this song, it is important that it begin or end with a line from *Gulliver's Travels*:

"…the offensive Matter should be carried off in wheelbarrows."

The Premier of the Province appears, accompanied by the Minister of the Interior and the Minister of Defense. The Premier studiously ignores the labors of the Chorus, and proceeds to ceremoniously dedicate a new section of *autopista*. A rising chorus of automobile engines follows the cutting of the ribbon.

The Interior Minister announces that the black tide is not a national emergency, but a minor mishap falling under the jurisdiction of the Department of Public Works.[7]

The Minister of Defense, who has been inspecting the Chorus, announces that the beaches are immaculate.[8] An adjutant arrives with a beach chair, an umbrella, and a tropical drink. Half of the Chorus continues to stand at attention, while the other half digs in the muck.

Here the notes trail off but, as the saying goes, the story isn't over…
The author would appreciate readers' further assistance with the following songs:

THE SONG OF THE LAST OLD-TIME FASCIST[9]

THE SONG OF THE SHIP INSPECTOR

"Money travels at the speed of light
until winter comes
and the sea reminds us…"

*"After twenty-five years
Those huge tankers
Are fatigue machines…"*[10]

"You can't send a postcard from the bottom of the sea."[11]

THE SONG OF SOCIETY AGAINST THE STATE, to be performed at the end of the opera, by the chorus, and which should include, somewhere, a passage from Albert Camus' *Myth of Sisyphus*:

"But when he had again seen the face of this world,
enjoyed water and sun,
warm stones and the sea,
he no longer wanted to go back to infernal darkness."

Allan Sekula
Galicia and Los Angeles
December 2002–January 2003[12]

[1] *Black Tide* was commissioned by, conceived and designed for, and first published in *Culturas*, the weekly magazine supplement of the Barcelona newspaper *La Vanguardia*, 12 February 2003. The project was co-commissioned by the Centre de Cultura Contemporània, Barcelona.
[2] Here the author, despite his unreasonable desire to proceed in the spirit of Federico García Lorca's *Six Galician Poems*, being only a photographer and not a librettist, unsuited for poetry in Spanish or his native English, would welcome further suggestions from the readers. Address all submissions to culturas@lavanguardia.es.
[3] Walter Benjamin, 'A Small History of Photography' [1931] in Edmund Jephcott and Kingsley Shorter, *One Way Street and Other Writings*, London, 1970, p. 256.
[4] *Los Angeles Times*, 21 January 2003.
[5] See note 2 above.
[6] See note 2 above.
[7] *El Pais*, 24 December 2002.
[8] *La Vanguardia*, 25–6 December 2002.
[9] For helpful hints, see Gustavo Luca de Tena, *Fraga. Retrato de un fascista*, Castillian translation from Gallego by Antia Milde Carballeira, Anglet, 2001.
[10] Ignace Sekula, retired aerospace engineer, in conversation with the author, February 2003.
[11] Bert Kanter, ship inspector for the International Transport Workers Federation, in conversation with the author, Rotterdam, October 1999.
[12] Thanks to Carles Guerra, Manuel Sendón, Olaia Sendón, Clara Ogando, Gustavo Luca de Tena, Frank Herbello, and Sally Stein.

'In mid-November of 2002 the oil tanker *Prestige* broke in half off the coast of Galicia. I had the immediate intuition that this calamity would resonate for some time, with unpredictable political effects, and considered going back to Vigo, having photographed fishing and other related aspects of the local economy ten years earlier for one of the early chapters of *Fish Story*. As if reading my mind, the Barcelona artist and critic Carlos Guerra contacted me a day later to invite me to make an open-ended project on the spill for the cultural magazine of the newspaper *La Vanguardia*.

The prodigious Sisyphean efforts to contain the spill had all the drama of opera, especially set against the curious indifference and complacency of the right-wing Spanish government of the time. And I was thinking, as usual, of an anti-photojournalistic approach, especially out of respect for the lingering effects of oil spills over time, which usually pass below the news radar.

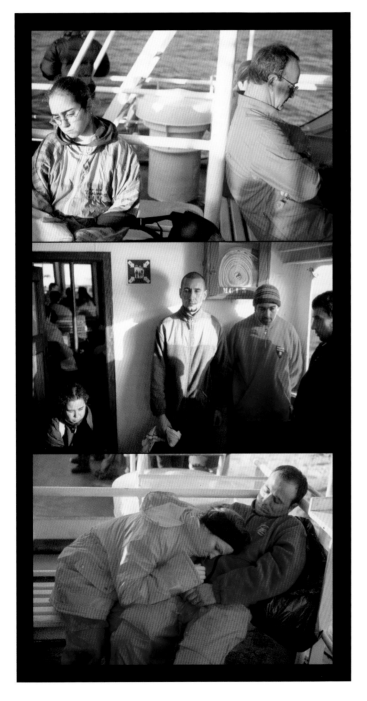

So what emerged was a specific picture layout for the magazine, running parallel to a sketch for an operatic libretto. Because it is only a sketch, I indulged in a bit of open-ended journalistic play, inviting readers to contribute lyrics for which I had sketched out only an opening phrase, or proposed a refrain. This seemed consistent with my other intuition, that Spain was a crucial battlefield in the war between neoliberalism and its democratic opposition.

Black Tide is framed by the notion that the fictional opera will be performed thirty years hence, when the dire effects of the spill will finally (hopefully) have dissipated. So the work's feeling-tone combines melancholic resignation to protracted difficulty and struggle with utopian anticipation of future celebration, both well beyond the purview of the news.'

LEFT ALLAN SEKULA, BLACK TIDE: EXHAUSTED VOLUNTEERS (EN ROUTE FROM ISLA DE ONS, 12-19-02), 2002–3
OPPOSITE ALLAN SEKULA, BLACK TIDE: VOLUNTEER'S SOUP (ISLA DE ONS, 12-19-02), 2002–3

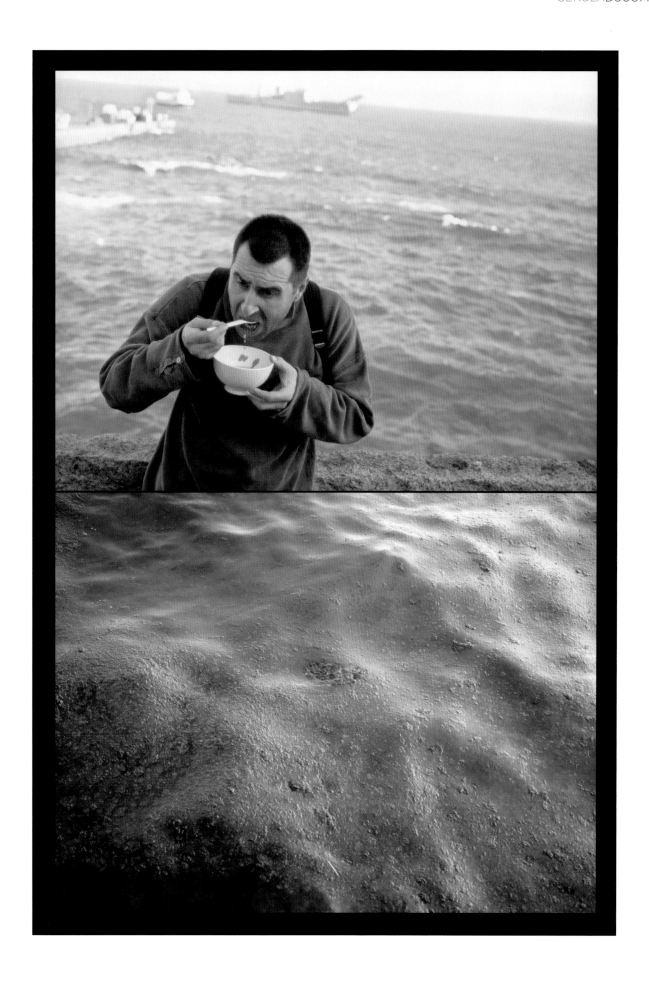

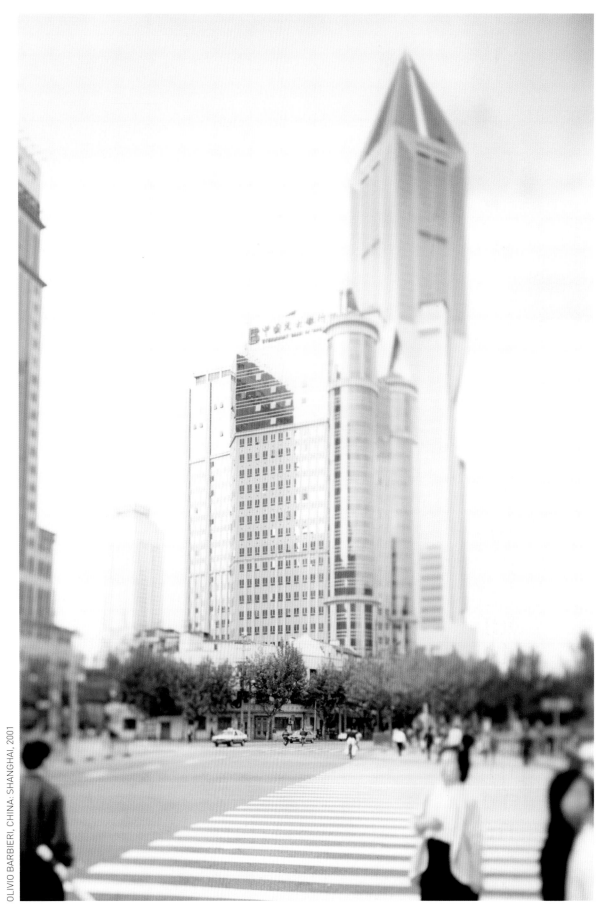

CITY

In his now famous essay 'The Work of Art in the Age of Mechanical Reproduction' (1936), Walter Benjamin discussed how the camera was the perfect medium for urban spaces, allowing the photographer to walk the streets choosing what to capture and what to leave, slowing the world down by purposely stopping and clicking as the world rushed by. This stopping and clicking, followed by the equally important photographic processes of editing and sequencing, could give order and structure to an ever-changing and modernizing world.

Benjamin turns in his essay to the work of Eugène Atget, a nineteenth-century photographer commissioned to record and document the architecture of Paris. Paris in the nineteenth century was a city of bold and exciting changes; the very fabric of the city was shifting as large boulevards carved it up and modern industrial buildings such as the Eiffel Tower and the Gare du Nord became part of the infrastructure. But the Paris that Atget shows us features none of these grandiloquent and exciting developments. Instead we see a silent, deserted space, as if 'a crime had just taken place or was about to take place'. The photographs are almost suffocating in their melancholy, full of suggestions of a time past.

Atget's work on the streets of Paris has been taken up and canonized in the history of art, and many artists have claimed him as their source of inspiration. The surrealists, most notably Man Ray and his then assistant Berenice Abbott, made sure his work was known to the Museum of Modern Art in New York and from there his reputation and status as an artist of huge importance was cemented.

This slowing down, this taking stock of modern urban changes that is so apparent in Atget's work and in Benjamin's essay, still resonates today for contemporary artists who take to the street and use the city as their backdrop to explore diverse and varied issues. Indeed a backing off from the ebb and flow and a taking stock of deserted spaces is characteristic of the work of many artists working in urban spaces today. There are often similar feelings of melancholy or suspense, and images of unpeopled cities are beginning to dominate in the gallery over more traditional street photography. The city is the perfect subject matter for the deadpan, seemingly objective large-plate camera photography that has been apparent in all the chapters of this book. Viewed from above or beyond, cities take on an almost magical and mystical appearance, highly seductive in their rare moments of calm.

Street photography has become a well-trodden and popular artistic genre for photographers and is most commonly associated with post-war American photographers such as Garry Winogrand, Lee Friedlander, Joel Meyerowitz, William Klein, Robert Frank and Diane Arbus who, although all very different in their approaches, employed their cameras not to represent modernist classics, social documents, or humanistic scenes as others had before them, but instead saw the street as a place where people let down their guard, a place where humanity is on show for all to see. They used the camera to criticize and comment on larger issues resonating for real people. Their styles differed enormously and they approached their subjects poetically, aggressively and metaphorically to produce work in which portraiture, landscape and architectural representation are lyrically combined.

What these photographers had in common was post-war disillusionment and a lack of sentimentality. There was no papering over the cracks of the disheartened, dysfunctional and desperate Nixon-era America. These street photographers created and cemented a tradition of image-making which in turned carved the way for contemporary artists to recast and rethink how they use the city and street.

To artists, knowledgeable of the tradition that has gone before, this most democratic of spaces now offers many different opportunities and prospects. They have recast the genre into something more 'deliberate' in terms of how pictures are constructed and what they mean. These different photographic strategies have produced some of the most intriguing, relevant and thought-provoking images of the street ever made. The 'smash and grab' approach of traditional street photography no longer seems relevant or appropriate, with issues of privacy and intrusion being much more complex than they once were. As curator and critic Carol Squiers has commented, 'The well-worn artistic practice of street photography seemed to have ended with the death of Garry Winogrand in 1984.'

In 1982 Jeff Wall produced *Mimic*. Carefully staged, the image shows an Asian man walking down the street with a Western male making a racist gesture just behind him. By controlling the whole situation and orchestrating the look of the image, Wall can be seen to have purposely broken with the tradition of how the city should be photographed and opened up exciting possibilities for others. The desire for control is no more apparent than in the city's volatile and changeable environment.

This desire to control can also be seen in the work of Philip-Lorca diCorcia. He has turned to the street in four important bodies of work and his unconventional approaches can be seen as deconstructions of traditional street photography. These include *Hollywood* (1989–92), *Streetwork* (1993–8), *Two Hours* (1999) and *Heads* (2001–2). Using a variety of approaches including the premeditation of scenarios, and rethinking the ethical issues around privacy, his work has reanimated street photography. His photographs are neither portraits nor images of types; they document the impersonal life of the city, and the generic roles at play within it.

So the city and the street are inextricably bound up with one another. While some artists such as Beat Streuli still pound the streets searching for their subject matter, many others pan out and look more widely, taking in a view of the city that may not be so intense or immediate. Others, like Naoya Hatakeyama, turn their camera downwards and literally into the foundations of the city in a concentrated way. Peeling away the layers that form a city, Hatakeyama finds unexpected beauty in the rivers and shadows of Tokyo's main urbanized environments. The city is a temporary space – it belongs to no one and each generation adds another layer. Cities are mutable and changeable sites constantly in flux and transition. The desire to freeze them, if even for a moment, is hard to resist.

MELANIE MANCHOT FOR THE LAST TWO YEARS MANCHOT HAS BEEN TRAVELLING CONSISTENTLY TO RUSSIA TO WORK ON A VARIETY OF DIFFERENT PROJECTS, BOTH VIDEO AND PHOTOGRAPHIC. MOSCOW, WITH ITS COMPLEX POLITICAL HISTORY, IS USED AS A BACKDROP AND THE STARTING-POINT OF THIS SERIES, FEEDING MEANING INTO THE STAGED DOCUMENTARIES THAT OPERATE ON THE BORDER BETWEEN REAL LIFE AND CONSTRUCTED CIRCUMSTANCE. IN RECENT WORK THIS DELICATE BALANCE IS INCREASINGLY APPARENT. HER INVESTIGATIONS INTO THE REALMS OF PUBLIC AND PRIVATE SPACE CAN BE SEEN MOST OBVIOUSLY IN HER COLLABORATIONS WITH HER MOTHER (1995–2000). ALTHOUGH TENDER, THE PROJECT WAS AT TIMES SHOCKING, BOTH BECAUSE OLDER NAKED BODIES ARE RARELY REPRESENTED AND BECAUSE THIS NAKEDNESS WAS AT ODDS WITH THE VARIOUS PUBLIC OUTDOOR LOCATIONS IN WHICH SHE WAS PHOTOGRAPHED.

'*Groups and Locations (Moscow)* explores ideas regarding street photography and contemporary urban culture. The work builds on two concerns central to my practice. One is the performative quality of photography; the other is an ongoing investigation into our understanding of and participation in the realms of the public and the private.

MELANIE MANCHOT, GROUPS AND LOCATIONS (MOSCOW): CATHEDRAL OF CHRIST SAINT SAVIOUR, 6.23PM, 2004

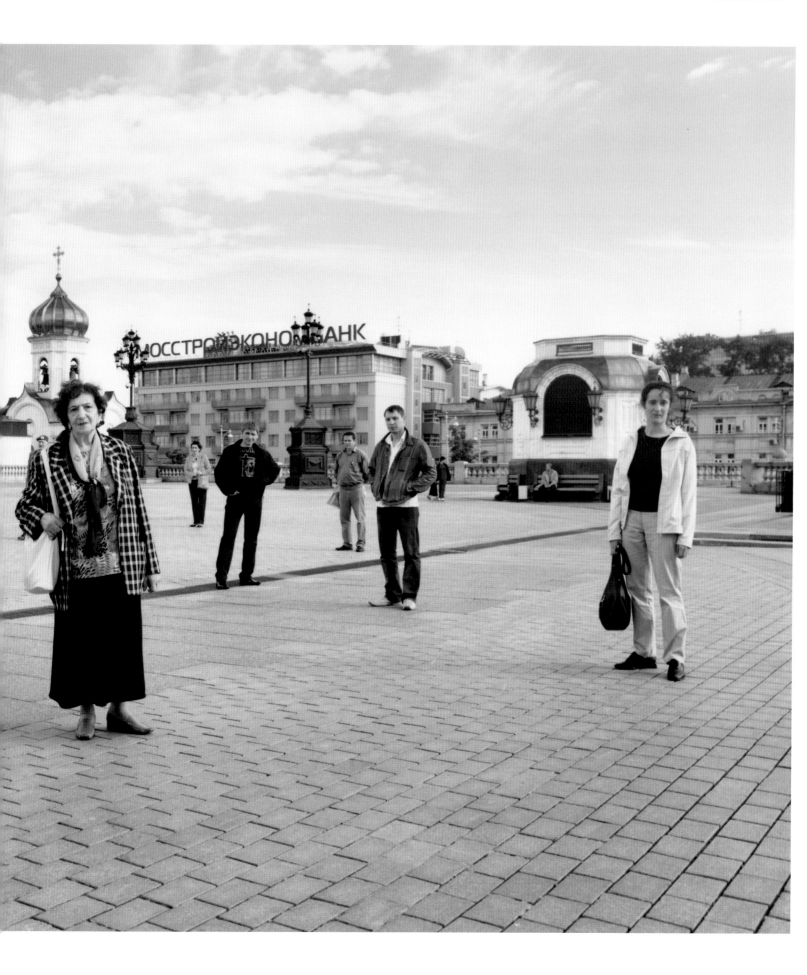

The series also references aspects of historical Russian photography, and combines them with observations on the use of and suspicion towards photography in contemporary urban space. In nineteenth-century Russian photography there is a proliferation of images of groups of people in a variety of cities and landscapes, categorized under the (problematic) title of "Types and Views". What has fascinated me about these images is the intensity of fifteen, twenty or forty pairs of eyes staring back out of the picture, and to what extent these gazes hold ours. My interest in these images was recently given a more current political charge, when in April 2004 the Russian parliament gave preliminary approval to a bill outlawing protests, demonstrations or rallies in or near public locations considered to be of political or cultural importance. Potentially this bill greatly restricts people's rights and freedom to use public space and it challenges our understanding of the boundaries between public/private, state/individual, etc.

MELANIE MANCHOT, GROUPS AND LOCATIONS (MOSCOW): MANEGE SQUARE, 3.15PM, 2004

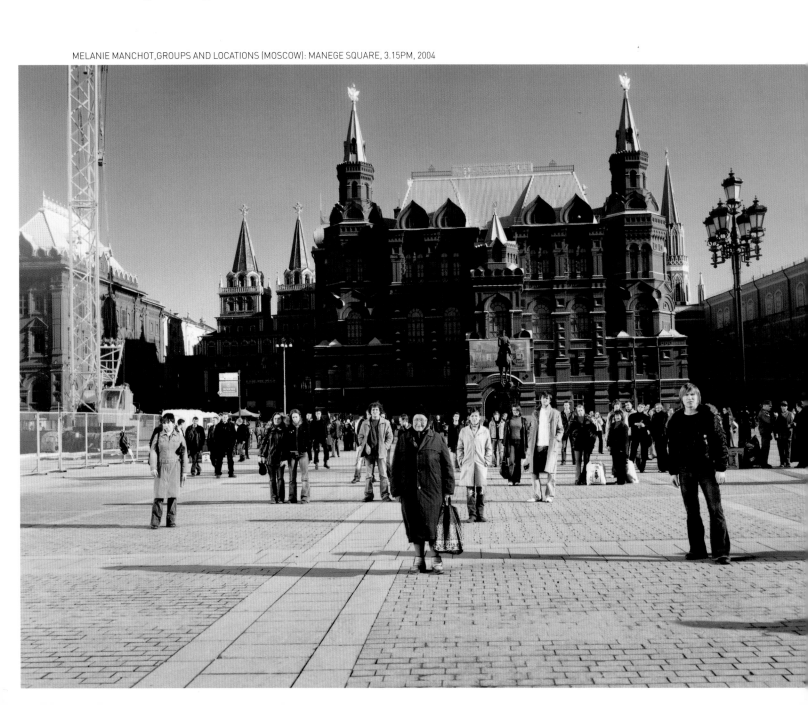

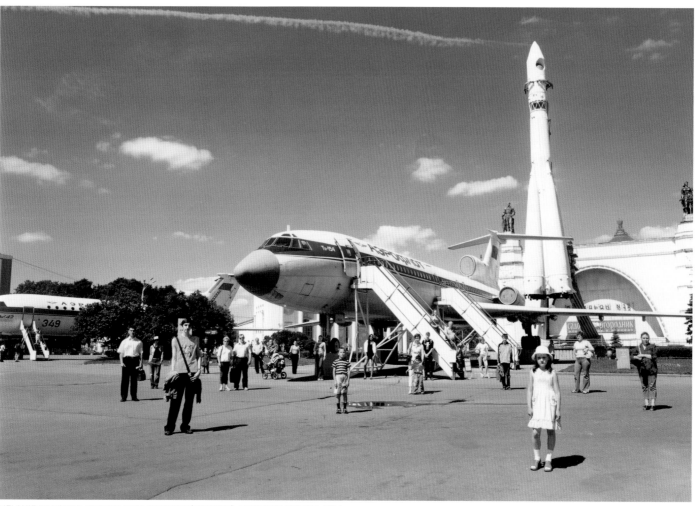

MELANIE MANCHOT, GROUPS AND LOCATIONS (MOSCOW): AEROFLOT,12.36PM, 2004

To make the images, I work performatively on location with people who happen to pass by. All are strangers to me and to each other. All the locations are chosen for their cultural or political significance, many of which are in fact public spaces where photography is prohibited. Once the camera is set up, I invite a cross-section of individuals to become part of a "group portrait". In this work, the "group" only comes to exist in the moment of the camera's exposure and for the purpose of the image only. The combination of working with people spontaneously as well as being under imminent threat of police or security intervention brings a certain tension to the working process which I think informs and charges the images. Each person's expression, stance and relationship to the camera become crucial.'

NAOYA HATAKEYAMA SINCE THE LATE 1980S, HATAKEYAMA HAS TAKEN PICTURES OF TOKYO. THEY SHOW HIS ADMIRATION FOR THE UNEXPECTED NATURAL BEAUTY FOUND IN URBAN SPACES BUT ALSO THE SENSE OF STRANGENESS OR ALIENATION THAT THE ACT OF PHOTOGRAPHING A SCENE CAN PRODUCE. THE NEAR-OPTICAL ILLUSIONS IN *SLOW GLASS* (2001), *RIVER SERIES* (1993–4) AND *RIVER SERIES/SHADOW* REVEAL A SOPHISTICATED USE OF THE LENS AND OF THE MECHANICS OF THE CAMERA TO PRODUCE POETIC COMMENTS ON CITY DWELLING.

'I feel invisible in the city. In it I find primitive signs left by human beings which my camera leads me to. I was working on this series from 2001 until 2003 and there are nine images in total. I found the city lights reflecting on the river surface and it looked so nostalgic to me. It was interesting to learn that even with a long exposure, the reflections looked still. When I focused my 4x5 camera, I could see the reflection of Tokyo. The images look upside down, but they are not – it's the reflection. I felt as if I were a fish, looking up at Tokyo from under the water. I worked at night with a ten-minute exposure and found that the expression of the water differed each time I visited, because the riverbed changes by season and if there is a flood.'

BELOW LEFT NAOYA HATAKEYAMA, RIVER SERIES/SHADOW #002, 2002
BELOW RIGHT NAOYA HATAKEYAMA RIVER SERIES/SHADOW #056, 2002 OPPOSITE RIVER SERIES/SHADOW #050, 2002

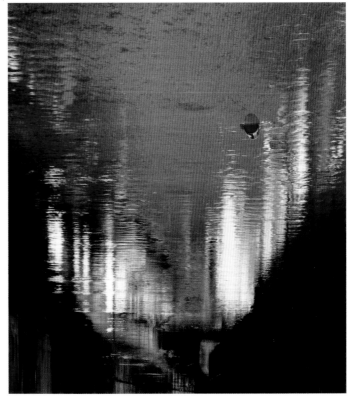

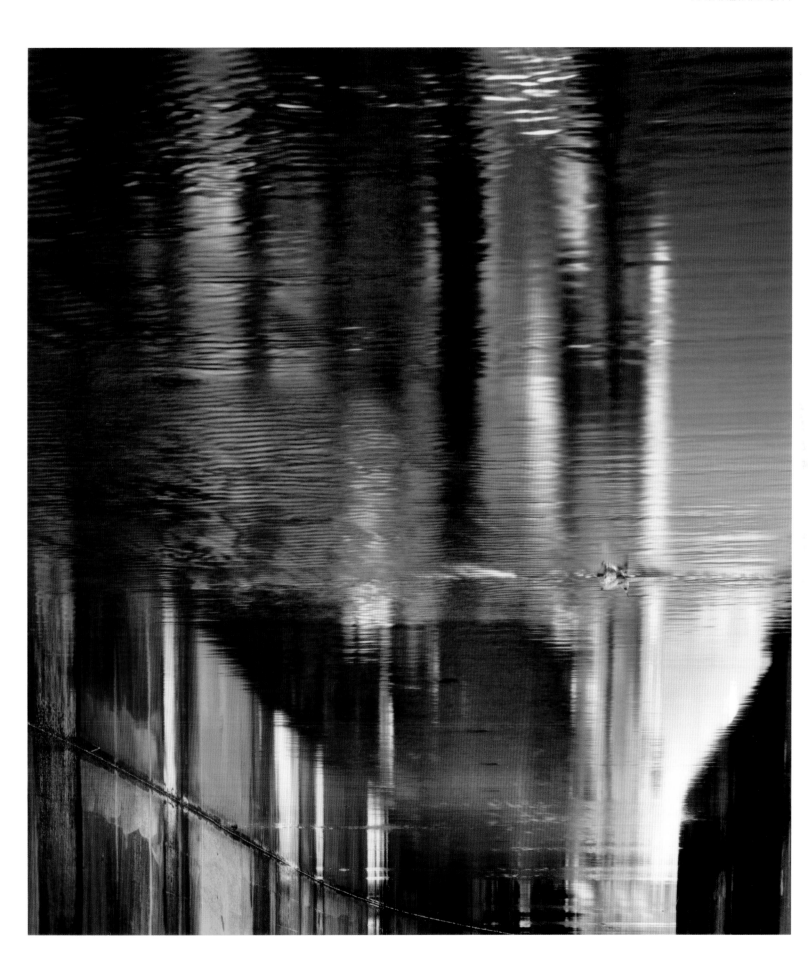

OLIVIO BARBIERI SINCE THE EARLY 1990S ITALIAN ARTIST BARBIERI HAS CONCENTRATED ON PHOTOGRAPHING EASTERN CITIES. HIS IMAGES HAVE NONE OF THE ROMANTICISM AND EXOTICISM THAT HAVE TRADITIONALLY FEATURED IN PHOTOGRAPHS OF THE EAST AND WHICH HAVE DOMINATED THE HISTORY OF PHOTOGRAPHY SINCE THE EXPANSION OF COLONIAL POWERS AND THE GROWTH OF TOURISM IN THE VICTORIAN ERA. HIS DISTINCTIVE EFFECT IS ACHIEVED BY SELECTIVE FOCUS, WHICH THROWS SOME AREAS OF THE IMAGE INTO SHARP FOCUS AND CAUSES OTHERS TO BLUR. ARTIFICIAL LIGHT PLAYS WITH PERSPECTIVE, GIVING THE EFFECT OF MANIPULATION IN POST-PRODUCTION.

'China features in nearly all of my work. In China it is easier to "find", rather than to "look for", images. What I found in China is surely similar to what was found by different photographers active in the United States in the fifties and sixties. China somehow is the America of nowadays, although this might sound paradoxical. I think that the East will be the cultural myth of the new millennium, and China will have a leading role in this. Maybe I'm wrong, but what's happening right now is rather convincing.

I am no longer interested in seeing and knowing everything all at once in my work. Technically I select the area of focus and if it's possible I try to make an amalgamation of every shape and colour in the picture so that it acquires a circular movement: from representation to abstraction, from life to death, and vice-versa. Reality looks as if it had been taken not on the ground but from some point hovering above the country.'

OLIVIO BARBIERI, CHINA: SHANGHAI, 2001

ABOVE RUT BLEES LUXEMBURG, PHANTOM: IMMOBILIÈRE, 2003 OPPOSITE RUT BLEES LUXEMBURG, PHANTOM: TYSON/BOMBARDIER, 2003

RUT BLEES LUXEMBURG WHERE MOST MIGHT VIEW AN UNINHABITED CITY AT NIGHT AS A FRIGHTENING AND THREATENING SPACE, GERMAN ARTIST BLEES LUXEMBURG TRANSFORMS IT INTO SOMETHING MUCH MORE SEDUCTIVE AND ROMANTIC. THE RICH GOLDS AND GREENS THAT CHARACTERIZE HER PHOTOGRAPHS ARE ACHIEVED THROUGH LONG EXPOSURES WORKING AGAINST THE EVER-PRESENT LIGHT FROM STREETLAMPS AND NEON. THIS SLOW CONTEMPLATIVE APPROACH WORKS IN POETIC CONTRADICTION TO THE MUNDANE ELEMENTS ON WHICH SHE OFTEN FOCUSES. IN DAYLIGHT THE SUBJECTS FOR HER PHOTOGRAPHS MIGHT BE IGNORED OR HURRIED PAST, BUT THROUGH PHOTOGRAPHIC TRANSFORMATION THEY BECOME PLACES WITH MAGICAL POSSIBILITIES.

'I travelled to Dakar, maritime capital of Senegal, to make the series *Phantom* for an exhibition commission at Tate Liverpool. The two cities, Dakar and Liverpool, are linked historically though colonialism and the sugar and slave trades. Dakar, which is the music and culture (and football) capital of West Africa connects with contemporary Liverpool in different and more positive ways, and the works suggest the possibility of a transfer of urban knowledge. The title *Phantom* refers to the French writer Michel Leiris's diary *L'Afrique fantôme*, a document of his ethnological expedition from Dakar to Djibouti in the early 1930s.

RUT BLEES LUXEMBURG, PHANTOM: EL MANSOUR, 2003

When you enter a city for the first time, you tend to be more visually sensitive. Dakar, like all interesting cities, forms its uniqueness from the amalgam of its histories. Names, signs and architectural forms reflect that history. I immediately responded to the city's way of displaying itself, looking for signs to interpret and decode the place.

The first signs I noticed were the immense posters announcing the imminent wrestling match between Mohamed Ndao Tyson and Serigne Dia Bombardier. The occasion of the fight was accompanied by great excitement and interest, and Youssou N'Dour, the internationally celebrated musician from Senegal, made a song in Homeric anticipation of the epic match. On the poster, one can see behind Tyson and Bombardier, their reverse images … phantom-like. Their presence is elevated to the status of mythological heroes – imagine the fight between Achilles and Hector being advertised in Troy!

The work "Immobilière", which shows an advert for a local architectural practice, elaborates my London series, where I was trying to understand how the built manifestations of a city suggest a specific way of urban dwelling. The graphic models of possible houses, drawn on such a building, are re-presented as a photograph, which pulls in all possible directions. "El Mansour", the Arabic inscription on the cinema, is one of the hundred names of the prophet Mohamed. The cinema, a beautiful example of African modernism, also suggests its function – the building extends itself like the bellows of a camera.'

BEAT STREULI WHERE TRADITIONAL STREET PHOTOGRAPHERS OF THE MID-TWENTIETH CENTURY AIMED TO CAPTURE THE SPECTACULAR MOMENTS OF THEATRE THAT OCCURRED ON THE STREET, SWISS ARTIST STREULI TURNS TO THE ORDINARY MOMENTS THAT ARE FAMILIAR TO US ALL. HIS SUBJECTS ARE UNAWARE OF HIS VOYEURISTIC OBSERVATIONS OF THE EVERYDAY, AS THEY ARE OFTEN TOTALLY SELF-ABSORBED, NAVIGATING THEIR BUSY CAPITAL CITIES. TINY SIGNS GIVE AWAY WHICH CITY HE MIGHT BE IN BUT IT IS AN OVERALL HOMOGENEITY THAT DOMINATES HIS WORK, HINTING AT LARGER ISSUES OF GLOBALIZATION AND THE WESTERNIZATION OF EASTERN URBAN SPACES.

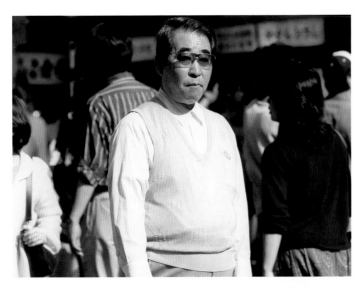

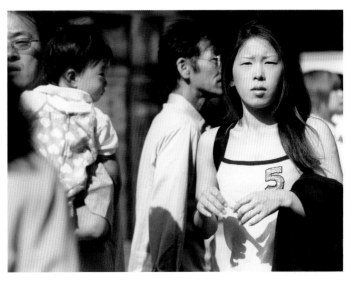

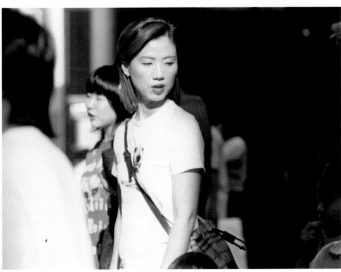

TOP LEFT BEAT STREULI, OSAKA 03 66/15, 2003
TOP RIGHT BEAT STREULI, OSAKA 03 66/11, 2003
ABOVE BEAT STREULI, OSAKA 03 66/17, 2003

'When I start working in a city, I walk around rather aimlessly, usually in the city centre, and try to find spots where lots of people from all parts of that city gather – bus stops, street corners, shopping areas. My approach is quite "unintentional", insofar as I am not hunting for any specific kind of person. Neither am I trying to illustrate what I have heard about the special qualities of a city or a culture. I use an average telephoto lens on my medium-format camera, and I snap-shoot people, generally without asking permission, as that is practically impossible. I do not use a tripod, I move around a lot, becoming part of the crowd, always visible myself. I sometimes shoot sitting in a street café or from behind the windows of a Starbucks café.

As I do not stage what I photograph, and as things and people in the city move quickly and unpredictably, only very few of the photos I shoot are actually good enough for what I want them to look like. So the selection process is very important to my work. It allows me to use bits and parts of the collected material to compose my own picture, to reconstruct a more general image of a place I have been to.'

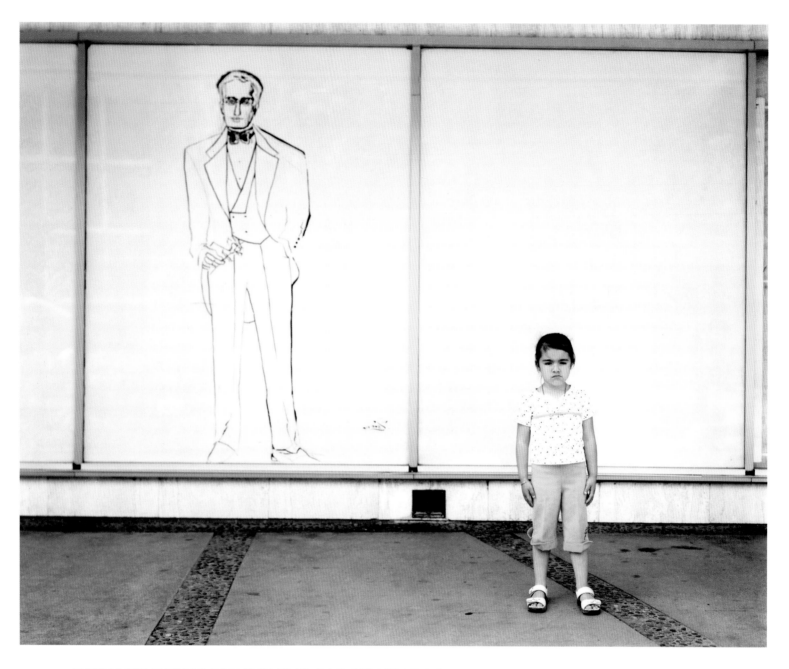

RICHARD RENALDI WORKING IN BOTH THE COMMERCIAL AND THE ARTISTIC ARENAS, AMERICAN ARTIST RENALDI'S PORTRAITS HAVE AN INTENSITY ABOUT THEM THAT HAS A LOT TO DO WITH THE LARGE-PLATE CAMERA HE USES. TO MAKE A PICTURE WITH THIS METHOD REQUIRES MORE THAN A SNATCHED MOMENTARY ENGAGEMENT. THESE IMAGES SHOW A DELIBERATE DECISION ON BOTH SIDES TO COLLABORATE. THE CHOICE OF THE CITIES IN WHICH TO TAKE PHOTOGRAPHS, AND MORE SPECIFICALLY THE AREAS WITHIN THOSE CITIES, OFTEN TAPS INTO UNSPOKEN ISSUES OF CLASS, MONEY AND THE ECONOMY OF LEISURE. WHERE THE PORTRAITS IN FRESNO HAVE A TENDERNESS, RENALDI'S IMAGES OF WEALTHY SHOPPERS ON MADISON AVENUE, NEW YORK, ARE MORE DISTANT AND CRITICAL, HONING IN ON THE SIGNS AND SYMBOLS OF WEALTH AND CONSUMERISM.

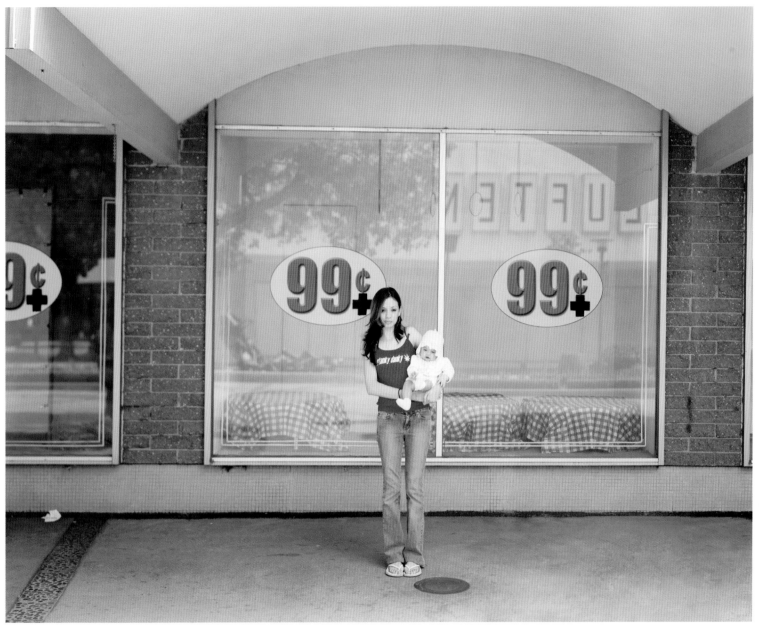

OPPOSITE RICHARD RENALDI, FRESNO: ALEJANDRA, 2004 ABOVE RICHARD RENALDI, FRESNO: MARIA, 2004

'It takes about fifteen minutes to take a portrait. People have to be very still once you have composed because they fall out of focus. I feel they have given me a gift by giving me their time. That's part of the beauty of the 10x8 camera. I think people have been trained to have their "Kodak moments" and are used to the conventions of snapshot photography. With my camera I don't have to ask my subject not to smile. The camera demands a certain gravitas and people react to it in a more serious way as it's like a formal sitting. I feel I get more out of my subjects because of the process.'

GABRIELE BASILICO PARIS HAS LONG BEEN ONE OF THE MOST PHOTOGRAPHED AND PHOTOGENIC OF EUROPEAN CITIES. ARTISTS SUCH AS EUGÈNE ATGET AND BRASSAÏ, WORKING AT THE START OF THE TWENTIETH CENTURY, AND THE FRENCH HUMANIST PHOTOGRAPHERS SUCH AS HENRI CARTIER-BRESSON, WILLY RONIS AND ROBERT DOISNEAU, WERE NOSTALGICALLY ATTRACTED TO THE ROMANTICISM OF THE CITY, ALMOST FREEZING IT IN THE PAST BY PHOTOGRAPHING IT. IN CONTRAST, ITALIAN ARTIST BASILICO PHOTOGRAPHS A TRANSITIONAL INDUSTRIAL CITY IN WHICH THE MUTABLE INFRASTRUCTURE SEEMS TO DOMINATE. HIS DISCIPLINED APPROACH TO PHOTOGRAPHING BUILDINGS REVEALS HIS ARCHITECTURAL TRAINING.

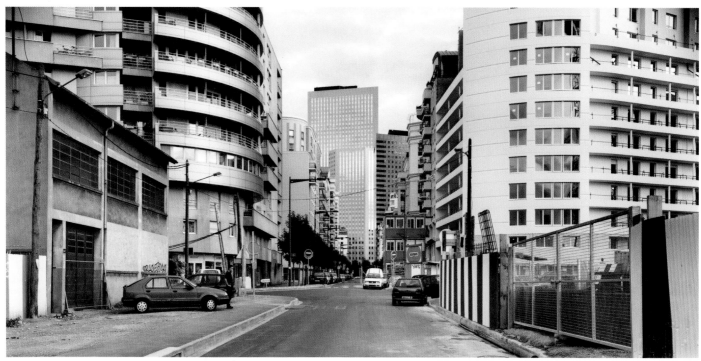

ABOVE AND BELOW GABRIELE BASILICO, PARIS PERIPHÉRIQUE, 2002

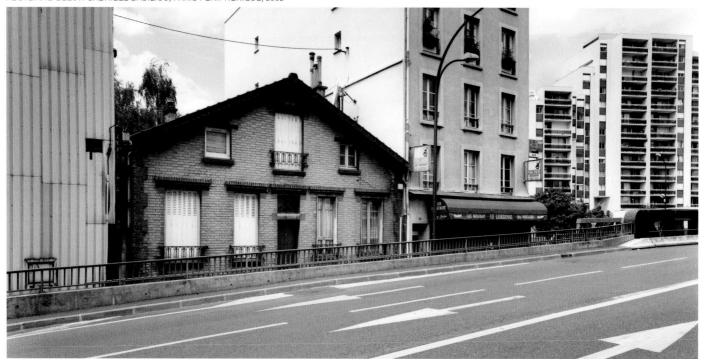

'The cities that interest me are those which are very clearly going through a process of urban transformation. I am interested in the marks of individual identity to be found in the urban fabric; the ways in which you can examine the body of the city in a very precise way, much as a doctor examines a human body.

The photographs of Paris were part of this project. I travelled the whole way round the Periphérique (the Paris ring-road), observing the main intersections. They are generally the parts of the city that experience urban change the most and where you can get a sense of a city's future. I almost never pointed the camera lens towards the city centre, except perhaps in certain instances when I was interested in a wider perspective. The topographical diversity of the urban fabric and its disconnection from the surrounding landscape is what really informs my work.

All types of photographs of architecture and cities have, inevitably, influenced my work. The places that I explored for this photographic project, however, are very different from the usual stereotypical Parisian images of the great photographers and it's difficult to see a real link. The impetus for "documentary style" work has always been the need to understand the urban reality that surrounds us.'

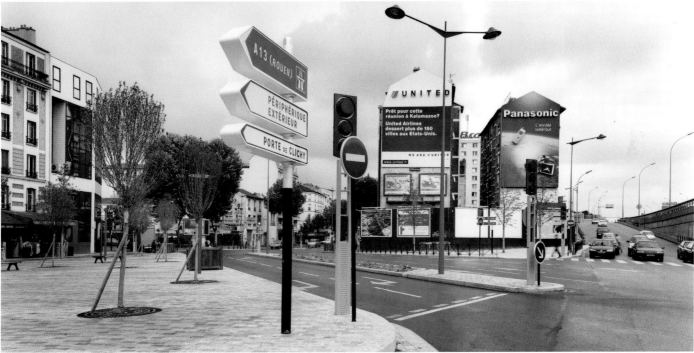

ABOVE AND BELOW GABRIELE BASILICO, PARIS PERIPHÉRIQUE, 2002

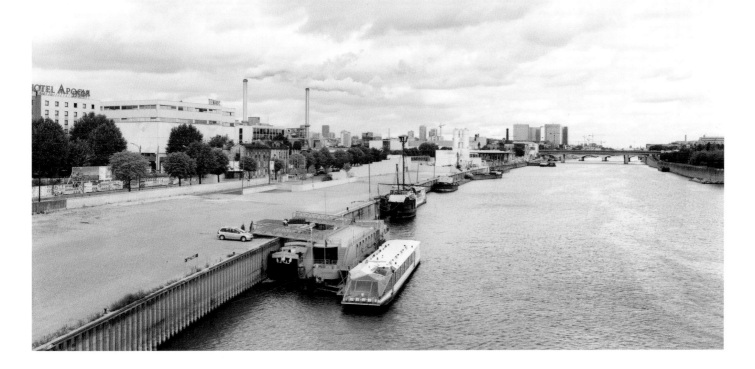

RICHARD WENTWORTH WENTWORTH HAS PLAYED A LEADING ROLE IN 'NEW BRITISH SCULPTURE' SINCE THE END OF THE 1970S ALONGSIDE OTHER ARTISTS SUCH AS TONY CRAGG, RICHARD DEACON, ANTONY GORMLEY AND ANISH KAPOOR. AS WELL AS HIS SCULPTURAL PRACTICE HE HAS ALWAYS TAKEN PHOTOGRAPHS BUT ONLY STARTED TO EXHIBIT THESE IN THE MID-1980S. OUT OF THE THOUSANDS TAKEN, A LARGE PROPORTION FORM AN ONGOING SERIES ENTITLED *MAKING DO AND GETTING BY*. AN INTEREST IN HUMAN ENERGY AND IN THE RESOURCEFULNESS OF SMALL AND OFTEN TENDER ACTS CHARACTERIZES WENTWORTH'S ENGAGEMENT WITH THE CITY. THESE TINY ACTS OF SURVIVALISM, THE FLOTSAM AND JETSAM OF URBAN LIVING, ARE OFTEN HUMOROUS AND THE IMAGES REVEAL HIS SCULPTURAL TRAINING IN THEIR UNDERSTANDING OF SPACE AND FORM.

'In many ways I am indifferent to photography. And I certainly didn't come to it through a love of photographs. I do know a gorgeous black and a good bit of printing, and lush paper, and good depth of field. I know what those parameters are and I am wary that my photographs can be on the edge of gorgeousness. It's really important that they feel prosaic, but also that they can just do that little bit more. I don't get precious about pictures I have taken. It's not the first time people have taken pictures of this stuff or dealt with it. What's more important is how it connects and how to deal with a bigger narrative. That is why I demote the individual image. The images are like fruits. Taking the picture is a bit like harvesting or picking (and the city is a kind of orchard from which I pick or snap).

RICHARD WENTWORTH, GENOA, ITALY, 2004

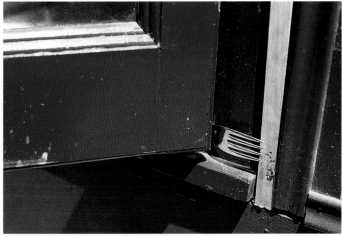

RICHARD WENTWORTH, GENOA, ITALY, 2004

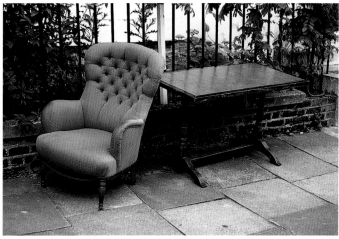

RICHARD WENTWORTH, ISLINGTON, LONDON, 2001

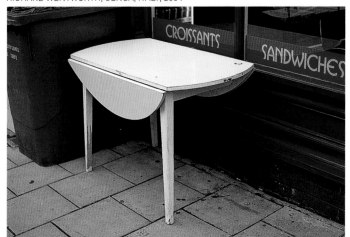

RICHARD WENTWORTH, OXFORD, ENGLAND, 2002

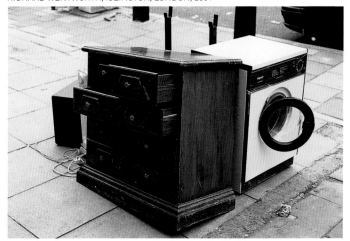

RICHARD WENTWORTH, CALEDONIAN ROAD, LONDON, 2004

RICHARD WENTWORTH, GENOA, ITALY, 2004

I have always been very puzzled about the raw and the cooked. Am I sitting on a tree or is this assemblage of wood a chair? What draws me in is how things are convertible and how humans give meaning. There is something about mutability that I have always been attracted to. I mean, what is a television that is sitting on the roadside miles away from the electricity supply? Is it still a television? It's something to do with being dead yet alive. It's the small human acts that reach out to my way of seeing. Without someone being able to raise a brick and deposit the right amount of mortar then there would be no walls. That's all a wall is really – a lot of brick raising. A little human act multiplied. A half brick raised, though, can be a murder weapon.

My work is also attached to the limits of purposefulness. If something is discarded you can read that and see that it's been rejected. To me, there is something terribly beautiful in that. Formal things are incredibly important to me. I always see the crack in the glass before I see the window. I have always had this "sickness". I am interested in the aberrant.'

THOMAS STRUTH AS A STUDENT AT THE DÜSSELDORF ACADEMY OF FINE ARTS UNDER GERHARD RICHTER AND LATER, BERND AND HILLA BECHER, STRUTH PHOTOGRAPHED CITIES. THIS WORK DEVELOPED THROUGHOUT THE 1970S AND 1980S INTO BLACK-AND-WHITE CITYSCAPES FROM AROUND THE WORLD. NOW WORKING IN COLOUR, STRUTH CONTINUES TO STUDY THE TRANSFORMATIONS OF URBAN SPACES AND THE WAYS IN WHICH ARCHITECTURE INFORMS US ABOUT THE HISTORY AND IDENTITY OF A CITY. DEVOID OF PEOPLE, THE IMAGES ARE OFTEN TAKEN AT UNEXPECTED VANTAGE POINTS FROM WHICH THE LAYERING OF BUILDINGS FULLY DEMONSTRATES THE MUTABILITY OF CITIES. WORKING ACROSS A WIDE VARIETY OF GENRES, STRUTH IS EQUALLY WELL KNOWN FOR HIS PORTRAITS, MUSEUM INTERIORS AND LANDSCAPES, ALL OF WHICH SHARE HIS RIGOROUS, SEEMINGLY OBJECTIVE APPROACH.

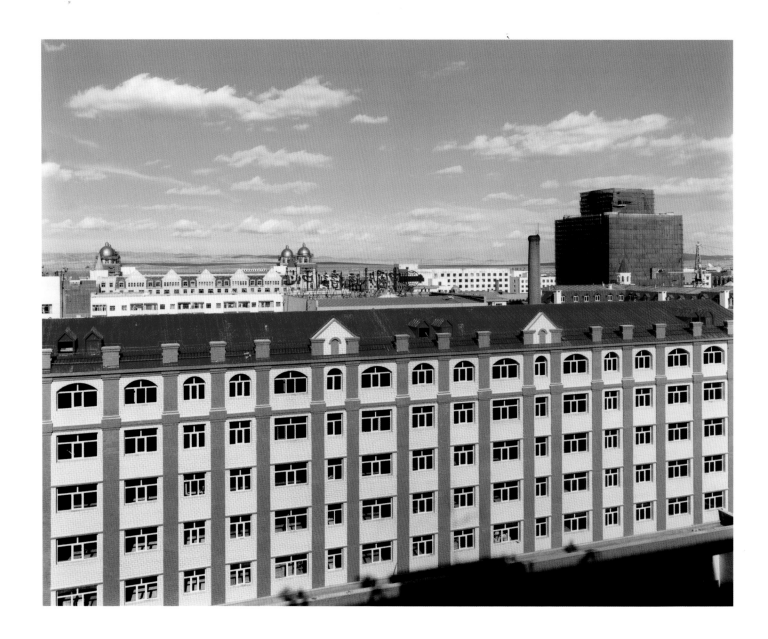

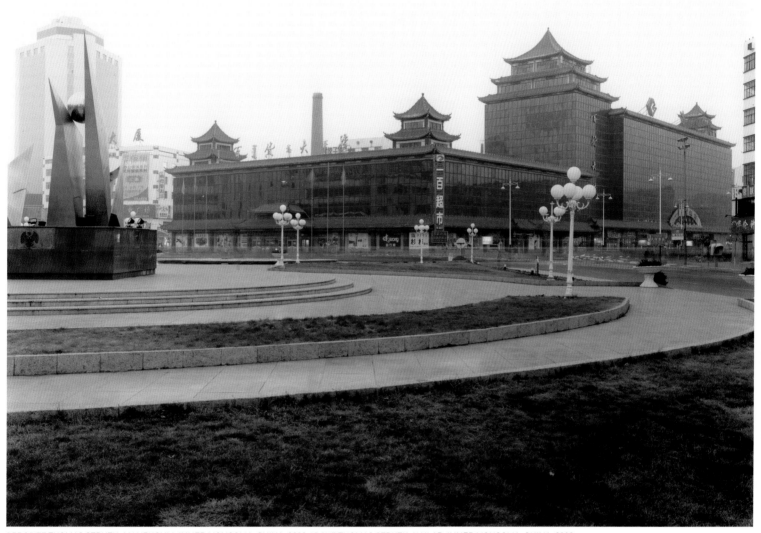

OPPOSITE THOMAS STRUTH, MANZHOULI, INNER MONGOLIA, CHINA, 2002 ABOVE THOMAS STRUTH, HAILAR, INNER MONGOLIA, CHINA, 2002

'In every city, specific individuals are responsible for what has been built, but more generally, the unconscious of the community has developed the culture in these places and it is something that you can see in every city, every day. History is a common process. People are thus responsible and add to the environment we live in. However, I am not interested in making an archive of cities around the world. I have a desire to raise questions about responsibility and the effects of the natural and built environment.

Between 1995 and 2002, I made several trips to China, which had interested me since the late sixties. There were four trips in total, each lasting around two and a half weeks. For the most recent trip we thought it would be interesting to go very far north to the Russian border. We stayed with a group of nomads in the Steppes and visited two of the more recent cities there, Manzhouli and Hailar.

The architectural scenery in the photographs of Manzhouli is a particular mixture of Russian and Western colonial influences. It is surprising to find this phenomenon in the middle of the desert, far away from the mainstream cities. There is a similarity to Las Vegas in the use of fake ornaments. These façades are like the skins or masks of buildings, indicating a globalization of culture which reaches into the farthest corner. The transition of China is amazing. The mentality of the country is turning upside down, but we don't know yet what the outcome will be. It's very exciting and dramatic as we watch it happen.'

PAUL GRAHAM THROUGHOUT THE 1980S AND 1990S, GRAHAM WAS A LEADING FIGURE IN THE BRITISH DOCUMENTARY SCENE, EXPLORING POLITICALLY LOADED SUBJECTS SUCH AS UNEMPLOYMENT (*BEYOND CARING*, 1986), NORTHERN IRELAND (*TROUBLED LAND*, 1987) AND THE UNEASY PAST OF AND CONTEMPORARY UTOPIAN ATTITUDES TOWARDS EUROPE (*NEW EUROPE*, 1996). OFTEN WORKING UNDER THE COLLECTIVE LABEL 'NEW DOCUMENTARISTS', WITH BRITISH PHOTOGRAPHERS SUCH AS MARTIN PARR, ANNA FOX, PAUL SEAWRIGHT AND PAUL REAS, GRAHAM CHALLENGES THE TRADITIONAL BOUNDARIES BETWEEN REPORTAGE, PORTRAITURE AND LANDSCAPE PHOTOGRAPHY.

'*American Night* came out of a period of living in America and seeing the huge social fracture there. As regards the working process, I'm not one of those photographers who sits in my study and thinks of a project which is then directly executed. To me it's much more about intuition combined with intellect, and when you have a worthwhile idea, you should be prepared to gamble on it, test it out and see what the world gives back. In this case that's pretty much what happened. I do all my own printing. By doing this you also make discoveries along the way. When I first made the white pictures, almost by mistake, I lived with them for about three months just not knowing what I myself thought of them – it was not just that they were new to other people, but they were also new to me. I am naturally very self-critical, with my own high standards, and it took time for me to realize just how valid this form of imagery was, how it was indeed valid and appropriate, how it shockingly mimicked the visual blindness of a society to itself. What you end up with is something that oscillates between beauty – people get very seduced by the pastel tones and misty whites – and the sharp punch that comes when you look closer and realize precisely what the image is about. I liked that contradiction between the subject matter and its form.

PAUL GRAHAM, AMERICAN NIGHT #14, MEMPHIS, 2000

'At the very beginning I was photographing in the avenues of Manhattan, in these huge canyons of shadow and sunlight. Initially the darker ones seemed more successful – partly because they are easier and partly because they look like other generic images of poverty, dispossession and urban street life. I remember realizing that this is one of the unwritten rules of photography – if you are doing something about marginalized or dispossessed individuals you somehow are supposed to take those pictures with weighty dark tones and shadows. It's the accepted visual expression of their condition. So, if you take an original negative which has been correctly exposed but printed a few degrees darker and full of shadows (an interpretation that is considered "right" or "faithful") and instead print it a few degrees lighter and high key, people think it's "manipulated" and ask what is going on – a question that it never occurred to them to ask about the first process. One expression is an accepted technique, while the other is regarded with suspicion.

In the end the project had three types of pictures. About 80% are the bright, burning-white images. About 10% are the full-colour houses. These are just regular colour photographs, but they look super-saturated after the starvation diet of the white pictures. Then there is a small set of dark street pictures. They act like a play within a play, using classic street photography language, intensely "inner city", closer, more claustrophobic, and full of drama.'

ABOVE PAUL GRAHAM, AMERICAN NIGHT #63, CLARKSDALE, 2000 BELOW PAUL GRAHAM, AMERICAN NIGHT #7, CALIFORNIA, 2002

PHILIP-LORCA DICORCIA AMERICAN ARTIST DICORCIA'S *HEADS* WAS FIRST PUBLISHED AND EXHIBITED IN 2000. TAKEN IN NEW YORK'S TIMES SQUARE, THE IMAGES SHOW UNSUSPECTING PASSERS-BY CAUGHT BY THE CONSTANT CLICKING OF A LONG-LENS CAMERA. DICORCIA'S WELL-CONSIDERED PROCESS TIPS THE BALANCE OF POWER AND CONTROL OUT OF HIS HANDS AND LEAVES MUCH MORE TO CHANCE, SO THAT THE EDITING BECOMES CRUCIAL. BECAUSE THE SUBJECTS WERE UNAWARE OF BEING PHOTOGRAPHED, THEY DO NOT POSE OR TRY TO PERSUADE THE PHOTOGRAPHER IN ANY WAY THAT MIGHT INFLUENCE THE FINAL REPRESENTATION. THE WORK RAISES QUESTIONS ABOUT TRADITIONAL STREET PHOTOGRAPHY AND ABOUT THE TRADITIONAL OUTCOMES OF PORTRAITURE.

'I often start with an abstract idea, which gets me there, and by the time I have finished the project the idea is no longer in my head and may even have altered. It doesn't begin with a really open investigation of something. I generally have a specific thing I am looking for, and I am looking to see if I can achieve that.'

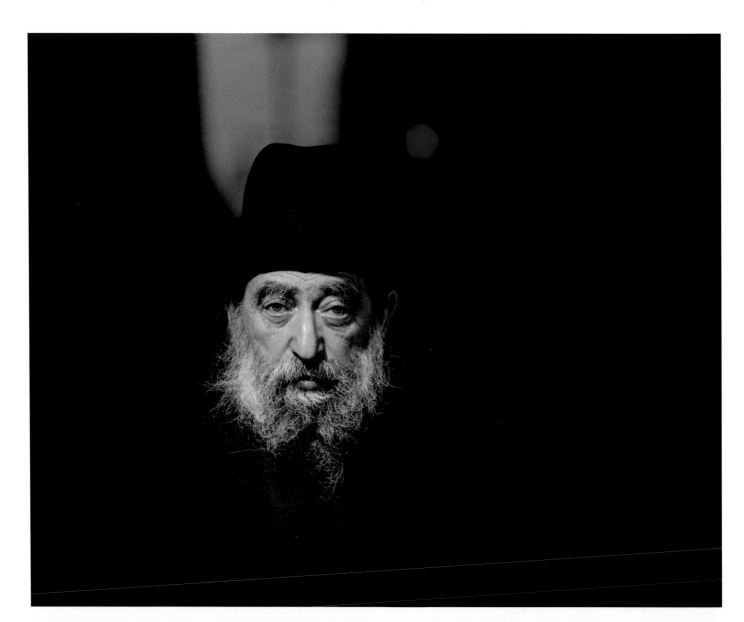

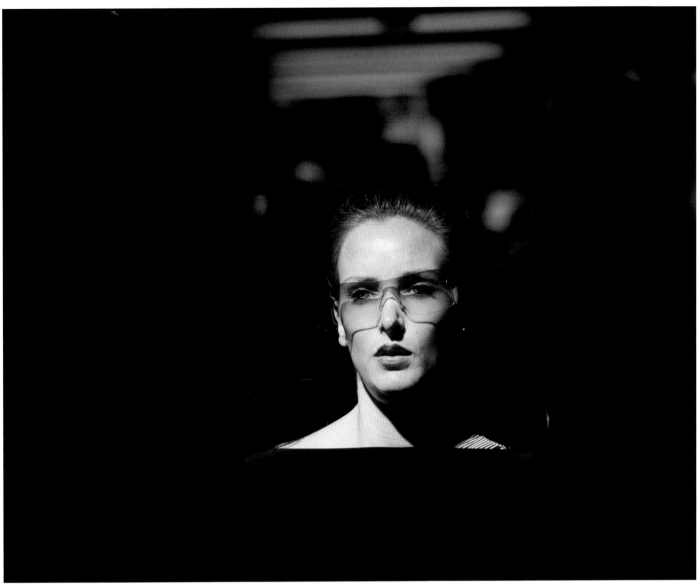

OPPOSITE PHILIP-LORCA DICORCIA, HEAD #13, 2000 ABOVE PHILIP-LORCA DICORCIA, HEAD #24, 2000

'In this particular case it was based on two things. The conceptual part had something to do with the Baader-Meinhof Gang, and the way it looks had something to do with *La Passion de Jeanne D'Arc*, a movie made in 1928 by Carl Dreyer. The working title for it was *The Passion of Hansel and Gretel* because the names of Baader-Meinhof were Hans and Greta. It seemed to me that New York was being transformed, somewhat oppressively, into something analogous to the corporate, almost fascistic, controlled State that existed in Germany at the time of the Baader-Meinhof Gang. Terrorism has actually been given a bad name. It used to be called "the Resistance Movement". There have been situations when there were legitimate justifications for it. To live underground and carry out certain acts. There's no way to be an innocent any more. I don't like the idea of hurting civilians, no matter which side does it.

The Baader-Meinhof Gang lived underground and each had to appear to be someone else to their neighbours. Their interior and private life was in no way reflected in their exterior. That was part of what I was interested in. Giuliani basically used middle-class fears to perpetuate his own agenda. Las Vegas and mall culture have a creeping malaise which has almost become the norm outside of New York City. So to see it happen in New York was extremely disturbing for me, as it seemed like one of the few places in America where all that crap didn't exist. To see Times Square transformed that way did represent to me a political shift and a social change, and that was what I was trying to investigate.'

NOTES

1 Aaron Scharf, *Art and Photography* (London: Penguin, rev. edn 1974)

2 Charles Baudelaire, 'Salon de 1859', in *The Mirror of Art*, translated by Jonathan Mayne (London: Phaidon, 1955). Quoted in John Szarkowski, 'The Photographer's Eye', in Jason Gaiger and Paul Wood (eds), *Art of the Twentieth Century: A Reader* (New Haven and London: Yale University Press, 2003), p. 133.

3 Art historian Abigail Solomon-Godeau has commented, 'Although the attempt to draw a distinction between art photography and photography done by artists might initially be taken for a semantic quibble, or worse, as informed by the desire to privilege the photographic work of artists over that of photographers, there remain significant differences in the two forms of practice.' Abigail Solomon-Godeau, 'Conventional Pictures', *The Print Collector's Newsletter*, vol. 12, no. 5 (November/December 1981), p. 138.

4 Marina Warner, 'Parlour Made', *Creative Camera*, no. 315, April/May 1992, p. 28.

5 Walter Benjamin, 'The Work of Art in the Age of Mechanical Reproduction', in *Illuminations* (London: New Left Books, 1973), pp. 219–53.

6 Peter Galassi, 'Photography is a Foreign Language', *Philip-Lorca diCorcia* (New York: Museum of Modern Art, 1995), p. 8.

7 Stieglitz founded the magazine *Camera Work*, which ran from 1903 to 1917. Featuring images that were beautifully produced on fine Japanese tissue using the photogravure technique and pasted in by hand, it was highly influential and featured artists such as Frank Eugene, Clarence White and Paul Strand. Stieglitz's 291 Gallery in New York was one of the first commercial galleries in the United States. Between 1908 and 1917 it exhibited painting, photography and sculpture. Exhibitions included the works of Matisse, Rodin and Cézanne, as well as African artefacts.

8 Some European museums had been collecting for much longer and had already established photographic departments. For example, the Victoria & Albert Museum in London collected photography from its founding in 1856, and in the same year the then director, Henry Cole, bought a number of fine-art photographs for the collection. Work made with artistic intent and merit by Julia Margaret Cameron was purchased in 1865, and the museum's first significant gift of a private collection of photographs (the Townshend Bequest) arrived in 1868. The Bequest included some of the finest Gustave Le Gray prints. See Mark Haworth-Booth, *Photography: An Independent Art* (Princeton: Princeton University Press, 1997).

9 David Campany (ed.), *Art and Photography* (London: Phaidon, 2003), p. 39.

10 Charlotte Cotton, *Imperfect Beauty: The Making of Contemporary Fashion Photographs* (London: V&A Publications, 2000), p. 6.

FURTHER READING

Histories of photography

Clarke, Graham, *The Photograph* (Oxford: Oxford University Press, 1997)

Fogle, Douglas, *The Last Picture Show* (Minneapolis: Walker Arts Center, 2003)

Frizot, Michel, *A New History of Photography* (Cologne: Könemann, 1998)

Haworth-Booth, Mark, *Photography: An Independent Art* (Princeton: Princeton University Press, 1997)

Gernsheim, Helmut and Alison Gernsheim, *A Concise History of Photography* (London: Thames & Hudson, 1965)

Grundberg, Andy and Chris Bruce, *After Art: Rethinking 150 Years of Photography* (Seattle: University of Washington, 1995)

Heron, Liz and Val Williams, *Illuminations: Women Writing on Photography from the 1850s to the Present* (London: I. B. Tauris, 1996)

Jeffrey, Ian, *Photography: A Concise History* (London: Thames & Hudson, 1981)

Jeffrey, Ian, *Revisions: An Alternative History of Photography* (Bradford: National Museum of Photography, Film and Television, 1999)

Marien, Mary Warner, *Photography: A Cultural History* (London: Laurence King, 2002)

Miller, Denise, *Photography's Multiple Roles* (Chicago: Museum of Contemporary Photography, 1998)

Mora, Giles, *PhotoSpeak: A Guide to the Ideas, Movements, and Techniques of Photography, 1839 to the Present* (New York and London: Abbeville, 1998)

Newhall, Beaumont, *The History of Photography: From 1839 to the Present Day* (New York: Museum of Modern Art, 1982)

Orvell, Miles, *American Photography* (Oxford: Oxford University Press, 2003)

Parr, Martin and Gerry Badger, *The Photobook: A History – Volume 1* (London: Phaidon, 2004)

Rosenblum, Naomi, *A History of Women Photographers* (New York and London: Abbeville, 1994)

Scharf, Aaron, *Art and Photography* (London: Penguin, 1968, rev. edn 1974)

Tucker, Anne Wilker et al., *The History of Japanese Photography* (New Haven: Yale University Press, 2003)

Various, *An Anthology of African and Indian Ocean Photography* (Paris: Editions Revue Noire, 1998)

Watriss, Wendy and Lois Parkinson Zamora, *Image and Memory: Photography from Latin America, 1866–1994* (Austin: University of Texas Press, 1998)

Contemporary photography

Browning, Simon et al., *Surface: Contemporary Photographic Practice* (London: Booth-Clibborn Editions, 1996)

Campany, David, *Art and Photography* (London: Phaidon, 2003)

Cotton, Charlotte, *The Photograph as Contemporary Art* (London: Thames & Hudson, 2004)

Fogle, Douglas, *Stills: Emerging Photography in the 1990s* (Minneapolis: Walker Art Center, 1997)

Hanhardt, John and Nancy Spector, *Moving Pictures: Contemporary Photography and Video from the Guggenheim Museum Collections* (New York: Guggenheim Museum, 2002)

Hung, Wu and Christopher Phillips, *Between Past and Present: New Photography and Video from China* (Göttingen: Steidl, 2004)

Janus, Elizabeth, *Veronica's Revenge: Contemporary Perspectives on Photography* (Zurich: Scalo, 1998)

Various, *Blink* (London: Phaidon, 2002)

Theories of photography

Barthes, Roland, *Image Music Text* (London: Fontana Press, 1977)

Barthes, Roland, *Camera Lucida: Reflections on Photography* (London: Cape, 1982)

Batchen, Geoffrey, *Each Wild Idea: Writing, Photography, History* (Cambridge, Mass., and London: MIT Press, 2001)

Batchen, Geoffrey, *Vernacular Photographies* (Cambridge, Mass., and London: MIT Press, 2001)

Benjamin, Walter, *Illuminations* (London: Cape, 1970)

Bolton, Richard, *The Contest of Meaning: Critical Histories of Photography* (Cambridge, Mass., and London: MIT Press, 1989)

Bourdieu, Pierre, *Photography: A Middle-Brow Art* (Cambridge: Polity Press in association with Blackwell, 1990)

Brittain, David, *Creative Camera: Thirty Years of Writing* (Manchester: Manchester University Press, 1999)

Burgin, Victor, *Thinking Photography* (London: Macmillan, 1982)

Crimp, Douglas, *On the Museum's Ruins* (Cambridge, Mass., and London: MIT Press, 1993)

Crow, Thomas, *Unwritten Histories of Conceptual Art: Against Visual Culture* (New Haven and London: Yale University Press, 1996)

Evans, Jessica, *The Camerawork Essays: Context and Meaning in Photography* (London and New York: Rivers Oram Press and New York University Press, 1997)

Flusser, Vilem, *Towards a Philosophy of Photography* (London: Reaktion, 1983)

Foster, Hal, *The Return of the Real* (Cambridge, Mass., and London: MIT Press, 1996)

Friday, Jonathan, *Aesthetics and Photography* (Aldershot: Ashgate, 2002)

Green, David (ed.), *Where is the Photograph?* (Brighton: Photoforum and Photoworks, 2003)

Hall, Stuart, *Representation: Cultural Representations and Signifying Practices* (Milton Keynes: Open University Press, 1997)

Langford, Martha, *Suspended Conversations: The Afterlife of Memory in Photographic Albums* (Quebec: McGill-Queen's University Press, 2001)

Lister, Martin, *The Photographic Image in Digital Culture* (London: Routledge, 1995)

Mellor, David, *Chemical Traces: Photography and Conceptual Art, 1968–1998* (Hull: Kingston upon Hull City Museums and Art Galleries, 1998)

Solomon-Godeau, Abigail, *Photography at the Dock: Essays on Photographic History, Institutions, and Practices* (Minneapolis: University of Minnesota Press, 1991)

Sontag, Susan, *On Photography* (London: Penguin, 1979)

Squiers, Carol, *The Critical Image: Essays on Contemporary Photography* (London: Lawrence & Wishart Ltd, 1991)

Tagg, John, *The Burden of Representation: Essays on Photographies and Histories* (Basingstoke: Palgrave Macmillan, 1988)

Wells, Liz, *Photography: A Critical Introduction* (London and New York: Routledge, 2000)

Wells, Liz, *The Photography Reader* (London and New York: Routledge, 2003)

Portrait

Clarke, Graham (ed.), *The Portrait in Photography* (London: Reaktion, 1992)

Durden, M. and C. Richardson, *Face On: Photography as Social Exchange* (London: Black Dog Publishing, 2000)

Irmas, Deborah and Robert Sobieszek, *The Camera I: Photographic Self-Portraits from the Sudery and Syndey Irmas Collection* (Los Angeles and New York: Los Angeles County Museum of Art and Harry N. Abrams, Inc., 1994)

Pultz, John, *Photography and the Body* (London: Weidenfeld and Nicolson, 1995)

Sobieszek, Robert, *Ghost in the Shell: Photography and the Human Soul 1850–2000* (Los Angeles and Cambridge, Mass.: Los Angeles County Museum of Art and MIT Press, 1999)

Townsend, Chris and Channel Four, *Vile Bodies: Photography and the Crisis of Looking* (Munich, New York and London: Prestel in association with Channel Four Television, 1998)

Landscape

Osborne, Peter, *Travelling Light: Photography, Travel and Visual Culture* (Manchester: Manchester University Press, 2000)

Stack, Trudy Wilner, *Sea Change: The Seascape in Contemporary Photography* (Tucson: Center for Creative Photography, University of Arizona, 1998)

Taylor, John, *Dream of England: Landscape, Photography and the Tourist's Imagination* (Manchester: Manchester University Press, 1994)

Wells, Liz et al., *Shifting Horizons – Women's Landscape Photography Now* (London: I. B. Tauris, 2000)

Narrative

Blessing, Jennifer, *Rrose is a rrose is a rrose: Gender Performance in Photography* (New York: Guggenheim Museum, 1997)

Kohler, Michael, *Constructed Realities: The Art of Staged Photography* (Zurich: Edition Stemmle, 1995)

Lingwood, James, *Staging the Self: Self-Portrait Photography 1840s–1980s* (London: National Portrait Gallery, 1986)

Nobel, Andrea and Alex Hughs, *Phototextualities: Intersections of Photography and Narrative* (Albuquerque: University of New Mexico Press, 2003)

Scott, Clive, *The Spoken Image: Photography and Language* (London: Reaktion, 1999)

Fashion

Chermayeff, Catherine, *Fashion Photography Now* (New York: Harry N. Abrams, Inc., 2000)

Cotton, Charlotte, *Imperfect Beauty: The Making of Contemporary Fashion Photographs* (London: V&A Publications, 2000)

Derrick, Robin and Robin Muir, *Unseen Vogue: The Secret History of Fashion Photography* (London: Little, Brown, 2002)

Kismaric, Susan and E. Respini, *Fashioning Fiction in Photography Since 1990* (New York: Museum of Modern Art, 2004)

Lehmann, Ulrich, Jessica Morgan and Gilles Lipovetsky, *Chic Clicks: Creativity and Commerce in Contemporary Fashion Photography* (Ostfildern-ruit: Hatje Cantz, 2002)

Lovatt-Smith, Lisa, *Contemporary Fashion Photography* (Cologne: Taschen, 1995)

Nickerson, Camilla and Neville Wakefield, *Fashion: Fashion Photography of the Nineties* (Zurich: Scalo, 1996)

Williams, Val, *Look at Me: Fashion Photography in Britain 1960 to Present* (London: British Council, 1998)

Object

Edwards, Elizabeth and Janice Hart (eds), *Photographs, Objects, Histories* (London: Routledge, 2004)

Gallagher, Anne, *Still Life* (London: British Council, 2003)

Haworth-Booth, Mark, *Things* (London: Jonathan Cape, 2005)

Sante, Luc et al., *Making It Real* (New York: Independent Curators Incorporated, 1997)

Weiermair, Peter (ed.), *The Measure of All Things: On the Relationship Between Photography and Objects* (Zurich: Edition Stemmle, 1999)

Document

Grundberg, Andy, *Crisis of the Real: Writings on Photography Since 1974* (New York: Aperture, 1999)

Liebs, Holger, *The Same Returns: The Tradition of Documentary Photography* (Zurich: Scalo, 1998)

Roberts, John, *The Art of Interruption: Realism, Photography and the Everyday* (Manchester: Manchester University Press, 1998)

Rosenblum, Naomi, *Documentary Photography: Past and Present* (Chicago: Museum of Contemporary Photography, 1998)

Rugoff, Ralph, *Scene of a Crime*, (Cambridge, Mass., and London: MIT Press, 1997)

City

Earle, Edward et al., *Strangers: The First ICP Triennial of Photography and Video* (New York: ICP and Steidl, 2003)

Museum of Modern Art Oxford, *Open City: Street Photographs Since 1950* (Oxford: Museum of Modern Art, 2001)

Westerbeck, Colin and Joel Meyerowitz, *Bystander: A History of Street Photography* (Boston: Little, Brown, 1994)

Artists' monographs

Aitken, Doug, *Notes for New Religions, Notes for No Religions* (Ostfildern-ruit: Hatje Cantz, 2001)

Aitken, Doug, and Francesco Bonami, *Doug Aitken: (New Ocean)* (London: Serpentine Gallery, 2001)

Sharp, Amanda et al., *Doug Aitken* (London: Phaidon, 2001)

Kish, Dan et al., *Doug Aitken: A–Z (fractals)* (Ostfildern-ruit: Hatje Cantz, 2002)

Barbieri, Olivio, *Nosofareast* (Rome: Donzelli Editore, 2002)

Barney, Tina, *Friends and Relations* (Washington, D.C., and London: Smithsonian Institution Press in association with Constance Sullivan Editions, 1991)

Barney, Tina, *Tina Barney: Photographs: Theater of Manners* (Zurich and New York: Scalo, 1997)

Barth, Uta, *Uta Barth: In Between Places* (Seattle: Henry Art Gallery, University of Washington, 2000)

Clark, Robert, and Joanne Lee, *Frame: Uta Barth, Duncan Higgins, Carter Potter* (Sheffield: Site Gallery, 2000)

Higgs, Matthew et al., *Uta Barth* (London: Phaidon, 2004)

Basilico, Gabriele, *Cityscapes* (London: Thames & Hudson, 1999)

Basilico, Gabriele, *Berlin* (London: Thames & Hudson, 2002)

Basilico, Gabriele, *Fotografie, 1978–2002* (Turin: Edizione GAM, 2002)

Blees Luxemburg, Rut, *Liebeslied* (London: Black Dog Publishing, 2001)

Blees Luxemburg, Rut, *London: A Modern Project* (London: RAM Publications, 2001)

Blees Luxemburg, Rut, *Ffolly* (Cardiff and Swansea: Ffotogallery and Glynn Vivian Art Gallery, 2003)

Brotherus, Elina, *Magnetic North: Current Installation Photography in Finland* (Helsinki: Finnish Museum of Photography, 2001)

Brotherus, Elina, *Decisive days: Elina Brotherus: valokuvia = photographies = photographs, 1997–2001* (Oulu: Pohjoinen, 2002)

The Citigroup Private Bank Photography Prize 2002 (London: Photographers' Gallery, 2002)

Bustamante, Jean-Marc, *Oeuvres photographiques, 1978–1999* (Paris: Centre National de la Photographie, 1999)

Bustamante, Jean-Marc, *Something is Missing* (Salamanca: Ediciones Universidad de Salamanca, 1999)

Bustamante, Jean-Marc, *L.P.* (Lucerne: New Museum of Art, 2001)

Bustamante, Jean-Marc, *Nouvelles Scenes* (London: Timothy Taylor Gallery, 2003)

Bustamante, Jean-Marc and Alfred Pacquement, *Jean-Marc Bustamante* (Paris: Gallimard, 2003)

Calle, Sophie, *Double Game* (London: Violette Editions, 1999)

Calle, Sophie, *M'as-Tu Vue* (Munich, Berlin, London and New York: Prestel, 2003)

Calle, Sophie, *Exquisite Pain* (London: Thames & Hudson, 2004)

Crewdson, Gregory, *Dream of Life* (Salamanca: Ediciones Universidad de Salamanca, 1999)

Crewdson, Gregory, *Twilight* (New York: Harry N. Abrams, Inc., 2002)

Day, Corinne, *Diary* (Hamburg: Kruse Verlag, 2000)

Dean, Tacita, *Selected Works 1994–2000* (Basel: Schwabe Museum für Gegenwartskunst, 2000)

Dean, Tacita, *Floh* (Göttingen: Steidl, 2001)

Dean, Tacita, *Tacita Dean* (London: Tate Publishing, 2001)

Dean, Tacita, *The Green Ray* (Cologne: Walther Koenig, 2003)

Delahaye, Luc, *L'Autre* (London: Phaidon, 1999)

Delahaye, Luc, *History* (London: Chris Boot, 2003)

Grosse Illusionen: Thomas Demand, Andreas Gursky, Edward Ruscha (Bonn: Kunstmuseum Bonn, 1999)

Bonami, Francesco et al., *Thomas Demand* (London: Thames & Hudson, 2000)

Beccaria, Marcella (ed.), *Thomas Demand* (Milan: Skira, 2002)

Galassi, Peter, *Philip-Lorca diCorcia: Contemporaries* (New York: Museum of Modern Art, 1995)

Brea, José Luis, *Philip-Lorca diCorcia: Streetwork 1993–1997* (Salamanca: Ediciones Universidad de Salamanca, 1998)

diCorcia, Philip-Lorca, *Heads* (Göttingen: Steidl, 2001)

diCorcia, Philip-Lorca and Jeff Rian, *Recontres 6* (Paris: Editions Images Modernes, 2001)

diCorcia, Philip-Lorca, *A Storybook Life* (Santa Fe: Twin Palms Publishers, 2003)

Lowry, Joanna and Michael Bracewell, *Rineke Dijkstra* (London: Photographers' Gallery, 1997)

Dijkstra, Rineke, *Portraits* (London: Art Data, 2004)

Dijkstra, Rineke, *Portraits: A Retrospective* (New York: D.A.P./Schirmer/Mosel, 2005)

Bonetti, Maria Francesca and Guido Schlinkert, *Samuel Fosso* (Milan: 5 Continents Editions, 2004)

Goldin, Nan, *I'll be your mirror* (New York and Zurich: Whitney Museum of American Art and Scalo, 1996)

Goldin, Nan, *The Devil's Playground* (London: Phaidon, 2003)

Graham, Paul, *Troubled Land: The Social Landscape of Northern Ireland* (London: Grey Editions, 1987)

Graham, Paul, *End of an Age* (Zurich: Scalo, 1999)

Graham, Paul, *American Night* (Göttingen: Steidl, 2003)

Graham, Paul, *New Europe* (Manchester: Cornerhouse, 2004)

Rugoff, Ralph, *Andreas Gursky: Photographs 1994–1998* (Edinburgh: National Galleries of Scotland, 1999)

Galassi, Peter, *Andreas Gursky* (New York: Museum of Modern Art, 2001)

Gursky, Andreas et al., *The Politics of Place* (Umea: Bildmuseet, 2002)

Hanzlová, Jitká, *Female* (Munich: Schirmer/Mosel, 2000)

The Citibank Private Bank Photography Prize 2003 (London: Photographers' Gallery, 2003)

Hatakeyama, Naoya, *Slow Glass: Naoya Hatakeyama* (Oxford and Winchester: Light Xchange and Winchester Gallery, 2002)

Hatakeyama, Naoya, *Atmos* (Tucson: Nazraeli Press, 2003)

Henson, Bill, *Lux et Nox* (Zurich: Scalo, 2002)

Cooper, Dennis, *Bill Henson* (Salamanca: Ediciones Universidad de Salamanca, 2003)

Henson, Bill, *Mnemosyne: Photographic Works 1974–2004* (Zurich: Scalo, 2005)

Höfer, Candida, *A Monograph* (London: Thames & Hudson, 2003)

Höfer, Candida, *Architecture of Absence* (New York: Aperture, 2004)

Knight, Nick, *Flora* (Munich: Schirmer/Mosel in collaboration with the Natural History Museum, London, 1997)

Knight, Nick, *Nicknight: The Photographs of Nick Knight* (New York: teNeues, 1997)

Kurland, Justine and Jonathan Raymond, *Old Joy* (San Francisco: Artspace Books, 2004)

Ferguson, Russell and L. A. Martin, *Nikki S. Lee: Projects* (Ostfildern-ruit: Hatje Cantz, 2001)

Leonard, Zoe and Cheryl Dunye, *The Fae Richards Photo Archive* (London: Artspace Books, 1996)

Letinsky, Laura, *Venus Inferred* (Chicago: University of Chicago Press, 2000)

Lockhart, Sharon, *Teatro Amazonas* (Rotterdam: NAI Publishers, 2000)

Lockhart, Sharon, *Sharon Lockhart* (Chicago: Museum of Contemporary Art, 2001)

McDean, Craig, *Lifescapes* (Göttingen: Steidl, 2004)

Manchot, Melanie, *Love is a Stranger: Photographs 1998–2001* (Munich and New York: Prestel, 2001)

Meene, Hellen van, *Portraits* (New York: Aperture, 2004)

Meiselas, Susan, *Carnival Strippers* (New York and Göttingen: Whitney Museum of American Art and Steidl, 2003)

Meiselas, Susan, *Encounters with the Dani* (New York and Göttingen: International Center of Photography and Steidl, 2003)

Mikhailov, Boris, *Case History* (Zurich: Scalo, 1999)

The Hasselblad Award 2000: Boris (Gothenburg and New York: Hasselblad Center, 2001)

Mikhailov, Boris, *A Retrospective* (Zurich and New York: Scalo, 2003)

Tupitsyn, Margarita, Victor Tupitsyn and Museu Serralves, *Verbal Photography: Ilya Kabakov, Boris Mikhailov and the Moscow Archive of New Art* (Porto: Fundação Serralves, 2004)

Misrach, Richard, *Desert Cantos* (Albuquerque: University of New Mexico Press, 1987)

Misrach, Richard, *Photographs 1975–1987* (Tokyo: Gallery Min, 1988)

Moffatt, Tracey, *Tracey Moffatt* (Bristol: Arnolfini Gallery, 1998)

Moffatt, Tracey, *Tracey Moffatt: Free-falling* (New York: Dia Center for the Arts, 1998)

Moffatt, Tracey, *Tracey Moffatt* (Brisbane: Institute of Modern Art, 1999)

Godby, Michael and Octavio Zaya, *Zwelethu Mthethwa* (Turin: Marco Noire Editore, 1999)

Muniz, Vik, *Seeing is Believing* (Santa Fe: Arena, 1998)

Muniz, Vik, *Reflex: A Vik Muniz Primer* (New York: Aperture, 2004)

Niedermayr, Walter, *Civil Operations* (Ostfildern-ruit: Hatje Cantz, 2003)

Nieweg, Simone, *Landschaften und Gartenstucken* (Amsterdam and Munich: Huis Marseille and Schirmer/Mosel, 2002)

Orozco, Gabriel, *Photogravity* (Philadelphia: Philadelphia Museum of Art, 2000)

Orozco, Gabriel, *Photographs* (Göttingen: Steidl, 2004)

Parr, Martin, *Small World* (Stockport: Dewi Lewis, 1995)

Parr, Martin, *The Last Resort* (Stockport: Dewi Lewis, 1998)

Parr, Martin, *Common Sense* (Stockport: Dewi Lewis, 1999)

Parr, Martin, *Think of England* (London: Phaidon, 2000)

Williams, Val, *Martin Parr* (London: Phaidon, 2002)

Winzen, Matthias (ed.), *Thomas Ruff: 1979 to the Present* (Cologne: Walther Koenig, 2001)

Ruff, Thomas, *Nudes* (Munich: Schirmer/Mosel, 2003)

Ruff, Thomas, *Machines* (Ostfildern-ruit: Hatje Cantz, 2004)

Schorr, Collier, *Conquistadores* (New York: Idea, 2003)

Sekula, Allan, *Dismal Science: Photoworks 1972–1995* (Illinois: Illinois State University, 1995)

Sekula, Allan, *Performance under Working Conditions* (Vienna and Ostfildern-ruit: Generali Foundation and Hatje Cantz, 2003)

Sekula, Allan, *Fish Story* (Düsseldorf: Richter, 2002)

Serralongue, Bruno, *Photographs by Bruno Serralongue* (Dijon: Les Presses du Réel, 2002)

Sherman, Cindy, *Retrospective* (New York: Thames & Hudson, 1997)

Williams, Edsel, *Early Work of Cindy Sherman* (New York: Glenn Horowitz Bookseller, 2001)

Sherman, Cindy, *Complete Untitled Film Stills* (New York: Museum of Modern Art, 2003)

Sherman, Cindy, *Clowns* (Munich: Schirmer/Mosel, 2004)

Williams, Val, *Hannah Starkey* (Dublin: Irish Museum of Modern Art, 2000)

Sternfeld, Joel, *Stranger Passing* (Boston: Bulfinch, 2001)

Sternfeld, Joel, *Walking the High Line* (Göttingen: Steidl, 2001)

Sternfeld, Joel, *American Prospects* (Göttingen: Steidl, 2003)

Streuli, Beat, *Beat Streuli (Avvistamenti = Sightings)* (Turin: Hopeful Monster, 2001)

Streuli, Beat, *New York City 2002–2003* (Ostfildern-ruit: Hatje Cantz, 2003)

Struth, Thomas, *Museum Photographs* (Munich: Schirmer/Mosel, 1993)

Struth, Thomas, *Portraits* (Munich: Schirmer/Mosel, 2001)

Struth, Thomas, *Still* (New York: Monacelli Press, 2001)

Struth, Thomas, *New Pictures from Paradise* (Munich: Schirmer/Mosel, 2002)

Sugimoto, Hiroshi, *Seascapes* (New York: Fotofolio, 1999)

Sugimoto, Hiroshi, *Portraits* (New York: Harry N. Abrams, Inc., 2000)

Sugimoto, Hiroshi, *Theaters* (New York: Matsumoto, 2000)

Sugimoto, Hiroshi, *Architecture* (New York: D.A.P., 2003)

Sugimoto, Hiroshi, *Conceptual Forms* (Paris: Fondation Cartier, 2004)

Sultan, Larry, *Pictures from Home* (New York: Harry N. Abrams, Inc., 1992)

Sultan, Larry and Mike Mandel, *Evidence* (New York: D.A.P., 2003)

Sultan, Larry, *The Valley* (Zurich: Scalo, 2004)

Bracewell, Michael et al., *Sam Taylor-Wood* (Göttingen: Steidl, 2002)

Taylor-Wood, Sam, *Crying Men* (Göttingen and New York: Steidl and Matthew Marks Gallery, 2004)

Tillmans, Wolfgang, *Berg* (Cologne: Taschen, 1998)

Halley, Peter et al., *Wolfgang Tillmans* (London: Phaidon, 2002)

Horlock, Mary et al., *If One Thing Matters Everything Matters* (London: Tate Publishing, 2003)

de Duve, Thierry et al., *Jeff Wall* (London: Phaidon, 1996)

Wall, Jeff, *Photographs* (Göttingen: Steidl, 2003)

Wang, Qingsong, *Romantique* (Beijing: Timezone 8/Courtyard, 2005)

Wearing, Gillian, *Signs that you want them to say and not Signs that say what someone else wants you to say* (London: Maureen Paley/Interim Art, 1997)

Ferguson, Russell et al., *Gillian Wearing* (London: Phaidon, 1999)

Welling, James, *New Abstractions* (Hanover: Sprengel Museum, 1999)

Rogers, Sarah and Michael Fried, *James Welling Photographs: 1973–1999* (Columbus: Wexner Center for the Arts, 2000)

Welling, James, *Abstract* (Toronto: Art Gallery, York University, 2002)

Dyer, Geoff and Peter Ackroyd, *Richard Wentworth – Eugene Atget: faux amis* (London: Photographers' Gallery and Lisson Gallery, 2001)

Richard Wentworth, *Making Do and Getting By* (London: Tate Publishing, 1984)

Wurm, Erwin, *One Minute Sculptures: 1988–1998* (Ostfildern-ruit: Hatje Cantz, 1999)

Wurm, Erwin, *I Love my Time, I Don't Like my Time* (Ostfildern-ruit: Hatje Cantz, 2004)

LIST OF ILLUSTRATIONS

Images are referred to by page number. Measurements are given in centimetres and inches (the latter in brackets), height preceding width.

JACKET
Hannah Starkey
March 2002, 2002
C-print
121.9 x 149.9 (48 x 59)
Edition of 5 + 1 artist's proof
Courtesy of Maureen Paley

[2] Hellen van Meene
Untitled, 2000
C-print
38.1 x 38.1 (15 x 15)
Courtesy of Sadie Coles HQ and Matthew Marks Gallery

[4] Richard Renaldi
Fresno: Dy, Thai, Sokha and Lay, 2003
C-print
121.9 x 152.4 (48 x 60)
Courtesy of Yossi Milo Gallery

[6] Laura Letinsky
I did not remember I had forgotten: Untitled #80, 2003
Digital C-print
71.1 x 83.8 (28 x 33)
Courtesy of the artist and Edwynn Houk Gallery

[8] Elsie Wright
Frances and the Dancing Fairies, Cottingley Fairies, 1917
Gelatin silver chloride
11.2 x 15.2 (4³/₈ x 6)
Reproduced in *The Coming of the Fairies* (1922) by Sir Arthur Conan Doyle

[9] Attributed to Kate E. Gough
Untitled (Ducks), c. 1870
Albumen prints, watercolour and inks
22.9 x 16.5 (9 x 6¹/₂)
Courtesy V&A Picture Library

[11] Gregory Crewdson
Twilight: Untitled (overturned bus), 2001–2
Digital C-print
121.9 x 152.4 (48 x 60)
Edition of 10
Courtesy of the artist and Luhring Augustine Gallery

[12] Justine Kurland
Houses of the Holy, 2003
C-print
81.3 x 114.3 (32 x 45)
Courtesy of Gorney, Bravin and Lee

[13] Julie Moos
Domestic (Mae and Margaret), 2001
C-print
101.6 x 132.1 (40 x 52)
Courtesy of Fredericks Freiser Gallery

[14] Koto Bolofo
Lesotho Horsemen, 2003
C-print
40.6 x 30.5 (16 x 12)
Courtesy of the artist

[15] Wolfgang Tillmans
Schlüssel, 2002
C-print
210.8 x 144.8 (83 x 57)
Courtesy of Maureen Paley

[16] Boris Mikhailov
The City (Berlin), 2002–3
C-print
90 x 60 (35³/₈ x 23⁵/₈)
Courtesy of Barbara Gross Gallery

[17] Richard Wentworth
King's Cross, London, 2001
Unique colour photograph
17.8 x 27.9 (7 x 11)
Courtesy of the artist and Lisson Gallery

[18] Gillian Wearing
Album: Self-portrait at 17 years old, 2003
C-print
115.6 x 92.1 (45¹/₂ x 36¹/₄) (framed)
Edition of 6 + 2 artist's proofs
Courtesy of Maureen Paley

[22] Hellen van Meene
Untitled, 2000
C-print
39 x 39 (15³/₈ x 15³/₈)
Courtesy of Sadie Coles HQ and Matthew Marks Gallery

[23] Hellen van Meene
Untitled, 2000
C-print
39 x 39 (15³/₈ x 15³/₈)
Courtesy of Sadie Coles HQ and Matthew Marks Gallery

[24] Cindy Sherman
Untitled #395, 2000
Colour print
91.4 x 61 (36 x 24)
114.3 x 83.8 (45 x 33) (framed)
Edition of 6
Courtesy of Cindy Sherman and Metro Pictures Gallery

[24] Cindy Sherman
Untitled #396, 2000
Colour print
91.4 x 61 (36 x 24)
114.3 x 83.8 (45 x 33) (framed)
Edition of 6
Courtesy of Cindy Sherman and Metro Pictures Gallery

[25] Cindy Sherman
Untitled #397, 2000
Colour print
91.4 x 61 (36 x 24)
114.3 x 83.8 (45 x 33) (framed)
Edition of 6
Courtesy of Cindy Sherman and Metro Pictures Gallery

[26] Tina Barney
The Europeans: The Daughters, 2002
Chromogenic print
122 x 152 (48 x 60)
Courtesy of Janet Borden, Inc.

[27] Tina Barney
The Europeans: The Two Friends, 2002
Chromogenic print
121.9 x 152.4 (48 x 60)
Courtesy of Janet Borden, Inc.

[28] Tina Barney
The Europeans: The Sunday Dresses, 2004
Chromogenic print
121.9 x 152.4 (48 x 60)
Courtesy of Janet Borden, Inc.

[29] Tina Barney
The Europeans: The Hands, 2003
Chromogenic print
121.9 x 152.4 (48 x 60)
Courtesy of Janet Borden, Inc.

[30] Sam Taylor-Wood
Self-Portrait Suspended IV, 2004
C-print
135.6 x 162.8 (53¹/₄ x 63⁷/₈)
Courtesy of Jay Jopling/White Cube
© Sam Taylor-Wood 2004

[31] Sam Taylor-Wood
Self-Portrait Suspended VIII, 2004
C-print
135.6 x 162.8 (53¹/₄ x 63⁷/₈)
Courtesy of Jay Jopling/White Cube
© Sam Taylor-Wood 2004

[31] Sam Taylor-Wood
Self-Portrait Suspended II, 2004
C-print
135.6 x 162.8 (53¹/₄ x 63⁷/₈)
Courtesy of Jay Jopling/White Cube
© Sam Taylor-Wood 2004

[31] Sam Taylor-Wood
Self-Portrait Suspended VII, 2004
C-print
135.6 x 162.8 (53¹/₄ x 63⁷/₈)
Courtesy of Jay Jopling/White Cube
© Sam Taylor-Wood 2004

[31] Sam Taylor-Wood
Self-Portrait Suspended VI, 2004
C-print
135.6 x 162.8 (53¹/₄ x 63⁷/₈)
Courtesy of Jay Jopling/White Cube
© Sam Taylor-Wood 2004

[32] Katy Grannan
Sugar Camp Road: Christopher and Zachary, Bay Farm, Duxbury, MA, 2002
C-print
121.9 x 152.4 (48 x 60)
Edition of 6
Courtesy of the artist and Greenberg Van Doren Gallery

[33] Katy Grannan
Sugar Camp Road: Danielle, Vacant Lot, Burleigh Road, New Paltz, NY, 2003
C-print
121.9 x 152.4 (48 x 60)
Edition of 6
Courtesy of the artist and Greenberg Van Doren Gallery

[34] Katy Grannan
Sugar Camp Road: Angie and Betty, Shoeneck Creek, Nazareth, PA, 2003
C-print
121.9 x 152.4 (48 x 60)
Edition of 6
Courtesy of the artist and Greenberg Van Doren Gallery

[35] Katy Grannan
Sugar Camp Road: Mike, Private Property, New Paltz, NY, 2003
C-print
121.9 x 152.4 (48 x 60)
Edition of 6
Courtesy of the artist and Greenberg Van Doren Gallery

[36] Rineke Dijkstra
Shany, Palmahim Israeli Airforce Base, Israel, October 8, 2002, 2002
C-print
126 x 107 (49⁵/₈ x 42¹/₈)
Courtesy of the artist and Marian Goodman Gallery

[37] Rineke Dijkstra
Shany, Herzliya, Israel, August 1, 2003, 2003
C-print
126 x 107 (49⁵/₈ x 42¹/₈)
Courtesy of the artist and Marian Goodman Gallery

[38] Zwelethu Mthethwa
Untitled, 2002
C-print
96.5 x 129.5 (38 x 51) edition of 3
179.1 x 241.3 (70¹/₂ x 95) unique print
Courtesy of Jack Shainman Gallery

[39] Zwelethu Mthethwa
Untitled, 2003
C-print
96.5 x 129.5 (38 x 51) edition of 3
179.1 x 241.3 (70¹/₂ x 95) unique print
Courtesy of Jack Shainman Gallery

[40] Nikki S. Lee
Parts: Part (3), 2003
C-print mounted on aluminium
Courtesy of Leslie Tonkonow Artworks + Projects

[41] Nikki S. Lee
Parts: Part (37), 2003
C-print mounted on aluminium
Courtesy of Leslie Tonkonow Artworks + Projects

[41] Nikki S. Lee
Parts: The Bourgeoisie (8), 2004
Lambda print mounted on aluminium
Courtesy of Leslie Tonkonow Artworks + Projects

[41] Nikki S. Lee
Parts: Part (18), 2003
C-print mounted on aluminium
Courtesy of Leslie Tonkonow Artworks + Projects

[42] Gillian Wearing
Album: Self-portrait as my mother Jean Gregory, 2003
Black-and-white print
149 x 130 (58⁵/₈ x 51¹/₈) (framed)
Edition of 6 + 2 artist's proofs
Courtesy of Maureen Paley

[43] Gillian Wearing
Album: Self-portrait as my father Brian Wearing, 2003
Black-and-white print
164 x 130.5 cm (64⁵/₈ x 51³/₈) (framed)
Edition of 6 + 2 artist's proofs
Courtesy of Maureen Paley

[43] Gillian Wearing
Album: Self-portrait as my sister Jane Wearing, 2003
Digital C-print
141 x 116 (55¹/₂ x 45⁵/₈) (framed)
Edition of 6 + 2 artist's proofs
Courtesy of Maureen Paley

[43] Gillian Wearing
Album: Self-portrait as my brother Richard Wearing, 2003
Digital C-print
191 x 130.5 cm (75¹/₄ x 51³/₈) (framed)
Edition of 6 + 2 artist's proofs
Courtesy of Maureen Paley

[44–5] Samuel Fosso
My Grandfather's Dream: Sans Titre, 2003
6 C-prints
Courtesy of JM. Patras T&S Ltd.

[46] Jitká Hanzlová
Forest: Untitled (Working title: Wet Morning Grass), 2003
Colour print
Courtesy of the artist

[50] Elina Brotherus
The New Painting: Der Wanderer, 2003
Chromogenic print on Fuji Crystal Archive paper mounted on anodized aluminium and framed
80 x 100 (31¹/₂ x 39³/₈)
Courtesy of & : gb agency

[52] Joel Sternfeld
Walking the High Line: Looking South, 19th Street, Late October 2001, 2001
Digital C-print
© Joel Sternfeld, courtesy of Luhring Augustine Gallery

[53] Joel Sternfeld
Walking the High Line: Looking South Towards Chelsea Markets, December 2000, 2000/1
Digital C-print
© Joel Sternfeld, courtesy of Luhring Augustine Gallery

[54] Joel Sternfeld
Walking the High Line: Ken Robson's Christmas Tree, January 2001, 2001
Digital C-print
© Joel Sternfeld, courtesy of Luhring Augustine Gallery

[55] Joel Sternfeld
Walking the High Line: Looking South on a May Evening (The Starrett-LeHigh Building), May 2000, 2000/1
Digital C-print
© Joel Sternfeld, courtesy of Luhring Augustine Gallery

[56] Richard Misrach
On the Beach: #394-03, 2003
C-print
188 x 213.4 (74 x 84)
Courtesy of Fraenkel Gallery and Pace/MacGill Gallery

[57] Richard Misrach
On the Beach: #892-03, 2003
C-print
152.4 x 310 (60 x 122)
Courtesy of Fraenkel Gallery and Pace/MacGill Gallery

[57] Richard Misrach
On the Beach: #192-02, 2002
C-print
132.1 x 290 (52 x 114)
Courtesy of Fraenkel Gallery and Pace/MacGill Gallery

[58–9] Richard Misrach
On the Beach: #136-02, 2002
C-print
132.1 x 271.8 (52 x 107)
Courtesy of Fraenkel Gallery and Pace/MacGill Gallery

[60] Jitká Hanzlová
Forest: Untitled (Working title: Summer Meadow), 2003
C-print
Courtesy of the artist

[60] Jitká Hanzlová
Forest: Untitled (Working title: Black Light), 2003
C-print
Courtesy of the artist

[61] Jitká Hanzlová
Forest: Untitled (Working title: Green Sea), 2003
C-print
Courtesy of the artist

[62] Doug Aitken
New Opposition IV, 2003
C-print mounted to Plexiglas
141.4 x 122.6 (55¹¹/₁₆ x 48¹/₂)
Courtesy of 303 Gallery, Galerie Eva Presenhuber and Victoria Miro Gallery

[62] Doug Aitken
New Opposition II, 2001
C-print mounted to Plexiglas
141.4 x 122.6 (55¹¹/₁₆ x 48¹/₄)
Courtesy of 303 Gallery, Galerie Eva Presenhuber and Victoria Miro Gallery

[63] Doug Aitken
New Opposition III, 2003
C-print mounted to Plexiglas
141.4 x 122.6 (55¹¹/₁₆ x 48¹/₄)
Courtesy of 303 Gallery, Galerie Eva Presenhuber and Victoria Miro Gallery

[64] Uta Barth
white blind (bright red) (02.12), 2002
Mounted archival pigment photographs, 4 panels
Each 54 x 67.6 (21¹/₄ x 26⁵/₈)
Overall 54 x 276.2 (21¹/₄ x 108¹/₄)

[64] Uta Barth
white blind (bright red) (02.13), 2002
Mounted archival pigment photographs, 4 panels
Each 54 x 66.4 (21¹/₄ x 26¹/₈)
Overall 54 x 273.1 (21¹/₄ x 107¹/₂)

[65] Simone Nieweg
Tableau V, 2003–4
C-print
114 x 216 (44⁷/₈ x 85)
Courtesy of Gallery Gaby Kraushaar/Gallery Luisotti

[66] Andreas Gursky
Rimini, 2003
C-print
297.2 x 207 (117 x 81¹/₂)
© Andreas Gursky/VG Bild-Kunst, Bonn and DACS, London
Courtesy of Monika Sprüth/Philomene Magers

[66] Andreas Gursky
Arena III, 2003
C-print
279.4 x 207 (110 x 81¹/₂)
© Andreas Gursky/VG Bild-Kunst, Bonn and DACS, London
Courtesy of Monika Sprüth/Philomene Magers

[67] Andreas Gursky
Untitled XIII (Mexico), 2002
Colour print
279.4 x 207 (110 x 81¹/₂)
© Andreas Gursky/VG Bild-Kunst, Bonn and DACS, London
Courtesy of Monika Sprüth/Philomene Magers

[68] Dan Holdsworth
Black Mountains, 2001
C-print triptych
Each 179.1 x 236.2 (70¹/₂ x 93)
Courtesy of the artist

[69] Dan Holdsworth
Untitled (The World in Itself No. 3), 2000
C-print
121.9 x 152.4 (48 x 60)
Courtesy of the artist

[69] Dan Holdsworth
Untitled (The World in Itself No. 2), 2000
C-print
121.9 x 152.4 (48 x 60)
Courtesy of the artist

[69] Dan Holdsworth
Untitled (The World in Itself No. 5), 2000
C-print
121.9 x 152.4 (48 x 60)
Courtesy of the artist

[69] Dan Holdsworth
Untitled (The World in Itself No. 1), 2000
C-print
121.9 x 152.4 (48 x 60)
Courtesy of the artist

[70] Justine Kurland
Fool of Moxie in a Canoe, 2003
C-print
114.3 x 148.8 (45 x 57)
Courtesy of Gorney, Bravin and Lee

221

INDEX